MARBLE QUEENS
AND CAPTIVES

JOY S. KASSON

MARBLE QUEENS AND CAPTIVES

Women in Nineteenth-Century American Sculpture

YALE UNIVERSITY PRESS

New Haven & London

Published with assistance from the
Louis Stern Memorial Fund.

Designed by Richard Hendel.
Set in Walbaum type by
Tseng Information Systems, Durham, North Carolina.
Printed in the United States of America by
Halliday Lithograph Corporation, West Hanover, Massachusetts.

Library of Congress Cataloging-in-Publication Data
Kasson, Joy S.
Marble queens and captives : women in nineteenth-century
American sculpture / Joy S. Kasson.
p. cm.
Includes bibliographical references.
ISBN 0-300-04596-4 (alk. paper)
1. Marble sculpture, American. 2. Marble sculpture—
19th century —United States. 3. Women in art. I. Title.
NB1210.M3K3 1990
730′.975′09034—dc20 89-77342
CIP

The paper in this book meets the guidelines for permanence and durability of the
Committee on Production Guidelines for Book Longevity of the Council on Library
Resources.

10 9 8 7 6 5 4 3 2 1

For John

My partner in everything important

And for Peter and Laura

Most wonderful results of our partnership

CONTENTS

Illustrations

ACKNOWLEDGMENTS

Like everyone who attempts to be a scholar and a parent at the same time, I am especially grateful for the gift of time. During most of the decade I worked on this book, I relied on the devoted childcare provided by Mrs. Charlotte Regester. I would like to thank the University of North Carolina at Chapel Hill for the support provided by a Pogue Leave in the fall of 1982. The final stages of research and writing were made possible by a year-long fellowship at the Humanities Institute at the University of California at Davis in 1987–88.

My research was expedited by the competent and friendly assistance of staff members at a number of libraries, including the Boston Athenaeum, the Boston Public Library, the Harvard Theatre Collection, the New-York Historical Society, the New York Public Library, Yale University Library, the Library Company of Philadelphia, the Pennsylvania Academy of the Fine Arts, the Chicago Historical Society, the Watertown Public Library, the Index of American Sculpture, and the Archives of American Art. To the interlibrary loan staff at the University of North Carolina at Chapel Hill and the University of California at Davis, I owe a debt of gratitude for retrieving many rare books and pamphlets. Staff members at the Sloane Art Library, University of North Carolina at Chapel Hill, offered much valuable assistance. For answering my queries and providing me with helpful suggestions, I would like to thank William Gerdts, Barbara Groseclose, Robert Rosenblum, and Megan Marshall.

Most of the photographs of nineteenth-century periodicals and books were taken by the Photographic Services, Wilson Library, University of North Carolina at Chapel Hill, and I thank the meticulous and helpful staff there. A few were provided by Illustration Services at the University of California at Davis, and I gratefully acknowledge their contribution. The task of obtaining photographs and permissions from museums was made much easier thanks to a generous grant from the Fund for the Support of Publications and Artistic Performances, College of Arts and Sciences, University of North Carolina at Chapel Hill. Study photographs and preliminary research travel were supported by the University Research Council, University of North Carolina at Chapel Hill.

Numerous friends have patiently read and commented on various drafts of parts of this book over the years, and to all of them I wish to ex-

press my sincere appreciation. Commentators I found especially helpful include Rosa Maria Bosinelli, Wanda Corn, Kay Flavell, Vivien Green Fryd, Elliot Gilbert, T. Walter Herbert, Iris Hill, Mary Kelley, David Lubin, Diane McLeod, Roberta Rubenstein, Shirley Samuels, Donald Scott, and Mary Sheriff. Peter Filene provided a thorough and helpful reading of the entire manuscript. Any errors and infelicities in which I nonetheless persist must be entirely my own fault.

I should also like to thank the research assistants who have helped me from time to time, especially Anita Washam and Steve Rosensweig. Unfailingly cheerful secretarial support was provided by Debbie Simmons in Chapel Hill and by Judy Lehman and Ann Chamberlain in Davis.

I would like to include a special word of thanks to Jules Prown, who first taught me how to look at art objects and how to ask questions about their cultural significance.

As always, my best critic and reader, most enthusiastic supporter and thoughtful commentator, is my husband, John Kasson.

Introduction

This book examines the cultural history of a group of art objects and their reception in nineteenth-century America.[1] At the same time it seeks deeper insights into what has been described as the cultural construction of gender among the segments of American society who made, bought, or viewed these artworks.[2] Statues of women as captives or queens, victims or avengers, formed an important part of the cultural landscape in mid-nineteenth-century America. Poised between what the twentieth century would consider high art and popular culture, richly documented by the narratives of artists, clergymen, poets, and others, viewed by hundreds of thousands of people, these artworks flourished during a period of social and economic change, one that raised questions about the role and status of women in American society. Subsequent standards of taste plunged these sculptures into obscurity; scorned and neglected by critics and collectors, they often disappeared into basements, obscure corners, and probably junk-heaps, from which they have only recently been recalled by art historians. These forgotten marble women, and the stories their contemporaries read in them, suggest both the conventional concepts of woman's nature held by artists and audiences alike and the tensions and contradictions behind these concepts.

Between about 1850 and 1880, Americans who took an interest in the contemporary arts—whether artists, patrons, travelers, or critics—recognized a type of art they described as "ideal" sculpture. As distinguished from portrait sculpture, public monuments, or genre pieces, ideal sculpture consisted of three-dimensional figurative works, usually marble, life-sized or slightly smaller, portraying subjects drawn from literature, history, the Bible, or mythology. Although male sculptors dominated the profession, some women gained respect and recognition as sculptors of ideal subjects. Interestingly, the works of men and women alike showed a strong tendency to favor female subjects.[3]

Art historians sometimes describe this type of sculpture as neoclassical because the nude figures often took their proportions and poses from Greek and Roman sculptures and because the Americans who practiced this art were influenced by the great nineteenth-century neoclassical sculptors of the preceding two generations, Antonio Canova and Bertel Thorwaldsen.[4] However, although some of the sculpture, such as Hiram

Powers' famous *Greek Slave*, adhered closely to classical models, such other works as Randolph Rogers' *Nydia the Blind Flower Girl of Pompeii* reflected a revived interest in the baroque and a romantic sensibility.[5] Regardless of stylistic differences, the qualities shared by all the works I am describing as ideal include a powerful interest in subject, with a stress on the intellectual and emotional response required from the viewer.[6] Henry James later commented that mid-nineteenth-century art was expected to appeal to "the sense of the romantic, the anecdotic, the supposedly historic, the explicitly pathetic. It was still the age in which an image had, before anything else, to tell a story."[7] When discussing ideal sculpture, nineteenth-century artists, patrons, and viewers alike consistently stressed the intellectual, emotional, and moral narratives they expected art to embody.

The vivid stories that works of ideal sculpture told their nineteenth-century audiences found expression in a variety of ways. Some were poorly articulated and can be recovered only indirectly, whereas others were recorded in letters between artists and patrons, in descriptions of sculptures published in newspapers and magazines, or in the catalogs that were printed to accompany art exhibitions. Imagining a past, present, and future for a fictional subject, audiences participated in the production of meaning and revealed many of their own assumptions. Fervent believers in the equivalence of words and images, they saw in art objects representations of the world as they understood it. But their understanding was not always free from conflict and contradiction, and the narratives they constructed sometimes affirmed and sometimes subverted the artworks' ostensible meaning.

The men and women who viewed nineteenth-century ideal sculpture often scrutinized these marble women with an intensity forbidden in the gaze of everyday life. These representations of women sprang from and spoke to the deeply embedded assumptions about gender shared by makers, buyers, and viewers of sculpture.[8] In the statues themselves and the elaborate narratives with which viewers responded to them we can find an encoded summary of nineteenth-century Americans' ideas, hopes, fears, and associations surrounding the subject of women—their nature, their role, their capabilities.

This drama of expression and reception was situated in a historical context that gave special urgency to the question of how to interpret woman's nature. Ideal sculpture flourished at the very time when the role of woman in American society was undergoing momentous changes.

During the middle decades of the nineteenth century, cultural authorities ranging from clergymen to popular poets, doctors, and writers

of etiquette manuals enshrined in their pronouncements an ideology of female passivity and vulnerability.[9] The idealized woman, who found vivid literary expression in Coventry Patmore's *The Angel in the House* (1854–62), was portrayed as submissive, altruistic, and above all domestic. This characterization of woman's nature was enthusiastically endorsed by some women. One female novelist, for example, invented these marriage vows for her fictional heroine: "I, Ernestine, take thee, Arthur, to be my wedded husband, to receive from you all the favors that you choose to bestow, all the love that you can conveniently spare, to be considered by you as the idol to whose wishes all other wills must bow, and promise in return—*to be satisfied*. Who could expect more?"[10] However, as Charlotte Perkins Gilman would vividly illustrate a few years later in *The Yellow Wallpaper*, for some women the restricted life of the domestic paragon, the "queen's garden," as John Ruskin had described it, was a suffocating prison.[11]

As Gilman trenchantly observed in her volumes of social analysis, the nineteenth-century conception of "woman's sphere" reflected important changes in economic and social structures.[12] As productivity moved increasingly out of the home and into the factory, and as modern technology transformed homemaking into a consumer activity, the role of women in the economic life of the family became more marginal.[13] At the same time, greater emphasis was placed on the role of women in the emotional life of the family. Increasingly, by the end of the nineteenth century, the family was defined as the proper sphere for women of the genteel classes, and the home had become a bastion of emotional retreat from a competitive, commercial culture.[14]

Ironically, the idealization of women as fragile, protected, helpless creatures occurred at the very time when some women were beginning to work in factories, to engage in public speaking, and to campaign for an expansion of their legal and political rights. The claim that women needed male protection outside the family represented a self-serving effort to preserve male dominance in a society undergoing rapid changes; but it also reflected a deeper and more ambiguous, if unacknowledged, fear of woman's social and sexual power. Cartoonists represented suffragists as distorted, misshapen figures, while a caricature of Frances Wright, one of the first women to appear as a platform speaker, pictured her with a female body and a squawking goose's head.[15] Again and again, powerful and independent women were portrayed as unnatural monstrosities.

Closely linked to this fear of women who transcended domestic bounds, however, was an element of desire. Peter Gay has recently shown that

the private lives of the nineteenth-century bourgeoisie harbored a wide range of sexual expression and experience despite its public prudery.[16] Although American artists and writers continued to treat the subject of female sexuality less openly than their European counterparts, the image of the fallen woman, the sensuous dark lady of romantic fiction, began to appear after midcentury. In the less prudish environment of the theater, actresses like Lola Montez depicted sultry seductresses in roles that were supposedly based on true adventures.[17] Woman's departure from the conventions of domesticity and self-sacrifice could be titillating, as well as threatening.

The changing social and economic conditions of the mid–nineteenth century created a climate of doubt and insecurity detectable even in forms of cultural expression that seem to support the values of the status quo. In a literary form as apparently affirmative as sentimental fiction, scholars have recently noted a dark vision of threatened domesticity.[18] Similarly, ideal sculpture appeared to offer a pantheon of idealized women: passive, submissive, vulnerable. Yet the images themselves and the narratives they inspired in their audiences seethed with contradictions. Captive women were said to be overwhelmingly powerful; famous queens were depicted as melancholy mourners. In the process of making, viewing, and responding to these art objects, nineteenth-century Americans recapitulated their deep ambivalence and burning anxiety about the meaning of woman's nature and about the survival of the family.

Marble Queens and Captives explores the cultural significance of several of the most celebrated examples of nineteenth-century ideal sculpture. The first two chapters establish the social context for these works of art by examining the identities of artists and patrons and by describing the various settings in which sculpture was viewed during this period. The following chapters focus on particular sculptures, documenting as fully as possible their production and reception and their relationship to a cultural matrix. Beginning with the best-known example of American ideal sculpture, Hiram Powers' *The Greek Slave*, the book demonstrates the interweaving of themes of captivity, female vulnerability, and spirituality with those of dangerous sensuality, loss of identity, and disrupted domesticity. By considering the interpretation of potentially powerful female subjects—Eve, Pandora, Cleopatra, Medea—we may see how artists and audiences struggled to deny their worst fears and to affirm conventional gender roles, even in the face of threatening challenges to those roles. From the sculptures themselves, and from the narratives they inspired, emerges a complex portrayal of the cultural construction of gender in nineteenth-century America.

1

IDEAL SCULPTURE
Artists and Patrons

The social history of nineteenth-century American art is still being written. Only in the past twenty-five years have scholarly biographies of important artists documented details that can help us reflect on their social origins, education, patronage, and the reception of their art.[1] Artists, like other citizens, hold and transmit values that reflect their social and economic experience; they also share with their patrons and their audiences certain assumptions that define the terms on which their art will be understood by its viewers.[2] Before we can assess the cultural significance of a group of art objects, we need to know more about the circumstances of their production and exhibition. Who were the makers of American ideal sculpture? Who bought it? Who viewed it, and under what circumstances?

Hiram Powers, creator of *The Greek Slave*, was unquestionably the best-known American sculptor of the mid–nineteenth century, and his career in many ways illustrates a common pattern. Born on a farm in Woodstock, Vermont, Powers moved to Ohio with his parents as a young man; after his father's death he supported his family with a variety of jobs. His skill at mechanical invention prompted an employer to suggest that he should study drawing and modeling at the Cincinnati Academy of Fine Arts. Hired by a wax museum to repair its figures, he was soon assigned the task of creating new ones, including a ticket-taker so lifelike that it deceived the crowds for a whole evening, and a terrifying diorama of the "infernal regions" complete with fire-breathing demons.[3] With the backing of a wealthy businessman and art patron, Nicholas Long-

worth, Powers toured the Eastern United States, sculpting portrait busts of famous Americans—including Andrew Jackson—and then accepted the financial support of another patron to study in Italy. Powers settled in Florence in 1837 and supported himself at first with portrait commissions; then in 1842 he completed his first ideal study, *Eve Tempted*. The success of this work and of *The Greek Slave*, which was exhibited throughout Europe and the United States, brought Powers fame and fortune and made his studio in Florence an important tourist attraction.

Powers' biography contains the elements characteristic of many Americans who became sculptors between 1830 and 1880. He was not particularly well-educated; he came to sculpture through an artisan tradition; he practiced sculpture as part of a continuum of popular entertainments and amusements (in this case the wax museum and the portrait gallery); he received enabling financial assistance from wealthy backers; he acquired technical skills in Europe; and he moved from portraiture to ideal sculpture as soon as he had begun to establish his reputation. Most American sculptors of his and the following generation followed this career pattern. Chauncey Ives (b. 1810) was a farmer's son who was apprenticed to a wood-carver; Thomas Crawford (b. 1811/13?) worked as a stonecutter and maker of marble mantlepieces; Erastus Dow Palmer (b. 1817) began as a carpenter in Onondaga County, New York, and then later became a cameo cutter; Edward Augustus Brackett (b. 1818) worked as a block cutter for a Cincinnati printer; Thomas Ball (b. 1819) was the son of a house and sign painter who also had a job repairing figures in a wax museum; Randolph Rogers (b. 1825) worked in a dry-goods store; Joseph Mozier (b. 1812) had a career as a merchant before becoming an artist; William Henry Rinehart (b. 1825) worked as a stonecutter. The only major exceptions to this pattern are Horatio Greenough (b. 1805) and his brother Richard (b. 1819), who came from an educated and intellectual New England family; William Wetmore Story (b. 1819), who had a distinguished career as a lawyer and poet before he took up sculpture; and the female sculptors: Harriet Hosmer (b. 1830), daughter of a physician; Louisa Lander (b. 1826), member of a prominent New England family with ties to the painter Benjamin West; Anne Whitney (b. 1821), another New Englander, who was known for her poetry before she studied sculpture; and Edmonia Lewis (b. 1845), daughter of a Chippewa mother and a black father, educated at Oberlin, protégée of William Lloyd Garrison.

From the biographies of these sculptors, three important observations emerge: first, access to an artistic career in mid-nineteenth-century America was relatively democratic; second, the line between what we

would today consider the popular arts and the fine arts was still fairly fluid. Furthermore, for individuals of humble origin to rise to success as artists, they needed financial support and backing. Access to an artistic career, then, was both open and brokered; it drew from a broad range of society, but it depended on the support of the socially established.

·

The development and popular reception of the arts in nineteenth-century America became part of a larger debate over national identity. Ideal sculpture rose to prominence at a time when many observers were anxiously seeking evidence that the American republic could support artistic and intellectual, as well as material, enterprises. Emerson was calling, in essays and lectures, for the poet who would express characteristically American themes, while the Young America school of literature was looking eagerly for the "greater than Shakespeare," as Melville expressed it, who would soon be born on the banks of the Ohio.[4] Ties of friendship and shared interest in romantic themes had linked writers and painters since the turn of the nineteenth century, and critics looked to such visual artists as Hudson River painter Thomas Cole, as well as to writers, for evidence that the American landscape would inspire art worthy of international attention.[5] William Dunlap's *History of the Rise and Progress of the Arts of Design in the United States* (1834) argued that the visual arts were on the rise in Jacksonian America, destined, as were other aspects of American culture, for glory. Dunlap and other defenders of the fledgling American artistic community struggled against the perception of such European visitors as Alexis de Tocqueville that Americans' genius turned toward the practical rather than the spiritual and that no significant achievement in the arts should be expected in democratic society. Young Americans choosing careers in the arts were eagerly greeted by commentators like Dunlap as patriots and heroes, whose careers proved that the new nation was rising above merely material and commercial endeavors.

Thirty years later, however, another art critic would reinterpret the role of the arts in American life in order to minimize the artist's separation from commercial culture. At the close of the Civil War, Dunlap's book was updated by Henry Tuckerman, a writer and sometime artist who, like Dunlap, personally knew most of the artists he wrote about.[6] On the brink of the Gilded Age, Tuckerman described the rise of the arts in America as a success story to rival that of the expanding commercial economy in the second half of the nineteenth century. Instead of portraying artists

as intellectual and spiritual leaders, he pictured them as representative men carrying out the dictates of a success-oriented culture within their own chosen field of work.

Published in the same year as Horatio Alger's *Ragged Dick*, Tuckerman's *Book of the Artists* told much the same story of hard work, good character, and upward mobility.[7] Like Ragged Dick, who slept in a box but rose from rags to respectability through hard work, the Albany sculptor Erastus Dow Palmer was described by Tuckerman as the wholesome product of humble origins: "We deem it indeed one of the most fortunate circumstances in the career of Palmer, that his youth was thoroughly disciplined by mechanical industry, his ingenuity taxed in the economical aptitudes of labor, and his hand and eye made strong and adaptive in the more humble vocation of the artisan."[8] Tuckerman pictured Thomas Crawford applying the lessons of thrift and hard work in the early days before he achieved recognition: "This is the great lesson of his career: not by spasmodic effort, or dalliance with moods, or fitful resolution, did he accomplish so much; but by earnestness of purpose, consistency of aim, heroic decision of character."[9] Tuckerman also paid tribute to the generosity and benign control exercised by art patrons. Like Ragged Dick, who received good advice, a new suit of clothes, and a five-dollar bill from a helpful benefactor, Palmer's life was changed, according to Tuckerman, by "a gentleman—one of those rare exceptions to the mere utilitarian character of our professional men" who gave him encouragement and support. And like Alger's hero, who discovered that people treated him differently when he wore good clothing and spoke like a gentleman, Hiram Powers found, according to Tuckerman, a change in social status along with a new vocation: "His chosen pursuit soon gained him the best social privileges. . . . In several instances he was the guest of [his sitters] . . . becoming familiar with them in their own homes."[10] Success as an artist, then, was for Tuckerman a path to social respectability and increased status; like Alger's heroes, Tuckerman's artists improve their material lot and their standing in society as they gain fame. "The commodious atelier and dwelling-house [of Erastus Dow Palmer]—fruits of his professional labors—plainly indicate that they have been successful, even according to the external American standard."[11]

At the same time, however, Tuckerman was concerned that the forward thrust of the ever more prosperous (northern and western) economy would distract and corrupt the artist. Lamenting that in art, as in other aspects of American life, the market determined success, Tuckerman commented that the practice of art was often reduced to "an exclusive mechanical facility and economical spirit."[12] It was easy to practice

art but difficult to become a true artist, Tuckerman contended. "There is, first of all, pressing upon [the artist's] senses and beleaguering his mind, the ideas of material success, whereby not only fortune, but wit, is measured in this prosperous land; then, the fever and hurry bred by commerce, political strife, and social ambition, insensibly encroach upon artistic self-possession."[13] Tuckerman feared not only the turmoil of what some commentators had called the "busy republic" but its materialism and emphasis on success; such pressures, he implied, might discourage individuals from pursuing artistic careers or else might tempt them to become mere popularizers. Passages such as the one above reveal his ambivalence toward the thriving commercial culture around him. He both celebrated and lamented the relationship between artistic and material success.

For the artists themselves, the ambiguous relationship between art and commerce raised pressing questions of personal survival. In the absence of state-supported art schools and scholarships for artists, private patronage or entrepreneurial exhibition provided the only sources of income for would-be artists. Ideal sculpture may have appealed to artists because its practice was more spiritual and intellectual than the making of portraits, but it could flourish only because it won the approbation of individuals with the resources to buy it or pay admission to see it. The overwhelming majority of American sculptors did not have independent means of income, and in order to survive, they had to find a common ground of taste and aspiration with those who had succeeded materially in the emerging commercial culture. Thus it is not surprising to find that ideal sculpture came to represent, for both artist and audience, a token of status and success.

Erastus Dow Palmer, whom Tuckerman had cited as an example of social and artistic mobility, in many ways embodied the ambiguous relationship between art and commerce for the nineteenth-century sculptor. A painting of Palmer's studio by Tompkins H. Matteson, done in 1857, suggests the connection between artistic success and rising social status (fig. 1). Palmer appears in the foreground of the picture in a heroic pose; rather than an artisan's work clothes, he wears an artist's tunic and soft hat, which, as Tuckerman had observed on a visit to Palmer, evoked the atmosphere of Rome or Florence.[14] The artist is working on a clay model, the first stage in the three-part process by which sculptors produced the finished marble sculpture.[15] Gazing intently at the work of art he is creating, carving tool poised in his hand, he represents artistic genius at the moment of creation; his pose is reminiscent of a celebrated American portrait of an artist from the preceding century, John Singleton Copley's

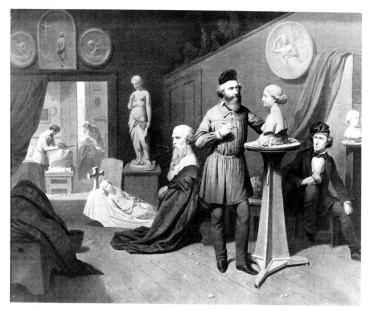

FIGURE 1. Tompkins H. Matteson, *A Sculptor's Studio*

Paul Revere. From this intent, creative gaze, the painting implies, flow all the surrounding art objects, and Matteson carefully reproduces Palmer's most celebrated works. The artist is not alone in the picture, however. Two assistants work with him, one in shirtsleeves in the back room, engaged in preliminary cutting of the marble, and another sitting at Palmer's feet, turning from his own task, the finer finishing of a marble bust, to admire the process of Palmer's genius.[16] Although the use of assistants was controversial (some misunderstood their significance and suggested that the sculptors were letting others do the work for them), Matteson clearly suggests a hierarchy of talents in the studio he pictures. The assistants are obviously subordinate, dressed in different clothing, deferring to the master. The painting suggests power and success, both by showing the works of art the sculptor has produced and by showing his command over others. The portrayal of Palmer's social standing is completed by the presence, in another back room, of a gentleman browsing among the works of art. The patron here is a client, kept waiting while the artist plays out his moment of inspiration. Although the patron is only dimly visible, his presence represents an affirmation of the artist's skill and status. The practice of ideal art opens the door to the world of commercial success.

Palmer was unusual in his ability to achieve this elevation in status and skill without traveling abroad. Most of the other successful sculptors

of ideal subjects spent at least part of their careers in Italy, where marble was cheap and skilled assistants plentiful. American artists also received valuable instruction in craftsmanship from the European sculptors who had been making, selling, and exhibiting ideal sculpture for nearly half a century before the Americans began to arrive. Although Tuckerman, eager to defend American originality, underemphasized the relationship between American artists and European mentors, some assistance from established artists was important for most of them: Crawford and Greenough worked with Thorwaldsen, Greenough and Randolph Rogers with Bartolini, Harriet Hosmer with English sculptor John Gibson. From these mentors, American sculptors derived both technical instruction and an introduction to a repertoire of ideal subjects.

For the female sculptors, most of whom came from genteel backgrounds, the experience of living and working in Europe was especially important. Like the painter Mary Cassatt, who left America in 1865, American women sculptors found that in Europe they could transcend the pervasive amateurism to which women's artistic pursuits were largely relegated in the United States. The group of women sculptors in Rome, whom Henry James dubbed the "white marmorean flock," formed a social and artistic community that also included writers and, most prominently, the actress Charlotte Cushman.[17] Nathaniel Hawthorne, too, employed bird imagery when he drew on his observations of Harriet Hosmer and Louisa Lander to create the character of Hilda, the dovelike heroine of *The Marble Faun*. A touch of condescension colors the views of both James and Hawthorne, although Hawthorne's first journal entry on Lander praises her "genuine talent, and spirit and independence."[18] Artistic success did not bring these women increased social status, but it did represent greater freedom.

That freedom had limits, however, as Louisa Lander's career attests only too well. In February 1858, Hawthorne marveled at Lander's ability to go "fearlessly about these mysterious streets, by night as well as by day, with no household ties, no rule or law but that within her; yet acting with quietness and simplicity, and keeping, after all, within a homely line of right."[19] By autumn 1858, something had happened to cause her to lose respect among the American community in Italy: Hawthorne recorded in his pocket diary, "Mr. [Cephas Giovanni] Thompson called before dinner, & spoke of Miss Lander. What a pity!"[20] When Louisa Lander and her sister tried to call on the Hawthorne family, Nathaniel Hawthorne sent them a stiff note saying that, considering the circulation of "reports . . . most detrimental to her character," she should not attempt to visit her "former friends" until she could refute these charges. The gates of

respectability swung firmly shut against her as Hawthorne indicated that she had transgressed what he saw as a clear boundary. "As far as her own conscience is concerned, Miss Lander's life (as she truly observes) lies between her Maker and herself, but in her relations with society, the treatment she receives must depend upon her ability to make a good and reasonable defense against the charges imputed to her."[21] After this Hawthorne refused "for reasons unnecessary to mention" to "communicate with the lady" at all, as he wrote to a friend.[22] Lander's cousin, John Rogers, was not so tactful. He wrote home describing his cousin's "loss of reputation," saying that some people asserted that she had "lived on uncommonly good terms with some man here," while others "affirm that she has exposed herself as a model before them in a way that would astonish all modest Yankees."[23] Rogers went on to add that he believed the latter story was true and "probably forms the foundation of all the rest."[24] Although her sculpture received favorable notices in the press, Lander eventually left Rome, her career stultified.

Lander's experience indicates that the boundaries of socially acceptable behavior were still narrowly drawn for these women. If Rogers' surmise is correct, Lander was ostracized for behavior (posing, probably nude) that would have been acceptable in a male artist or a lower-class woman. Class and gender expectations were part of the insistent cultural matrix within which ideal sculpture developed.

•

Works of ideal sculpture also represented a social statement of sorts for the patrons who bought them. In the early nineteenth century a vigorous effort was made to establish some forms of public patronage for American artists, including commissions for painting and sculpture in national, state, and local government buildings.[25] However, private patronage formed the most important source of support for the arts in nineteenth-century America, and during the course of the century, ownership of art objects took on social significance for wealthy Americans.

It is important to distinguish between two types of private art patronage in nineteenth-century America. All of the artists needed buyers for their sculptures, even those—like Story, Hosmer, and Lander—with some financial resources. But many artists also received more extensive assistance: Powers, Greenough, Ives, Rogers, Rinehart, and others had sponsors, wealthy individuals who paid for all or part of their expenses while they studied and set up their studios. These benefactors took an abiding interest in the arts and aided artists through direct grants and

commissions. They often had private art galleries, many of which later formed the core collection for a museum, such as the Corcoran Gallery in Washington or the Walters Art Gallery in Baltimore. Benefactors were often active in civic art associations as well. [26]

The early career of Horatio Greenough shows the crucial importance of benefactors and their social networks. While Greenough was a student at Harvard, he had become friendly with Washington Allston, the respected painter who traveled in Italy and worked in England before settling in Cambridgeport to paint and develop his aesthetic theories.[27] "Allston . . . was to me a father, in what concerned my progress of every kind," Greenough later wrote; from the painter he derived an aesthetic impulse toward ideal subjects, a desire to go to Italy, and a connection with wealthy Boston art patrons who had been supporting Allston.[28] When Greenough left America in 1825, his trip was financed by a loan from Boston merchant Amos Lawrence.[29] After a brief return to the United States, Greenough set out for Europe again in 1828, having been offered free passage on a merchant ship by Col. Thomas Handasyd Perkins, one of Allston's benefactors, as well as a thousand-dollar loan from a group of Boston merchants headed by William Harvard Elliott.[30] Although Perkins later visited Greenough in Florence and Greenough shipped some casts of statues by Michelangelo to him, the Boston merchants were acting more as philanthropists than as art patrons, and there is no record that Greenough even sculpted their portraits. [31]

Greenough's later career was furthered by two other individuals who provided both orders for sculpture and aesthetic advice and encouragement. Robert Gilmor, a wealthy Baltimore merchant, had met Greenough in Washington, where Greenough was earning money for his second trip abroad by carving busts. Gilmor invited Greenough to come to Baltimore to make portraits of himself and his wife; he showed the sculptor his library and his extensive art collection. Gilmor was apparently instrumental in helping to arrange the loan Greenough received from William H. Elliott and the other Boston merchants.[32] Furthermore, Gilmor encouraged Greenough to propose an ideal sculpture for him and allowed him to draw money from his European bankers before the statue was finished.[33] This work, *Medora*, started in 1830 and shipped to its purchaser in 1833, was the first ideal female subject by an American sculptor. Gilmor further aided Greenough by giving permission for—and going to significant pains to arrange—the public exhibition of *Medora*. [34]

Greenough also received financial assistance and encouragement from the American author James Fenimore Cooper, whom he met in Florence in 1828. Greenough had planned to carve Cooper's bust as part of his

ongoing bread-and-butter portrait collection.[35] But the American author took a lively interest in the sculptor and offered him support in the form of a commission for the first ideal group sculpted by an American artist, *Chanting Cherubs* (1830). Cooper also lent Greenough money and advanced his career by writing enthusiastically of him to the press and to friends.[36]

Greenough later received important public commissions, with the assistance of Cooper and others, but at the beginning of his career it was through private philanthropy that he established himself as a sculptor. Similarly, Hiram Powers was supported by Nicholas Longworth, a Cincinnati merchant, and John Preston of South Carolina. Longworth had offered to buy a wax museum and place Powers in charge, but Powers had instead accepted financing for a trip to Washington, D.C.[37] There he met Sen. William Campbell Preston, and in 1837 the senator's brother, John Preston, offered Powers a thousand dollars a year for three years to help him establish a studio in Italy.[38] Chauncey Ives went to Florence in 1844, thanks to the assistance of three wealthy Philadelphians, Charles Chauncey, William H. Dillingham, and Charles McAllister.[39] Randolph Rogers received financial backing from the merchant for whom he worked when he came to New York from Ann Arbor, Michigan. According to a fellow employee's recollections, the merchant, John Steward, told Rogers, "Well, Randolph, if you think this is your forte I'll put up the necessary money for your education in your art abroad. You can equip yourself with such clothing as you will want, going to my tailor, and you can take anything you may require. When you are ready, I will give you the money you will need."[40] Harriet Hosmer relied on financial aid from Wayman Crow, St. Louis businessman and father of one of her close friends, after her father suffered financial losses in 1854.[41] William Henry Rinehart received support for European travel in 1858 from William Thompson Walters, a Baltimore financier whom he had first met when he repaired a marble fireplace in Walters' home.[42] Nicholas Longworth, the same Cincinnati lawyer who aided Hiram Powers, also financed the European studies of Shobal Vail Clevenger and commissioned a sculpture by Larkin Mead after reading a newspaper story about the young sculptor.[43]

All these art benefactors shared with William Dunlap the conviction that support for American artists constituted a patriotic duty.[44] Furthermore, their generosity and nationalism reflected their position in a rapidly-changing social and economic environment. These benefactors represented a particular sector of antebellum American society.

Recent studies of American economic growth and of income distri-

bution have begun to reshape our view of wealth and social class in nineteenth-century America. In the first half of the nineteenth century economic growth was rapid; at the same time the distribution of wealth was becoming more and more unequal.[45] By 1860, the richest 1 percent of the American population held 29 percent of the wealth, while the top 10 percent owned 73 percent.[46] A painstaking study of individual wealthy Americans in major American cities has shown that few of the wealthiest Americans of the antebellum period were self-made men who had risen from obscurity to riches; most were born to well-established families whose wealth was based in commerce and landholding.[47]

Most of the art benefactors who assisted ideal sculptors fit this description. The Boston merchants who aided Greenough belonged to families that had been prominent in New England for many years. Thomas Handasyd Perkins was a third-generation merchant who became a bank president and an early investor in railroads; Amos Lawrence was descended from a member of John Winthrop's colony and ran a successful merchant firm with his brother before becoming one of the earliest New England industrialists. Nicholas Longworth's biographies stress his rapid rise to wealth as a result of clever land investment (his first case, the defense of an alleged horsethief, yielded two second-hand copper stills, which he traded for thirty-three acres of land later worth two million dollars), but he came from a distinguished Loyalist family that had held extensive property before the American Revolution. William Thompson Walters, the patron of William Henry Rinehart, was the son of a merchant and banker. Hiram Powers' patron John Preston, who had earned his fortune in a Louisiana sugar plantation, came from a well-connected South Carolina family.[48]

The art benefactors most closely involved with nineteenth-century ideal sculpture, then, represented an older, well-established class of wealthy Americans. Most of them were well-educated: William Campbell Preston became the president of the University of South Carolina; John Preston and Nicholas Longworth were educated as lawyers, and William Thompson Walters was an engineer. James Fenimore Cooper had attended Yale and was, of course, an important literary figure. They were also philanthropists of wide-ranging interests: Thomas Handasyd Perkins and Amos Lawrence helped to found the Boston Athenaeum; Lawrence supported both Williams College and Groton Academy, while Perkins endowed the Perkins Institute for the Blind. Charles McAlester, one of the patrons of Chauncey Ives, founded McAlester College in Minnesota, and William Campbell Preston, patron of Hiram Powers, established the Lyceum in Columbia, South Carolina. Robert Gilmor was

president of the Maryland Academy of Sciences and Literature and of the Washington Monument Association of Baltimore.

For the art benefactors, then, support for young artists was part of a larger effort to exercise cultural leadership, educate, and uplift in a rapidly changing American society. An economic elite, they sought to maintain a public culture that stressed the values of a disciplined, educated sensibility. Admirers of this class praised them for their enlightened aesthetic taste and went so far as to suggest that a new age of the Medicis might be dawning.[49] In the *Book of the Artists* Henry Tuckerman flattered American collectors in just such terms, praising the collections of "prosperous citizen[s], even in some isolated district or minor town, who boasted the refinements of an educated ancestry."[50] Of another art patron, he commented "that a call upon him was like visiting a venerable burgomaster of Holland, or a merchant-prince of Florence, in her palmy days."[51] Tuckerman's repeated call for a more elevated public taste can thus be read as a yearning for a more deferential society, more appreciative of the values of the educated.

But Tuckerman was also worried that the wealthy classes did not appreciate art sufficiently. Art patronage, he suggested, could be a remedy for some of the problems besetting the wealthy: nervousness, exhaustion, and boredom. "Reader," he asked in the introduction to the *Book of the Artists*, "did you ever spring into an omnibus at the head of Wall Street, with a resolution to seek a more humanizing element of life than the hard struggle for pecuniary triumphs? Did you ever come out of a Fifth Avenue palace, your eyes wearied by a glare of bright and varied colors, your mind oppressed with a nightmare of upholstery, and your conscience reproachful on account of an hour's idle gossip?" The first question appears to be addressed to his male readers, the second to women. In either case, the answer is clear: "Go and see the artists."[52] James Jackson Jarves, art critic and collector, a man of leisure and wealth himself, put it even more strongly. "We accumulate riches in families so rapidly that an intellectual safety-valve becomes an urgent necessity to turn idle talents to use, and prevent their self-destruction. Actually it is a grave social problem to know what to do with the increasing numbers of young men born to great incomes; rather for them to know what to do with themselves after leaving college."[53] Alcoholism and suicide, Jarves continued, threatened the wealthy youth who did not find some constructive outlet. Art patrons, then, may have invested more than money when they supported rising young artists. Tuckerman and Jarves clearly suggested that an interest in the arts might have filled a painful void in the lives of privileged Americans from established families.

Control of others and self-control are two important themes in the writings of critics and collectors about the significance of art in nineteenth-century American life. The art benefactors, who came from an established wealthy class, assisted the artists, who came from artisan or farming backgrounds, to produce art that was particularly identified with high moral purpose, designed to "elevate and refine," as Jarves put it, and also, by implication, to control.[54] Not surprisingly, many of these same themes are echoed in the artworks themselves, as further chapters will attest.

What significance, if any, can we attach to the social and economic condition of the other type of art patron—the individual who bought ideal sculpture either as part of a larger impulse to collect or as an isolated purchase? No thorough study has been made of the purchasers of ideal sculpture; the lists of names that have been generated for such individual artists as Powers, Rogers, and Story suggest great variation in the types of patrons. Some of them seem to be the same kinds of wealthy Americans who served as art benefactors: Hamilton Fish, distinguished New York politician, governor, U.S. senator, and secretary of state, bought sculpture from both Powers and Palmer; Edward Everett, writer, orator, and statesman, bought from Greenough and Powers. Russell Sturgis, who bought one of Story's early ideal works, was a senior partner in an important merchant firm.[55]

By the 1850s, however, a much broader spectrum of Americans was buying ideal sculpture—if not full-sized statues, then reductions or busts. Beginning in the decade before the Civil War, and in even greater numbers after the war had ended, more Americans than ever were visiting Europe, and the sculptors' studios became an important part of the grand tour.[56] Tuckerman told a humorous story of "a Western man, rather a novice in European travel," who asked Hiram Powers the price of a statue. "Upon being told three thousand dollars, he gave a long whistle, raised his eyebrows, buttoned up his pockets, and strode away exclaiming, *How sculpter's riz!*"[57] A refreshing hint of Mark Twain blows through this anecdote, but Tuckerman's assurance that sculpture often resold for an even higher price and was therefore a good investment reveals the class anxiety that lurked behind his geniality.

In fact, many of the purchasers of ideal sculpture, especially in the 1850s and 1860s, seem to have been members of a different socioeconomic group from that of the art benefactors: newly wealthy Americans with little education or cultural experience. One of the largest collections of ideal sculpture during the 1860s, which included works by Hiram Powers, Harriet Hosmer, Thomas Crawford, and Randolph Rogers, be-

longed to New York department store magnate A. T. Stewart. Stewart, an Irish orphan who had arrived in New York at the age of seventeen, made a fortune as a merchant and is considered the inventor of the modern department store. Newly wealthy, newly patriated, he emulated the more established families of New York, building a mansion with an art gallery on Fifth Avenue and participating in various philanthropic enterprises.[58] Of course, the classic depiction of a nouveau riche business-man's aspiration to gentility is William Dean Howells' novel, *The Rise of Silas Lapham*. Just as Lapham, the mineral-paint king, tried to gain acceptance into Boston society by building a big house, so many newly wealthy Americans in the decades after the Civil War sought to embody their new social status in architecture and art. On the west coast, Judge Edwin B. Crocker, brother of the railroad magnate and an early inves-tor in and manager of the Central Pacific himself, built a large home in Sacramento and traveled to Europe to buy art for a collection that eventually included two ideal sculptures by Randolph Rogers and one by Joseph Mozier.[59] For the newly wealthy, ornate homes and works of art represented what French sociologist Pierre Bourdieu has called "cul-tural capital," the claim to good taste that is the mark of the socially privileged.[60]

·

The artists who produced ideal sculpture, the benefactors who supported them, and the patrons who bought their works, then, all had a stake in the emerging commercial culture of nineteenth-century America. The benefactors saw art as a form of social control and social redemption; for the artists and many of the newly-wealthy patrons, the world of high art represented an affirmation of their own status and importance in the world. All saw support for American art as a patriotic gesture. There may be some connection between the sense of social drama in which these artists and art patrons were involved and the highly dramatic narrative content they preferred in the sculpture they chose. In the story of the imperiled captive, the shipwrecked mother, the vanquished queen, could they find some equivalent to the challenges and changes their lives were undergoing? Images of worldly vulnerability and moral triumph, sugges-tions of a never-ending struggle, spoke to the concerns of both an older economic elite and a rising business class on the brink of a period of social and economic transformation.

What significance can we attach to the overwhelming preference among both artists and patrons for female subjects? To some extent, American artists were merely participating in an aesthetic convention

that had dominated European sculpture for the previous half century. The depiction of beauty, commentators insisted, was art's chief goal, and the female form was inherently more beautiful than the male.[61] Thorwaldsen and Canova, Bartolini and Gibson, all sculpted numerous female subjects drawn from history, mythology, and the Bible.

There are, however, striking differences between American ideal female subjects and many of their European counterparts. American sculpture was far less sensuous; there is nothing as overtly erotic as Canova's *Cupid and Psyche* (1793) or *Pauline Bonaparte Borghese as Venus Victorious* (1805–8). American sculptors were mindful of a greater prudery in American popular taste, as illustrated by the controversy over the nudity of Horatio Greenough's *Chanting Cherubs*; as we shall see, subsequent public exhibitions took care to educate the public about the uses of nudity in art.[62]

If American subjects tended to be particularly chaste, they also tended to be especially dramatic. Scenes of captivity, transformation, violence, and death recur. Such emotionally charged subjects seemed to confirm the sense of both artist and patron that they were living in a time of social and economic change; perhaps they also reflected a heightened sense of domestic dislocation.

The rise of ideal sculpture coincided with an important shift in the American economy and culture—the movement away from a household to a commercial economy—which brought important changes for American women of the middle and upper classes. Removed from active participation in the economic life of the family, isolated in a woman's sphere hedged with prescriptive limitations, women of the business and commercial classes entered a period of limbo that would last until the emergence of the "new woman" at the turn of the century.[63] To fill this vacuum, women of the upper classes defined art and culture as part of their domain, so it is not surprising to see women emerging as art patrons by the 1860s.[64] As many as one-quarter to one-third of the purchasers of Randolph Rogers' ideal sculptures, as recorded in his notebooks, were women.[65] In addition, women probably played a role in many purchases recorded in their husbands' names; Erastus D. Palmer's correspondence with one of his patrons, James Watson Williams, suggests that Mrs. Williams participated in planning for the sculpture.[66] No women appear to have been art benefactors, although the actress Charlotte Cushman provided moral support for and shared a household with Harriet Hosmer in Rome. Like the rising businessmen, the middle- and upper-class women of the mid–nineteenth century were trying to define their roles in a changing culture. Perhaps the dramatic urgency many of the ideal

sculptures evoked had a counterpart in the need of genteel women to find a place for themselves within nineteenth-century commercial culture.

The social history of the making and buying of ideal sculpture can at this point only be sketched. More thorough examination of the account books of sculptors and of patrons may provide a more detailed view of the social networks involved. Most artists were themselves socially mobile, aspiring toward the class represented by their sustaining benefactors, the older genteel culture that was fast being transformed by the rising commercial economy. The few women who figured as artists or as art patrons faced a double set of unknowns in the shifting of both economic and social grounds. The making and buying of ideal sculpture thus acquired a web of social and economic associations that provide the background against which the sculptures and their perceived meanings must be evaluated.

2

VIEWING IDEAL
SCULPTURE
Contexts and Audiences

Although nineteenth-century American sculptors supported themselves primarily by sales of artworks to individual buyers, they also earned money and gained fame by exhibiting their works publicly. To understand the cultural significance of these works, we must know more about who viewed them, under what circumstances, and with what assumptions about art and what expectations about the act of viewing. During the period of its greatest popularity, ideal sculpture reached a variety of audiences in diverse settings: private galleries; newly formed public exhibition spaces; entrepreneurial exhibitions, where an artist or agent charged admission for the viewing of a single work of art; and massive fairs or expositions where art objects were viewed side-by-side with machinery, agricultural products, and geological displays. Photographs and engravings can help us understand what nineteenth-century audiences saw when they viewed ideal sculpture; comments and descriptions written by contemporary observers can suggest how they interpreted what they saw.

·

The most private setting in which ideal sculpture was displayed was the home of its owner. By the third quarter of the nineteenth century, many Americans had become interested in collecting art, in the spirit—if not on the scale—of Henry James' Adam Verver in *The Golden Bowl*. Works

FIGURE 2. Mr. Henry C. Gibson's Dining Room, *Artistic Houses*

of art were often on view throughout their owner's house or apartment, with painting, sculpture, china, wall hangings, Japanese prints, wood-carvings, and other forms of the fine and decorative arts displayed as part of a total environment.

An extraordinary book, published in 1883, gives us a closer look at the settings within which art was exhibited in many private homes. *Artistic Houses, Being a Series of Interior Views of a Number of the Most Beautiful and Celebrated Homes in the United States, with a Description of the Art Treasures Contained Therein* offered to the reading public a rare glimpse of the living environment of wealthy art collectors.[1] A photograph of Henry Gibson's dining room, for instance, shows a large sculpture, Joseph Bailly's *Paradise Lost*, on an elaborately carved sideboard between two animal paintings, surrounded by antique furniture, oriental rugs, and smaller decorative objects (fig. 2). The parlor of Mr. F. W. Hurtt, decorated in Moorish style, featured easel paintings, tapestries, hangings, and rugs, a bas-relief, and numerous small sculptures and busts, including a reproduction of Canova's *Cupid and Psyche* directly under a Madonna and child (fig. 3). Walking through Mrs. Bloomfield Moore's

FIGURE 3. Mr. F. W. Hurtt's Parlor, *Artistic Houses*

hall, the visitor could look at Randolph Rogers' *Nydia the Blind Girl of Pompeii*, and also at woodwork, wallpaper, floor tile, and chandeliers, and could glimpse a cabinet of china through the doorway beyond (fig. 4).

Such eclecticism often seems cluttered and confused to twentieth-century viewers. What must strike us, however, as we observe the way art was displayed in the homes of its collectors, is the enormous receptivity —the great hunger for visual stimulus—its audiences must have felt. Nineteenth-century viewers, we must conclude, were not distracted from *Nydia* by the carved staircase behind her; they saw no disturbing irony in the juxtaposition of sacred and secular scenes, of cupids and Madonnas. Books on interior design favored a profusion of prints and patterns in homes until the end of the century. In the field of public display, the great art museums of the world, like the Louvre, were still arranged in a floor-to-ceiling array of canvases, hung without space between works and without regard for the relation of one to another.[2] Nineteenth-century viewers valued complexity; they prized their ability to uncover layer after layer of visual pleasure.

We do not know much about how people looked at artworks in private

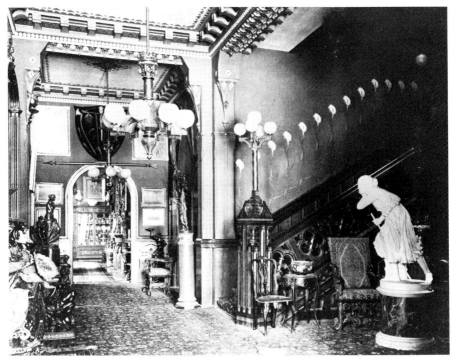

FIGURE 4. Mrs. Bloomfield Moore's Hall, *Artistic Houses*

homes. Walking past an object every day, seeing it while dining, sitting near it while reading the newspaper, creates an experience of spectatorship different from viewing a work in a gallery or at an exhibition. In a painting like Edward Lamson Henry's *The Parlor of Mr. and Mrs. John Bullard on Brooklyn Heights* (1872), the collectors are depicted among their works of art (including Harriet Hosmer's bust of *Medusa*), but they are not looking at the art objects.[3] On some occasions, visitors might be invited to view the artwork directly, in which case they might discuss it from the point of view of connoisseurship or subject, or as a memento of travel. At other times, art objects simply formed the backdrop for social interactions: parties, receptions, teas, or dinners. Not only was the art object embedded in its context of other things to see, but the act of looking was part of a larger context of social exchange.

Artworks in private homes functioned as both spectacle and possession. As Thorstein Veblen pointed out, the more removed an object is from practical use, the more effectively it indicates its owner's wealth and status.[4] Similarly, Pierre Bourdieu has argued that ownership of works of art implies power and superiority because it suggests that the owner is not

limited by the ordinary contingencies of life. Bourdieu points out that the owner of an artwork lays claim not only to the tangible object itself but to the taste by which it is appreciated; similarly, visitors viewing artworks in private homes could assume some of the same distinction by showing that they shared the owner's aesthetic taste. Such concerns shape the way viewers look at art; as Bourdieu suggests, "the detachment of the pure gaze" is really another form of insisting that the viewer is freed from the exigencies of practical necessity. Both as spectacle and as possession, art in private homes functioned as a form of "cultural capital."[5] Such capital was enormously important in nineteenth-century America, both for families of established wealth and for newly rich families who emulated them.

·

Outside of private homes, nineteenth-century ideal sculpture could be seen in a variety of public exhibition spaces. Some collectors built art galleries in their houses and opened them to the public on a regular basis. Before the Civil War, New Yorkers Luman Reed, James Lenox, and Thomas Jefferson Bryan displayed their collections of painting and sculpture in this way.[6] In the decade after the end of the war, A. T. Stewart in New York and Edwin B. Crocker in Sacramento built even more lavish art galleries. The space they created was larger in scale than a parlor or even a ballroom—Crocker's art gallery was housed in a separate building —suggesting both the exclusive private galleries of European aristocracy and the sumptuous public spaces that had become part of every American city by the Civil War: hotels, railroad stations, steamboats, and the opera halls, theaters, and museums that were just beginning to be built.[7]

A visit to a private art gallery was something between a public event and a social occasion. It is difficult to know just how widely accessible such galleries were. Although W. H. Vanderbilt constructed a separate entrance to his picture gallery "for the convenience of the public," a description of the gallery in the 1880s announced that on every Thursday, from eleven to four o'clock, "the public may be admitted into the gallery be cards of invitation."[8] Clearly the curious could not wander in from the street; but whoever the visitors were, they were considered "the public" by the owner and the writer alike. A description of A. T. Stewart's art gallery, published in 1879, stated that on the "few occasions of their exhibition in public" the artworks had "drawn crowds of admiring spirits around them." The writer continued, "only great favor can gain admission for the stranger to these sacred precincts."[9] Of course, Stewart had

died in 1876, and three years later his widow had good reason to remain reclusive, since his remains had been stolen from his grave and were being held for ransom.[10]

Engravings and photographs of private art galleries suggest that their genteel and privileged environment encouraged visitors to view the art with the same reverence and respect with which they would greet its wealthy owners. An engraving published with the 1879 *Harper's Weekly* description of Stewart's collection supplies a visual account of a visit to the art gallery (fig. 5). Amid the profusion of artworks, three visitors—a solitary man and a man and woman together—stand decorously admiring the art. The woman is wearing a jacket and hat, suggesting both formality and transience. Although the caption suggests that the engraving was taken from a photograph, the perspective appears distorted, and the paintings and sculpture in the foreground loom unnaturally large, dwarfing the visitors. The picture itself is large in size, covering a double-page spread in the magazine, and forces the viewer to turn the large volume on its side in order to look at it. The chandelier hangs heavily from the ceiling, the walls are laden with paintings, and only the light-colored central floor area suggests space or openness. In this picture, the gallery itself seems imposing and gigantic, while the visitors, small and insignificant, pay homage to the art.

Photographs of the Stewart gallery from *Artistic Houses* show a less vertiginous but still reverential view of the art gallery (fig. 6). No viewers are present, and the works are arrayed in an inviting though crowded way. The works of ideal sculpture, which in the *Harper's* engraving appeared to loom above the visitors, here seem almost to stand in for the spectators, turned graciously toward the paintings as if inspecting them.[11] The floor-to-ceiling display of paintings, together with the cluster of statues and easel-propped canvases in the center of the room, gives an impression of rich abundance, reminding visitors that they are in the presence of great wealth as well as great art.

As another photograph from *Artistic Houses* demonstrates, Stewart's ideal sculpture was not displayed only in the art gallery. In fact, probably the most impressive collection of sculpture stood in the entrance hall, which led from the front door—where the visitor entered after climbing a tall marble staircase—to the door of the picture gallery (fig. 7). This antechamber to the art gallery (and to the rest of the house as well) was lined with a series of marble statues. Closest to the entrance, two Italian sculptures, *Water-Nymph* by Tandardini and *Fisher-Girl* by Tadolini, were the first sights that greeted the visitor, framed against massive columns and reflected in ceiling-high mirrors. As the writer of the sketch

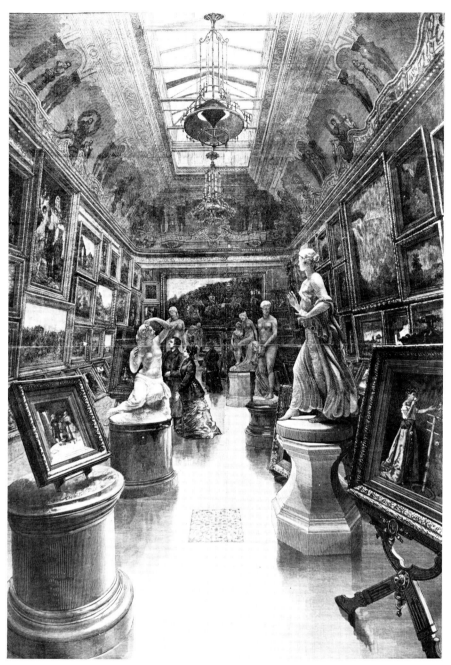

FIGURE 5. "The Stewart Art Gallery," *Harper's Weekly*

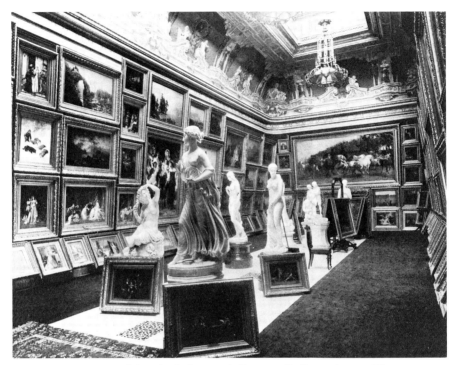

FIGURE 6. Mrs. A. T. Stewart's Picture-Gallery, *Artistic Houses*

in *Artistic Houses* observed, somewhat prudishly, both sculptures were "nearly nude."[12] One figure turned away from the visitor, while the other reached toward the passageway. Once past this Scylla and Charybdis of sensuous European sculpture, the viewer was faced with two monumental figures by American sculptors, representing historical personages from classical times: Thomas Crawford's *Demosthenes* and Harriet Hosmer's *Zenobia*. A large standing urn in the hall forced the visitor to walk close to one or the other of these larger-than-life-sized figures. After passing a fourteen-foot-high clock, the visitor confronted two fanciful subjects, Thomas Crawford's *Flora*, whose feet and dress are just visible in the photograph, and Randolph Rogers' *Nydia the Blind Girl of Pompeii*. Recapitulating the major themes of ideal sculpture, the entrance hall gallery thus led the viewer through neoclassical subjects to historical and finally literary and allegorical ones. Placed in a dominant, even domineering position, the ideal sculptures became a part of every visitor's experience of the house. Both as spectacle and as possession, the sculptures proclaimed their owner's taste and erudition, a subject on which the self-made Stewart could have been expected to feel sensitive,

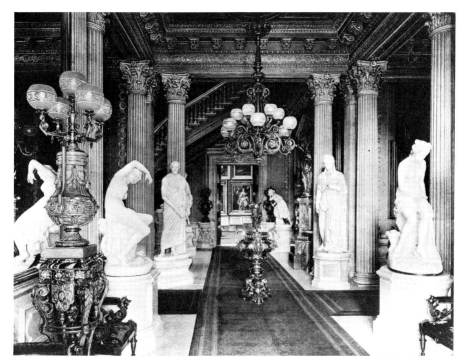

FIGURE 7. Mrs. A. T. Stewart's Hall, *Artistic Houses*

and prepared the visitor for the impressive display provided by the more formal arrangement of the art gallery.[15]

•

Another semipublic arena for viewing ideal sculpture was the studio of the artist. As illustrated in the Matteson painting of Erastus Dow Palmer's studio, patrons came to select artworks for purchase, making the studio a kind of showroom. In addition, other visitors would come merely to look at the art. Some artists had regular hours when they welcomed visitors (similar to the custom of calling which found the hostess "at home" at certain times), but in other cases, visitors merely called at their own convenience.[14] By the 1860s, when more Americans were beginning to travel to Europe, the artists' studios in Rome and Florence had become a standard stop for American tourists and were described in articles and books by literary travelers.[15]

The artist's studio was a particularly intimate setting in which to view sculpture. Viewers could see not only finished pieces but works in progress, and they might have a chance to speak with the sculptor as

well. Nathaniel Hawthorne's *French and Italian Notebooks* recorded the writer's struggle to educate himself in the visual arts, including long meditations on famous paintings and sculptures in museums and other public collections. But his accounts of visits to artists' studios are much livelier, and although he took an interest in the works, he was even more interested in the artists themselves. While sitting for a portrait bust by Louisa Lander, Hawthorne studied the artist while she was studying him. "During the sitting, I talked a good deal with Miss Lander, being a little inclined to take a similar freedom with her moral likeness to that which she was taking with my physical one."[16] Just as Hawthorne used what he called Lander's "available points" to help shape his character Hilda in *The Marble Faun*, he also included in the novel descriptions of sculptures he had seen in process in the artists' studios, most notably William Wetmore Story's *Cleopatra*.[17]

Viewing sculpture in an artist's studio encouraged the notion that the work of art represented an act of communication between artist and audience, since the maker of the artwork was usually on hand, eager to offer explanation and interpretation. Hawthorne commented that Hiram Powers "talks very freely about his works"; displaying his *California*, Powers told Hawthorne, "She says to the emigrants . . . here is the gold, if you choose to take it."[18] Thus a visit to the artist's studio (or the description of it read in a book or magazine article) inculcated the viewer with the artist's point of view about the artwork. It reinforced the belief that a piece of sculpture was designed to tell a story and that the viewer's task was to read that story as the artist intended it to be read.

•

Private homes and semiprivate art galleries and studios offered some nineteenth-century Americans an opportunity to view ideal sculpture. But, many thousands, even hundreds of thousands, of viewers encountered sculpture in public exhibitions. Before the rise of the municipal museums in the 1870s and 1880s, only a few art institutions maintained permanent or changing exhibitions of sculpture: the Boston Athenaeum, the Pennsylvania Academy of Fine Arts, the Dusseldorf Gallery in New York, as well as such short-lived institutions as the American Art-Union and the New York Gallery of Fine Arts.[19] Alternatively, a public exhibition might be staged by an individual entrepreneur, either the artist or an agent, in rented rooms in cities large and small. A single work, whether painting, sculpture, panorama, or wax figure, would be displayed and admission charged. Such paintings as Samuel F. B. Morse's *Gallery of the Louvre*, Rembrandt Peale's *Court of Death*, and Thomas

Cole's *Voyage of Life* series, sculptures like Horatio Greenough's *Angel and the Child*, Harriet Hosmer's *Zenobia*, and of course Hiram Powers' *The Greek Slave*, reached large audiences in this way and sometimes earned substantial sums for their owners or makers.[20] A form of popular entertainment, the art exhibition thus shared its audience with musical and theatrical displays, freak shows, and other curiosities to be seen in American cities.[21]

Spectators attending public exhibitions of ideal sculpture often received printed pamphlets or sheets intended to guide them in interpreting the artwork.[22] These documents took the place of the sculptor who could explicate his or her own works to visitors, and like a visit to the sculptor's studio they suggested that each work of art communicated a particular set of ideas, told a particular story. They led viewers through a series of reactions—tears, spiritual reflections, historical meditations—that suggested an interpretation of the meaning of the artwork.[23] The pamphlets served both as art criticism and as instruction in the process of spectatorship in the fine arts. In this sense they may be considered part of the prescriptive literature of the nineteenth century, like etiquette books, sex manuals, and health guides.[24] Like other advice literature, the pamphlets were normative rather than descriptive; that is, they suggested how an audience *should* behave rather than telling us how spectators actually did view art. We will never know how many viewers actually shed tears or sat for hours in front of the sculptures, but the fact that someone—artist, entrepreneur, patron—felt the need to articulate such instructions on how to view sculpture tells us that the audience expectations on viewing a work of sculpture, especially a sculpture of a nude woman, were by no means universally clear.

Hundreds of thousands of nineteenth-century spectators viewed ideal sculpture in yet another setting: major public expositions such as the 1851 Crystal Palace Exhibition in London, its New York imitation in 1853, the International Exhibition of 1862 in London, the Sanitary Fairs that were held in cities throughout the northern states during the Civil War to raise money for union hospitals, and the Centennial Exhibition in Philadelphia in 1876. These exhibitions drew large crowds, and they sometimes launched an artist from obscurity to fame: Hiram Powers in 1851 and William Wetmore Story in 1862 both saw their careers blossom after a successful exhibition in London. Such large public fairs were particularly interesting because art objects were displayed in a setting in which serious attention was paid to decorative and industrial arts as well, and in some cases mechanical, geological, and agricultural exhibits, ethnographic collections, and commercial products. Reviews of the exhi-

bitions, guidebooks, and newspaper and magazine articles suggest both the ways in which specific writers viewed and responded to the works of ideal sculpture and the assumptions about the act of viewing and the significance of the viewed object that underlay their responses.

•

Almost everything written about the public display of ideal sculpture in nineteenth-century America emphasized the narrative content of the works of art. Henry James had observed that William Wetmore Story's career was shaped by his audience's expectation that art would, above all, tell a tale.[25] Reviews and catalog entries routinely focused first of all on subject, the story told by the sculpture, and some commentators even constructed their own explanatory narratives in poetry or prose. Henry Tuckerman, the leading American art critic of the mid–nineteenth century, insisted on his belief in the storytelling function of art: "Art is a language. . . . Language is but the medium of ideas, the expression of sentiment. . . . The first requisite for its use is to *have something to say*, and the next, to say it well."[26] Artists too agreed that they regarded their art as a vehicle for the expression of ideas. "Thoughts mould stone, even as earthquakes knead the rocks and when the stone gets the upper hand it is because the *faith* was wanting," wrote Horatio Greenough in 1852.[27] "No work in sculpture, however well wrought out physically, results in excellence," declared Erastus Dow Palmer, "unless it rests upon, and is sustained by the dignity of a moral or intellectual intention."[28]

An emphasis on the intellectual and moral content of art had, of course, dominated aesthetic theory, particularly in the English-speaking world, for nearly a hundred years, from Reynolds to Ruskin. Ideal sculpture flourished just at the time when the first serious challenges to that notion were being mounted by followers of the aesthetic movement. If "art for art's sake" seems a congenial idea to postmodern twentieth-century viewers, in the mid–nineteenth century it was still very much overshadowed by what we may call the notion of "art for morality's sake." Public monuments, like Crawford's frieze for the United States Capitol, popular prints like Currier and Ives' *Across the Continent*, blockbuster paintings like Frederick Church's *Icebergs*, were all expected to tell a story, to point to a moral. Although writers like Mark Twain and Emily Dickinson had begun to question the narrative moralism expected of artists, others from Nathaniel Hawthorne to Harriet Beecher Stowe continued to look for the "sermons in stones."[29]

What are the implications of the widely shared assumption that art, and especially ideal sculpture, found its chief significance as a vehicle for

intellectual and moral ideas? First, such a notion assumes an audience ready and able to "read" the meaning of the sculpture. Since interpretation often involved the understanding of historical, literary, or biblical references, this suggests an educated, and therefore elite, audience. But this conclusion should not be drawn too hastily. Lawrence Levine *Levine* has skillfully deconstructed the distinction between "high" and "popular" culture in nineteenth-century America; Shakespeare's plays, for instance, found an enthusiastic reception among a variety of classes and regions.[30] The same audiences that waxed enthusiastic over *The Greek Slave* also appreciated P. T. Barnum's Fejee mermaid. Public school education, as revealed in the *McGuffey's Readers*, gave many citizens a set of classical and biblical referents; for those whose recall was shaky, the pamphlets and reviews that accompanied the sculptures could recall once-familiar material to mind.

If viewers from a variety of backgrounds accepted the notion that artworks should be read in a moral and intellectual context, the act of viewing then became a process of interpretation. As the semioticians would say, the art object constructs its meaning by means of a code shared by maker and viewer; understanding is achieved through what Jonathan Culler has called "the pursuit of signs."[31] To make sense of the art object, viewers had to share with its makers and interpreters what Hans-Georg Gadamer has called a "horizon" or historically-determined understanding of the world.[32] Similarly, E. H. Gombrich described the "viewer's share" in the understanding of the visual object, the product of his or her assumptions about representation and meaning.[33] If ideal sculpture demanded, and usually received, acts of interpretation from its spectators, its historical significance may lie as much within the process of interpretation—and in our insight into the changing modes of interpretation—as in the specific meanings it produced.

Prints and engravings that illustrate the encounter of audiences with works of art, especially with sculpture, in nineteenth-century America often stress the act of interpretation. Two views of the Dusseldorf Gallery in New York, published in 1856, for example, show not only the accepted dress and decorum required for a visit to an art gallery, but the proper intellectual response. In "Interior View of Gallery—The East Room," spectators are busily engaged in the interpretation of art objects (fig. 8). In every case where more than one person stands in front of an artwork, conversation is occurring. The speaker in front of the bust at the left gestures toward the work of art, looking at his listeners, while they look intently at the object he describes (except for the child, who looks to the speaker for further guidance). Three other pairs enact this

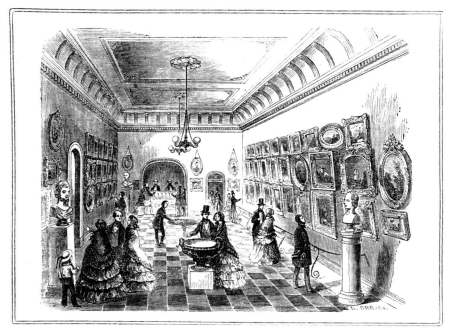

FIGURE 8. "Interior View of Gallery—The East Room," *Cosmopolitan Art Journal*

drama of interpretation, and in every case the man speaks and gestures while the woman listens. At the left rear a solitary man looks intently at a painting, using a book as guide. "Interior View of the New Gallery" shows a larger and more crowded scene, but again speaking and reading are prominently featured (fig. 9). The seminude sculpture in the foreground is surrounded by interpreters gesturing and discussing and by a man consulting a book.

Both visualizations and written descriptions of ideal sculpture and its audience thus stress the importance of the act of interpretation, insisting that visual experience can be successfully translated into language and that the art object can be read as clearly as the books the viewers hold in their hands. One critic praised a nineteenth-century sculpture for its legibility: "The group needs no interpreter, no labored explanation of its import. The spectator reads its whole sorrowful story at a glance."[34] Another reviewer wrote of another sculpture: "Sentiment, character, being for us the chief qualities of a work of art, when these are visible and effective, the artist has labored to great purpose."[35]

Not only should the sculpture be easy to read, but the emotions it conveys should be easy to grasp, according to many commentators on ideal sculpture. Not surprisingly, sentimental writers such as Grace Green-

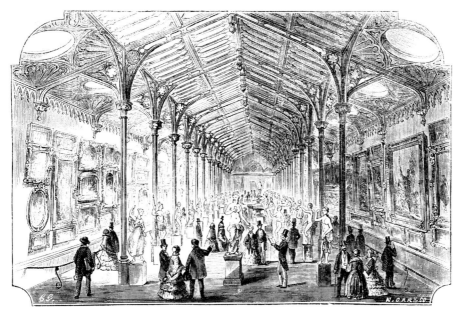

FIGURE 9. "Interior View of the New Gallery," *Cosmopolitan Art Journal*

1840s ?

wood and Harriet Beecher Stowe commented on the emotional content of the art they viewed. "I believe that in the world of letters, *heart,* the feminine spirit of man's nature, is to be exalted to the throne of intellect, and they are to reign together," wrote Greenwood, who praised a work by Hiram Powers for its "surpassing loveliness [that] weighs on the heart, and fills the eyes with tears."[36] Stowe wrote in her travel sketches about a sculpture that moved her to tears, the monument to Princess Charlotte in St. George's Chapel at Windsor. "Now, I simply put it to you, or to any one who can judge of poetry, if this is not a poetical conception. I ask any one who has a heart, if there is not pathos in it. Is there not a high poetic merit in the mere conception of these two scenes, thus presented?" The impetus behind Stowe's forceful defense of the sculpture was a comment by an artist of her acquaintance criticizing the sculpture for being too melodramatic. Indignantly, she responded: "A thing may be melodramatic, or any other *atic* that a man pleases; so that it be strongly suggestive, poetic, pathetic, it has a right to its own peculiar place in the world of art. . . . And even if by being melodramatic, as the terrible word is, he can shadow forth a grand and comforting religious idea—if he can unveil to those who have seen only the desolation of death, its glory, and its triumph—who shall say that he may not do so, because he violates the

lines of some old Greek artist?"[37] Stowe, whose fiction was considered melodramatic by some, had a special stake in insisting on the primacy of moral content, but we can wish for no clearer statement of the belief that the visual arts should be "poetic" and should be judged by the ideas they convey, and that those ideas should touch the heart.

In a variety of ways, commentators insisted that ideal sculpture succeeded most when it was seen by viewers as something other than itself, when the experience of viewing it transported spectators to an interior realm of thought, meditation, even fantasy. Horatio Greenough, himself a sculptor, offered instructions for viewing sculpture that seem puzzling to a twentieth-century audience. Writing in a pamphlet that accompanied the exhibition of Edward Brackett's *Shipwrecked Mother and Child*, Greenough observed that many spectators made the mistake of looking at the sculpture too closely. "I was a little puzzled at the eagerness of many spectators to get so near this work that it was impossible for them to see it," he wrote, suggesting that this "close" vision represented the gaze of daily life or of simple curiosity and was not poetic enough. It was not enough to look at sculpture; in Greenough's view one had to "see" it correctly. "I venture to suggest to those who wish to enjoy it, that they sit quietly on the several sides of the room, and even there survey it with half-closed eyes. The work is of marble: it is vain that you will seek aught else by crowding upon it. By remaining at a proper distance, you will find that it is no longer marble, but poetry."[38] In this prescription Greenough urged his audience away from considerations of carving skill or even visual realism; he insisted that formal values of all kinds were subordinate to the importance of subject and that the chief aim of the sculpture was to stimulate a train of thought in its viewer.

The desire to intellectualize or poeticize the visual object makes more sense when we remember that the objects being examined were often representations of nude or seminude women in postures of distress or danger. As we shall see in a more detailed discussion of the most famous of these works, *The Greek Slave*, elaborate debates over the moral meaning and poetic sentiment of the sculpture were defenses against the charge that the display of nude sculpture was immoral. Even the sophisticated art connoisseur James Jackson Jarves felt it necessary to defend the practice of viewing nude sculpture, and to surround it with prohibitions, in his early book *Art-Hints*: "Female loveliness is the most fascinating type of humanity. In it we have the highest development of form and color as united in beauty. . . . If to the physical ideal be added the greater loveliness of mind, which radiates from the features as light from the sun, elevating and purifying all things on which its glances

rest, we have all that Art might aspire to and yet not reach, unless its lamp were replenished at the divine fountain from which beauty itself was created." Yet Jarves warned against art that is too sensual: "Our own sensual passions have sufficient innate force without the excitements of pictured or sculptured temptation. . . . No! let ignoble features alone! Give us the subduing power of love, the tenderness of sympathy, the fullness of joy, the sweetness of hope, the strength of faith, the heroism of virtue, the power of intellect, the lessons, and if need be the suffering of self-denial, the repose of constancy, and the patience of charity."[39] The injunction to view ideal sculpture from afar, to meditate on its poetical and moral meaning, may represent a form of repression and denial of its more sensual, seductive aspects.

At the same time, artists, patrons, and audiences were choosing to contemplate works whose subjects raised troubling questions about death and sexuality, power and powerlessness, and the act of viewing them was identified as an invitation to reflect upon their meaning. The latent sensuality so obvious to twentieth-century viewers of these sculptures evoked in nineteenth-century viewers a variety of intellectual, moral, and sentimental responses. Viewers were invited to enter a state of heightened feelings—one commentator reported that she sank into a six-hour trance in front of *The Greek Slave*—that brought tears, sighs, and emotional catharsis.[40] As commentators stressed, again and again, the intensity of the response became a measure of the artwork's success.

·

In the act of looking at marble women in dramatic poses, nineteenth-century men and women confronted some of the underlying structures of gender and power that shaped their culture. Discussing the twentieth-century art form that most resembles ideal sculpture in its cultural significance, film, recent critics have stressed the importance of the spectator's gaze in constructing meaning. According to Laura Mulvey, cinema offers to its viewers pleasures of looking which may be defined in Freudian terms as those of scopophilia, "taking other people as objects, subjecting them to a controlling and curious gaze," and of narcissistic identification with the image seen. The process of looking, according to Mulvey, reflects the configurations of power in the culture as a whole, particularly those of gender. "In a world ordered by sexual imbalance," she wrote, "pleasure in looking has been split between active/male and passive/female. The determining male gaze projects its phantasy on to the female figure which is styled accordingly. In their traditional exhibitionistic role women are simultaneously looked at and displayed, with their

[margin annotations: "structures of gender & power"; "gaze"]

appearance coded for strong visual and erotic impact so that they can be said to connote *to-be-looked-at-ness*."[41] There seems to be an interesting connection between what Mulvey calls woman's to-be-looked-at-ness in art and in the culture that nourished that art. As another critic, Judith Mayne, has pointed out, the act of looking at a representation of a woman and the act of looking at living women have much in common. "One of the most basic connections between women's experience in this culture and women's experience in film is precisely the relationship of spectator and spectacle. Since women are spectacles in their everyday lives, there's something about coming to terms with film from the perspective of what it means to be an object of spectacle and what it means to be a spectator that is really a coming to terms with how that relationship exists both up on the screen and in everyday life."[42] Although many nineteenth-century commentators, like Greenough, insisted that the gaze of the art spectator was profoundly different from the "looking" of everyday life, other indications, such as engravings that show men explaining art and women listening, suggest that structures of gendered experience underlay the very process of looking at ideal sculpture.

We can decipher some of the ways historical audiences practiced the gaze of art and the gaze of life by looking carefully at representations of spectatorship. A particularly rich source exists in a series of engravings published to illustrate the Centennial Exhibition held in Philadelphia in 1876. Created as a spectacle to be viewed and interpreted, widely reported in the press and in popular publications like *Frank Leslie's Weekly*, as well as intellectual journals like *Atlantic*, the Centennial Exhibition was to America what the Crystal Palace Exhibition of 1851 was to England: a display of a culture's own view of itself and an opportunity for large numbers of people to see artifacts, works of art, and living people to which they had never before been exposed.

Numerous illustrations show that the power to see and understand is related to the power to possess and control or to the class and authority structures in society at large. One picture in *Frank Leslie's Historical Register* shows a crowd of viewers grouped behind a restraining bar, kept in their place by a sign that reads Positively No Admittance and by a uniformed policeman (fig. 10). A well-dressed couple look patient and knowledgeable, and the man gestures confidently toward something in the distance. But the other spectators stand amazed, mouths agape. Their awkward posture (hands in pockets, necks craning upward) marks them as visually unsophisticated, while their clothing suggests that they are probably poor and from the country (one man seems to be carrying all his possessions in a valise at his feet). The caption reads "Lost in Wonder,"

FIGURE 10. "Lost in Wonder"

and the implication is that those who do not know how to look properly are lost indeed. The "gentleman" displays both his economic status and his confidence as a viewer. He controls his space, reaching out across the barrier, his pointing finger almost poking the nearby policeman. The officer's authority does not represent a challenge but rather a protection for this viewer who, through gender and wealth, appropriates the spectacle as his own.

By contrast, an illustration showing visitors admiring paintings in the art gallery depicts the power of gender within a setting of class privilege (fig. 11). Elaborately dressed ladies and gentlemen crowd around art objects in a knowing way. One woman peers close for a detailed look, while another consults a book. Even while these women are lookers, however, they are also the objects of the stares of the men who stand back and admire them. This engraving seems perfectly to illustrate the notion that the gaze directed at art is but a variant of the gaze to which women are continually submitted. The wealthy men assume a satisfied and proprietary stance, both as viewers of art and as observers of the social spectacle.

FIGURE 11. "Sketch in the Art Gallery"

The way in which the gaze of the spectator becomes an exaggeration and fulfillment of the gaze of everyday life is illustrated in an engraving showing a display of Lyall's Positive Motion Looms at the Centennial Exhibition (fig. 12). Working looms are staffed by live people, who go about their tasks in full view of the crowds who watch them. Spectators, separated only by a railing from the objects of their gaze, regard the

FIGURE 12. "Lyall's Positive Motion Looms"

workers as if they were works of art; the subjects of the gaze do not look back in return. Like the man seated at a desk, who controls the women who work the looms, the spectators feel a proprietary right to the scene. As workers and as women, the subjects of their gaze have no choice but to submit to it.

Spectators at the Centennial Exhibition looked at objects as diverse as machinery, soil samples, clothing, wine, new inventions, and furniture, as well as objects of fine art. An engraving of "The Indian Department, in the United States Government Building" shows how artifacts not previously regarded as art were brought under the control of the interpretive gaze (fig. 13). Although two spectators at the far right chuckle with condescension or derision at what they see in the cases, the gigantic carvings are flanked in the foreground with two deferential viewers representing the epitome of respectability: a well-dressed woman and a bespectacled, balding man, perhaps a clergyman, carrying a book. In the middle ground a woman teaches her child, and by implication the viewer, how to look at the objects before them. Held within the bounds of interpretation, perhaps with the anchor of a book, even unfamiliar Indian objects, in the year of Little Big Horn, could be comprehended and therefore controlled by means of the gaze.

A composite engraving, "Character Sketches in Memorial Hall and the Annex," presents some humorous, as well as solemn, observations on the process of observation (fig. 14). In the upper left engraving, "The French Gallery," a gentleman pokes with his umbrella at the monumen-

FIGURE 13. "The Indian Department, in the United States Government Building"

tal painting *Rizpah Defending the Bodies of Her Sons* beside a sign that says, "Do not Touch with Canes or Umbrellas." In the upper right a young man steps on the dress of an attractive young lady, tipping his hat with an expression that suggests that, despite the book in his hands, the art objects are not his only interest. In the lower right, a woman touches a picture with outstretched finger. Perhaps, like etiquette books, this engraving enlivens prescription by humorously showing characters transgressing rules of decorum. Taken together, the five engravings do

FIGURE 14. "Character Sketches in Memorial Hall and the Annex"

suggest that viewing art at the Centennial Exhibition was not a tranquil or solitary experience: every gallery is crowded, and in the upper center view, exhausted spectators rest on benches before returning to the demanding task of proper viewing. Despite its humorous touches, however, "Character Sketches" continues to insist on the seriousness of the act of looking and the need for interpretation, and shows that art is not the only category of objects to be looked at with intensity. In the largest scene, at the bottom left, spectators throng around ideal sculpture in the Italian gallery, looking, discussing, gesturing, referring to books, and educating children. Yet the viewer's eye is drawn equally to the audience that crowds around the artworks: a heavily-veiled woman dressed in black (a young widow with her child?), a bearded man and a woman who looks like Queen Victoria, a man with goatee and long hair holding a Japanese fan (a foreign visitor?).

The connection between the gaze of the art spectator and the position of women in American culture is explored in the engraving "The Art Department in the Woman's Pavillion" (fig. 15). The decision to display art by women in a separate building had been a controversial one: some felt it honored women, others that it prevented them from being taken seriously.[43] In either case, every visitor to this building must have been aware

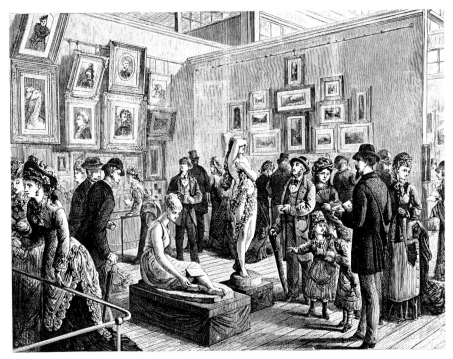

FIGURE 15. "The Art Department in the Woman's Pavillion"

that, no matter what the ostensible subject of the displays, the subtext in each case was "woman." In this engraving we have all the familiar features of a display of the proper way to look at art: well-dressed people with serious faces, open guidebooks, explanatory gestures, interested children. Indeed, the two little girls are the liveliest spectators; presumably they need no guidebook to help them interpret the story of Cinderella, the subject of the seated—and modestly clothed—statue.[44] The response of the adult female spectators in this gallery of art by women is particularly interesting, however. Several women are looking at paintings and drawings with decorous interest, but the women who are close to the sculpture, particularly the seminude standing sculpture, turn away from it. In one case, the husband, holding a book, gazes at the sculpture while his wife, fanning herself, looks away; in the second case both husband and wife avert their eyes. In this engraving we have a clear example of gendered spectatorship, with women manifesting embarrassment in the presence of nude sculpture while men gaze in interest and with authority, controlling the subject of the art as they control the women whose arms clutch theirs in submission to social propriety. No wonder the story of Cinderella attracts the little girls, whose clothing suggests their genteel

origins and expectations: by submitting with downcast eyes to the gaze of her viewers, as to the mistreatment by her stepmother, the fairy-tale heroine will be rewarded with rich clothing and a handsome husband.

.

Instructed by exhibition pamphlets, magazine articles, guidebooks, and engravings, nineteenth-century audiences looked at ideal sculpture with the expectation that it had complex and moving stories to tell them. Spectators in contexts as diverse as exhibition halls and world's fairs demonstrated their participation in a shared culture by following the artist and the explicators of art in a process of interpretation, decoding the message they assumed the sculpture conveyed. By their attendance at fairs and exhibitions, by the poems sent to newspapers by amateur poets, the reviews published in popular journals, and the comments of tourists and sentimental writers, many attested to the resonance these stories held for them. Since the narratives returned again and again to questions of woman's role and woman's nature, audiences, artists, and patrons revealed their fascination with and anxiety about the changing construction of gender in nineteenth-century America.

3

NARRATIVES OF THE FEMALE BODY

The Greek Slave

cultural construction of gender

No nineteenth-century artwork tells us more about the cultural construction of gender than Hiram Powers' *The Greek Slave* of 1844 (fig. 16). This life-sized standing nude woman whose hands are chained in front of her both displayed the beauty of the female body and, thanks to a cluster of narrative details, invited spectators to tell themselves a complex and disquieting story. The chain suggested violence and degradation, but the woman's expression was pensive and tranquil. These seeming contradictions spoke to some of the most fundamental concerns of its viewers, who responded to *The Greek Slave* with an outpouring of words—poetry, reviews, letters, and diary entries—that outline some of the deep conflicts within nineteenth-century culture.[1]

 The Greek Slave reached an unprecedented audience. Over the course of fifteen years, Powers produced six full-length versions of the statue, numerous three-quarter-sized replicas, and scores of busts, many of which found their way into American homes and art collections.[2] Thousands of viewers saw the work when it was displayed at the Crystal Palace Exhibition in London in 1851; a decade later, the plaster model could still be seen by visitors to Powers' studio in Florence. Traveling exhibitions brought the sculpture to more than a dozen American cities, where it was viewed by more than a hundred thousand people. With great fanfare, the Cosmopolitan Art Association offered a full-length version of the sculpture in a raffle for subscribers and then bought it back again at

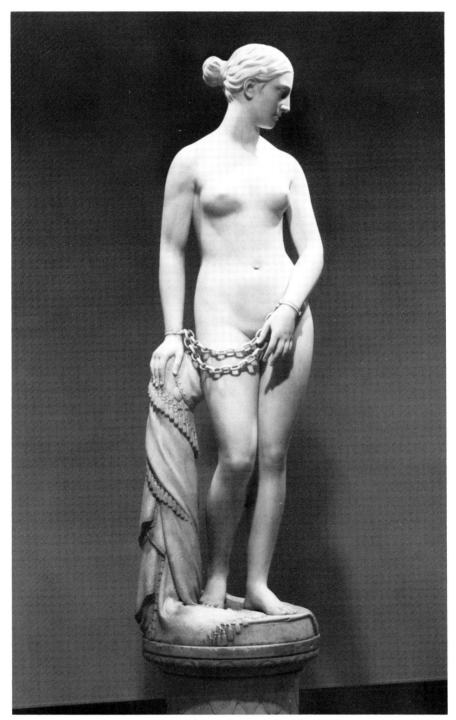

FIGURE 16. Hiram Powers, *The Greek Slave* 1844

an auction attended by five thousand spectators.[3] In the middle years of the nineteenth century, no American artwork was better known.

By the end of the century, *The Greek Slave* had become synonymous with respectable, even staid, taste. Henry James, remembering its popularity in small and inexpensive reproductions, wryly described it as "so undressed, yet so refined, even so pensive, in sugar-white alabaster, exposed under little domed glass covers in such American homes as could bring themselves to think such things right."[4] Yet James' oxymorons—undressed yet refined, exposed yet protected under glass—suggest some of the ambivalence with which this sculpture was received. A nude woman in chains represented an explosive subject, shocking, titillating, potentially even pornographic, and the explanations by which Powers and his supporters sought to shape his viewers' response to the sculpture help us trace the outlines of an ideology of gender as it came under pressure in nineteenth-century America. The problem of how to understand *The Greek Slave* was in some sense the problem of how to understand woman, in her complex spiritual and sensual nature. In their comments on this sculpture and the narratives they constructed to explain the enormous appeal it exercised upon them, Powers and his contemporaries sketched their sense of the symbolic significance of the female body. And since, as Mary Douglas has pointed out, images of the human body often reveal shared assumptions about the body politic, a careful examination of the reception of *The Greek Slave* also offers some insights into the complexities of a changing culture in nineteenth-century America.[5]

•

Powers' own views on the meaning of his celebrated statue are well documented. An entertaining talker and inveterate explainer, he offered detailed comments in letters and interviews on the genesis of the statue and the way it should be read. From the beginning, the construction and interpretation of a narrative was central in the artist's thinking about his sculpture.

When he began work on *The Greek Slave*, Powers was still a newcomer to the art world, hoping to move from notoriety as an adept portrait maker to success as a sculptor of ideal subjects. His first venture into the realm of the ideal revealed both the rewards and pitfalls of his aspirations toward a "higher" form of art. *Eve Tempted* (1842) received praise from the distinguished Danish sculptor, Bertel Thorwaldsen, and was much admired by visitors to Powers' studio in Florence.[6] But a prospective buyer later canceled his order, accused by his own brother of "indiscretion" in seeking to bring a nude sculpture home to "a quiet, old fashioned, utilitarian

place" like Albany, New York.[7] The implications of this experience were clear: to succeed with an American audience unaccustomed to nudity in art, Powers would have to find a way to fit his conception of the ideal to an "old fashioned, utilitarian" frame of reference.

In *Eve*, Powers depicted a biblical figure whose nudity had an obvious sanction in an authoritative and morally irreproachable text, but the subject still seemed too daring to some viewers. Eve, depicted with the forbidden fruit cradled in her hand, might have seemed to "old-fashioned" Albany too active, too clearly culpable, too much the temptress (fig. 70). For *The Greek Slave*, Powers invented his own story, one which redressed this problem by stressing his subject's powerlessness rather than her power. To "utilitarian" American culture he offered a modern tale of pathos and violence—the story of a contemporary Greek woman captured by invading Turks, abducted from her own country, and sold into slavery. The narrative had historical and literary echoes, for American and European interest in the Greek war of independence had run high; Byron had died supporting the cause of Greek independence, and Shelley wrote compassionately of Greek slave women.[8] But Powers did not draw his subject from a specific literary source. Rather, he created his own fiction. Visual details carefully informed the audience that the subject was a pious, faithful woman: a locket and a cross hanging on her abandoned clothing suggest a lost love and a sustaining Christian faith. Stripped naked, displayed for sale in the marketplace, her hands chained, the Greek slave, unlike Eve, was absolved from responsibility for her own downfall.

In constructing a narrative frame for his ideal sculpture, Powers demonstrated a finely tuned appreciation for the moral and intellectual context in which his work would be viewed. Drawing perhaps on his experiences designing exhibits for the wax museum in Cincinnati, Powers had a keen sense of his audience and its expectations. He was particularly aware of the highly charged mixture of curiosity and suspicion that accompanied any public display evoking erotic or even sensual associations.

American audiences had been notably prudish in their response to nudity in art. Earlier in the century Adolph Ulrich Wertmüller's *Danaë and the Shower of Gold* (1787) had caused a scandal when it was exhibited in New York and Philadelphia, as had other painted nudes in the first quarter of the century.[9] A pair of French paintings depicting the temptation of Adam and Eve and the expulsion from the Garden of Eden were criticized for their nudity during an American tour in 1832–35.[10] Horatio Greenough's *Chanting Cherubs* (1831) had been attacked

as immodest when it was displayed in New York and his bare-chested *Washington* ridiculed.[11] When Powers sent *The Greek Slave* on a tour of American cities in 1847, he made sure the sculpture was accompanied by texts that would instruct and direct the viewers' gaze. Press notices, poems, tributes by American diplomats and travelers, stressed the propriety, even the nobility, of Powers' undertaking. The American tour, which earned twenty-three thousand dollars in receipts, thus introduced a large audience not only to a work of art but to a series of narratives, ostensibly describing the sculpture, but also defining a morally and socially acceptable framework for the consideration of the explosive subject of woman's body and woman's nature.

In *The Greek Slave*, Powers presented an attractive female subject that would simultaneously invite and repel erotic associations. His earliest description of the statue, in a letter to his benefactor, John Preston, recognized the need to balance a powerful appeal to the senses with an equally strong protection against charges of immorality. Perhaps thinking of the controversy aroused by the unembarrassed nudity of his *Eve*, Powers defended *The Greek Slave* by pointing out the greater modesty of its pose. Although the statue was nude, he wrote, "her hands [will be] bound and in such a position as to conceal a portion of the figure, thereby rendering the exposure of the nakedness less exceptionable to our American fastidiousness. The feet also will be bound to a fixture and the face turned to one side, and downwards with an expression of modesty and Christian resignation." [12] Although Powers later changed some of the details, this description contains the crucial elements that made *The Greek Slave* a success: nudity combined with modesty, constraint, and Christian resignation.

By the time his statue was ready for public exhibition, Powers had refined his notion of how its nudity might be made acceptable to its audience. In an interview published at about the same time *The Greek Slave* was delivered to its first owner, Powers tried to define the moral uses of nudity in art. "It was not my object for interest's sake to set before my countrymen demoralizing subjects, and thus get even my bread at the expense of public chastity," he declared. He went on to insist that "a pure abstract human form tempered with chaste expression and attitude" was "calculated to awaken the highest emotions of the soul for the pure and beautiful." He even tried to argue that since the "society of chaste and well educated women has a tendency to exalt the mind," redeeming feminine influence is not "limited to the face alone," a suggestion whose humor was undoubtedly unintentional. [13]

In this same interview, Powers commented on the importance of nar-

rative in the struggle to control the powerful emotions generated by his nude subject. Audiences could best experience the uplifting effects of the pure abstract human form when they had access to a story that encased the nude figure in a protective web of explanation.

Protective web of explanation

> The Slave has been taken from one of the Greek Islands by the Turks, in the time of the Greek Revolution; the history of which is familiar to all. Her father and mother, and perhaps all her kindred, have been destroyed by her foes, and she alone preserved as a treasure too valuable to be thrown away. She is now among barbarian strangers, under the pressure of a full recollection of the calamitous events which have brought her to her present state; and she stands exposed to the gaze of the people she abhors, and awaits her fate with intense anxiety, tempered indeed by the support of her reliance upon the goodness of God. Gather all these afflictions together, and add to them the fortitude and resignation of a Christian, and no room will be left for shame. [14]

Powers now gave a more elaborate and nuanced narrative, focusing on the imagined emotions of his subject. In this description, he also instructed his audience on how to view a nude figure. Redirecting the viewer's gaze from the female subject's body to her face, he gave his audience something other than the woman's nudity on which to focus. His emphasis now fell not on the modesty of the slave's pose described in his letter to Preston, but on the narrative details that explained her situation.

Powers knew that his viewers were already prepared to respond emotionally to a story in which a character very much like themselves was threatened by a mysterious Other, in this case the "barbarian strangers" who conquered Greece, the cradle of Western civilization. Observing that the Turks considered this Greek woman too valuable to be thrown away, Powers suggested that other things of value might be in danger of being reduced to the status of a commodity and even thrown away in a conflict with another culture. Many nineteenth-century observers were fascinated by the often unsettling glimpses of foreign cultures brought to them through the expanding European colonial empires. [15] When cultural difference suggested that gender identity and sexual practice might be relative rather than universal, the very basis for Western civilization seemed to be at risk. Commentators were thus intrigued and disturbed by the institution of the harem, which suggested attitudes toward sexuality and female identity that were profoundly different from accepted Western ideas. [16]

Powers knew that his audience would be able to embellish the imagi-

relative not universal

fear unstable

Invite & repel

harem

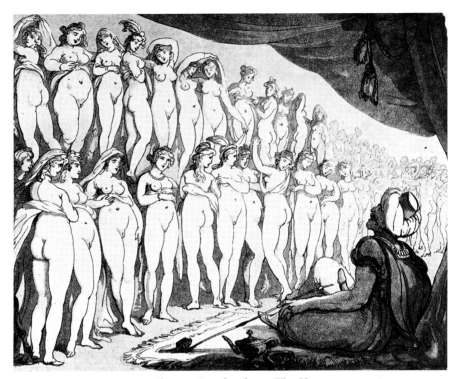

FIGURE 1 7. Thomas Rowlandson, *The Harem*, engraving

native context to explain the nature of the threat faced by the Greek slave. Literary Orientalism abounded in the nineteenth century and included such poetry as Byron's "The Bride of Abdyos" (1813) and Thomas Moore's "Lalla Rookh" (1817) and such operas as *The Caliph of Baghdad*, which played in New York in 1827, and Mozart's *Abduction from the Seraglio*.[17] A classic work of English pornography, *The Lustful Turk* (1828), portrayed the sexual awakening of English girls captured by a Turkish dey; among the women of his harem is a Greek girl pining for her homeland.[18] The erotic engravings of English artist Thomas Rowlandson included a vision of the harem women as seductive, sexually available, and enormously stimulating (fig. 17). Travel accounts of the seraglio and writings on sexual hygiene agreed with the pornographers that "Turkey is literally the empire of the senses" and suggested that Turkish women were seduced by luxury into a twilight world outside morality.[19]

Orientalism had provided an occasion for expressions of sensuality in the visual arts, as well. The French painter Jean-Auguste-Dominique Ingres had been painting scenes from the Turkish baths since the beginning of the century and had worked in Florence in the same studio as sculp-

"fine"

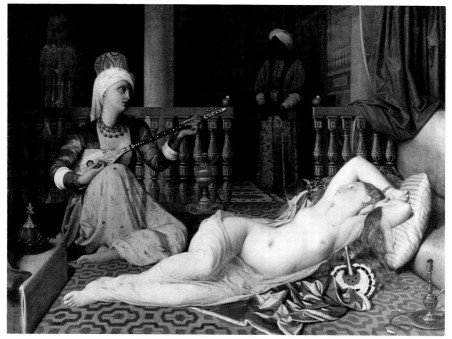

FIGURE 18. Jean-Auguste-Dominique Ingres, *Odalisque with the Slave*

tor Lorenzo Bartolini, who later became Powers' friend.[20] In 1839, Ingres painted a composition, *Odalisque with the Slave*, that made explicit the luxuriant sexuality that Westerners associated with the Turkish harem (fig. 18); the acquiescent, reclining figure suggests a world in which the female body exists only for man's pleasure. The painting was widely known in a contemporary engraving, and Ingres produced another copy in 1842.[21] In the same year that Powers began *The Greek Slave*, French sculptor James Pradier exhibited an *Odalisque* in Paris, a nude, seated figure wearing a turban and looking back over her shoulder with a seductive glance (fig. 19).[22] Powers and his viewers were thus surrounded with a profusion of images that depicted the harem as the epitome of Eastern sensuality.

Art, pornography, and much reform literature shared a male perspective, viewing the harem culturally and sexually as the world of forbidden desire. The sensuous odalisques of Ingres or Pradier challenged the viewer to define his own responses, to decide whether he was similar to or different from the "lustful Turk," or the viewer in Rowlandson's engraving with the monumental erection. Popular Orientalism allowed Western

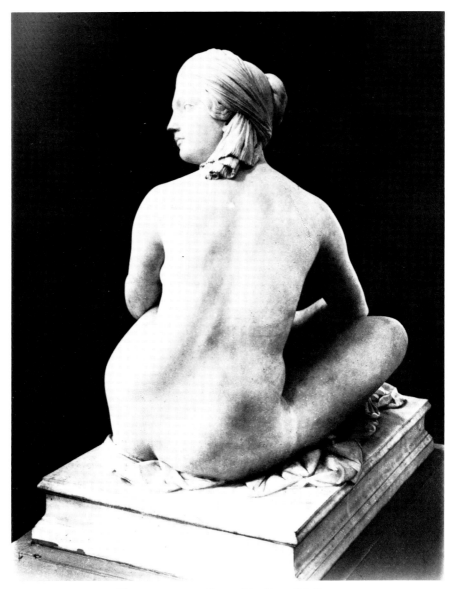

FIGURE 19. James Pradier, *Odalisque*

distanced
(safe)

observers to flirt with their own sensuality, still keeping it at arm's length as "foreign" or "exotic." As Edward Said has convincingly shown, West-erners have often seen in the Orient a projection of their own fears and desires.[23] For women viewers, Orientalism offered a glimpse of a world of passion and desire that was largely repressed in their own environment. In the figure of the odalisque, nineteenth-century women could contem-

plate a female sexuality that was doubly foreign, springing from another culture and coming to them as seen through men's eyes.

In alluding to the Turkish harem, Powers plunged his audience into an alluring and alarming world, a place of enslavement and sensual gratification, a forbidden realm in which viewers confronted their own erotic impulses. Yet, as he suggested in the interview published in 1845, the device of the imaginary Turkish captors enabled his audience to participate in the gaze of sensuality and to distance themselves from it simultaneously. By objectifying improper viewing, the unseen "barbarian" Turks absolved the audience from responsibility for her plight. The viewers to whom the sculpture was addressed, the men and women of the nineteenth-century West, accepted the distinction between themselves and her captors and agreed to view her in a different way. Thus Powers could invite his audience to look without embarrassment at *The Greek Slave*, leaving intact the suggestion that the female nude would under other circumstances be synonymous with shame. *O·K· b/c of circum.*

Powers, furthermore, offered viewers an opportunity to experience powerful emotions without having to contemplate a scene of violence and degradation. He expected his audience to be able to imagine both a past and a future for the Greek slave far removed from the tranquility and contemplativeness of the present moment. Powers did not, like Ingres or Pradier, depict a woman of the harem. He chose instead a subject that played upon his audience's assumptions about the harem without actually portraying it. His *Greek Slave* pauses on the threshold of a momentous change in her life; her future in the harem is the great unstated drama that gives the sculpture its poignancy. *imagine past & future*

Similarly, viewers could imagine a violent past that brought the Greek slave to her present plight. Twenty years later a Czechoslovakian artist would paint a picture that made explicit the horror and passion at which Powers had only hinted. Jaroslav Čermák's *Episode in the Massacre of Syria* (1861) depicts a woman struggling with two men who are trying to carry her away (fig. 20). Like the Greek slave, she has been stripped of her clothes, and a cross lies at her feet; in this ferocious painting she is surrounded by the corpses of her husband and child. The painter contrasts the whiteness of her skin with the swarthiness of her captors, who grasp her thighs and bind her arms. By 1879, when the painting was reproduced in *The Art Treasures of America*, it had found its way into the respectable collection of T. A. Havemeyer of New York.[24] Whereas Powers felt it necessary to muffle the drama that gave *The Greek Slave* its poignancy, later artists and patrons were willing to confront more directly

later artists more explicit

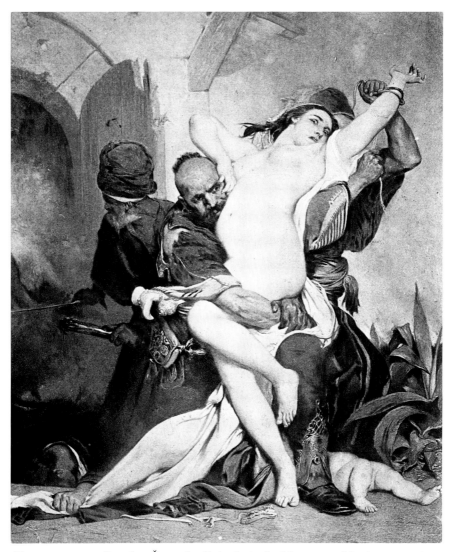

FIGURE 20. Jaroslav Čermák, *Episode in the Massacre of Syria*, engraving

what one commentator called the "hot energy" of the scene.[25] Perhaps the popularity of Powers' sculpture inspired Čermák's painting, but at any rate, the later painting brings to the surface the violence, the fear of the swarthy captors, and the erotic energy that formed the emotional core for *The Greek Slave*.

•

Popular response to *The Greek Slave* indicated how well Powers had judged his audience and its imperatives. Soon after its completion, the

first version of the statue was shipped to England, where its owner, Capt. John Grant of Devonshire, placed it on display in the showroom of Graves and Company, in Pall Mall. Here the sculpture attracted much atten- *England* tion, partly because it represented the debut of a previously unknown American sculptor.[26] The early reviews praised the work as "charming" *?* and "sweet," and noted Powers' technical accomplishments.[27]

The event that established *The Greek Slave* as one of the most celebrated of American art productions, however, was the tour of American cities arranged by Powers in 1847–48. An American patron, James Robb *USA* of New Orleans, had offered to buy a replica of the statue in July 1847. Powers had on hand a copy he had executed for an English patron, Lord Ward, and he decided to send it to America under the management of Miner Kellogg, an American artist Powers knew in Florence, to earn fame and fortune by public exhibition before it was delivered to Robb. Eventually, this arrangement caused many legal complications and bitter recriminations between Robb, Kellogg, and Powers, over who owned which version of the sculpture and who deserved what proportion of the proceeds of the exhibition.[28] But the exhibition tour brought the sculpture favorable publicity throughout the United States and outlined the terms in which it would subsequently be discussed.

Miner Kellogg, a close friend of Powers from Cincinnati days, proved to be a shrewd and knowledgeable art publicist who shared Powers' interest in the juxtaposition of female beauty and vulnerability. He had painted a *Portrait of a Circassian* that received favorable reviews at the Academy of Fine Arts in Florence in 1846. Perhaps inspired by Powers' sculpture, he portrayed the Circassian woman as a combination of alluring beauty and touching modesty.[29] In the two decades after he managed the successful tour of *The Greek Slave*, he exhibited his own *Circassian* (under slightly different titles) four times; he also exhibited three paintings entitled *The Greek Girl*.[30] Kellogg returned to the Oriental theme with a nude subject, *The Oriental Princess; or, After the Bath*, which toured the United States in 1866; although Tuckerman thought the painting was "perhaps objectionable," it was defended by a clergyman as "a sermon on *purity* and *innocence*."[31] Kellogg clearly understood that American audiences would accept a potentially erotic subject only if it was encased in a suitably moral narrative. Under his guidance, *The Greek Slave* attracted favorable reviews, which were promptly gathered together into a pamphlet that was distributed to viewers in each of the cities where the statue was displayed. The pamphlet, published in 1848, included a biography of Powers by the popular orator and politician, Edward Everett, testimony to the sculptor's technical skill by an Italian artist, A. M. Migliarini, an

excerpt from a travel book, *Scenes and Thoughts in Europe*, by G. H. Calvert, and miscellaneous poems and reviews from English and American journals.[32] With such a guidebook, viewers in cities across the United States were soon admiring *The Greek Slave* as an exemplar of beauty and morality. Perhaps because of its successful American tour, *The Greek Slave* was given a place of honor in the American section of the Crystal Palace Exhibition in London in 1851, thereby establishing its place in the international art world.

The most important single item in the 1848 pamphlet was an enthusiastic review by an influential clergyman, which Kellogg reprinted in full. The Reverend Orville Dewey, a Unitarian minister and associate of William Ellery Channing, had preached in Boston, New Bedford, and New York and was well known for the warmth and vigor of his oratory. "Palpitating with emotion," preaching with "fervid and tender appeal," Dewey himself seemed to understand the value of dramatic expressivity in the service of spiritual ends.[33] He was the ideal spokesman for the idea already formulated by Powers that art, properly seen, could arouse viewers to a higher state of moral consciousness.[34] In an article on "Powers' Statues" in *The Union Magazine of Literature and Art*, Dewey compared *Eve* and *The Greek Slave* to the standard examples of excellence in ancient sculpture, the Apollo Belvedere and the Venus de Medici, and pronounced Powers superior. "There is *no* sentiment in the Venus, but modesty. She is not in a situation to express any sentiment, or any *other* sentiment. She has neither done anything nor is going to do anything, nor is she in a situation, to awaken any moral emotion. . . . There ought to be some reason for exposure *besides* beauty." Insisting that Powers' sculpture expressed more than "the beauty of mere form, of the moulding of limbs and muscles," the clergyman explained that the sensuous appeal of the statue was justified by its higher moral purpose.

Dewey particularly emphasized the centrality of narrative to the interpretation of the artworks. The story, he insisted, was more important than the appearance of the sculpture itself. Indeed, Dewey suggested that the "sentiment" evoked by the sculpture could change the very way the viewer looked at it. In looking at *The Greek Slave*, Dewey asserted, the receptive viewer—the Christian, he might have added, rather than the "barbarian"— ceased to see a nude sculpture at all. "The Greek Slave is clothed all over with sentiment; sheltered, protected by it from every profane eye. Brocade, cloth of gold, could not be a more complete protection than the vesture of holiness in which she stands." Whereas Powers had suggested that the viewer's gaze could avoid the subject's body and focus on her face, Dewey went one step farther, suggesting that

the viewer could see *The Greek Slave* without seeing her body at all. The artist is able "to make the spiritual reign over the corporeal; to sink form in ideality; in this particular case, to make the appeal to the soul entirely control the appeal to sense."[35]

Despite such disclaimers, however, many other commentators revealed the statue's powerful appeal to their senses. Male viewers often wrote what amounted to love poetry when reflecting on *The Greek Slave*. "Why hauntest thou my dreams," asked one poet, describing the "maiden shape" and "lustrous brow," finding her "Severe in vestal grace, yet warm/ And flexile with the delicate glow of youth."[36] Another writer sidestepped the captivity theme to imagine the marble maiden coming to life in the presence of true love:

> Ah, then I know should gush the woman's tears!
>
> The marble eyelids lift—the pale lips should
> Quick pant, as Love his flashing pinion bent.[37]

By removing the chain and imagining a welcomed lover, this poet allowed himself to experience the feelings of desire that other commentators had associated with the "barbarian" masters of the harem.

Female viewers could also participate in a pleasurable recasting of the narrative. One woman remarked that she could now for the first time understand the story of Pygmalion. "I could imagine the devotion with which the statue was gazed upon, day by day . . . until he grew mad with love for the creation of his own genius!"[38] This comment legitimated the emotions of love and desire that the male viewer might be expected to feel. At the same time, interestingly, it suggested a corresponding response by the woman who is the focus of desire. Viewing the "rosy tinge flushing the pure marble," the result of the light reflecting off the crimson drapery that surrounded it, the writer of the paragraph found herself responding with the same emotions she attributed to *The Greek Slave*: "I could have wept with a perfect agony of tears."[39] Presumably the awakening Galatea felt some such emotion upon coming to life in Pygmalion's arms.[40]

The Greek Slave thus served viewers as a focus for their intensely ambivalent interest in the human body and female sexuality in particular.[41] As Peter Gay has argued, nineteenth-century reticence about sexuality does not mean that sexuality was not an important force in people's lives. "It is a mistake to think that nineteenth-century bourgeois did not know what they did not discuss, did not practice what they did not confess, or did not enjoy what they did not publish."[42] In his multivolume work, *The*

Bourgeois Experience, Victoria to Freud, Gay traces a history of sexual expressiveness in European and American bourgeois culture, arguing that works of nude sculpture like *The Greek Slave* played an important role in providing morally sanctioned erotic pleasure.[43]

Other modern critics have commented on the importance of *The Greek Slave* as a focus for sexual fantasy among its viewers, male and female. Like the popular literature that could be read in gift books and annuals and in the journals that reviewed *The Greek Slave*, the narrative suggested by the statue offered viewers an opportunity to identify with the desired-love-object-as-victim, as well as with her pursuer.[44] Suzanne Kappeler has argued that pornography is defined by conventions of representation in which the author and the spectator share an illusion of power over the victim.[45] Without suggesting that *The Greek Slave* was actually pornographic, we may speculate that the subject of a woman in bondage provided a similar kind of excitement for male spectators. Women spectators may have responded to the sculpture as a fantasy of domination. In fact, E. Anna Lewis reported sinking into a trance for five hours, and Clara Cushman declared that the sculpture put her into "a train of dreamy delicious revery, in which hours might have passed unnoticed."[46] Both these observers reported an experience that paralleled that of the slave herself: an emotional captivity, which they experienced as satisfying and pleasurable.

Furthermore, *The Greek Slave* provided, in an environment of self-conscious respectability, some of the same stimulation as the illicit forms of entertainment that were beginning to develop in American cities in the 1840s: dance halls with scantily clad or naked performers, restaurants that hung paintings of nude women on their walls, and "model artist" shows, where naked women engaged in tableaux vivantes illustrating scenes from history, literature, or even the Bible.[47] One writer reported in 1850 that he had visited an establishment called "Walhalla," where he saw a "brawny female" impersonating Venus, Psyche, the biblical Susannah surprised by the Elders, and the Greek Slave.[48] Even as pornography reached toward high culture for a veneer of respectability, a work like *The Greek Slave* that claimed for itself a high moral ground nonetheless provided audiences with a vehicle for the expression—and the repression—of deeply felt desires.

That desire was an important component of *The Greek Slave*'s appeal is suggested by one of Powers' most personal reminiscences. After hearing that his statue had been exhibited in Woodstock, Vermont, his birthplace, Powers wrote to a cousin, Thomas Powers, about an "oft-repeated dream" he used to have when he lived there as a child. "I used to see

in my sleep . . . a white, female figure across the river, just below your father's house. It stood upon a pillar or pedestal; was [] to my eyes very beautiful, but the water was between me and it, too deep to ford, and I had a strong desire to see it nearer, but was always prevented by the river, which was always high."[49] In this account of his childhood dream, Powers explicated his own conflicts of desire and repression. Drawn to the beautiful white figure (he does not allow himself to say whether it was clothed or naked), but prevented from reaching it by a deep and dangerous river, Powers was left with a sense of longing so profound he remembered it some thirty years later. Female beauty seemed infinitely desirable but hopelessly unattainable, and the effort to face it directly would take him into waters "too deep to ford" metaphorically as well as literally.

Exhibitors seemed to recognize at least tacitly the erotic potential of the statue, for it was sometimes displayed with special viewing times for women and children.[50] But most commentators took special pains to deny the sculpture's sensual appeal. Hence the importance of the words *chaste* and *chastity* in poems about and descriptions of *The Greek Slave*. "O chastity of Art!" proclaimed the writer of the prize ode to Powers' *Greek Slave*, winner of a contest in the *New York Evening Mirror*. "Beneath her soul's immeasurable woe, / All sensuous vision lies subdued." The writer goes on to celebrate "Her pure thoughts clustering around her form, / Like seraph garments, whiter than the snows."[51] Dewey's insistence that the nude sculpture was clothed in morality was echoed by numerous other commentators. "Unclothed, yet clothed upon," began a poem by Unitarian minister James Freeman Clarke; he continued, ". . . She stands not bare—/ Another robe, of purity, is there."[52] A poet writing in *The Knickerbocker Magazine* amplified the image:

> Naked yet clothed with chastity, She stands
> And as a shield throws back the sun's hot rays,
> Her modest mein repels each vulgar gaze.[53]

This insistence that the nude sculpture is really clothed, and that a woman who is about to be sexually violated is chaste, seems paradoxical, to say the least. A Freudian critic might see in this insistence on purity a repressed eroticism, with viewers denying their own sense of the danger and appeal of the nude as a physical force by focusing on the opposite qualities of spirituality and ideality.

Many observers followed the lead of Powers and Dewey by insisting that the Greek slave's spirituality was essential to her appeal. Although an occasional critic wished she showed more anger and defiance (like

the subject of Čermák's later painting), most observers praised her for her tranquility and found it appealing.[54] As one poet put it:

> Though all Earth's ties were snapt by that sharp pain,
> Though hope nor fear within her breast remain,
> Life's wrongs are over; neither shame nor harm
> Can reach that inner realm of perfect calm.[55]

Similarly, art critic and poet Henry Tuckerman described the Greek slave as almost superhuman in her transcendence of her painful situation:

> Do no human pulses quiver in those wrists that bear the gyves
> With a noble, sweet endurance, such as moulds heroic lives?
>
>
>
> Half unconscious of thy bondage, on the wings of Faith elate
> Thou art gifted with a being high above thy seeming fate!
>
>
>
> Words of triumph, not of wailing, for the cheer of Hope is thine,
> And, immortal in thy beauty, sorrow grows with thee divine.[56]

Both of these poems stress the subject's aloofness, her isolation in a spiritual state that puts her beyond the reach of her worldly woes. In these narratives, as in some of the others that reveal the writer's attraction to the female subject, the subject's remoteness and self-possession are seen as part of her appeal. In this sense she seems to embody the aspect of female sexuality that Freud described in his essay, "On Narcissism: An Introduction": "Women, especially if they grow up with good looks, develop a certain self-containment which compensates them for the social restrictions that are imposed upon them in their choice of object. Strictly speaking, it is only themselves that such women love with an intensity comparable to that of the man's love for them. . . . Such women have the greatest fascination for men . . . for it seems very evident that another person's narcissism has a great attraction for those who have renounced part of their own narcissism and are in search of object-love."[57] Freud suggested that female self-containment might originate as a response to social restrictions; the Greek slave in her dire extremity certainly could be seen as symbolizing the restraints placed upon all women in society. If female narcissism was especially attractive to men who had renounced a measure of their own narcissistic impulses, as Freud suggested, then *The Greek Slave* might have been expected to speak particularly strongly to the bustling culture of nineteenth-century America which, as numerous commentators lamented, allowed so little time for aesthetic cultivation or reflection.[58]

In their ambivalent attitude toward the female body—as beautiful but dangerous, to be admired but not to be seen—Powers and his supporters reflected the complex and contradictory attitudes toward human sexuality that characterized antebellum America. As Stephen Nissenbaum has pointed out, American anxiety about the integrity of the body, and in particular about the dangers of sexuality, sprang into full force in the decade of the 1830s.[59] Medical literature of the same period stressed female vulnerability, woman's delicate nervous system, and the way in which modern life posed a threat to her role as a wife and mother.[60]

The Greek Slave addressed this anxiety about the body and sense of female vulnerability. Literally imperiled by a dangerous sexuality, the female subject represents woman's body at risk. The first published engraving of the sculpture made it seem leaner, less robust, and more conventionally pretty than it was, all of which suggested that the engraver responded to a sense of the subject's vulnerability and portrayed her more like a pale and wan heroine than a Venus-like figure (fig. 21).[61] By the 1830s, as Nancy Cott has suggested, the doctrine of female passionlessness had begun to gain widespread popularity, giving women moral authority at the cost of a repression of their sexuality.[62] Of course, sexuality did carry risks for nineteenth-century women, ranging from death in childbirth to venereal disease.[63] The figure of *The Greek Slave*, chained and acquiescent in the face of imminent sexual violation, served as an epitome of female sexuality as many understood it at the time: resigned, aloof, passionless, and endangered.

The slave has also been deprived of her ability to serve as a wife and mother. Several of the written narratives focused on this aspect of the story: torn from her family and home, the Greek slave represented the fragility of woman's domestic life, as well as of her physical integrity. One writer, E. Anna Lewis, reported the train of thoughts that rushed through her mind as she gazed at the statue: "The history of her fallen country, her Greek home, her Greek lover, her Greek friends, her capture, her exposure in the public market place; the freezing of every drop of her young blood beneath the libidinous gaze of shameless traffickers in beauty; the breaking up of the deep waters of her heart; then, their calm settling down over its hopeless ruins."[64] Similarly, some of the poetry inspired by *The Greek Slave* stressed her separation from home and family. According to one poet, her

> . . . expressive, drooping,
> Tender, melancholy eyes, are vainly
> Looking for that far-off one, she fondly

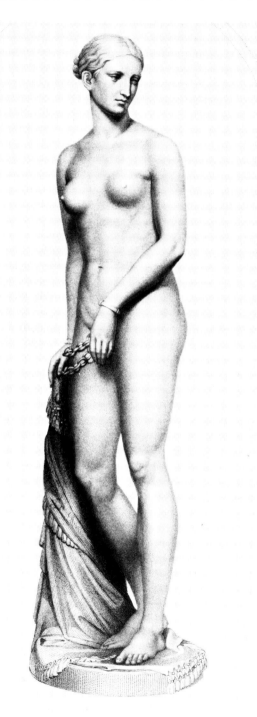

Barbie

FIGURE 21. Hiram Powers, *The Greek Slave*, engraving

> Loves in her deep sorrow, and her weary
> Heart is throbbing, with dear memories of
> Her distant, happy cottage-home in Greece.
> Alas! The spoiler came, and ruthless, tore
> The lily from its pearly stem, to bloom
> In base Constantinople's foul Bazaar![65]

Here the language of ravishment is applied to the removal of the young woman from her home, and the reader's emotions are carefully focused on past domesticity rather than future sexual exploitation. Similarly, another poem uses loss of home as a metaphor—or euphemism—for physical violation:

> Dim through veiling lids she ever sees
> Those sweeping mountain lines, those clustered trees,
> The low home clinging to the hillside, where
> Glitters each point and line amid the purple air.
> Her happy home! She sees it as it stood—
> Before the wave of war swept over it in blood.
> Now all is gone! No more for her, no more—
> Of Love, Trust, Hope and Joy on Life's dull shore
> All cruel wrongs, all bitter anguish borne
> Her virgin soul is crushed, her heart is torn.
> Debased, defiled and trampled in the dust.[66]

Construction of a sentimentalized, domestic past placed the Greek slave more securely in the realm of respectability, but it also reminded viewers of their own fears of domestic disarray. If, as Nissenbaum has argued, heightened anxiety about illness and sexuality corresponded to enormous changes in the everyday life of most Americans—the shift from a household economy to a market economy and the creation of woman's sphere apart from the world of work—the image of the slave's disrupted domestic idyll might have resonated with the concerns of its audience as much as the suggestion that she faced physical danger. The note of nostalgia and regret for a lost past, barely suggested by Powers himself, appears so frequently in popular responses to the sculpture as to suggest that Powers had tapped a deeper vein than he knew.

Many of the narratives about *The Greek Slave* comment specifically on the fact that she is about to be sold in the slave market. One art historian has argued that the sculpture evoked the issue of American slavery and reflected Powers' abolitionist views.[67] The connection was evident to some observers: when *The Greek Slave* was displayed at the Crystal

Punch

Ironic

Palace exhibition in 1851, the British magazine *Punch* published an engraving showing a black woman chained to a pedestal, with the caption, "The Virginia Slave. Intended as a companion to Powers' 'Greek Slave'" (fig. 22).[68] However, *The Greek Slave* was as popular in New Orleans, home of one of its purchasers, as in Boston, and much of its audience was apparently oblivious to the ironies of driving past American slave marts to shed tears over the fate of the white marble captive. Just as the sculpture might be said to have displaced its viewers' sexual anxieties, so it displaced their anxieties about slavery as well.

An abolitionist framework was apparently far from the minds of New York newspaper readers in 1857, when the Cosmopolitan Art Association publicized its auction of one of the copies of *The Greek Slave* by humorously suggesting that the sale recapitulated the plight of the sculpture's subject. "THE GREEK SLAVE TO BE SOLD," proclaimed the headline in the *Cosmopolitan Art Journal*, and the article added that the "renowned statue" was about "to be brought to the ignominious block."[69] Indeed, the journal reprinted a facetious commentary from the *New-York Evening Express* deploring the sale of "not only a slave, but a woman; not only a woman, but a young and exquisitely beautiful one—white as driven snow, with a most faultless form and most perfect features! Was ever such a thing heard of!" Apparently without recognition that abolitionists might make the same comments about the quadroon markets of New Orleans, the frivolous tone of the journal seems to dismiss the idea of a serious antislavery interpretation of the sculpture, but it also suggests discomfort with the implied connection between viewing and possessing. Perhaps when the statue was treated as a commodity, the nineteenth-century audience sensed a dissolution of the distinction between themselves and the lustful Turks. "And still more awful," continued the article, "for a week before the sale this slave will be exposed, perfectly nude, in the most public places in the city . . . that all the rich nabobs may feast their eyes upon her beauties, and calculate how much she would be worth to ornament their palatial residences up town."[70] Feminist film critics have argued that the gaze of the viewer necessarily suggests power over the viewed subject.[71] Sale of the statue, in this sense, is not so different from sale of the slave, and in both cases viewing is as much an act of appropriation as owning.

To extend the argument further, the position of *The Greek Slave* as a market commodity suggests the contention by Claude Levi-Strauss that women function in the social structure both as signs and as objects of value, as a result of their role as signifying exchange between men.[72] The viewers' fascination with an image of a woman displayed for gaze and

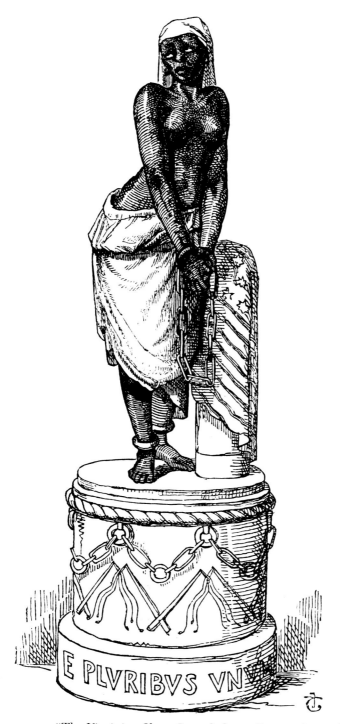

FIGURE 22. "The Virginian Slave, Intended as a Companion to Powers' 'Greek Slave,'" *Punch*

sale may thus reflect the position of women in culture generally, subject to observation and commodification. The special understanding claimed by such female viewers as Clara Cushman may suggest a broader sense in which the Greek slave, exposed and vulnerable, seemed an appropriate symbol for women in American culture.[73]

Finally, the recurrent comments on the "mart" in which the Greek slave stands for sale recall the fears of such critics as Henry Tuckerman and James Jackson Jarves that the commercial spirit was overwhelming other values in nineteenth-century American culture. In the *Book of the Artists*, Tuckerman lamented the dehumanizing effects of "the hard struggle for pecuniary triumphs."[74] Art, he suggested in his book, might provide an escape from the impersonal world of commerce. In his poem on *The Greek Slave*, Tuckerman had characterized her as standing among "a herd of gazers, . . . a noisy mart," in imagery that recalled his description of Wall Street.[75] The rise of commercial culture brought about many changes in American life, and the image of a victim sacrificed to commerce struck a responsive chord on many levels.

•

Much of the energy behind the narratives generated by *The Greek Slave*, narratives constructed by the artist, his defenders, viewers, and critics of all sorts, centered on the subject's relationship to the exercise of power. On one hand, the sculpture seemed to depict the epitome of powerlessness: a woman completely at the mercy of others, stripped of her clothing, as well as her culture (represented by the locket, the cross, and the Greek liberty cap laid aside with her clothing on the post beside her). On the other hand, Powers and his supporters all insisted that the female subject transcended her suffering to become an example of spiritual power.

The chain is the clearest expression of her powerlessness. Although some reviewers criticized Powers' use of the chain, arguing that it was historically inaccurate as well as physically improbable (had her captors unchained her to undress her, then chained her again?), others recognized immediately its symbolic importance.[76] As sculptor John Rogers observed, "Look at Powers Greek Slave—there is nothing in the world that has made that so popular but that *chain*. . . . There are plenty of figures as graceful as that and it is only the effect of the chain that has made it so popular."[77] The chain suggested hopeless constraint, overwhelming odds. It helped to hide the genitals of the statue even while it explained why they were exposed.

Interestingly enough, however, many of those who commented on *The*

Greek Slave during the height of its popularity saw this enslaved female subject as a symbol of spiritual power. For many observers the narrative became one of the triumph of faith over adversity. "It represents a being superior to suffering, and raised above degradation by inward purity and force of character," declared the introduction to the pamphlet that accompanied the sculpture on its American tour. "The Greek Slave is an emblem of all trial to which humanity is subject, and may be regarded as a type of resignation, uncompromising virtue, or sublime patience."[78] For most observers, this spirituality gave the Greek slave a measure of superiority over her captors. The readers of these pamphlets apparently accepted the notion that the apparent powerlessness of this victimized woman could, from another point of view, be seen as a position of spiritual superiority, ascendence, even triumph.

Even the chain, the symbol of her powerlessness, to some commentators also represented her power. "What is the chain to thee, who has the power / To bind in admiration all who gaze upon thine eloquent brow and matchless form?" asked Lydia Sigourney. "We are ourselves thy slaves, most Beautiful!"[79] For Elizabeth Barrett Browning, the slave's moral power had revolutionary implications:

> . . . Appeal, fair stone,
> From God's pure heights of beauty against man's wrong!
> Catch up in thy divine face, not alone
> East griefs but west, and strike and shame the strong,
> By thunders of white silence, overthrown.[80]

Like Browning, other commentators saw in the sculpture the possibility of a violent reversal of roles: the strong could be overthrown. Numerous observers elaborated upon *The Greek Slave*'s potential for working a transformation. A reviewer in the *New York Courier and Enquirer* reported that the statue's beauty "subdues the whole man. . . . Loud talking men are hushed . . . and groups of women hover together as if to seek protection from their own sex's beauty."[81] In this passage the language of conquest applied to the slave in the narrative version of her situation is directed toward the viewer, who is in turn conquered by her: the audience is subdued, held; they yield, they are hushed, they seek protection. A poet in the *Detroit Advertiser* made the analogy explicitly:

> In mute idolatry, spell-bound I stood
> MYSELF THE SLAVE, of her, the ideal of
> The Sculptor's inspiration! For I felt
> I was indeed a captive.[82]

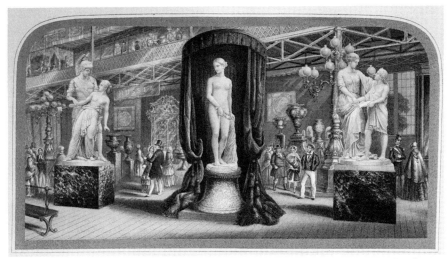

FIGURE 23. George Baxter, *The Genius of the Great Exhibition, Number 3*, chromolithograph

In all of these examples, an encounter with the statue deconstructed the very notions of power and powerlessness, suggesting to its viewers change, overthrow, and the reversal of roles. The revolutionary implications sensed by Elizabeth Barrett Browning were not only political but social and suggested the uneasiness that underlay the delineation of gender in a transforming nineteenth-century culture.

Visual depictions of the experience of viewing *The Greek Slave* stressed the dignity and authority, and by extension the power, of the image. An engraving of the sculpture as displayed at the 1851 Crystal Palace exhibition in London exaggerated the size of the sculpture (fig. 23). Although only the size of a small woman (65½ inches high), the statue appears to tower over the figures of the spectators.[83] The sculpture also appears larger than it was in an engraving published in 1857 showing *The Greek Slave* on display in the Dusseldorf Gallery in New York (fig. 24). In the engraving, spectators stand respectfully around the sculpture. Although men elsewhere in the gallery are wearing hats, the men closest to *The Greek Slave* have removed theirs. Two groups are conversing quietly; a young girl walking past in the foreground has stopped in her tracks and looks back, fascinated. The catalog of the Cosmopolitan Art Association, which sponsored the exhibition depicted in this engraving, emphasized the atmosphere of decorum, even reverence, that surrounded the sculpture. "Its presence is a magic circle, within whose precincts all are held spell-bound and almost speechless," one review read.[84] "It is most curi-

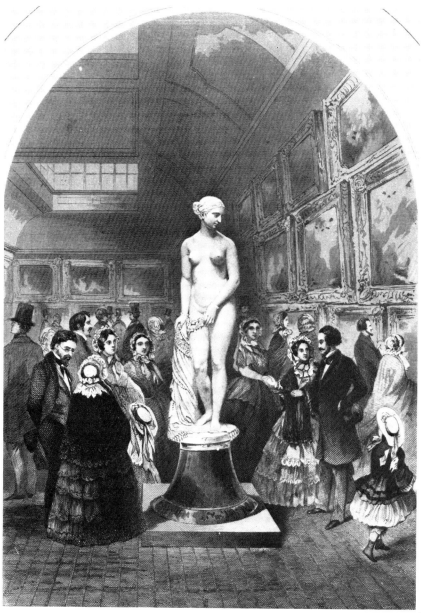

FIGURE 24. *The Greek Slave*, engraving

didactic
— how should
be viewed.

ous to observe the effect produced upon visitors," wrote another viewer. "They enter gaily, or with an air of curiosity; they look at the beauteous figure, and the whole manner undergoes a change. Men take off their hats, ladies seat themselves silently, and almost unconsciously; and usually it is minutes before a word is uttered. All conversation is carried

on in a hushed tone, and everybody looks serious on departing."[85] Such descriptions, of course, were prescriptive, informing readers of the attitude and decorum that would be expected of them in the art gallery. The descriptions, like the engraving, stressed the weight and solemnity of the occasion. Furthermore, the engraving emphasized the relationship between the women in the audience and the sculpture. Unlike other depictions of art spectatorship published at about the same time, this engraving shows women actively looking at the sculpture, appearing to explain and interpret it to their male companions, who look not at the sculpture but at them. The sculpture appears larger than life, and its proximity enlivens the women who surround it.

in contrast to last chapt.

Although overtly an image of submission and resignation, *The Greek Slave* thus suggested to its viewers a suppressed possibility of resistance, of overthrow, of the empowerment of the powerless. It is for this reason that the sculpture, judged vapid and bland, static and derivative by the standards of twentieth-century taste, seemed so vivid and moving to its contemporaries. *The Greek Slave* seethed with meanings for nineteenth-century viewers, who articulated many of their interpretations in the form of narratives: stories of loss and danger, faith and triumph. The narratives told the story of the female body as their authors understood it—vulnerable, dangerous and endangered, representing beauty and shame, attractive in its self-absorption but threatening to overwhelm the viewer. By extension, they told the story of the body politic, which was undergoing transition to a commercial culture amid contemplation of unsettling changes in gender roles and family life. The contradictory meanings embodied in *The Greek Slave*—eroticism indulged and denied, passion and passionlessness, power and powerlessness—were the meanings with which its viewers themselves struggled in a rapidly transforming culture.

but found resolution in this piece whereas w/ Shipwrecked Mother & child no resolution.

4

B ETWEEN TWO
W ORLDS

The White Captive

The tremendous popularity of *The Greek Slave* inspired other American sculptors to explore the subject of the endangered but ennobled female captive. Striving for artistic recognition and social respectability, these sculptors created works that told stories of fear and desire. Captive women, caught between two worlds, raised the question of the stability of female identity in the face of change and dislocation. Evoking nostalgia for a lost domestic idyll and suggesting the dangers of an alien environment, other sculptors elaborated on the themes Powers had sounded, confronting both the perils of female sexuality and the specter of the dissolution of the family. In the sculptures themselves and the narratives that surrounded them, artists and viewers expressed their contradictory beliefs about woman's nature and role in a changing society.

·

Erastus Dow Palmer made the transition from carpenter to cameo cutter to sculptor at the very time *The Greek Slave* was receiving so much publicity on its American tour.[1] Although he would later write an admiring letter to Powers without mentioning any direct encounter with the latter's work, he did visit New York City only a few months after *The Greek Slave* was displayed there, so he would have been aware of its reputation even if he did not actually see it.[2] One of his first attempts at sculpture, *Flora*, a seminude bas-relief completed by the autumn of

1849, recalls *The Greek Slave* in a general way, with one arm crossing the body and the head turned slightly to one side. Palmer, who settled in Albany, attracted considerable attention in the mid-1850s, particularly after Henry Tuckerman published a very favorable account of his work in *Putnam's Monthly Magazine*. Unlike most other American sculptors rising to prominence at the time, Palmer had not traveled to Europe, and many viewed him as a sort of homegrown Hiram Powers. " 'He has never been abroad,' remarked a gentleman at Florence to Powers, when showing him a daguerreotype of one of Palmer's works. 'He never need to come,' replied the artist."[3]

Palmer paid tribute to Powers most directly in *The White Captive* (1859), taking the essential elements in *The Greek Slave* and applying them to an American setting (fig. 25). Although in 1841 a buyer from Albany had refused to risk alienating his neighbors with Powers' *Eve*, after the success of *The Greek Slave* American viewers knew how to appreciate a nude subject surrounded by an explanatory narrative. *The White Captive* never matched *The Greek Slave* in number of viewers or popularity, but it was well received. A public exhibition in New York in 1859 was very profitable. According to one newspaper report, three thousand people came to see it during the first fortnight of the exhibition, and by the end of the first month attendance had swelled from one hundred to about four hundred per day.[4]

When Palmer described his work in progress in a letter in 1858, he had already given it a powerful narrative structure. "It represents the young daughter of the pioneer in 'Indian bondage,' " Palmer wrote, "standing and bound with bark thongs at the wrist to a truncated tree, as if with the hands behind her; but as she turns her person away (keeping her eyes and face toward the foe) from the objects of terror, it brings the tree at her side, and the right hand is nervously clasped against the rough bark of the stump, which is between the hand and the hip. She is entirely nude; her only garment, the night-dress (as if she had been taken from her home during the previous night), is torn from her and lies upon the ground at her feet, excepting a portion of it which is held between her hip and the tree and falls to the ground."[5] The similiarities to *The Greek Slave* are obvious: a female subject constrained, exposed, victimized. Palmer's subject is younger than Powers' maiden, and his narrative defined her more concretely as a member of a now-fractured family: "the young daughter of the pioneer" was "taken from her home the previous night." In the fate of his young captive, Palmer invited his viewers to contemplate the breakdown of domestic as well as sexual order. Following the narrative guidelines supplied by the sculptor, viewers could (and

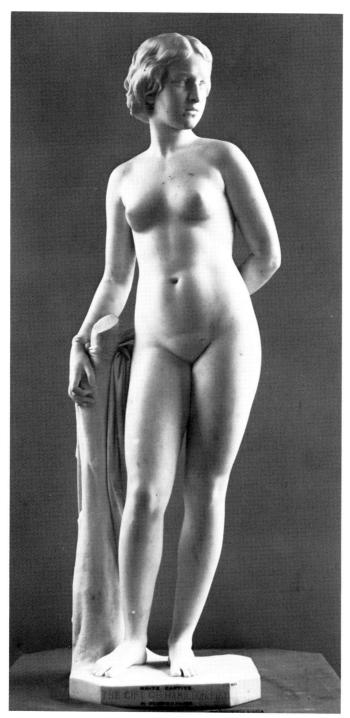

FIGURE 25. Erastus Dow Palmer, *The White Captive*

did) elaborate their own versions of the story, using every detail of the sculpture to spell out the emotional drama. As one observer wrote, "Her brows show a three-fold feeling of self-pity, self-reliance, and a sense of wrong; the last visible also in the mouth. The parted lips, the opening nostril, the tremulous cheek, the shrinking shoulder, the breast drawn in as with a catching breath, the slight backward inclination of the person, and the conscious hand seeking to clasp the tree as if for support, all betray the sudden thought of coming trial; and yet the pose of the head and neck is living with attention, and the calm, pausing feet, like the middle of each brow, show that self-control is not and may not be dissolved in personal fear."[6] Such comments demonstrate both the seriousness with which viewers attended to the most minute details of expression in the sculpture and the way such observations became part of its narrative web.

Just as *The Greek Slave* achieved its dramatic tension by drawing upon viewers' fascination with and fear of the sensuous Turks, Palmer's statue invoked conventional images of native Americans as the mysterious and threatening Other. Henry Tuckerman declared, "No more suggestive incident can be imagined for either poetry, romance, or art, than the fair, youthful and isolated hostage of civilization surrounded by savage captors."[7] James Fenimore Cooper had similarly suggested violence and sexuality at the hands of the Indians in *The Last of the Mohicans* (1826), when the captive maiden Cora is threatened with death or ravishment: "Woman . . . choose; the wigwam or the knife of Le Subtil!"[8] Painter John Vanderlyn had illustrated an Indian massacre in *The Death of Jane McCrea* (ca. 1804), and Horatio Greenough had sculpted a marble group for the U.S. Capitol which showed an Indian with tomahawk threatening a woman and her baby.[9]

Published narratives of whites taken captive by Indians had horrified and titillated American readers since the eighteenth century, and Palmer's daughter suggested that one such account, that of Olive Oatman, had inspired *The White Captive*.[10] As feminist critic Annette Kolodny has pointed out, captivity narratives represented an alternative to the male adventure story, one that recognized the conflict of cultures in the New World and embodied a confrontation with the unknown.[11] Many of the accounts also showed the fragility of "civilized" culture, and sanity itself, by constructing parables of female vulnerability. "The Panther Captivity," first published in 1787 and in print until 1814, described a young woman who eloped with her lover (already violating the boundaries of society); in the forest they were attacked by Indians, and the lover was killed. She was captured by a man who threatened her sexually, but she killed him and then, adopting his way of life, lived alone in a cave

for nine years.[12] In this narrative, as in many others, the captive-victim's ability to retain her "civilized" identity was the very issue, for the physical privations of Indian bondage challenged the captive's mental and emotional integrity.

In fact, captivity narratives may have fascinated readers partly because they raised the specter of the disintegration of personal identity. If Americans had always wanted to be Robinson Crusoe, maintaining "civilization" in the teeth of the wilderness, they still feared that, like the main character of Charles Brockden Brown's *Wieland*, they would lose their bearings, and sanity itself, in a world without familiar guideposts. The white captive of the Indians risked just such a fate. Cut loose from her past, but not yet initiated into a new life, the captive existed in a no man's land between two worlds, her future and her identity at risk.

A poem published in *Godey's Lady's Book* three months before Palmer began work on *The White Captive* may have provided at least part of the impetus for his choice of a subject and shows how widespread was the fascination with the captivity theme. "The White Captive" by Miss M. Louisa Southwick clearly portrayed Indian captivity as a tragedy of a young girl out of place. The poem's speaker, captured six years earlier by Indians, tells of her longing for her lost home and family:

> Yon broad, swift river's rolling tide
> Shall bear me to sweet mother's side.
> I'll paddle in my small canoe
> Adown its bosom, wide and blue,
> Till I may rest, the drippling o'er,
> Before sweet mother's cottage door.[13]

Repeated twice in five lines, "sweet mother" is the controlling figure in the poem. Nature itself, the wide bosom of the river, suggests the missing mother's body, and the "dropping maple-tree" under which she sits reminds her of the weeping mother who "never can forget." The river runs eastward, toward her old home, but the girl does not seriously consider escaping in a canoe; rather she accepts the "stars' sweet promises" and waits, "patient," for rescue. Like Palmer and Powers, the author portrayed a captive who responds to her melancholy situation with resignation rather than resistance. Southwick filled out the narrative frame, contrasting the gloomy present with the idyllic past; she flooded the poem with nostalgia for "my childhood's golden hours" and "the home where I was born." Although the captive must be approaching puberty, she is not portrayed as a sexually vulnerable woman. There is no indication that she is threatened sexually in captivity or attracted to the idea of marriage

in her own community. She hopes "to see some white man come for me," but she imagines only that he will return her to her mother.

In Southwick's account, the captive's ability to retain her white identity is taken for granted, and captivity becomes a state of separation from home and family. Her narrative lacks the dramatic tension evoked by the statue's nudity and the suggestion of physical and sexual violence. Yet the implication of the girl's absence from her mother is that she is also deprived of her own potential role as a wife and mother; the flowers that she gathers for the missing mother "when she takes me home" represent her own attempt to create a domestic refuge in the "gloomy shade." Passive, waiting, dreaming, the young girl has lost her mother, but she has not gained an adult life of her own; she is in transition, suspended between competing, and irreconcilable, worlds.

Some anthropologists have noted the special importance that many cultures attach to the perilous transitions of the life cycle: from childhood to adulthood, to marriage, childbirth, and death.[14] Individuals who are moving from one stage to the next are often considered dangerous to themselves and others because they stand on the borderline between two worlds: powerful, out of bounds, these liminal beings are not subject to ordinary rules. The survival of the community depends upon bringing them under control, reincorporating them into the ordinary world, accomplishing their transition or passage to a new state of existence.[15] In a culture which is itself undergoing rapid change, we should expect a fascination with transitions of all sorts, and nineteenth-century American literature is replete with images of liminality, from the Pequod's decks in *Moby Dick* to the dark room where Judge Pyncheon sits motionless in *The House of the Seven Gables*. Many of Poe's mysterious women owe their power to their tremulous foothold between life and death: the lost Lenore, Madeline Usher, Ligeia. Similarly, constructing narratives about the endangered white captive, viewers of Palmer's sculpture could confront their own fears about the uncertainties of a changing world. The rise of a commercial culture, the growth of cities, the changing role of women and men in the workplace and in the family may have given special resonance to these images of displaced persons. The theme of the captive maiden, so powerfully evoked in art and literature, thus suggested transitions of all kinds: from virginity to sexual experience, from the known to the unknown, from domesticity to wildness, from control to loss of control.

In Palmer's statue, captivity suggested just such a perilous transition, although the viewers of *The White Captive*, like those who commented on *The Greek Slave*, were often evasive about the exact nature of the

danger the subject faced. Some insisted that she was about to be executed by the Indians, while others hinted at sexual violation. Her integrity, however, was never questioned, and one viewer even invented a happy ending: "The revengeful savages acknowledged the divinity of her beauty and Christian reliance, and the 'White Captive' went free—the spirit of civilization triumphed!"[16] Such positive thinking was rare, however, and most commentators found the sculpture thrilling precisely because it represented a moment of transition to an unknown, even unthinkable, state.

Despite, or perhaps because of, the suggestion in *The White Captive*, of death and sexual violation, many of the narratives constructed by its viewers told stories of domestic disruption, like that in M. Louisa South-wick's poem. A review in *The Atlantic Monthly* began by creating an elaborate narrative frame. "Once on a time, a maiden dwelt with her father,—they two, and no more,—in a rude log-cabin on the skirts of a giant old Western forest,—majestic mountains behind them, and the broad, free prairie in front."[17] Not only did this narrative provide a past time for the statue, cast in a dreamy, almost fairy-tale nostalgia, but it suggested that in her captivity the family itself was at risk. In a household already disrupted by the loss of a mother, the young girl became the guardian of domestic values in the wilderness. While "the sturdy hunter beat the woods all day, on the track of panthers, bear, and deer," the daughter "kept the house against perils without and despondency within." The rude log-cabin became, like the bourgeois home in the age of industrial capitalism, a "haven in a heartless world."[18] According to this narrative, the young girl was kidnapped by the Indians one night when her father was delayed in his return: the protector of the family failed in his duty. "They dragged her many a fearful mile of darkness and distraction, through the black woods, and over the foreboding river, and into the grim recesses of the rocks; and there they stripped her naked, and bound her to a stake, as the day was breaking." Although Palmer did not, like Powers, include a cross in the sculpture, this viewer found religious consolation to be the only possible resolution to the horrors of the narrative. "But the Christian heart was within her, and the Christian soul upheld her, and the Christian's God was by her side; and so she stood, and waited, and was brave." Praised, like *The Greek Slave*, because she "waited" for a doom that was inevitable, the captive could only show courage through acceptance of things as they were. Her resignation spelled the helplessness of the family itself in a hostile world.

The *Atlantic* review was reproduced and distributed as a guide to viewing *The White Captive* during its successful New York engagement.[19]

Read in the presence of the sculpture, the *Atlantic* article encouraged spectators to tell themselves stories while looking at the art object, stories that focused on the twin themes of female vulnerability and the fragility of the family. Furthermore, the *Atlantic* reviewer also suggested gender-specific readings for the sculpture. Praising the "flesh-and-bloodedness and the soul of it," he asserted that "our women may look upon it, and say, 'She is one of us.' " As for himself, he imagined that the statue "stands and waits for the pity and the help of you and me, her brothers and her lovers. We long to rescue her and take her to our hearts." The sculpture, thus, seemed to this reviewer to belong the real-life world of gender roles, in which men viewed themselves as powerful and chivalric, while women, weak and passive, awaited their assistance. Yet, the narrative placed the blame for the kidnapping on the dilatory father. Perhaps, in a rapidly changing world, female victimization signaled the failure of the very gender structures that seemed to be unshakably entrenched.

Furthermore, the *Atlantic* article suggested that the victim could also be viewed, like *The Greek Slave*, as an exemplar of moral strength. Interestingly enough, what the viewer found particularly admirable in the female subject was her psychological resistance to her fate. Unlike a fainting Andromeda, to which he compared the work, he found this subject conscious, tense, spirited. " 'Touch me not!' she says, with every shuddering limb and every tensely-braced muscle, with lineaments all eloquent with imperious disgust,—'Touch me not!' " Apparently the epitome of female powerlessness, *The White Captive* fascinated this writer precisely because she suggested some of the sources of female authority. Furthermore, if he believed that female viewers would recognize her as "one of us," the *Atlantic* reviewer revealed his own ambivalence about women and about domesticity itself.

Some viewers of *The White Captive* responded to the tension in the implied narrative by focusing on her character rather than her fate. Many saw the sculpture in the same terms that had been applied to *The Greek Slave*, as an illustration of courage in adversity, of spiritual power arising from temporal powerlessness. An admiring description of the sculpture by Henry Tuckerman was published in the *New York Post* in November 1859 and reprinted as another gallery guide.[20] "Standing there in the wilderness, desolate and nude, [she] realizes through every vein and nerve the horrors of her situation," wrote Tuckerman; "but virgin purity and Christian faith assert themselves in her soul, and chasten the agony they cannot wholly subdue; accordingly, while keen distress marks her expression, an inward comfort, an elevated faith, combines with and sublimates the fear and pain." As if to justify both the nudity and the

suffering represented in the sculpture, Tuckerman insisted that it told a story of spiritual triumph. "The 'White Captive' illustrates the power and inevitable victory of Christian civilization; not in the face alone, but in every contour of the figure, in the expression of the feet as well as the lips, the same physical subjugation, and moral self-control, and self-concentration are apparent. The 'beauty and anguish walking hand in hand the downward road to death' are upraised, intensified, and hallowed by that inward power born of culture, and that elevated trust which comes from religious faith." Her "soul," he insisted, is "triumphant," maintaining that physical vulnerability resulted in spiritual power.

Even while Tuckerman praised the spirituality of the subject, however, her physical attributes kept thrusting themselves into his field of vision: the "contour of the figure," her lips, even her feet.[21] Tuckerman insisted that the real conflict portrayed in the statue was an internal one, the struggle for self-mastery. In this effort, he asserted, the young girl is triumphant, able to "chasten" and "sublimate" her distress. This commentator, who admired the almost superhuman aloofness of *The Greek Slave*, similarly praised the inward focus and self-control he detected in every detail of the figure, its narcissistic "self-concentration." Struggling with his own sense of attraction to her physical beauty, Tuckerman located the need for self-control in the female subject.

In the themes of control and self-control we may also trace a suggestion of the concerns shared by upwardly mobile artists such as Palmer and by patrons representing the economic and political establishment during a period of rapid social and economic change. We have already examined the suggestion that artistic self-control could bring a measure of social control, as indicated in the engraving showing Palmer at work in his studio.

Concerns about the social order played an important part in the thinking of the purchaser of *The White Captive*, Hamilton Fish, a Whig politician who viewed with alarm the rising sectional tensions that overwhelmed American politics during the 1850s. As U.S. representative, governor of New York, and then senator from 1850 to 1856, Fish deplored the rancorous tone of American politics and tried to work quietly for conciliation and compromise. The end of his Senate term coincided with the demise of the Whig party, and Fish, who did not run for re-election, only reluctantly cast his lot with the Republicans.[22] Just months before he left the Senate, furthermore, a shocking and highly symbolic event demonstrated clearly the disastrous possibility of social breakdown that could follow the loss of self-control. Massachusetts Senator Charles Sumner, famous for his fiery antislavery speeches, was badly injured dur-

ing a physical attack by South Carolina Congressman Preston Brooks on the floor of the Senate in May 1856. Brooks, who claimed that he was avenging the honor of the South and of an elderly relative insulted by Sumner, broke a gold-handled cane over the senator's head as he beat him into unconsciousness, yet he received only a token fine, and a vote of censure against him failed in the House of Representatives. For a whole generation the caning of Sumner represented the dangers of the loss of self-control.[23] Fish had been sworn in as a new senator on the same day as Sumner, and they were warm friends during the 1850s and 1860s.[24] In 1857, when Fish commissioned *The White Captive* from Palmer, Sumner was still recuperating from the attack, and Fish was about to embark on a two-year tour of Europe, leaving behind the turmoil of American politics. The theme that Palmer and his viewers found so engaging as they constructed narratives to explain the appeal of *The White Captive*, the theme of self-control in the face of domestic disruption, held special resonance for Fish and for other Americans concerned about political and social change during the 1850s.

The climate of political instability, when added to the continuing social and economic transformations wrought by the rising commercial culture, surrounded Palmer's statue with some of the same intimations of revolution that Elizabeth Barrett Browning had sensed in Powers' work. Some observers saw in *The White Captive*, as in *The Greek Slave*, an example of the power of the powerless. An article in *Harper's Weekly* began, "No: it is not she, it is we who are captive," and another commentator described the sculpture as "herself a captor who in turn enthralls."[25] The same critic who invented a happy ending to the narrative went on to describe the statue's meaning in terms of conflict and conquest, insisting, as Tuckerman had, that it told a story of the triumph of white civilization over the Indians: "The swarthy warrior feels himself in the presence of a superior power—a ruler! As we gaze on in mute admiration, we behold the race of the red man receding westward before that same power pictured in this wonderful face."[26] The unstated question in this smugly racist account of the struggle between European and Indian civilizations is, what role did the white male viewer play? Although his sympathy was aroused, he was powerless to rescue the captive; was he then subject, like the "swarthy warrior," to her power?

The nudity of *The White Captive* did not pass unremarked, even though ten years had elapsed since the success of *The Greek Slave* made nude sculpture more widely accepted by American audiences. Palmer's defenders used language that at times suggested a paraphrase of Orville Dewey's article on Powers: "Mere physical beauty . . . can never satisfy

the requirements of the Christianized taste of modern times," insisted one writer.[27] Although criticism of Palmer's "naked art" came from an unexpected quarter, the art journal *The Crayon*, other reviewers stressed the "chastity" and spirituality of *The White Captive*, suggesting the same ambivalence that surrounded *The Greek Slave*.[28]

On the very eve of the Civil War, Palmer's sculpture elicited few comments relating the sympathetic portayal of a white captive to the dilemma of black slavery. A short article in the *New York Times* referred to the trial of John Brown and suggested facetiously that the sculpture was "part of the original plot laid by Seward, Brown, Greeley and Forbes for the conquest of Virginia."[29] Another writer suggested that Palmer might use the subject of the black slave for a future statue.[30] As in the case of *The Greek Slave*, however, the sculpture's predominantly white bourgeois audience declined to make the imaginative leap that would allow them to explore the relationship between their own sense of vulnerability and the situation of African Americans held in slavery. This audience registered its uneasiness at the threat of political and social change by envisioning the victimization of its own wives, mothers, and daughters.

•

One of Palmer's distinctive features as a sculptor was said to be his mastery of realistic detail. Commentary on his sculpture often roamed, in the space of a paragraph or two, from his evocation of immortal beauty to his exquisite rendering of hair or fingernails.[31] *The White Captive* has usually been described as more "realistic" than the more idealized figure of *The Greek Slave*, and this lifelikeness invested the sculpture with even more troubling associations for many viewers.[32] *The White Captive*, whose hands were bound behind her back rather than in front of her, revealed the female body more completely than did *The Greek Slave*. Some of the commentators debated on such questions as whether the girl's nude figure was an accurate depiction of an unmarried woman's body, and one writer reported, tantalizingly, that when he visited the sculptor's studio, Palmer "carefully justified every detail." The same article commented that "few medical men are so capable of pronouncing upon certain points and shades of anatomical precision so surely as a deeply accomplished sculptor."[33] This anatomical precision introduced a new element into the question of the gaze with which its audience beheld the sculpture. The spectators seemed to receive permission to look at the sculpture with clinical curiosity. Accounts of audience response to this invitation conflict. One writer reported that "a sentiment of modest reserve at the sight of a nudity without attenuation, keeps the ladies at a distance."[34] For

another commentator, the clinical gaze veered uncomfortably close to the prurience of the fictive tormentors: "We feel we are almost as ruthless as her savage captors in continuing to look at her while she suffers so much."[35] "In gazing upon it," another viewer protested, "are we not taking the first returning step toward the barbarism of the savages, whose act of obscene cruelty it is intended to depict?" Such a gaze, far from bringing spiritual enlightenment, represented an "attack on the decorum of American manners," this writer continued, describing "young girls, hanging on the arms of leisurely-looking men, eye glass in hand, surveying the 'White Captive' from every point, coolly making their criticisms, or warmly expressing their admiration."[36] In a cascade of dangling gerunds, the commentator does not make clear who was surveying, making criticisms, and expressing admiration, but the physical intimacy of the male and female viewers, with entwined arms, suggested sensuality, and the adverbs "warmly" and "leisurely" evoked an atmosphere of dalliance rather than the intellectual uprightness of reading and discoursing that had been prescribed by descriptions and engravings of spectators in nineteenth-century art galleries.

Although commentators debated the propriety of viewing nude sculpture and the realism of Palmer's depiction of the female body, one aspect of the representation of woman's body was never addressed by viewers of either *The White Captive* or *The Greek Slave*: the convention by which the female genital region was portrayed unrealistically, as a smooth and unbroken triangle, without any indication of the vulva. American sculptors were only following a long tradition of prototypes, from Greek and Roman statues to the neoclassical sculpture of Houdon and Thorwaldsen, and the works of their own European contemporaries.[37] This convention was not observed for less respectable erotic art, as seen, for example, in Thomas Rowlandson's engravings. In a rare moment of candor, Hiram Powers had admitted to C. Edwards Lester that occasional visitors to his studio made jokes about his statues' incomplete genitalia, and on one occasion they supplied the lack by drawing on the marble with pencil.[38] The veil of ideality which, these sculptors and their critics insisted, enveloped their nude subjects could thus be associated specifically with suppression of the most concrete manifestation of woman's sex. These nude women were, literally, inviolable, for they had no organs to penetrate. Edith Wharton later recounted that on the eve of her marriage, her mother had turned away questions about sex and lovemaking by saying, "You've seen enough pictures and statues in your life. . . . You can't be as stupid as you pretend."[39] Yet those who expected life to imitate art were surprised and shocked, like John Ruskin, who was reportedly so revolted

by his first sight of female pubic hair that he never consummated his marriage. Even when they were being praised for anatomical realism, American ideal sculptors insisted that their viewers see the female body in a way that denied its most basic features.

·

The Greek Slave and *The White Captive*, with their nudity, their evocation of a mysterious liminality, their implied sexual and physical violence, and their themes of domestic disruption and spiritual transcendence, set the pattern for other American captivity subjects. One of the most unusual of these was modeled by an American woman working in Rome and was completed in the same year as *The White Captive*: Louisa Lander's *Virginia Dare* (1859) (fig. 26). Lander depicted the first English child born in the New World as a grown young woman in Indian captivity. Of course, no trace was ever found to indicate that any member of the ill-fated Roanoke colony survived, but so powerful was the appeal of the captivity theme in ideal sculpture that Lander projected the image of the captive maiden onto the tragic tale of the abandoned settlement.

The context for Lander's statue had been established several years earlier in a poem by one of America's most popular sentimental poets, Lydia Sigourney. Published in the widely read *Graham's Magazine*, Sigourney's "Virginia Dare" portrayed the destruction of the English colony as a domestic tragedy. The poet described the Roanoke settlement as an idyllic pastoral landscape where a young husband and wife dote upon their baby, little Virginia Dare.

> And through the shades the antlered deer
> > Like fairy visions flew
> And mighty vines from tree to tree
> > Their wealth of clusters threw.
>
>
> While from one rose-encircled bower,
> > Hid in the nested grove,
> Came, blending with the robin's lay,
> > The lullaby of love.

In this New World bower, husband and wife celebrate domestic pleasures, she tending the child and he subduing the wilderness.

> And when the husband from his toil
> > Returned at closing day,
> How dear to him the lowly home
> > Where all his treasures lay.

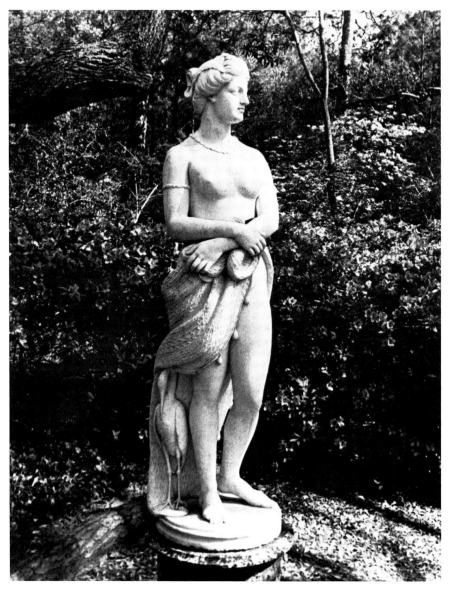

FIGURE 26. Louisa Lander, *Virginia Dare*

"O, Ellinor! 't is naught to me,
　The hardship or the storm.
While thus thy blessed smile I see,
　And clasp our infant's form."

But this happy home will be shattered by the "red-browed Indian" with his "wily, wary step." The last section of the poem is told from the view-

point of John White, the colony's governor and Ellinor's father, who returns from England to find the colony, including his daughter, son-in-law, and granddaughter, vanished.

> Where the roofs that flecked the green?
> The smoke-wreaths curling high?
> He calls—he shouts—the cherished names,
> But Echo makes reply.
>
> So, o'er the ruined palisade,
> The blackened threshold-stone,
> The funeral of colonial hope,
> That old man wept—alone! [40]

Like the narratives imagined for *The Greek Slave* and *The White Captive*, Sigourney's poem focused on the interrupted idyll, the tragedy of domesticity destroyed. The ruined palisade and blackened threshold-stone represent the literal ruin of the home and symbolize the human death and despoilation implied in the narrative. Avoiding too-graphic description of the disaster itself, the poem dwells on the fairy-tale-like perfection of the now-lost domestic scene.

Like the other statue on which Lander was working at the same time, *Evangeline*, *Virginia Dare* tells a story of lost domestic bliss. The statue has a dreamy air that suggests memory or nostalgia. The female subject wears no manacles, although her crossed wrists suggest her captive status. She stands nude, wearing Indian adornments on her neck and arms, but her faraway expression and her modest pose suggest a reserve, perhaps a Christian self-consciousness (historically improbable, since she was captured as an infant), and the same kind of narcissistic self-containment Tuckerman admired in *The Greek Slave* and *The White Captive*. The animating drama of *Virginia Dare* is not the danger posed by the mysterious Other, for this maiden has already come face-to-face with her captors. Rather, the sculpture suggests a struggle within the subject between two competing worlds, English and Indian, past and present: nostalgia for a domestic past and acceptance of a transformed present. She clings to the fishnet around her waist, perhaps to express a Christian modesty, or perhaps because it represents a remnant of her vanished life. One commentator suggested that the net, "being of English manufacture, . . . connects her early life with her present one of exile." [41] Yet the egret beside her is also a fisher and represents the competing claims of the New World. A wild thing sitting tamely at her feet, it is, like the girl, a displaced creature. Lander herself was an exile when she

sculpted *Virginia Dare* in Rome; suffering from the rebuffs of her fellow Americans, she might have considered herself a captive as well. Perhaps by choosing the subject Powers had made so eminently respectable she hoped to regain her social, as well as artistic, reputation.

Furthermore, Lander's sculpture raised the important question of the ability of the captive maiden to retain her integrity in the face of physical and psychological suffering. One reviewer commented on Virginia Dare's "anomalous position," suspended between European and aboriginal societies. "The European girl [is] thus partially transfigured without loss of identity."[42] Like Palmer and Powers, Lander insisted that spiritual power transcends temporal powerlessness. Unlikely as it might seem, this English girl retains her identity even though she will never see white civilization again. In her gentle version of the captivity subject, Lander evoked the pathos of the captive woman to stress not her physical vulnerability but the strength of the domestic impulse. Dreaming of her lost home, her captive is not so much a victim as a woman out of place.

•

Sculptors who followed Hiram Powers' example by depicting scenes of female captivity thus found a rich and suggestive subject which appealed to audiences on multiple levels. *The Greek Slave*, *The White Captive*, and *Virginia Dare* offered white bourgeois viewers an opportunity to construct romantic narratives about people like themselves removed from a familiar environment and confronted with a terrifying and dangerous Other. The sculptures took much of their energy from the tension between the threat to the subject's integrity and the assurance that the captive, no matter how hopeless her plight, would never change her essential nature or relinquish her spiritual power. The dogged determination of viewers to read the captivity narrative as a story of triumph—like their insistence that the nude was not unclothed—may represent a defense against the threatening implications of liminality. If the Christian Greek maiden were to become a sensual odalisque, if the daughter of the pioneers or Virginia Dare accepted membership in an Indian tribe, then perhaps the female spectators, or the wives and daughters of the male spectators, might have the potential to change in unexpected ways: to abandon domesticity, to express their sensuality, to become someone else. The poems, stories, reviews, and prescriptions for viewing that surrounded the captivity sculptures built a solid defense against this idea of female transfiguration, but this certainty wavered when the identity of captor and captive were reversed.

Nearly as popular as the depictions of white women captured by

Indians were a group of sculptures of Indian maidens acquiescing in the triumph of white civilization. As William Gerdts has pointed out, nineteenth-century depictions of Indian men tended toward "either the noble, contemplative primitive" or "the representative of a dying way of life."[43] More congenial, and less threatening, the Indian woman could be shown in sympathy with the white settlers rather than in resistance or defeat.

Completed three years before *The White Captive* and sold to the same collector, Hamilton Fish, Erastus Dow Palmer's first ideal statue depicted an Indian girl undergoing a momentous change in her life. *The Indian Girl, or the Dawn of Christianity* (1856) portrays a young girl, partially nude, with an Indian garment draped around her hips, looking intently at a cross she holds in one hand (fig. 27). Like *The Greek Slave*, the statue is full of visual clues to help the viewer construct a narrative: the feathers she is holding in her left hand suggest the pagan pleasures of nature, and they hang slackly, forgotten in the face of the spiritual illumination she is receiving from the cross in her right hand. The implied narrative is clear from the title: the young girl stands on the brink of a major transformation.

In a description of the sculpture printed in the catalog of an 1856 exhibition of Palmer's works, Rev. A. D. Mayo wrote enthusiastically of "the great work going on within" the girl's spirit, and predicted that Christianity would become "a guide through her future career."[44] Yet Mayo described the Indian girl's response in the language of violent disruption: she is struck by a "piercing" thought, her soul "melts," she "trembles." Not coincidentally, this is also the language of passion, and Mayo wrote enthusiastically of her physical beauty: her "perfect health," "beautiful face," "youthful innocence and exuberance of joy." According to Mayo, she stands on the threshold of physical as well as spiritual change, "in the hour when girlhood is passing over to womanhood," and the advent of Christian belief is described like a sexual awakening: "a passion, wherein the full tide of nature is swollen by a vaster love, heaves the bosom and speaks from the parted lips." Undoubtedly unconscious of his association of spirituality with sexuality, Mayo testified to the power of the image of the woman about to experience a momentous transformation.

For a white Christian audience, this spectacle held none of the horrible fascination of *The White Captive* or *The Greek Slave*, for her transition would be assumed to be beneficent. But although he viewed the change that awaited her as a joyous one, Mayo described the Indian maiden as immobile, thunderstruck, self-absorbed, very much like a captive: "She stands arrested. . . . The face is fixed with an entire absorption. . . . The

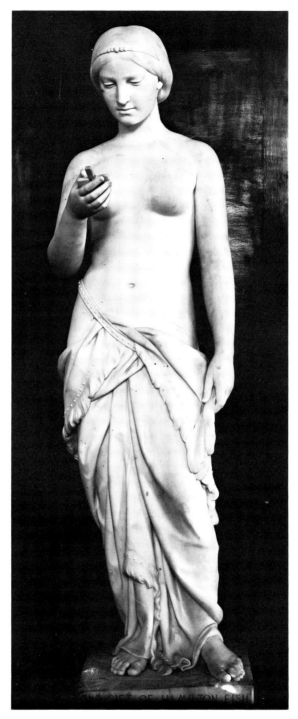

FIGURE 27. Erastus Dow Palmer, *Indian Girl, or the Dawn of Christianity*

moment is an era in her life." A poem by Alfred B. Street that accompanied Mayo's commentary in the gallery guide linked the Indian girl with another captive, a white missionary who was burned at the stake by her tribe; in Street's account it is this man's teachings that she recalls when she finds the cross. Like *The Greek Slave* or *The White Captive*, the Indian girl faces the prospect of a new life. She is captivated by the cross, and although her submission is voluntary, it signals a break from her past, her home, and her former way of life.

Palmer himself acknowledged a connection between *The Indian Girl* and *The White Captive*, writing to a friend, "In the two statues I desire first to show the influence of Christianity upon the savage, and second the influence of the savage upon Christianity."[45] Palmer's formulation reflects his sense of the superiority of European civilization: the Indian submits to Christianity, but the Christian must never submit to an alien culture. However, if both subjects are viewed as women and as captives, the implications are far more troubling, suggesting that a woman's identity might not always be stable in the face of challenge. What if the Indian girl rejected Christianity and fled? What if the white woman did not resist her captors?

Hiram Powers addressed the first of these questions in *The Last of the Tribes* (1873), which showed an Indian woman running away from white civilization (fig. 28). Powers never again matched the popularity of *The Greek Slave*, but toward the end of his career he returned to the theme of the captive female. Carefully establishing a narrative framework for his sculpture, he described his plans for it in a letter in 1866: "I am doing a new statue, *The Last of the Tribes*. Cooper wrote *The Last of the Mohicans*, but I am writing in marble. The last of them all. It is an Indian girl dressed in a kirtle ornamented with wampum and feathers—moccasin and leggins—fleeing before civilization. She runs in alarm, looking back in terror. The upper parts of the figure will be nude."[46] Metaphorically, the Indian maiden is fleeing the generalized advance of civilization, but concretely her situation suggests that of *The White Captive* in reverse: she will soon be captured by those she fears. By referring to Cooper's *The Last of the Mohicans*, Powers suggested the same literary context of conflict and captivity that stood behind Palmer's statue. But Cooper's novel ended in death for both the noble savage and the white woman he loved. Powers avoided the darker implications of Cooper's vision, locating this sculpture in the sentimental world of pathos and nostalgia rather than the Byronic world of high drama toward which he had aimed with *The Greek Slave*. In *The Last of the Tribes*, the sense of danger is muted because the viewer would identify both with the victim and with

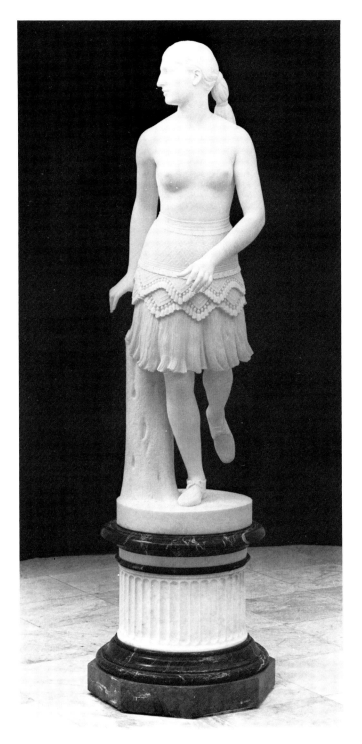

FIGURE 28. Hiram Powers, *The Last of the Tribes*

her pursuers, whose intentions could be assumed to be relatively benevolent. Although Powers wrote of his subject's "terror," the expression on her face suggests a dreamlike state from which she will soon awaken. The subject's posture, with the left arm in front of the body and right arm at the side, resembles an animated version of *The Greek Slave*. The tree stump at the left (necessary structurally to bear the figure's weight with one foot lifted from the ground) echoes the draped pedestal at the side of his earlier statue. But in contrast to the cool, still, remote affect of *The Greek Slave*, *The Last of the Tribes* suggests turmoil and emotion. This running figure, glancing backward, has left behind one state of being and has not yet entered another. Her movement through space symbolizes her mysterious liminality. Yet the figure lacks the power and tension embodied by the white captives. Although Powers could imagine that an Indian girl might not welcome the transition to white civilization, he could not present her story as a tragedy.

The question of whether the white woman might ever fail to resist transformation was raised in a pair of sculptures by a New York businessman turned artist, Joseph Mozier. *Pocahontas* (1859) drew its composition and emotional impact from Palmer's *Indian Girl* (which one critic misremembered in 1859 as a Pocahontas subject) (fig. 29).[47] In Mozier's statue an Indian maiden again contemplates a cross. Knowledge of history assures the viewer that the young girl will indeed choose to make the transition from her culture to that of the white Christian newcomers; furthermore, her choice will be motivated by love as well as religion. The more highly costumed figure appears less spiritual than Palmer's maiden, but the associations are remarkably similar. The deer at her feet, like the egret in *Virginia Dare*, suggests both the American wilderness and the transitional state of the wild creature in captivity. Here the deer wears the fetters of captivity; so too, the young girl will accept, even welcome, her transformation.

Mozier raised the disturbing possibility that a white woman might similarly submit voluntarily to Indian captivity in another statue, which was owned by at least one collector as a pendant to *Pocahontas*.[48] *The Wept of Wish-ton-Wish* (1859) drew its subject from James Fenimore Cooper's novel of the same name, published in 1829 (fig. 30). One of Cooper's bleakest and most tragic treatments of the hardships of pioneer life and the clash of cultures in the wilderness, *The Wept of Wish-ton-Wish* revolved around the theme of captivity. Set in western Connecticut in the second half of the seventeenth century, the novel traced the history of a small group of Puritans who established a settlement deep in the wilderness, in a valley named for the wish-ton-wish, or whip-poor-will.

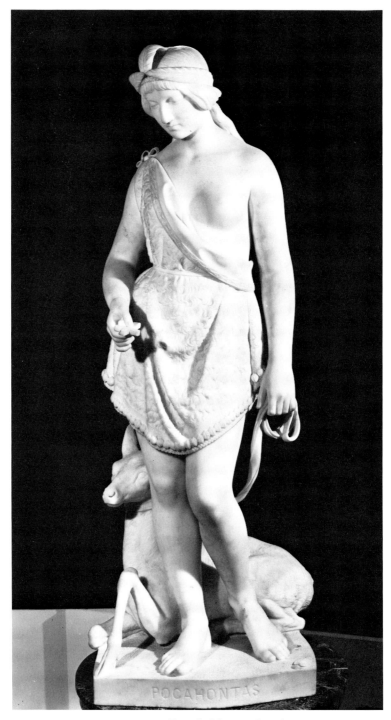

FIGURE 29. Joseph Mozier, *Pocahontas*

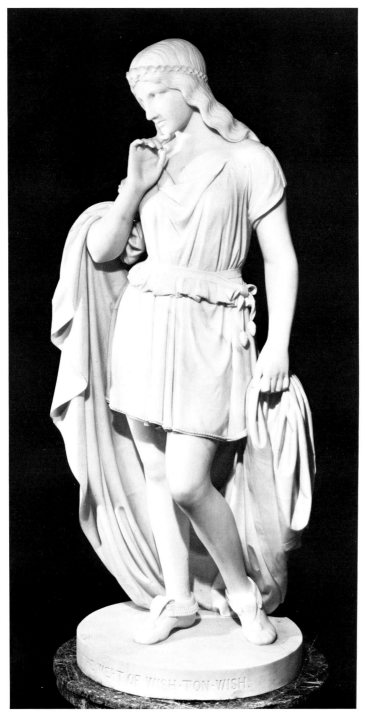

FIGURE 30. Joseph Mozier, *The Wept of Wish-ton-Wish*

Like Templeton in *The Pioneers* and like the early colony founded by the castaways in *The Crater*, Cooper's pioneer village is simple, just, and prosperous. A young Indian boy, found lurking outside the pallisades, is taken prisoner, and the family treats him kindly, trying to Christianize him. However, the boy's tribe storms their stronghold in a violent attack, devastating the settlement and carrying off not only the Puritan's Indian captive but a young daughter of the settlers as well. Years pass with no news of the captive girl, although her family never ceases to seek her ransom. Contemplation of the probable death or dishonor of the lovely young woman amid the savage Indians casts a shadow over the community. At last, in the turmoil of King Philip's War, the settlement is again threatened by the combined forces of various Indian tribes. The boy who was once the settlers' prisoner appears as the chief of the Narragansetts, accompanied by his wife, the long-lost captive. The blond, blue-eyed girl has completely adopted the ways of the Indians. Even when reunited with her family, she ignores the pleas of her own mother and refuses to leave her husband, escaping with her baby to follow him into the woods. In the turmoil of the war, the book ends tragically, with the brave young Indian saving the lives of the white settlers but falling victim to his greatest rival, the Mohegan chief, Uncas. After her husband's death, the captive maid reverts momentarily to the Christian ways of her childhood, before dying of a broken heart. Like so many of Cooper's novels, *The Wept of Wish-ton-Wish* romanticizes the "good" Indian but draws an inviolable line between the races. Crossing that barrier brings sorrow and death.[49]

In choosing to portray a scene from *The Wept of Wish-ton-Wish*, then, Mozier evoked not only the generally moving subject of Indian captivity but even more particularly the tragic and conflicted situation of the novel's heroine. When the young girl, Ruth (whose biblical namesake forsook her own culture to follow her husband's people), reappears as the Indian wife Narra-mattah, Cooper provides a long description of her that reflects his very mixed feelings about her strange mingling of white and Indian characteristics. Cooper defined her beauty in terms of her Caucasian features: tall stature, blue eyes, "just" limbs, "regular, delicate, and polished" features, blonde hair. At the same time he expressed his reservations about the artificialities of white civilization, where the "mistaken devices of art," such as corsets, can "mar the works of nature." With her "light and buoyant" step, "ingenuous beaming of the eye," and "freedom of limbs and action," the captive has also drawn benefits from her exposure to Indian culture.[50] Cooper's attitude toward his fictional captive was extremely ambivalent. At times he seemed to suggest that she belonged with the white settlers, as in the touching scene where she half-

recognizes her mother; yet at other times he wrote approvingly of her loyalty to her husband, giving her a long speech in the eloquent, meta-phorical language of the Indians. Ultimately, although she has a baby of her own, Cooper was most comfortable portraying her as childlike; in the final scene she reverts to a hysterical infancy. Cooper could not resolve the dilemma of her divided domestic loyalties and declined, in the end, to confront the implications of the possibility that a white woman might embrace Indian culture.

Mozier's statue carefully followed Cooper's description of the young European girl in Indian costume. The subject's pose, head slightly cocked, finger on her chin, suggested not only modesty but childish-ness. A catalog entry for an 1873 exhibition gave the impression that the sculpture represented the triumphant return of the white captive, as-serting that "the statue is an attempt to express the feelings of surprise and bewilderment with which she listened to the long-forgotten voice of her mother," and adding, reassuringly, "it is historically true that by this means the heathen woman was first aroused to the remembrance of her Christian parentage."[51] Mozier sold several copies of *The Wept of Wish-ton-Wish*; in at least one version he followed the controversial prac-tice of English sculptor John Gibson and tinted the marble to make it appear more lifelike, and presumably to emphasize the subject's blonde hair and light skin.[52] Although some felt this process made sculpture too sensual, Mozier had guarded against such a response with his heavy use of drapery, which softened the figure and forestalled any suggestion of exposure or constraint. The only aspect of the sculpture which observers felt to be disquieting was the subject's gaze, raised to the side rather than downcast or dreamily distant. A reviewer in the *Art Journal* complained of the "peculiarly eccentric cast of the eye," which was "a direct violation of . . . equanimity."[53] Unlike *The Greek Slave*, *The White Captive*, and *Virginia Dare*, who could be presumed to be enduring the gaze of their captors, *The Wept of Wish-ton-Wish* is being looked at by her mother, and she responds with animation rather than distant stoicism. Yet in her hesitation and sideward glance a viewer might sense some of the am-bivalence—and a hint of the tragedy—of Cooper's character. A reunion of mother and child, like that longed for by M. Louisa Southwick's white captive, did not resolve the dilemma posed by Cooper's novel.

In this pair of statues, Mozier flirted with the deepest, most disturbing possibilities of the captivity theme: what if the white woman, like Poca-hontas, should cross the threshold of the new life willingly? What if her identity proved malleable? What if she did not withdraw into a chaste, remote silence? In the end, Mozier did not pursue this possibility even as

FIGURE 31. Chauncey Ives, *The Willing Captive*

far as Cooper had; he turned tragedy into costume drama and reassured his viewers by making the captive childlike and responsive to her mother.

•

The conflicts Mozier chose to ignore were expressed more clearly in Chauncey Ives' sculpture group *The Willing Captive* of 1868 (fig. 31). Known today only through a bronze copy cast in 1886, the sculpture shows a young white girl clinging to the arm of her Indian husband,

refusing the entreaties of a kneeling woman who implores her to return to the white settlements. The subject may have been based on a well-known episode that occurred in Deerfield, Massachusetts, when the family of John Williams, the minister of the settlement, was captured by Indians and taken to Canada in 1704. Although others were ransomed, the Indians would not part with his young daughter, Eunice. Years later, she visited Deerfield with her Indian husband and children, but she steadfastly refused to return to white civilization. Although the settlers persuaded her to put on a European dress and to attend church, she soon returned to Indian costume and left the settlement. Eunice Williams' story was related in the eighteenth century in her father's captivity narrative and her pastor's sermon urging her to return to the faith; in the nineteenth century, both Francis Parkman and George Bancroft described the incident in their frontier histories.[54] Both historians stressed the personal hardships of captivity and the tragedy of disrupted domesticity. "Death hung on the frontier," wrote Bancroft, setting the scene for the attack on Deerfield. "All that winter, there was not a night but the sentinel was abroad; not a mother lulled her infant to rest, but knew that, before morning, the tomahawk might crush its feeble skull."[55] The Williams family indeed suffered the greatest possible disruption, for not only was each of the children taken to a different destination from the father, but the mother, weak from the recent birth of a child, was killed when she could not keep up with the party. Bancroft described her death as an episode in the life of the family, not, like the eighteenth-century narrative, as a Christian trial. "The mother's heart rose to her lips, as she commended her five captive children, under God, to their father's care; and then one blow from a tomahawk ended her sorrows."[56] The daughter's refusal to return to white ways puzzled both historians, although Bancroft saw in it a kind of domestic appropriateness: "she returned to the fires of her own wigwam, and to the love of her own Mohawk children."[57]

In *The Willing Captive* Ives completely reversed the narrative of *The White Captive*. Instead of longing, like the girl in the poem, for her "sweet mother," Ives' subject sides with her Indian captor and refuses to look at the kneeling white woman. Eunice Williams' mother was no longer alive when she returned to Deerfield, but Ives knew that her presence in his composition would make the tragic conflict clear. The kneeling mother, shrouded in drapery, suggests a figure of mourning or of memory. The captive bride, nestling against her husband's chest, expresses both submission and defiance. The diagonal backward thrust of her leg completes the group's triangular structure, but it also suggests movement, transition. Like the running girl in *The Last of the Tribes*, this captive finds

herself between two worlds. And that liminality, portrayed so benignly by Mozier, is in this sculpture full of tension, activity, and conflict. The composition plays against its viewers' expectations: visually the stiff kneeling figure is an intruder, threatening the smooth harmony of the two clinging lovers. Yet to accept the logic of the sculpture is to submit to the logic of captivity, to deny the claims of the lost domestic idyll. Instead of a paragon of spiritual self-containment, woman may be sexually available; her encounter with the unknown may not be too horrible to contemplate; she may embrace it. Family solidarity may not be an effective bulwark against a chaotic world, but woman may choose a transformed role in a new domestic configuration. Behind viewers' praise for the heroism of the captive maiden may lurk the unspoken fear that she will not resist, not retain her identity. Remove the chain, and every captive might be at heart a willing captive. A critic who saw Ives' *The Willing Captive* in its early stages observed that the subject would "test his powers for the highest range of composition."[58] The critic might have added that it would also plumb one of the most fundamental anxieties of his culture.

5

DEATH AND
DOMESTICITY
Shipwrecked Mother and Child

A fascination with female victimization dominated American ideal sculpture in the mid–nineteenth century, most notably in such captivity subjects as *The Greek Slave*, but also in a variety of works that represented women in peril.[1] Artworks and the narratives that elaborated on them told an overt story of female passivity, resignation, and self-abnegation, yet these same tales throbbed with anxious uncertainty as they insisted that victimized women could triumph over their enslavers, wielding a spiritual power that belied their temporal powerlessness. Tales of female vulnerability reflected a widespread uneasiness about the stability of woman's identity in a period of rapid and disorienting change. Idealizing a lost idyll of domestic tranquility, narratives of endangered women suggested a dangerous transition to an unknown world. The most stirring—and disturbing—representations of female victimization, in sculpture as in literature, were those that portrayed female powerlessness at its most extreme: in death.

In 1850 a young sculptor, Edward A. Brackett, attempted to emulate Hiram Powers and launch his career by publicly exhibiting a nude female subject. Brackett displayed *Shipwrecked Mother and Child* (1850) in Philadelphia, New York, and Boston, and it received favorable comments from artists and writers that were collected in a pamphlet to accompany the exhibition (fig. 32). Unlike Powers and later Palmer, however, Brackett did not win widespread popular approval. His career stag-

FIGURE 32. Edward A. Brackett, *Shipwrecked Mother and Child*

nated, and his life-sized statue went unsold; today it has been preserved but rests unseen in a museum basement. In his portrayal of a female victim, Brackett followed the path Powers had laid out, but the narrative that encased his sculpture did not provide the spiritual reassurance that so many observers found in the story of the Greek captive. A life-sized, nude, dead woman—who was both sentimental victim and endangered mother—suggested, even more powerfully than the captivity subjects, the deep fears that underlay nineteenth-century audiences' attraction to the subject of the victimized woman. Brackett misjudged both his own ability to control his narrative and the nature of his audience's response.

•

No aspect of nineteenth-century sentimental culture is harder for a twentieth-century audience to grasp than the fascination with death and dying that was reflected in virtually every aspect of American culture: art, literature, and education, as well as religious and social practices.[2] Our own age has seen profound changes in clinical and medical attitudes toward death, its role in family and religious life, and the valuation of emotional expression itself. As Geoffrey Gorer pointed out in the 1950s, by the mid–twentieth century, death had become a forbidden topic, and the discussion of death considered virtually pornographic.[3] A revulsion

against sentimentality has dominated American literature since Ernest Hemingway so vividly debunked the glorification of war in *A Farewell to Arms*, insisting in a memorable passage that death on the battlefield had no more meaning than slaughter in the stockyards of Chicago.[4] Today the invitation to shed tears has been relegated to the world of popular culture, of soap operas and bestsellers like Erich Segal's *Love Story* (1970).[5] Only very recently has serious literature begun to confront themes of death and loss directly, as in Toni Morrison's compelling *Beloved* (1987). The cultural assumptions of the late twentieth century make it difficult to evaluate the wealth of elegies, deathbed scenes, memorial paintings, and comments on mortality found throughout nineteenth-century high and popular culture alike.

To some extent, the nineteenth-century fascination with death reflected expectations about health and the fragility of life that were vastly different from those of our own age of advanced medical technology. Clearly, death was a more familiar event for nineteenth-century Americans than for us today. Childbirth deaths of women and infants, death by disease of young children, mortality from dysentery, consumption, and venereal disease, were all more common before the early years of the twentieth century, when mortality statistics began to show rapid improvement, at least for middle-class Americans.[6] Furthermore, death was more visible since it usually took place in the home, where the dying person was surrounded by attentive family members.

Compared to earlier periods, however, nineteenth-century Americans lived in a period of improving expectations for long life and good health. It seems that nineteenth-century anxiety about death intensified at a time when life expectancy was actually increasing. Lawrence Stone has suggested that higher survival rates encouraged stronger affectional ties in families, thereby making each death more painful.[7] Whether or not one accepts Stone's explanation, it is evident that nineteenth-century Americans wrote, and presumably thought, a great deal about death as a powerful and disruptive force, transforming individuals' lives, relationships, and, especially, families.

Furthermore, nineteenth-century expectations about the process of death differed sharply from those of the twentieth century. In consonance with Western practice dating back centuries, the dying person was expected to be fully aware of his or her condition, prepared for the coming of death.[8] The desire for a prepared death was, of course, partially religious, and Jane Tompkins has reminded us that literary deathbed scenes like those in Harriet Beecher Stowe's *Uncle Tom's Cabin* performed important "cultural work," advancing the claims of evangelical religion and

instructing readers how to prepare for their own end.[9] Ann Douglas has pointed out that sentimental consolation fiction became popular at a time when religious certitude was waning among many Americans and when both ministers and women were losing status in American society; rituals of mourning and consolation offered a realm of continued influence for both.[10] A fascination with the details of illness, death, and mourning, common to highly articulate and barely literate Americans alike, suggests a weakening of the explanatory powers of the two institutions within which the drama of death was enacted: religion and the family.[11]

·

The twin themes of religious anxiety and fear for the integrity of the family dominated the intellectual and literary context in which Brackett's viewers would place the story they read in his sculpture. Writers as different as Lydia Sigourney and Edgar Allan Poe participated in an anguished cultural debate over the significance of death in nineteenth-century culture and the possibilities for meaningful consolation.

Lydia Sigourney, who was celebrated in her own time as the "sweet singer of Hartford," was one of the best-known writers of sentimental consolation literature in antebellum America.[12] In her poems readers confronted again and again the painful themes of the separation of families, the agony of parting from loved ones, and the anxious search for religious certitude. A characteristic volume of Sigourney's verse, the pocket-sized *Poems* published by John Locken in 1842, contained just over a hundred poems. Of these, forty dealt directly with death, with titles like "Thoughts at the Funeral of a Friend," "Tomb of a Young Friend at Mount Auburn," "The Dying Mother's Prayer," "Death of a Beautiful Boy." Another forty used death imagery or referred to death in the context of romantic narrative ("The Swedish Lovers") or nature poetry ("The First Morning of Spring"). Of the remaining poems, many addressed religious themes, including several on the departure of Christian missionaries for faraway places. The design of the book itself, a handsome little volume, small enough to fit into a pocket, suggests that it was meant to be carried around, to be read over and over again. What concerns would impel a reader to give these poems such devoted attention? To what needs did they speak? What story did they tell?

Like many fictional and autobiographical accounts of death, Sigourney's writings gave readers an opportunity to rehearse an experience anxiously recollected or anticipated in their own lives: the deathwatch.[13] Most readers would have experienced the terrifying responsibility of witnessing someone else's death, and all could anticipate their own.[14] Yet

unlike many other descriptions of deathbed scenes, Sigourney's poetry did not linger on such details as the pale appearance, labored breathing, or even the last words of the dying individual. Death haunted her poetry, not as a bringer of physical suffering but as an agent of painful separation: mother from infant, husband from wife, child from parents. "*Why art thou absent now?*" exclaimed one poem; another demanded, "*Where is she? . . . The mother* is not here."[15] In "Dirge," Sigourney insisted that the bereaved, rather than the dead, deserve our tears:

> . . . Moved with bitterness, I sighed—
> Not for the babe that slept,
> But for the mother at its side,
> Whose soul in anguish wept. (123)

"Depart! depart! The silver cord is breaking," began another account, which went on assure its readers that death is but a transition to a better state: "The seraph-marshall'd road is toward the realm of day." (85–86). Repeatedly, Sigourney struggled to place the anguish of domestic disruption within the bounds of Christian hope, and her poems constructed a tenuous dialogue between grief and consolation, between the expression of despair and the assertion of religious faith.

At almost the exact center of the pocket-sized volume of Sigourney's poems, "The African Mother at Her Daughter's Grave" explored the tension between despair and hope in the face of death's disruptions. Using an exotic setting, a woman weeping at her daughter's grave in far-off, "pagan" Africa, Sigourney could give full vent to the grief of separation.

> "Daughter! my youthful pride,
> The idol of my eye;—
> Why didst thou leave thy mother's side,
> Beneath these sands to lie?"

Sigourney ended the poem with a wish for "some voice of power, / To soothe her bursting sighs" with the assurance that "There is a resurrection hour; / Thy daughter's dust shall rise!" (109–11). Her American readers would presumably share this faith, but Sigourney had poignantly expressed a grief and desolation that belied her reassuring assertion. Although the poem affirmed a Christian viewpoint, offering solace to a mourner, the device of the African mother introduced a voice that could express the dread that lurked behind the consolation.

Although poem after poem affirmed Sigourney's religious faith and expressed the hope for a heavenly reunion of sundered families, the words of comfort followed particularly vivid evocations of the pangs of part-

ing. An almost unbearable yearning for connection wracks the dying, as well as the survivors. In one harrowing scene, Sigourney's own sister was jolted from the "calm endurance" of her deathbed by the sight of her newly born child. Her eye, wrote Sigourney,

> Kindled one moment with a sudden glow
> Of tearless agony, —and fearful pangs,
> Racking the rigid features, told how strong
> A mother's love doth root itself. (59)

Another dying mother "checks / The death-groan" to embrace her child once more; a babe "stretch[es] its arms for her who comes no more" (142, 247). Although Sigourney also depicted the death of men and boys, the parting of mothers and children epitomized death's most dreaded sting.

A collection of Sigourney's poetry like the 1842 John Locken volume, then, focused on the impact of death on the family. While overtly offering a Christian assurance that the circle would be unbroken, that the family would be reunited in heaven, the poems examined again and again the agonizing pain experienced by those who watched their loved ones die. The consolation she wrings with such determination from these pitiful stories lies in the certainty that the dead loved one would find religious salvation, that her identity was secure among the blessed.

Another view of death that was open to Brackett's viewers, however, was not so reassuring. For Edgar Allan Poe, the horror of death, particularly the death of a woman, lay precisely in the uncertainty of the victim's fate and even her identity. The emotion of dread that Sigourney carefully wrapped in a mantle of religious faith was at the heart of Poe's poetry, and his most famous work, "The Raven," played directly upon the conventions of consolation literature.[16] The narrator of "The Raven" is a mourner, struggling with his "sorrow for the lost Lenore," asking, like Lydia Sigourney, whether those who are parted by death will be reunited in heaven: "Tell this soul with sorrow laden if, within the distant Aidenn / It shall clasp a sainted maiden whom the angels name Lenore—."[17] Of course, the raven replies to this question, as to every other demand for consolation, with the ominous dirge, "Nevermore." The existence of heaven, the identity of the lost Lenore among the blessed, all are darkly doubted by the supernatural messenger. Without the assurance of religious salvation, the mourner was left with only the fearful pangs of separation. In "The Raven," Poe spoke directly to the hopes and fears that were also addressed by sentimental consolation poetry, and revealed the pain and dread that underlay it.

Sigourney viewed death and loss primarily from the point of view of

the family, especially the mother, but Poe consistently adopted the stance of the bereaved male lover. This emphasis suggests another aspect of the sentimental fascination with the dying woman: its suppressed eroticism. Poe's dying women inspire the narrators of his short stories with both horror and desire, like the unfortunate Berenice, stricken with a mysterious degenerative illness. "I shuddered in her presence, and grew pale at her approach," says the narrator; yet he marries the once-beautiful woman.[18] Poe wrote to an editor that he chose the gruesome subject of "Berenice" (the narrator's obsession with the teeth of his dying wife) in response to a bet, and he subsequently deleted several paragraphs from the tale, presumably to temper its graphic morbidity.[19] The omitted paragraphs, however, represented the narrator's most direct experience of his wife's dangerous attraction. After Berenice's death, the narrator is invited to view her corpse, and as he leans over the bed on which she lies, it is not too farfetched for us to see in the scene a nightmare version of a marriage-night. Enclosed by the bed-curtains, shut out from the rest of the world, the narrator is alone with Berenice, and he is her captive: "I would have given worlds to escape. . . . But I had no longer the power to move—my knees tottered beneath me—and I remained rooted to the spot."[20] The male narrator assumes a passive, submissive role, while the apparently powerless, silent, victimized woman wields a terrible power; she bares her teeth in a grimace of triumph. It is those teeth, symbol of her erotic attraction as well as her dangerous power, that the maddened narrator strips from her. Similarly, Madeline Usher goes to her tomb with a "suspiciously lingering smile" and "the mockery of a faint blush" on her skin.[21] Like Berenice, she returns from the dead, breaking her silence with "a low moaning cry" of pain or of sexual arousal.[22] Like so many of Poe's depictions of the death of a beautiful woman, "The Fall of the House of Usher" suggests the complex interrelationships between death and desire. In Poe's work, woman both attracts and repels; she inspires man's devotion and drags him down to destruction. The bereaved lover is not only separated from his loved one, but he is changed forever by witnessing her struggle with death.[23] Unlike Sigourney, Poe placed death in a context that denied both religious consolation and the comfort of the family.

•

The agony of parting from loved ones and the need for reassurance that the dead will rest in peace constitute important themes in the works of visual art that formed the most direct context for viewers of Brackett's *Shipwrecked Mother and Child*: graveyard sculpture. A long tradition of

FIGURE 33. John Gibson, *Model for the Monument to Sarah Byron*

1830s

memorial sculpture stretched back to Greek grave reliefs and Renaissance tombs; more recently, church monuments had undergone a revival in England for middle-class as well as wealthy patrons.[24] Although much memorial sculpture in America, as well as in England and Europe, consisted of such architectural forms as crosses or obelisks, figurative sculpture continued to be important, and statues were commissioned to mark the tombs of both men and women. A particularly rich group of sculptures flourished in England in the late eighteenth and early nineteenth centuries, memorializing women who had died in childbirth.[25] And since many of England's most notable sculptors—John Flaxman, Francis Chantrey, John Gibson—produced these sculptures, the works were often engraved in English and American art journals and were frequently discussed in travel books, letters, and memoirs.[26]

The themes of grief, the sundered family, and religious consolation were epitomized in John Gibson's *Monument to Sarah Byron*, carved in the 1830s (fig. 33). In this relief sculpture, the dying woman is portrayed, recumbent on a couch, her outstretched arm touching, with its last ges-

ture, the baby held in the grieving husband's arms. Overhead an angel appears, carrying the robe that the dying woman will wear in heaven and pointing upward to signal her translation to a heavenly home. The sculpture embodies perfectly the tension between the agony of parting and the hope of salvation that surged through the work of sentimental poets such as Lydia Sigourney. The elements gathered so forcefully in Gibson's sculpture appear separately in the sculpture of others, some of which depict the dying woman surrounded by mourners, or clasping a baby, or being conducted to heaven by angels. All of these elements were familiar motifs to viewers of cemetery art or ideal sculpture in mid-nineteenth-century America.

American graveyard sculpture began to reach a wide audience beginning in the 1830s, with the rise of the garden cemetery movement. Tourists as well as mourners visited the parklike surroundings of the new memorial gardens, such as Mount Auburn Cemetery outside Boston.[27] A visit to a garden cemetery combined the pleasures and consolations of landscape with those of sentimental narrative. Viewing memorial sculpture in such a setting was much like reading the poetry of Lydia Sigourney: it suggested the sadness of early death, the pain of parting from loved ones, and the consolation of knowing that the dead found blessed rest. In 1850 the popular writer Grace Greenwood described a viewer's response to a child's funeral monument during a visit to Laurel Hill Cemetery outside of Philadelphia on a cold December day. Greenwood watched while a young woman, weeping "as perhaps she had but lately wept for her own dear babe," paused near a statue of a sleeping baby on a tomb, gave "a convulsive shudder and a low cry of pitying anguish," then "caught the warm shawl from her own shoulders, and flung it over the railing and on to the sculptured child!"[28] Whether this account represented an actual event or a sentimental fiction, it suggests that viewers of monumental sculpture, no less than visitors to an art gallery or exhibition hall, responded powerfully to the stories told by the sculpture they viewed, stories that reflected some of their deepest concerns.

When the first memorial sculpture was unveiled in Mount Auburn Cemetery, Henry Dexter's monument to Emily Binney (1842), it achieved instant notoriety (fig. 34). As a Boston minister remembered in 1898, "I can myself recall the time when it was a common excursion, if one wished to take a walk or entertain a friendly stranger, to go out to Mount Auburn to see *The Binney Child*."[29] Dexter's sculpture affectingly evoked the pathos of a child's death, but by implication it also raised the richer, more disturbing subject of the death of a beautiful woman. Its subject, a young girl, lay as if asleep, hands and bare feet crossed, under a canopy sup-

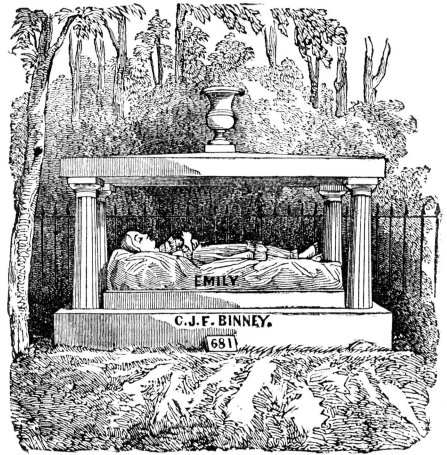

FIGURE 34. Henry Dexter, *Emily Binney*, engraving 1842

ported by Doric columns.[30] Dexter appears to have drawn on two sources: on one hand, a tradition of English memorial sculpture that provided consolation by portraying its subjects peacefully asleep, most notably represented by two recumbent sculptures of little girls, Thomas Banks' *Monument to Penelope Boothby* (1793) (fig. 35), and Francis Chantrey's *The Sleeping Children* (1817) (fig. 36).[31] On the other hand, Dexter could draw from a very different tradition, represented by Horatio Greenough's *Medora* (1832) (fig. 37), an ideal sculpture that had been exhibited in Boston a few years earlier.[32] Unlike memorial sculpture, whose chief object is consolation, Greenough's female subject, taken from Byron's *The Corsair*, suggested some of the tragedy and turmoil of early death. Lying on a marble slab, with her head tilted backward, her nude body draped below the waist, her hand limply touching a sprig of flowers, the figure

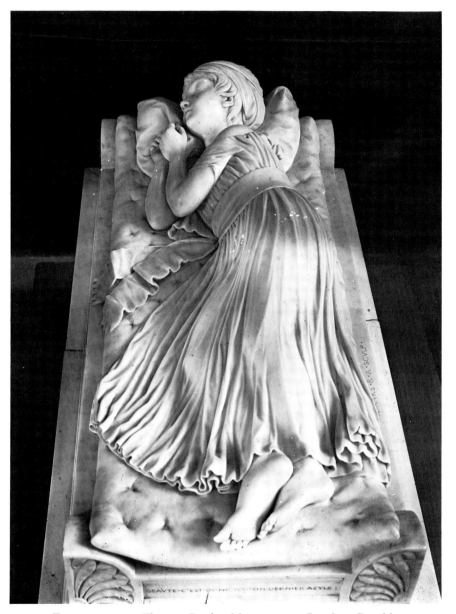

FIGURE 35. Thomas Banks, *Monument to Penelope Boothby*

English 1793

of the dead Medora seemed vulnerable, exposed. Unlike the tranquil fig-
ures of the dead children, Medora was an object of desire as well as of
pity.

The suggestion that the dead girl might be considered a romantic vic-
tim, or that she might rest uneasily in her tomb, was pushed far from

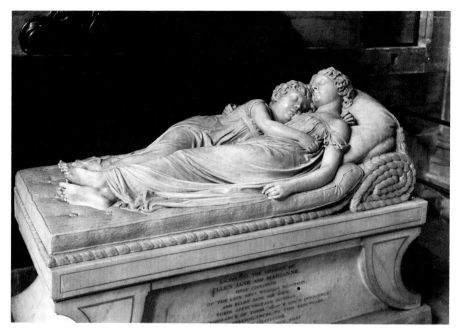

FIGURE 36. Francis Chantrey, *The Sleeping Children*

English 1817

the thoughts of most viewers of Dexter's sculpture, however. *The Binney Child*, fully clothed and chastely posed, belonged to the world of Lydia Sigourney rather than that of Edgar Allan Poe. It evoked not the pain but the pathos of death and offered comfort to many viewers. On a marble slab beside the statue, a short poem expressed the consolation of religious certitude:

> Shed not for her the bitter tear,
> Nor give the heart to vain regret,
> 'Tis but the *casket* that lies here—
> The *gem* that filled it sparkles yet. [33]

Lydia Sigourney, who wrote a tribute to the Binney child, characteristically focused on the parting of mother and child, lamenting that death, "the spoiler," had sealed the lips of a child whose voice had "claim[ed] its mother's ear, / charming her even to tears." But Sigourney found comfort in the assurance that the dead child was among the blessed: her smile, "so fixed and holy" seemed to bear the impress of "the signet ring of Heaven." [34]

Another poet also found consolation in Dexter's tranquil portrayal of the dead girl. "If the sculptor's art / May ever soothe the mourner's sorrowing heart," wrote one viewer,

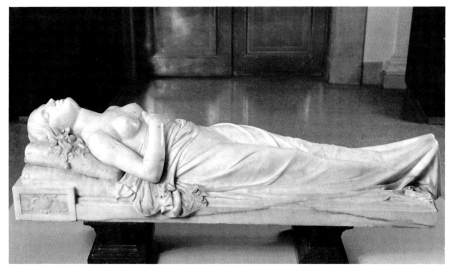

FIGURE 37. Horatio Greenough, *Medora*

It may console the friends who weep for thee,
Young, innocent, and gentle Emily.

The source of this comfort, continued the poet, was the sculpture's meta-phorical assurance that the sleep of death would be a tranquil one.

We stand beside thy couch; to hear thy breath
We almost pause; and is it sleep or death
The cunning hand of art would seek to trace
On the sweet features of thy placid face?[35]

Like Lydia Sigourney, who wrote a poem on the text, "Not Dead, But Sleepeth," Dexter explored the mysterious border between life and death, and viewers could interpret the image to affirm Sigourney's assurance that the tranquil sleeper would arise in another life.[36] From this perspective, the family burial plot was the scene not only of parting but of potential reunion. Enclosed by an iron fence and sheltered by a marble slab, the peaceful figure of Emily Binney suggested protection, survival, and, implicitly, that heavenly reunification for which Sigourney's poetry yearned.

Two other American sculptors built upon Dexter's example in the decade of the 1850s as they explored the theme of death in both monumental and ideal sculpture. In 1856, Erastus Dow Palmer received a commission for a monument to Grace Elizabeth Williams, who had died two years earlier at the age of seven (fig. 38). An early study for the

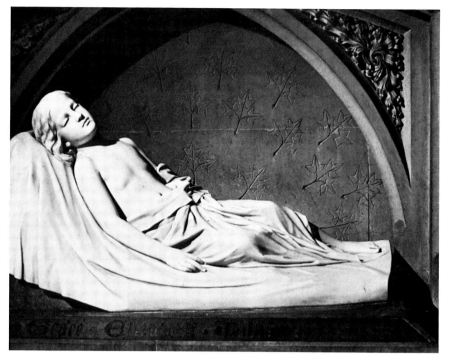

FIGURE 38. Erastus Dow Palmer, *Grace Williams Memorial*

1856

sculpture showed a fully-dressed child reminiscent of Emily Binney, re-clining with her head propped at an angle, loosely holding a little bunch of flowers like those Greenough had placed beside the dead woman in *Medora*.[37] As Palmer worked on the sculpture, he decided to replace the dress with drapery spread over the child's nude body, a change that made her parents uneasy.[38] The revised sculpture resembled a de-eroticized *Medora*; in fact, Palmer realized that his memorial statue had begun to lose its consolatory function and could be made to evoke the more general poetic associations of ideal sculpture. He later sold a marble version of the figure, nude, with a slightly different face, under the title *Sleep* (fig. 39).[39] If the same figure could suggest both the sleep of life and the sleep of death, however, the underlying assumptions behind sentimental consolation must be called into question. When Grace Williams' monument was installed in the church her family had helped to found, the inscription above her head read, "Concerning them which are asleep, Sorrow not."[40] Like Sigourney's poetry and *The Binney Child*, the memorial to Grace Williams seemed to suggest that death was merely a gentle sleep from which the Christian could expect to awake to the joy of resurrection and family reunification. However, if the same figure suggested

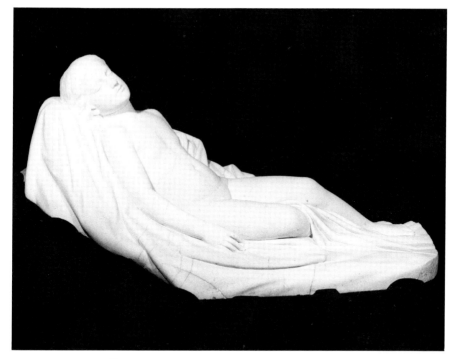

FIGURE 39. Erastus Dow Palmer, *Sleep*

mere bodily relaxation, or even the physical beauty of the female body, then her tranquil sleep was not a promise of everlasting life but a threshold to the unknown, and the sleeper was not safely among the blessed but rather, like the captive maiden, risked change, transformation, and a fluid rather than a fixed identity.

Another American sculptor explored the connection between the sleep of life and the sleep of death in the mid–nineteenth century. Harriet Hosmer, a young American woman just establishing herself as a sculptor in Rome in the late 1850s, received a commission to sculpt a memorial to a sixteen-year-old girl who had recently died, Judith Falconnet.[41] Falconnet's mother, an Englishwoman, may have chosen Hosmer because she was a pupil of the noted English sculptor, John Gibson. Since Mrs. Falconnet was Catholic, she received permission to erect a monument to her daughter in the Church of St. Andrea delle Fratte in Rome.[42] The first sculpture by an American to be placed in one of the historic churches in Rome, *Judith Falconnet* (1858) excited interest and admiration within Rome's international community (fig. 40).

Hosmer's portrayal of Judith Falconnet, reclining, with feet lightly crossed, on a couch, head propped up with pillows, owes much, as art

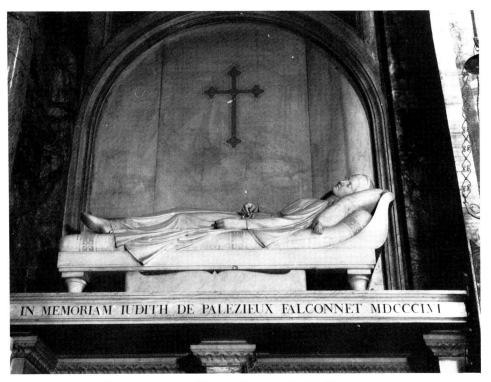

IN MEMORIAM IUDITH DE PALEZIEUX FALCONNET MDCCCLVI

FIGURE 40. Harriet Hosmer, *Judith Falconnet*

1858

historian Barbara Groseclose has pointed out, to English and Italian memorial sculpture.[43] However, it also drew importantly on the tradition behind Palmer's *Grace Williams* and Brackett's *Shipwrecked Mother and Child*—Dexter's monument to Emily Binney. Hosmer, who had grown up in Watertown, Massachusetts, very near Mount Auburn Cemetery, had seen her mother, brothers, and sister die of consumption when she was still a young child. Her sister died and was buried in Mount Auburn the same year the Binney monument was erected, and Hosmer may have associated the statue with her own sense of grief.[44] Technically more polished than Dexter's statue, the monument to Judith Falconnet none-theless evoked some of the same emotions that viewers had attributed to the Binney statue. Tranquil, dignified, finely detailed, Hosmer's sculp-ture was praised in its own time for its "unaffected simplicity and ten-der feeling."[45] Unlike some of the recumbent English tomb sculptures, such as P. Hollins' *The Monument to Mrs. Thompson* (1841) (fig. 41), which had been illustrated in the London *Art-Journal* in 1851, *Judith*

FIGURE 41. P. Hollins, *The Monument to Mrs. Thompson*, engraving

London Art J. 1851

Falconnet did not show the sleeper awakening to another life; nor did it suggest, like J. Edwards' monument to Miss Hutton, engraved in 1858 (fig. 42), the dying woman's vision of heaven. In tone and spirit it resembled Francis Chantrey's *Resignation* (1825) (fig. 43), a monument to Mrs. Digby, which had been engraved in the London *Art-Union* in 1847 and praised for its "elevated sentiment."[46] Yet Hosmer had chosen to portray her subject, like Emily Binney, resting peacefully in the sleep of death. Hosmer's *Judith Falconnet* relied for its emotional effect on a sweet, simple image of tranquility that implied religious certainty: a belief in salvation and a belief in the stable identity of its beautiful young subject.

At the same time she was constructing this image of sweet certainty, however, Hosmer was working on another statue that opened the door to the dark doubts and fears that lay, as Poe had demonstrated, behind sentimental consolation literature.[47] *Beatrice Cenci* (1857) portrayed a young girl who had experienced the greatest horrors that haunted the nineteenth-century imagination (fig. 44). The daughter of a Renaissance nobleman, the historical Beatrice Cenci had been executed for murder after killing the father who had imprisoned and sexually abused her. Nineteenth-century writers were deeply attracted to the dreadful story, and a painting attributed to Guido Reni, which purported to show the

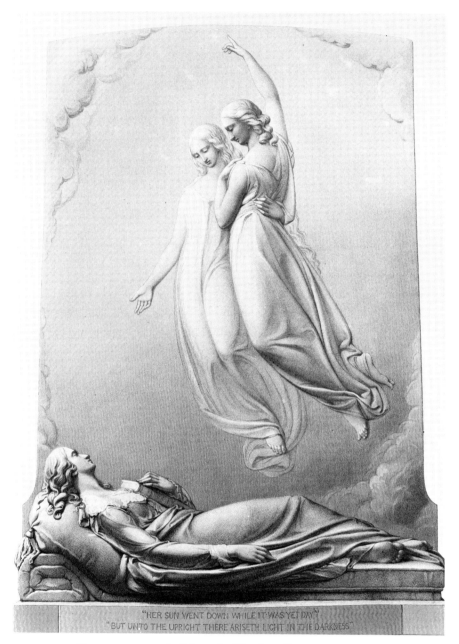

"HER SUN WENT DOWN WHILE IT WAS YET DAY"
"BUT UNTO THE UPRIGHT THERE ARISETH LIGHT IN THE DARKNESS"

FIGURE 42. J. Edwards, *The Last Dream*, engraving

Art Journal 1858.

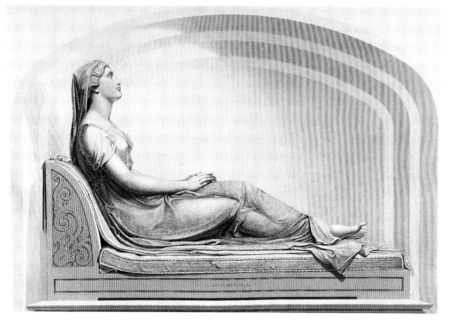

FIGURE 43. Francis Chantry, *Resignation*, engraving

mon· to Mrs. Digby
London Art Union 1847

young girl on the eve of her execution, was widely described in travel books and engraved in art magazines (fig. 45). Nathaniel Hawthorne used the painting and the historical character it represented as an important touchstone in his novel of Roman artist life, *The Marble Faun*.[48] In the novel and in his notebook entries, Hawthorne reflected the romantic view that Beatrice, despite her dreadful crimes, was more a victim than a sinner. Percy Bysshe Shelley had portrayed Beatrice sympathetically in his verse play *The Cenci*, where she defended her innocence in stirring terms: "Tho' wrapt in a strange cloud of crime and shame, / [I] lived ever holy and unstained."[49] The subject of Beatrice Cenci brought two highly charged themes together: the vulnerability of the young girl and the fragility of the family, violated by the abusive father and forever sundered by Beatrice's death.

In choosing the subject of Beatrice Cenci, Hosmer followed Powers into the realm of the captive maiden, with many of the powerful emotional associations it evoked. The hard stone of the prison cell functioned, like the chain of *The Greek Slave*, to startle the viewer and to suggest harsh constraint. The rosary in Beatrice's hand indicated her Christian faith and by implication, the innocence of soul that contrasted with both the grim setting and the violent events of the narrative that surrounded her. Interestingly enough, Hosmer chose to portray Beatrice asleep, surren-

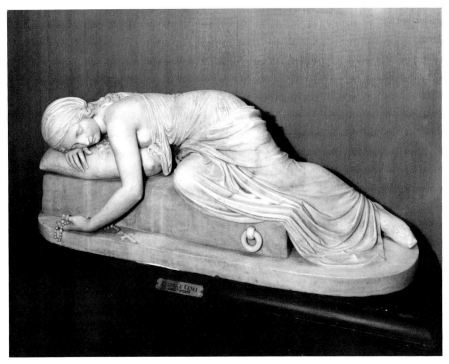

FIGURE 44. Harriet Hosmer, *Beatrice Cenci*

dering not only freedom but consciousness, relaxed, submissive, awaiting her dreadful fate.

Commentators who praised Hosmer's statue sought to read it in the manner of *The Greek Slave*, as a celebration of a woman's endurance of suffering. "How posterity reverses and revenges the judgment of tribunals, the verdict of executioners!" exclaimed a writer in an American art journal. "To this girl, judged worthy of a felon's death, the scaffold of shame has become a pedestal of glory. Her name is a synonym for suffering innocence, the type of a sorrowing beauty, which, appealing to our sympathies, wins our unconscious homage." [50] Like the viewers who maintained that *The Greek Slave* was clothed with purity, these commentators insisted that female beauty must be a sign of innocence, that the suffering victim would triumph over her persecutors, and above all that the spectacle they witnessed when they looked at the statue was one of triumph, not of despair. In this sense the commentators affirmed, like the writers of sentimental consolation poetry, a belief in the stability of female identity, an assurance that, whatever the pain of separation, the suffering victim would be numbered among the blessed. The very proof and sign of Beatrice's innocence, according to these commentators, was

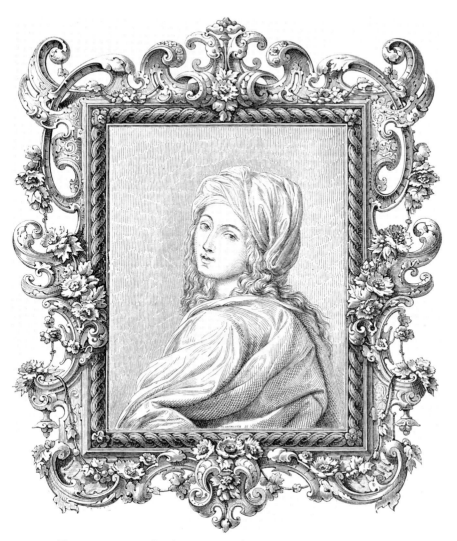

FIGURE 45. Guido Reni, attrib., *Beatrice Cenci*, engraving

the sweetness of her sleep.[51] Like the narcissistic self-possession of *The Greek Slave*, Beatrice Cenci's sleep removed her from the world around her; it gave her an aura of mystery. Ironically, it forecast the eternal sleep that would follow, but viewers saw in it a note of triumph, a transcendence of the anguish expressed by her huddled pose, her disarranged clothing.

Hosmer's exploration of the extremes of human suffering in *Beatrice Cenci*, however, casts an interesting light on her other recumbent sleeper, *Judith Falconnet*. It is tempting to see in the *Cenci* the emotional anguish that was repressed in the calm, consoling image of Falconnet. Both young women are about the same age; both grasp a rosary in nerveless fingers. Judith Falconnet lies tranquilly on her back, the lines of her dress straight, even, and parallel; though she cannot feel its softness, she lies on a mattress and pillow. Beatrice Cenci, though living, sprawls face-down on a hard stone floor, cushioned only by a pillow; the lines of her clothing are twisted, and her dress has slipped off one shoulder. In *Judith Falconnet*, nineteenth-century viewers would see an exemplary life, a beloved daughter commemorated by her loving family; but *Beatrice Cenci* plumbed the underside of woman's life, her sexual vulnerability and the fragility of the family. Even while she was working on the calm, consoling image of *Judith Falconnet*, Hosmer pondered the possibility that the female victim might fall prey to passion, the family might suffer disruption, and peaceful sleep might yield to nightmarish awakening. Through the sweet calm of *The Binney Child* gleamed flashes of the emotional turmoil of *Medora*.

·

The Greek Slave, *The Binney Child*, and *Medora* all formed the context for Edward Brackett's bid for artistic fame in *Shipwrecked Mother and Child*. Like Palmer and Hosmer, Brackett attempted to grasp and develop the powerful emotions evoked in a nineteenth-century audience by the contemplation of the death of a woman. By selecting a subject whose implied narrative was so dramatic and so disturbing, however, Brackett failed to fulfill his viewers' expectations that sculpture, like the poetry of Lydia Sigourney, would lead to consolation and tranquility. Rather, like Poe, he unleashed haunting doubts and anxieties.

Because Brackett never found the formula for popular success as a sculptor, he has been relatively little studied.[52] Like Powers, he had moved with his family from Vermont to Cincinnati, and there he began modeling sculpture in the 1830s. However, he was not able to win the approval of Cincinnati's most important art patron, Nicholas Longworth, who had launched the career of Powers, as well as those of Shobal Clevenger

and Larkin Goldsmith Mead. In 1839 Brackett exhibited in Cincinnati a statue of Nydia, the blind girl in Bulwer Lytton's *Last Days of Pompeii* (anticipating by sixteen years Randolph Rogers' successful version of the same subject), and although a group of citizens tried to raise a subscription to buy the sculpture for the Western Museum, Longworth wrote disparagingly that Brackett should have had "the sense enough to destroy it when finished."[53] Unable to follow Powers to Europe, Brackett went to New York, and then Boston, where he attracted some attention for his portrait busts. In 1844 he published a collection of line drawings with accompanying literary texts, proposals for sculptures that were never, apparently, commissioned.[54] In 1850 and 1851 he tried to establish a national reputation by exhibiting *Shipwrecked Mother and Child* in the major Eastern art centers. Although it received admiring notices from popular writers like Grace Greenwood and Charles Leland, and a warm endorsement from Horatio Greenough, it never achieved the popularity of *The Greek Slave*, which had toured triumphantly only a few years earlier. A group of Boston art patrons met at the Athenaeum to initiate a subscription to buy Brackett's sculpture, but the money was never raised.[55] In 1859 Brackett was able to convince a patron, G. L. Stearns, to send him to Virginia to model a bust of John Brown, awaiting execution, but in general Brackett received so little recognition that he gave up his sculpture studio in 1873 and served as chief specialist for the Massachusetts Fish and Game Commission for the rest of his working life.[56] Perhaps Brackett would have been more successful had he been able to go to Europe like Powers, Crawford, or Hosmer; or he might have attracted more consistent patronage in a smaller community, like Palmer in Albany. Perhaps, like Washington Allston, whose bust he modeled, he lacked entrepreneurial instincts; he certainly shared Allston's romantic notion of the artist's calling. Or perhaps his great gamble, the *Shipwrecked Mother and Child*, cut too close to his viewers' deepest anxieties.

In the portfolio of drawings he published in 1844, Brackett explored the themes of death and memory in terms that recall the consolation poetry of Lydia Sigourney. Each of his three designs illustrated a poem. "The Guardian Angel," based on a poem by Elizabeth Oakes Smith, showed a baby sleeping, watched over by a cherub who chases away a snake with a staff (fig. 46). In "Excelsior," illustrating Henry Wadsworth Longfellow's poem, a man, a woman, and a dog look sadly at the body of a young man, while a shooting star blazes overhead (fig. 47). The third drawing, "The Ascension," shows a young woman being carried to heaven by two angels, a theme that had been popular in English mortuary sculpture since John

FIGURE 46. Edward A. Brackett, "The Guardian Angel"

FIGURE 47. Edward A. Brackett, "Excelsior"

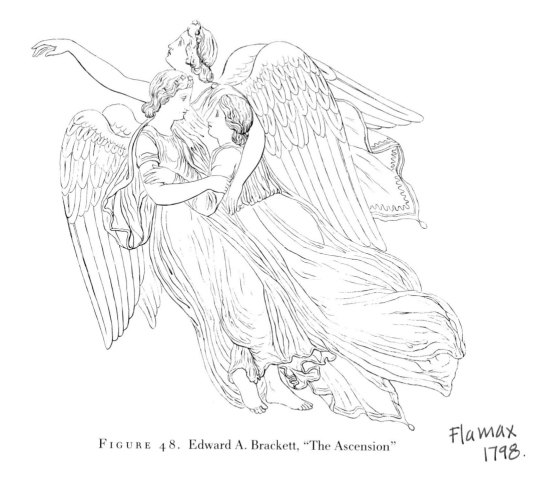

FIGURE 48. Edward A. Brackett, "The Ascension"

Flamax 1798.

Flaxman's *Monument to Agnes Cromwell,* completed in 1798 (fig. 48).[57] The poem, by T. B. Read, that accompanied the drawing stressed, like Lydia Sigourney's consolation poetry, the "cords of love" that link the living and the dead.

> There's pain on earth; a new made mound
> Is sprinkled with the dew of grief;
> And age and youth still linger round;
> For love is lasting, beauty brief.[58]

Taken together, these three engravings introduced all of the major elements that would make up *Shipwrecked Mother and Child*: the innocent babe, tragic death, and the painful separation of families. Brackett suggested that such sculpture could have consolatory powers, and he called in the introduction to the volume for more monumental sculpture in cemeteries. "The effect would be highly beneficial. [Cemeteries] would

cease to be wholly the home of the dead, and would become silent, but powerful teachers of the immortality of virtue. There faith would be strengthened, the spiritual would become more real, and our feelings would be less often chilled."[59] But his proposals met with little enthusiasm, and none of the sculptures was commissioned.[60]

In a volume of poetry published the year after the portfolio of his drawings, Brackett further explored themes of death and parting. In "Sleep and Death, An Illustration of a Group of Sculpture," Brackett played with the idea that had fascinated viewers of Emily Binney's monument, the difference between the sleep of life and the sleep of death.

> Death and Sleep twin brothers are;
> Death is folded to the breast;
> Gentle Sleep he soothes life's care,
> Death doth give eternal rest.[61]

Brackett imagined two children personifying Death and Sleep lying cheek-to-cheek, as do Chantrey's *Sleeping Children*; his idea anticipated Thomas Crawford's popular *Babes in the Wood* (1851) and William Henry Rinehart's *Sleeping Children* (1869). If Brackett had exhibited such a work, it might have been well received, but this sculpture was apparently never executed.

In another poem, "Annabelle," published the same year as Poe's "The Raven," Brackett wrote in the voice of a bereaved lover. Poe had already published "Lenore" (1843), but his great poem, "Annabel Lee," lay four years in the future, and Brackett's poem may be added to the list of sources for it.

> Sweet Annabelle, dear Annabelle,
> When thou was weak and pale,
> And leaning on my arm, we went
> Adown the lonely vale,
> I well remember thou didst tell
> That I should lose thee, Annabelle.[62]

Brackett's poem expresses the pathos of loss: the word *lonely* is repeated three times in the four stanzas, and the narrator cries, disconsolately, "But where art thou, sweet Annabelle?" Like Poe, Brackett offered not consolation but a cry of despair; the poem ends without comfort, with a repetition of the first mournful stanza. Unlike his proposals for memorial sculpture, Brackett's poetry focused on the pathos of death and the pain of parting, rather than on religious faith and consolation.

In *Shipwrecked Mother and Child*, Brackett followed the example of

The Greek Slave, taking a subject with literary resonance but creating his own implied narrative, to be constructed by viewers from the visual evidence in front of them. The life-sized nude woman lies sprawled on a rock, with her hair trailing behind her, tatters of her clothing looped over her arm and spread under her. Her left arm clutches a baby, whose body lies nestled against hers. The rough rock and carefully carved shells, together with the flow of her sea-drenched hair, make the circumstances of the shipwreck clear; the body of the child, its head tilted back, at the center and highest point of the sculpture, stresses the fact that this is not only a drowned woman, but a devoted mother. Some commentators have suggested that the sculpture was intended as a memorial to Margaret Fuller, who drowned in a shipwreck with her husband and twenty-two-month-old son in July 1850, but Brackett's sculpture had been finished in clay by January of that year.[63]

Brackett expanded on what he saw in the images of a drowned woman and her child in a poem, "The Wreck," which he published near the end of his life:

> Within the storm-tossed bay
> Drifted forms, here and there,
> With pallid face and floating hair,
> Mocking life with vacant stare.
> While up the beach, beyond the reach
> Of the restless, foaming tide,
> Where the wreckage had been piled,
> Without pulse, without breath,
> Folded in the arms of death,
> Lay the mother with her child.
> Not in the garb of fashion dressed,
> But in the beauty God expressed
> When he made all mankind
> In the glory of his mind.[64]

The poem clearly explicates the sculptural image: the drowned woman lies on the beach with her child in her arms, her clothes stripped from her. Brackett differentiates this beautiful victim from the grotesque bodies still drifting in the bay. She lies "up the beach, beyond the reach" of the threatening tide, tenderly "folded in the arms of death." Like the Greek slave, the female subject is both exposed and protected.

In the poem, Brackett addressed the doubts that American audiences still felt when confronted with nude sculpture. The drowned woman has exchanged "the garb of fashion" for "the beauty God expressed" at the

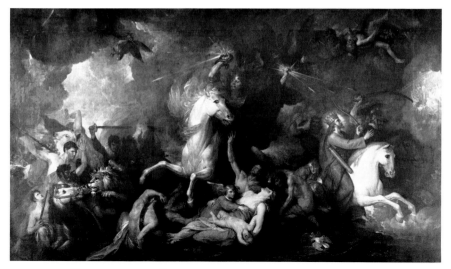

FIGURE 49. Benjamin West, *Death on the Pale Horse*

moment of creation. But if "the glory of [God's] mind" would reconcile viewers to the figures' nudity, it did not console them for the deaths of the shipwreck victims. Brackett depicted the mother and child starkly, as lifeless as the inanimate "wreckage" of the ship. Like his earlier poetry, "The Wreck" evoked pathos but not consolation.

In designing his sculpture, Brackett drew not only on the tradition of graveyard sculpture but on a group of contemporary artworks that depicted the turmoil and painful disruptions of death. One of the best known was Benjamin West's *Death on the Pale Horse* (1817), which had toured America from 1835 to 1837 (fig. 49); earlier, William Dunlap had exhibited a copy of the painting. In 1802, a sketch for *Death on the Pale Horse* had been shown in Paris to great acclaim, and it had been engraved in 1807 and again in 1831. In this dramatic scene from the Book of Revelation, the four horsemen of the Apocalypse ravage the land, dominated by the figure of death, surrounded by scenes of slaughter. Human vulnerability is most vividly epitomized by a group in the foreground, where a dead woman lies with a baby sprawled across her lap. Contemporary commentators saw antecedents for this group in Hogarth's print, *Gin-Lane*, where a drunken woman lets a child fall from her lap, and, more pointedly, in Nicolas Poussin's *The Plague at Ashdod* (1630) (fig. 50), where a dead woman and child form the vortex of a swirl of suffering and grief.[65] Delacroix, who had seen West's painting in Paris, used a similar anecdote in the corner of *The Massacre at Chios* (1824), where a living

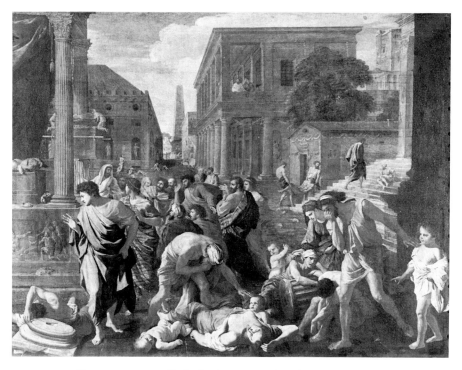

FIGURE 50. Nicholas Poussin, *The Plague at Ashdod*

baby seeks vainly to nurse at its dead mother's breast (fig. 51). In these paintings, the great innovators of romantic art used the incident of the dying mother to suggest extremity, anguish, and victimization; in large-scale dramas of human suffering, the death of a mother provided a vivid and easily understood narrative of tragic loss and suggested not only the death of an individual but the destruction of the family.

In the decade of the 1840s, several other sculptors had attracted international attention for their dramatic depiction of a recumbent dead figure. Brackett was probably aware of a sculpture that had been engraved in the London *Art-Union* in 1847, *Barra* by David D'Angiers (fig. 52). This sculpture depicted a young man who had been killed for refusing to abandon his allegiance to the French Republic during the Vendée uprising, and it suggested both the pathos of early death and the heroism of one who sacrifices himself for others. Brackett may also have been aware of Giovanni Dupré's *The Dead Abel* (1842) (fig. 53). This sculpture caused a sensation when it was first exhibited because of its realistic depiction of death.[66] With its arms flung out, its body bent backward, lying on uneven rocks, *The Dead Abel* portrayed the violent death

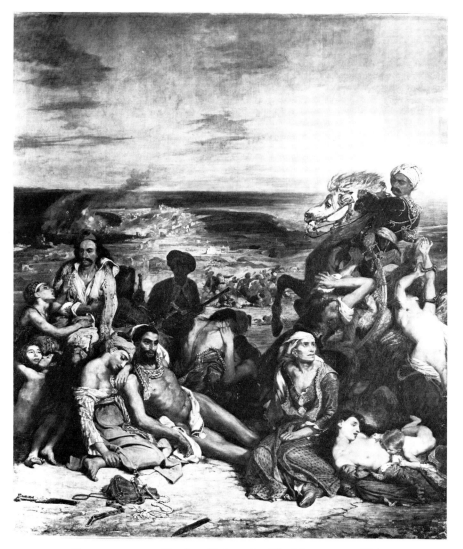

FIGURE 51. Eugène Delacroix, *The Massacre at Chios*

of an archetypal victim that contrasted with the calm repose of most mortuary sculpture.[67] An even more dramatic sculpture depicted the death of a beautiful woman a few years later. Auguste Clésinger produced in *Woman Bitten by a Snake* (1847) a writhing, erotic version of the dying woman as romantic victim (fig. 54). Unlike the mortuary sculpture, or even Greenough's *Medora*, these sculptures offered a stark and disturbing view of death, one that could not possibly be confused with peaceful sleep.

Shipwrecked Mother and Child also drew upon another tradition: art

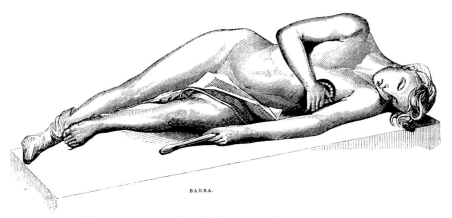

FIGURE 52. David D'Angiers, *Barra*, engraving

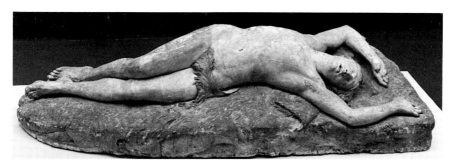

FIGURE 53. Giovanni Dupré, *The Dead Abel*

depicting the awesome power of the sea. One of the most effective early American paintings of man's struggle with the sea was John Singleton Copley's *Watson and the Shark* (1778), which showed the rescue of a swimmer attacked by a shark (fig. 55). The figure of Watson, clothing ripped away, lying on his back in the water with arm extended and hair streaming behind him, suggests another source for the arched back and dripping hair of Brackett's figure. Another popular subject for painting was the biblical flood (a version by Poussin was in the Louvre), and Benjamin West's *The Deluge* (1791) had been exhibited in the West Gallery in 1821. Of course, the most famous shipwreck scene of the nineteenth century was also the most controversial, Théodore Géricault's *Raft of the Medusa* (1819), and it is hard to believe that Brackett did not intend at least a contrast to the painting, with its jumble of bloated bodies limply trailing into the ocean (fig. 56). A starker and less consolatory image of death at sea could hardly be imagined. Constance Mayer's *The Shipwreck*

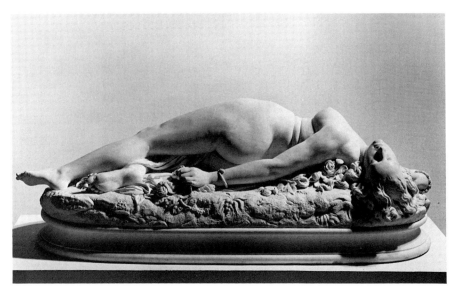

FIGURE 54. Auguste Clésinger, *Woman Bitten by a Snake*

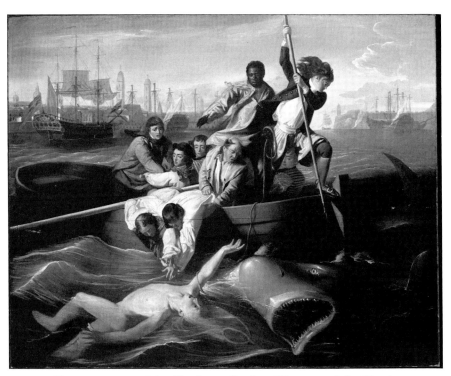

FIGURE 55. John Singleton Copley, *Watson and the Shark*

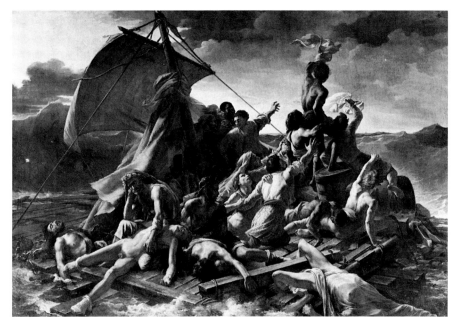

FIGURE 56. Théodore Géricault, *Raft of the Medusa*

(1821) anticipated Brackett's more intimate and pathetic interpretation of the subject, depicting a dead mother lying on her back, her arm clutching a still-living baby. It is likely that both Brackett and Mayer drew on a popular literary source for their depictions of the pathos of a woman's death by water: *Paul et Virginie* (1788) by Jacques-Henri Bernardin de Saint-Pierre, available in numerous illustrated editions (fig. 57).

Later, the theme of the sea's power, and a focus on women as its victims, would receive masterly treatment by Winslow Homer, who was growing up in Boston when *Shipwrecked Mother and Child* was exhibited at the Athenaeum. A wood engraving in *Harper's Weekly*, "The Wreck of the Atlantic—Cast up by the Sea" (1873), showed a man gazing at the body of a beautiful drowned woman lying on the rocks of the shore (fig. 58). Her pose, arm extended and hair spread out behind her, recalls Brackett's statue. And there is a sculptural quality to the female figures in Homer's other famous sea-rescue scenes, *The Lifeline* and *Undertow*. In the later nineteenth century, Homer was able to combine realistic execution with pathos, and even with controlled eroticism, in his depiction of the sea's most vulnerable victims, beautiful women.

•

FIGURE 57. T. Johannot and E. Isabey, from *Paul et Virginie*

From this variety of sources, Brackett constructed an image that stirred its viewers to contradictory responses. Some commentators praised it for its sentiment and, interestingly enough, its restraint. In 1850, Charles Leland contrasted Brackett's work with what he called "the vilest materialism" of a statue in the Museo di Storia Naturale in Florence showing a "mother just dead of the plague, holding in her arms a bloated little corpse." Furthermore, Leland found West's *Death on the Pale Horse* too romantic, its "scenes of slaughter and terror" evoking "associations widely remote from the calm and majesty of death." On the contrary, in terms that recall the reception of *The Greek Slave*, Leland praised *Shipwrecked Mother and Child* as a work of art that "lifts us, even above the highest romantic associations, into the sphere of absolute purity and goodness."

What did Leland find in Brackett's work that made it emotionally acceptable to him, that tempered the violence of its depiction of death? Like viewers of *The Greek Slave*, Leland insisted that the narrative content of the sculpture was more important than its physical appearance.

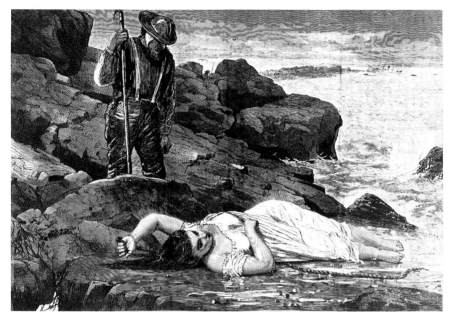

FIGURE 58. Winslow Homer, "The Wreck of the Atlantic—Cast Up by the Sea"

Although Leland admired Brackett's rendering of anatomy, citing an article in the Boston Medical Journal about the accuracy of Brackett's portrayal of the corpses, he urged his readers to view the sculpture with its spiritual meaning rather than its physical appearance uppermost in their minds. "We are by the subject lifted above the ordinary irregularities and oppositions of life," he insisted.[68] Like the captive women, the shipwrecked mother was believed by its admirers to require a special kind of gaze, one that transmuted physical reality into spiritual meaning and suppressed the very erotic energy that drew the spectator's attention.

Yet other observers suggested by their comments that there was something disturbing in the direct encounter with the sculpture, some element that had to be muted. The sculptor of *Medora*, Horatio Greenough, provided a testimonial to Brackett's skill in an effort to improve attendance at the Boston exhibition of the sculpture.[69] Greenough wrote that he was "pained" to think that this sculpture "was almost overlooked in the hurry of busy life, amid the crowd of competitors for the spare time of the public," suggesting both that too few people were coming to see the sculpture, and also that those who came did not look at it properly. By contrast, he reported that "I have several times sat for an hour" in front of the statue. Yet, he insisted, spectators made a mistake when they tried to look too

closely at the statue; rather they should "sit quietly on the several sides of the room, and even there survey it with half closed eyes." [70] Greenough, whose sculpture had been received with scant comprehension by many of his viewers, suggested that an audience could protect itself from responses that might seem too intense by viewing the sculpture through a kind of personal filter.

Other commentators tried to control their powerful emotional response to the sculpture by following Powers and looking for a narrative that would allow them to see in it a version of the captivity tale. Sentimental writer Grace Greenwood outlined the process by which her experience of viewing became an exercise in storytelling.

> I once spent a twilight hour in gazing on this group. Then my imagination conjured up the doomed vessel, driving on, and on before the tempest—the dash against the rocks—the parting of the timbers— then a white form on the wreck, clasping a babe to her bosom—her plunge into the midnight deep—the brief struggle with the flood— the last agony of the mother's heart—till those forms before me grew awfully human—were indeed a dead woman and her poor babe, cast up by the relenting waves, and lying there, so fearfully white and cold, with their still, damp faces upturned to a stormy sky! [71]

As Greenough suggested, the sculpture was most meaningful for Greenwood when it was half-seen; then it seemed to be transformed into something else, into flesh and blood, and it suggested a specific narrative of struggle and agony. The story of the mother's "plunge into the midnight deep" may be reminiscent of a captivity narrative, its victim wrenched from her home in the middle of the night, crossing the border between the known and the unknown. Greenwood tried to give her story a resolution, if not a happy ending, by remarking on the "beautiful fitness in such a death, for one of God's most glorious creatures. There is grandeur in the thought, that such beauty, unwasted by disease and undarkened by sorrow, should yield itself to that 'mighty minister of Death,' the Sea." [72] Like the captive maiden, praised for her acquiescence in the face of violence and degradation, the shipwrecked mother seemed to Greenwood most glorious when she submitted to a superior force, enacting a drama of powerlessness in its most extreme case. This submission, Greenwood suggested, was the essence of her womanly nature: "To me, the pathos of this work was in the principal figure alone— . . . the *wreck* was the going down into the deep of that fair woman-life, so richly freighted with mature and perfect loveliness." Greenwood's narrative finds both pathos and majesty in the scene; though mournful, the subject seemed to her

also appropriate, and she tried to find consolation in it by presenting it as a vision of woman's nature and woman's fate.

Some viewers used a religious framework to find consolation in the sculpture. Unlike Powers, who included a cross and a locket at the Greek slave's side, Brackett left any Christian interpretation to the imagination of his viewers. A writer in the Boston *Journal* tried to supply the ship-wrecked mother with the kind of final moment Lydia Sigourney would have wished for her: "We cannot doubt, while gazing tearful and silent, that [her] serenity was . . . the result of a firm and lofty faith, a full as-surance that beyond that hour of mortal anguish there should open an eternity of peace and blessedness." The same writer went on to praise the dying mother, in words that recall the reception of *The Greek Slave*, for her "resignation and holy trust."[73]

For some writers, however, the sculpture's religious meaning was found in its celebration of maternity. Charles Leland insisted that he saw in the sculpture, not a nude woman, but a devoted mother: "What emotion, would we ask, is better, purer, or holier than the love of a mother for her child?"[74] The Rev. Henry Giles remarked that the sculpture revealed "that love which is stronger than death," which is evidence of "divine light."[75] "She is a mother still," commented another observer, "and the wrath of the storm has not been able to tear away from her side, the babe which lies on her left arm, peaceful in the embrace of its mother and of death."[76] Not just a woman, but a mother; not just accepting her own fate, but fulfilling her maternal duties to the very last, Brackett's drowned woman seemed to her admirers to embody aspects of woman's character they fervently wished to affirm.

Because it spoke to some of its viewers' most fundamental assumptions about women's nature and the value of the family, *Shipwrecked Mother and Child* was greeted by some who praised it as a cultural icon like *The Greek Slave* and the captive maidens. Various observers commented that the sculpture seemed to exert a spiritual power over its viewers. One writer described "the hushed voices and tender intentness of the specta-tors," and another declared that "a holy quiet reigned around" as "visitors came in, and looked on in solemn, speechless silence."[77] "Tread softly! all is holy here!" began a poem by Thomas Buchanan Read, reproduced in the exhibition guide.[78]

This reverential response was by no means unanimous, however. A re-view in the *Bulletin of the American Art-Union* questioned whether the subject fell "legitimately within the province of sculpture."[79] In a letter to Asher B. Durand, Richard Henry Dana wrote that the sculpture "has not drawn so large in number of visitors as its great beauty naturally led

one to believe it would do."[80] Although one writer suggested that visitors viewed the sculpture "just as friends approach to gaze into the coffin, on the face of the departed," nineteenth-century Americans were not accustomed to seeing their dead friends sprawled naked on the rocks. The statue evoked the pathos and the pain of death without the calm reassurance they sought in such sculptures as *The Binney Child*, *Grace Williams Memorial*, or *Judith Falconnet*. Ironically, when the sculpture remained unsold after several years in the Boston Athenaeum, it was temporarily placed in the place for which Brackett had wished to receive commissions: Mount Auburn Cemetery. It seemed funereal to its viewers, but they missed in it the closure and resolution of memorial sculpture.

In the end, the sculpture's most potent theme may have been its most disquieting. The "wreck" that it displayed represented a threat not only to a beautiful woman but to the institution of the family itself. Like the spectators who saw in the captive maiden's story the narrative of domestic disruption, the viewers of *Shipwrecked Mother and Child* confronted their own worst fears about the vulnerability of the family. The drowned mother yields to the sea not only her life but that of her child, and she gives up her future as the mainstay of a family as well. Try as they might to read in the incident a message of consolation, viewers returned again and again to the recognition that, like Brackett's own poetry and that of Edgar Allan Poe, the sculpture sounded one note, a mournful one.

Would Brackett's sculpture have been more or less successful if it had not been nude? Like *The Greek Slave*, the sculpture offered viewers an opportunity to gaze at a woman's nude body under morally sanctioned conditions. Various writers insisted, like Powers' defenders, that the sculpture was not really nude at all. Asserting that the spectator "does not look with eyes alone," one writer claimed that the sculpture was "so skillfully wrought, that no other sense of nudity remains than would be instinctive in every noble mind which came, unawares, upon such a reality."[81] The claim to realism, however, was a two-edged sword for Brackett, as it had been for Palmer, inviting close inspection that might undercut the sculptor's appeal to a higher purpose. Various observers commented on the accuracy of Brackett's portrayal of his subjects' recent death. One viewer noted that the figures were "lithe with the first flexibility of death," while another commented that the bodies showed "how short has been the hour since life, and blood, and joy were there."[82] Charles Leland defended the sculpture as a "singular specimen of accuracy" in anatomy and cited medical experts on the subject of the appearance of children's corpses.[83] These claims gave viewers permission to inspect the subject's naked body in close detail, and it may have been

such curiosity that made Greenough urge spectators to stand back and view the sculpture more poetically. At the same time, writers may have seized upon a framework of medical detail in order to blunt their response to the eroticism of the nude sculpture. The printed descriptions surge with suppressed admiration for "the fullness of the womanly form," "the glorious perfection of female loveliness," and "the rounded beauty of the limbs."[84] Like Poe's dying women, the subject of Brackett's sculpture exercised an unacknowledged attraction for its viewers.

Twentieth-century observers have been offended by the sculpture's frank portrayal of death; Wayne Craven speculated that *Shipwrecked Mother and Child* was "too brutally realistic and morbid" for its viewers.[85] However, as the proliferation of consolation poetry, the popularity of Poe's poetry and tales, the success of *The Binney Child*, and the stream of visitors to Mount Auburn attest, nineteenth-century viewers did not recoil from the contemplation of death, even when it was vividly portrayed. Rather, *Shipwrecked Mother and Child* might have disturbed its viewers because of the contexts and associations with which Brackett surrounded the sculpture. Although manifestly a sentimental contemplation of the pathos of death, on a deeper level *Shipwrecked Mother and Child* challenged its viewers' certainties about woman's identity and the security of the family. If Brackett had portrayed a dying mother in a bed reaching out to her baby, he would have stayed safely within the bounds of sentimental culture. But he put his victimized woman at risk to elemental forces, exposed and battered. Instead of sweetly sleeping, passively awaiting the angel of salvation, she has been tossed in the arms of the sea. This raises the question: is she a meek victim or a powerful, liminal being? As William Butler Yeats would later ask of another victim of elemental forces, Leda raped by Zeus in the guise of a swan: "Did she put on his knowledge with his power / Before the indifferent beak could let her drop?"[86] Brackett's victimized woman has been mastered by an overwhelming force. It strained his viewers' credulity to imagine that, ravished by the sea, she could still, like the captive maiden, retain her purity.

Hoping to emulate the enormous success of Powers' *The Greek Slave*, Brackett had applied the conventions of the captive maiden to the subject of the death of a beautiful woman. In his own poetry, Brackett stressed the pathos of death rather than its consolations, and his sculpture struck the same note. Although some viewers assented to the narrative he suggested, completing the story of terror and pain, others tried to transform it into more conventional consolation. But the sculptural equivalents to Lydia Sigourney's verse were the graveside images of peaceful sleep-

ers; Brackett's sculpture offered some of the same mixture of stimula-
tion and discomfort as Poe's poetry. Furthermore, Brackett portrayed not
one death but two. Viewers struggled to interpret the mother's death-
embrace as an affirmation of maternal feeling, but the sculpture could
be seen as the wreck of the family as well as the destruction of two
individuals. At exactly this same time in England, sculptors ended a
half-century-long tradition of depicting mothers embracing their dead
babies in memorials to women who had died in childbirth. While a lead-
ing art historian suggests that "a squeamishness had gradually grown up
around the whole subject," it is interesting to note that this celebration
of deathless maternal devotion disappeared at a time when the family
itself was changing its function and coming under increasing stress.[87]
Like Sigourney, whose deepest emotions were reserved for the sunder-
ing of family ties, Brackett's viewers may have been disturbed above all
by the need to tell themselves stories about vulnerable women who were
also mothers. Eschewing the calm certainty of consolation literature and
memorial sculpture, *Shipwrecked Mother and Child* penetrated deeply
into the anxieties of nineteenth-century American viewers.

6

THE PROBLEMATICS
OF FEMALE POWER
Zenobia

Nineteenth-century spectators, male and female, read in ideal sculpture compelling narratives of gender. In a variety of female subjects they saw qualities and situations that they associated with their real-life attempts to understand woman's nature and place in society. But did men and women interpret these sculptures in the same way? Or did their differing perspectives on female identity and its significance shape the narratives they invented in response to the sculpture?

We have already seen that some female viewers accepted their culture's assertions about woman's nature, or at least they did not dissent from them. E. Anna Lewis, a popular poet who reported that she "sank in a sort of trance" before *The Greek Slave*, interpreted the sculpture in the same vein as her male colleagues:

> But such a sinless, meek rebuke is thine
> That thy mute purity abashes crime.
> Thou art become a soul, sweet marble life,
> A pleader for the good, not knowing evil strife. [1]

Another popular female writer, Grace Greenwood, had responded sympathetically to the theme of sacrifice and suffering in Edward Augustus Brackett's *Shipwrecked Mother and Child*.[2] Even Elizabeth Barrett Browning had admired the remote "white silence" of *The Greek Slave*, although she also saw in it intimations of woman's revolutionary power

for change.[3] Even though many female viewers of the statues of victim-
ized women insisted that the statues spoke to them of woman's spiritual
power, most continued to follow the patterns of response set by male com-
mentators like Orville Dewey. The powers that female viewers saw in the
statues consisted of passive qualities such as self-possession, steadfast-
ness, and courage in the face of adversity.

To find a female perspective that began to take issue with the senti-
mental narratives of female powerlessness, we must turn to a vigorous
and independent-minded woman sculptor, Harriet Hosmer. More than a
decade after Powers established his career by exhibiting *The Greek Slave*
to large audiences, Hosmer made her bid for artistic fame by propos-
ing a variation on the theme of the female captive. Her *Zenobia* (1859)
depicted a woman who was both a great queen and a melancholy cap-
tive (fig. 59). On one hand, Hosmer dared to depict a woman who had
excelled in the male spheres of war, politics, and diplomacy, but on the
other hand, she portrayed her female subject at a moment of sorrow and
defeat. Hoping for popular approval, Hosmer did not defy her audience's
expectations about woman's nature, but she did try to propose a different
perspective on the captivity theme. When the sculpture was exhibited in
1864–65, copious comments, both published and unpublished, reflected
on the significance of the story the statue told and, not coincidentally, on
the meaning of Hosmer's own career.

•

Although Henry James would later reminisce condescendingly about the
"white, marmorean flock" of female sculptors who seemed to him more
or less indistinguishable, Hosmer was by far the most successful of the
women artists working in Rome in the 1850s and 1860s.[4] She sold her
sculpture to British, American, and European patrons, spent long holi-
days as a houseguest in English country homes, and enjoyed the friend-
ship of Robert and Elizabeth Barrett Browning. She was written about
in art journals in America and England, and her biography appeared in
such books as *Eminent Women of the Age* (1869) and *Women Artists in
All Ages and Countries* (1859).[5]

Efforts to interpret Hosmer's sculpture were inextricably bound, for her
contemporaries, with the problem of "reading" Hosmer herself. Almost
every commentary on her works included a reflection on her anomalous
position as a woman at work in a field dominated by men. One analy-
sis of "Harriet Hosmer, the Woman Eminent in Sculpture" invoked the
study of phrenology to interpret her character, and the author of this arti-
cle sought to find the balance between her "robust artistic nature" and

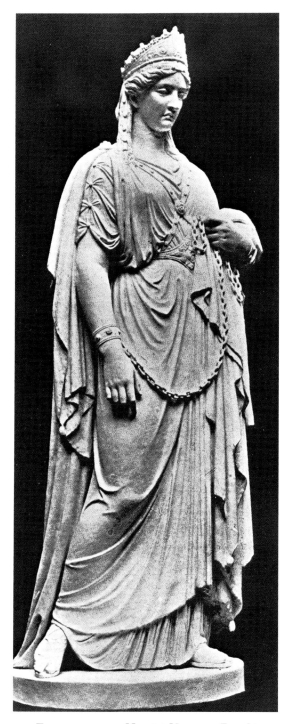

FIGURE 59. Harriet Hosmer, *Zenobia*

her "feminine delicacy." Although the author discovered in Hosmer's physiognomy evidences of judgment, practicality, and imagination, these qualities appeared in some ways incompatible with her femininity, which the author imagined she had renounced in order to pursue her artistic ambitions. "We doubt not that Miss Hosmer, by giving herself up to the prosecution of her artistic enjoyment, has sacrificed many of her most interior yearnings, for in the contour of her face are seen the evidences of strong affection, and appreciation of all that enters into domestic relationship."[6]

Other observers also worried about the sacrifice of her femininity and, by extension, her assumption of male powers. Hosmer, who wore a man's jacket and cap in her studio, seemed to many commentators to violate the rules that distinguished one sex from the other. Her visitors often felt their ability to interpret gender signs challenged. One writer described "a compact little figure, five feet two in height, in cap and blouse, whose short, sunny brown curls, broad brow, frank and resolute expression of countenance, give one at the first glance the impression of a handsome boy," although she went on to assure readers that Hosmer's "trim waist and well-developed bust" as well as her "modest dignity of deportment" marked her clearly as a woman.[7] After a visit to her studio in 1858, Nathaniel Hawthorne commented, "she had on petticoats, I think; but I did not look so low, my attention being chiefly drawn to a sort of man's sack of purple or plum-colored broadcloth, into the side-pockets of which her hands were thrust as she came forward to greet us." Neither her clothing nor her posture seemed appropriate to Hawthorne, who reported his embarrassment at feeling the need to "look so low" to solve the interpretive puzzle. One may speculate about just what he was afraid of finding in the forbidden regions below the waist: evidences of femininity or, more alarmingly, a male sexual apparatus to complement her creative powers? Did Hawthorne see in the woman who shaped clay and cut stone what feminist critics of our own time have called the "phallic woman," the fantasized creature who could bypass the seeming disabilities of her sex, to retain the phallus and all its powers?[8] At the same time, Hawthorne reported that he enjoyed Hosmer's "frank and pleasant" manner. He solved the dilemma of how to regard her by portraying her as a kind of elf, "a small, brisk, wide-awake figure, of queer and funny aspect. . . . Her face was as bright and funny, and as small of feature, as a child's."[9] Perhaps, like her own best-selling sculpture, the figure of *Puck*, an accomplished woman seemed less threatening when she was small, playful, and genderless. Biographical sketches in newspapers and magazines stressed Hosmer's lively childhood as "full of fun and frolic," and

"as wild as a colt on the prairies, and as tricksy as Puck."[10] By stressing her childish pranks, interpreters could view her masculine qualities as "boyish" rather than confronting the possibility that an adult woman possessed some of the powers and qualities of a man.

Another way for observers to blunt the threatening prospect of a woman who could swing a mallet and wield a knife was to marvel at her small stature. Although she was three and a half inches smaller than *The Greek Slave*, both Harriet Beecher Stowe and Sophia Peabody Hawthorne were even shorter.[11] Nonetheless, many of Hosmer's friends and acquaintances spoke of her size and her unorthodox accomplishments in virtually the same breath. The anatomy professor with whom she had studied in St. Louis reminisced about the "little Quaker girl in the brown sacque and close-fitting bonnet" sitting on a bench in his lecture hall.[12] A few months later this twenty-year-old woman had demonstrated her physical hardihood and intrepid spirit by traveling alone to New Orleans, climbing a cliff that was then named for her, and visiting the Dakotah Indians.[13] Yet, in an age when medical instruction was still considered inappropriate for women, the professor found it reassuring to envision her as young, small, and wrapped in protective garments, both physical and spiritual (she was not, in fact, a Quaker). John Gibson, the English sculptor who accepted her as a pupil in Rome, habitually addressed her in letters as "My dear little Hatty" or "My dear little Hosmer."[14] Her youth and her size gave observers a way to insist that Hosmer, despite her ambition, her independence, and her achievements, could still be contained within conventionally feminine categories: attractive, vulnerable, quaint. One of the earliest notices of her work in the prestigious *Art-Journal* of London spelled her name wrong and described her as a picturesque curiosity: "to see her with her little artist-cap jauntily stuck on one side of her head, her glowing, beaming eyes bent upon her work, and her delicate little hands labouring industriously on the clay, is as pretty a sight as one would wish to see any fine summer day."[15] Against all evidence, this observer struggled to see Hosmer solely in terms of gender, obscuring her artistic achievements and portraying her as a jaunty, beaming, delicate, pretty little creature, an artist for a "summer day," rather than a serious professional.

As Hosmer gained recognition, her friends constructed for her a myth of origin that would help explain her apparent deviation from nineteenth-century standards of femininity. As explained in a biographical sketch published in 1858, Hosmer's independence and physical robustness developed as a reaction to a sense of her very feminine vulnerability. Her mother and sister had died of consumption; fearing the same fate for her,

Hosmer's father, a physician, had encouraged an unorthodox regime of physical and mental exercise, including horseback riding, rowing, hunting, swimming, and attendance at a progressive private school.[16] Her masculine qualities were, in this narrative, called into existence by the specter of the most feminine of fates, invalidism. A few years later, her old friend Lydia Maria Child wrote a biographical sketch of Hosmer that portrayed her quite differently, stressing her "energy, vivaciousness, and directness," and praising her for daring to be an individual. "Here, was a woman, who, at the very outset of her life, refused to have her feet cramped by the little Chinese shoes, which society places on us all, then misnames our feeble tottering, feminine grace."[17] However, the more sentimental account of Hosmer's background, accounting for strength by reference to weakness, had become firmly entrenched and was repeated by subsequent biographers. Hosmer's own life offered observers a vexing interpretive problem: how to acknowledge independence, ambition, and artistic skill—in short, elements of power usually reserved for men—in a woman.

·

Some of the same issues of gender and power informed Hosmer's sculpture as well. Unlike most of the other American sculptors working in Rome, Hosmer was well-educated, socially well-connected, and, for much of her career, financially independent. Many of her sculptures were created for patrons who were also friends, like the Brownings, or her supportive patron, Wayman Crow of St. Louis, and therefore she was free to choose subjects in which she was truly interested, without worrying about whether they would sell.[18] Given this freedom and considering her artistic ambition, it is not surprising to discover that she was drawn to ideal sculpture from the very beginning of her career. Her early works all depicted female subjects drawn from mythology and romantic literature: busts of *Hesper* (1852), *Daphne* (1854), and *Medusa* (1854), and full-length statues of *Oenone* (1855) and *Beatrice Cenci* (1857). At the beginning of her career, Hosmer worked hard to master the prevailing tone of melancholy spirituality that had proved so successful for Palmer and Powers, and she often portrayed women who were captives or victims, like Beatrice Cenci and the mythological figure Daphne. All of her early works have a poetical, reflective air, common both to American and to English ideal sculpture as represented by her mentor John Gibson and his countrymen Wyatt, Marshall, MacDowell, Theed, and Foley, whose works were being engraved in leading journals like the London *Art-Journal*.[19]

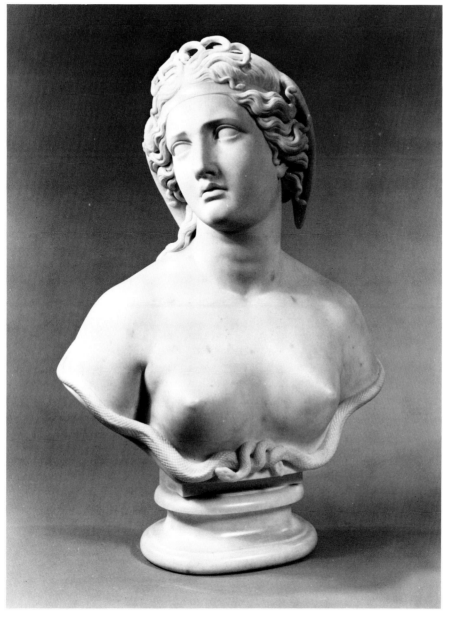

FIGURE 60. Harriet Hosmer, *Medusa*

Medusa might seem like a demonic rather than a melancholy figure to anyone familiar with the story of Perseus or the portrayls of his triumph by Benvenuto Cellini, Leonardo da Vinci, and Antonio Canova (fig. 60). Following an alternative tradition, however, Hosmer interpreted her as a kind of a victim.[20] According to Ovid, Medusa was a beautiful woman

who was changed into a monster by a jealous Athena, and Hosmer portrayed her as languid, lovely, and sad-faced. Her thick, curling hair seems to change before our very eyes into writhing snakes. The coiled serpents that mark the base of the bust constrain and encircle Medusa like the chains on the wrists of *The Greek Slave*, and they evoke both the hapless Eve and the struggling victims of the celebrated Greco-Roman sculpture, the *Laocoon*.[21] Hosmer's *Medusa* is thus a victim of a terrible curse, who, like the Greek slave or the white captive, confronts with resignation a dreadful destiny. Like the captive maiden, she is a liminal figure, caught between two worlds, and Hosmer chose to portray the very moment of her transition from desirable to deadly.

Hosmer's victims, however, were also women of power. The Medusa she portrayed so sympathetically would become a dreaded destroyer of men. At least one visitor to Hosmer's studio found himself responding to the implicit threat that underlay Medusa's transformation: "It was hard for me to look away from this statue; if long gazing could have turned one to stone, the old tradition would have been fulfilled."[22] Not only was Medusa a woman of power, but her sculpted image seemed to threaten this viewer with a reversal of roles, an overthrow of conventions: the stone woman seemed alive, and the observer felt he was being turned into stone. In a similar vein, Daphne, the maiden transformed into a laurel tree to escape the pursuit of Apollo, was empowered, through metamorphosis, to triumph over her pursuer. Hesper, the evening star, represented the transition from wakefulness into sleep; by alluding to a passage from Tennyson's "In Memoriam," Hosmer, who was interested in spiritualism, also suggested the mysterious power of those who moved from life to death.[23] In choosing these subjects, Hosmer joined her male predecessors and competitors in exploring the pathos of female victimization and the mystery of liminality. But Hosmer's women are often only a step away from the possession of vital, even deadly, power.

Hosmer took up the subject of woman's power in her first full-length sculpture, created soon after she arrived in Rome. *Oenone* (1855) portrayed a female victim whose melancholy cloaked fearsome powers (fig. 61). The daughter of a river-god, Oenone was the wife of Paris, who deserted her for Helen of Troy. Hosmer showed her sitting in an attitude of mourning or dejection, fondling her husband's abandoned shepherd's crook, in a pose suggesting a classical figure of grief. The drapery on her lap hung down over the edge of the pedestal like crepe on a tombstone. The *London Art Journal* wrote that the statue portrayed "deep and speechless grief," and declared that it succeeded "in the highest degree."[24]

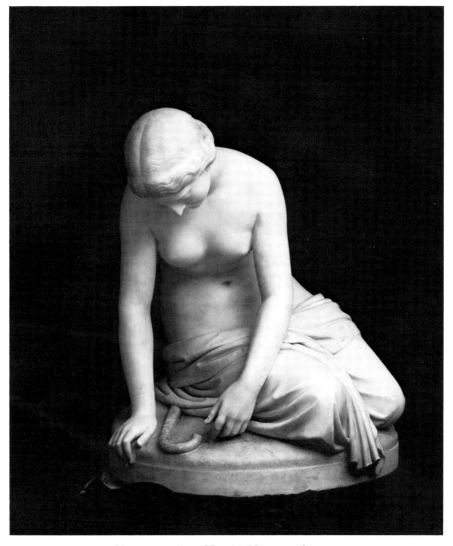

FIGURE 61. Harriet Hosmer, *Oenone*

Hosmer drew her subject from a well-known literary source that em-
phasized not only melancholy but romantic retribution. Although the
subject was classical in origin, Hosmer's audience would have recognized
her reference to a poem by Alfred Tennyson, "Oenone," first published in
1833 and republished in a revised form in 1842. In the poem, "mournful
Oenone" pours out her grief to her mother, the spirit of the vale:

> 'O mother Ida, many-fountain'd Ida,
> Dear mother Ida, harken ere I die. . . .

My eyes are full of tears, my heart of love,
My heart is breaking, and my eyes are dim,
And I am all aweary of my life.'

Mourning for her lost love, Oenone laments, "let me die," but the poem ends on a curiously active, even sinister note. In the last two stanzas Oenone's thoughts turn to vengeance: "I will not die alone, for fiery thoughts / Do shape themselves within me, more and more." She vows that she will not leave "my ancient love / With the Greek woman" but will go to Troy and "talk with the wild Cassandra." Tennyson concluded with a grim portent of the fall of Troy and of Oenone's eventual suicide on Paris' funeral pyre after refusing to save his life:

I know
That, wheresoe'er I am by night and day,
All earth and air seem only burning fire. [25]

In Tennyson's poem the victimized woman exerted a mystical, visionary power; like the death song of the Lady of Shallot in the poem published in the same volume as "Oenone," this mournful lament did not simply arouse its readers' pity, but brought a sense of fear and foreboding. Hosmer's Oenone, then, suggested to its audience both the powerlessness of the betrayed woman and the possibilities of reversal and transformation. The graceful, half-reclining figure is an emblem of melancholy, but she possesses a reservoir of strength and the capacity for retribution as well.

In choosing her ideal subjects, then, Harriet Hosmer appears to have emulated her male colleagues who emphasized the pathos of woman's victimization. At the same time, however, her sculptures suggested an added psychological dimension, a deeper probing of the experience of transformation in *Daphne* and *Medusa*, a stronger suggestion of the ambiguities of power and powerlessness in *Oenone* and the parricide *Beatrice Cenci*.

Furthermore, Hosmer's early sculptures represented the point of view of the female subject herself, rather than the spectacle of a woman as seen from the outside. *Hesper, Daphne*, and *Medusa* exist apart from the male gaze, in moments of reflection and self-transformation that are not fictively witnessed by anyone else. This female self-reflectivity is suggested by the very poses she chooses for her figures. The upright posture of *The Greek Slave* and the other captive maidens left them exposed, accessible to the gaze of the viewer. By contrast, Hosmer's first two full-length statues, *Oenone* and *Beatrice Cenci*, both use horizontal, closed, inward-turning poses that suggest privacy and reflection.

Hosmer's sculpture differed in one other way from that of her male colleagues, for she eschewed the theme that was so potent in all the earlier treatments of the female victim, the fear of domestic disruption. The family is a source of evil in *Beatrice Cenci*, and there is no idyllic past to which her character can return. In *Oenone* it is the man rather than the woman who has left home. Both Beatrice and Oenone are presented as daughters, but there is no suggestion that they are also potential mothers whose incapacity threatens society. Although the phrenologist who studied Hosmer's features insisted that she must regret her sacrifice of a conventional family life, this independent, strong-minded, sociable woman never manifested in her work the anxiety about family integrity that haunted so many of her contemporaries.

•

In the colossal figure of *Zenobia*, on which she worked from 1857 to 1859, Hosmer confronted directly the tradition of the female captive and also began a searching exploration of the subject of female power. An upright rather than an inward-turning figure, a captive in chains, *Zenobia* invited mid-nineteenth-century viewers to compare her to *The Greek Slave*. But Hosmer's female captive was a powerful queen rather than a nameless victim. *Zenobia* told two overlapping and sometimes conflicting stories: an assertion of female power and an evocation of female vulnerability. Different viewers would stress different aspects of the narrative.

The statue itself marked a new stage in Hosmer's artistic career, the end of her apprenticeship as a sculptor. On its exhibition she pinned her hopes for recognition as a major artist. To some extent, her hopes were fulfilled, for she received at least three commissions for full-sized marble versions of the statue, as well as at least one reduction. The sculpture received favorable reviews when it was exhibited in New York, Boston, and Chicago; more than thirty thousand visitors were said to have viewed it in the first two cities alone.[26] But *Zenobia* did not burst on the scene like another *Greek Slave*, although Hosmer emulated Powers by entering it in an international art exhibition in London before sending it on an American tour.[27] Her reception in England was decidedly cool, and American viewers embedded their admiring comments within narratives that puzzled over their complex reactions to the spectacle of a powerful woman subdued.[28]

It is not surprising that Hosmer, taking the step that she hoped would establish her reputation as a first-rate sculptor, would search for a weighty and dignified subject, one that most spectators would recognize and respond to, one that bore similarities to the sculpture that had already won

popularity but that could be admired for its originality. In Rome, Hosmer had been introduced to one of the leading art critics of the day, Anna Jameson, an English writer who was a friend of Hosmer's mentor, John Gibson. The two women corresponded throughout the period when Hosmer was working on *Zenobia*, and Jameson gave the sculptor historical and stylistic advice.[29] Jameson, who had published the two-volume work *Memoirs of Celebrated Female Sovereigns*, may well have suggested the subject of Zenobia to Hosmer. Although Jameson was an advocate of woman's rights, especially in the field of the arts, her study of female sovereigns stressed the tragic consequences that often followed the exercise of worldly power by a woman.[30] "Women, in possession of power, are so sensible of their inherent weakness, that they are always in extremes," she wrote. "Were we to judge by the past, it might be decided at once, that the power which belongs to us, as a sex, is not properly, or naturally, that of the sceptre or the sword."[31] *Memoirs of Celebrated Female Sovereigns* presented fascinating narratives of women who had changed the course of history, but like many of her male contemporaries, Jameson saw the powerful woman as a problematic, even threatening, anomaly. For Hosmer, in search of a weighty subject for a major work of sculpture, a woman of power "in extremes" offered just the kind of challenging topic that could help establish her career.

Hosmer based her interpretation of *Zenobia* on a thorough exploration of historical sources. She studied ancient coins and medieval mosaics, showed sketches and photographs of the work-in-progress to friends in America, England, and Italy, and sought the advice of fellow artists and critics. Lydia Child reported that Hosmer's "mind was almost constantly occupied with planning" her statue of Zenobia when she visited America in 1858: "she searched libraries, and read everything that could be found concerning that great Queen of the East."[32]

Zenobia had ruled Palmyra, in Syria, for six years after her husband's death in A.D. 267. A forceful warrior and diplomat, she had challenged Rome's dominance in the Mideast, but she was finally defeated by the forces of Emperor Aurelian. Refusing to accept Aurelian's terms for the surrender of her besieged city, she slipped out of Palmyra to seek help from a former ally. The Romans pursued and captured her, and took her to Rome, where they forced her to march in chains through the streets of the city. Palmyra was destroyed and her counselors were executed, but Zenobia lived out her life in a Roman villa assigned to her by Aurelian.

The historical record of Zenobia's life, incomplete even today, presented Hosmer with several interpretive questions. Some accounts described Zenobia's ancestry as Arab, others suggested she was Jewish,

and still others believed that she was a kinswoman of Cleopatra, descended from the Macedonians; each of these alternatives would have suggested a different personality to Hosmer.[33] Cleopatra, of course, was known for her sexual manipulativeness, and historian Edward Gibbon suggested that Zenobia too used sexuality to dominate and control: "She never admitted her husband's embraces but for the sake of posterity."[34] While all commentators praised Zenobia's abilities as a leader, some, like Anna Jameson and Edward Gibbon, believed that such martial qualities were unnatural in a woman.[35] Some saw Zenobia as a demonic schemer, implicating her in her husband's death; others hinted that she betrayed Longinus and her other counselors, condemning them to secure her own pardon.[36] A popular novel by William Ware, written in the 1830s, portrayed Zenobia as beautiful and spirited but haughty and ambitious, faults that were corrected with her defeat. Ware depicted the once-proud queen enduring the forced march through the streets of Rome in a state of profound melancholy, bursting into tears when the emperor (in a fictional episode) took pity on her and invited her to ride in his chariot.[37] Hosmer's sources, historians and novelists alike, saw Zenobia as an intriguing character, whose life raised challenging questions about woman's nature and woman's destiny. Is a woman of power unnatural, demonic, as Gibbon and Jameson suggested? Is a woman truly feminine only in weakness, as Ware implied?

Nathaniel Hawthorne had used the name Zenobia for his doomed woman of passion in *The Blithedale Romance* (1852). Like the heroine of William Ware's novel, Hawthorne's Zenobia was overly ambitious, and like her, too, she was at last reduced to womanly sobs and a confession of human weakness. Parting with narrator Miles Coverdale shortly before her suicide, Hawthorne's Zenobia summarized the meaning of her own tale. "A moral? Why, this: that in the battlefield of life, the downright stroke, that would fall only on a man's steel head-piece, is sure to light on a woman's heart, over which she wears no breastplate, and whose wisdom it is, therefore, to keep out of the conflict."[38] Using martial metaphors that recalled the ancient queen of Palmyra, Hawthorne suggested, as Ware had, that the powerful, passionate woman was a contradiction in terms, that woman's true nature was weak and vulnerable. Hawthorne's Zenobia turned out to be the sister of the pale, wan Priscilla, and at the end of the novel the powerful and the powerless women had exchanged roles. Defeated in her ambitions, Zenobia was transformed into a romantic victim, and the novel drew to a close soon after her mournful funeral.

Hawthorne admired the clay version of Hosmer's *Zenobia* when he

saw it in her studio in March 1859, and he mentioned the sculpture by name in the preface to *The Marble Faun*, giving Hosmer some welcome publicity.[39] In his notebook he called it a "noble and remarkable statue indeed, full of dignity and beauty," and commented that it showed "a soul so much above her misfortune, yet not insensible to the weight of it."[40] As his own fictional use of the subject had demonstrated, Hawthorne saw in the story of Zenobia chiefly a tale of misfortune and defeat, although he stressed, in the tradition of *The Greek Slave*, the "nobility" of woman's acquiescence to her fate.

But Hosmer did not choose the subject of Zenobia in order to portray another acquiescent victim. The size and weightiness of the statue emphasized Zenobia's unconquered dignity. In *The Greek Slave*, nudity had suggested vulnerability, while the chain conveyed both temporal power-lessness and spiritual power. By contrast, the heavy drapery surrounding Zenobia, including both a dress and a long cloak around her shoulders, shielded her body and increased her stature. Zenobia's chain was also a symbol of her captivity, but Hosmer showed her grasping it with "impatience," gathering it up in her left hand while letting her right hang down under its weight.[41] In historical accounts Zenobia is described as burdened beneath chains so heavy that attendants had to march beside her to carry them, but Hosmer showed her carrying their weight herself.[42] In *Zenobia*, Hosmer played her own variation on the theme of the captive maiden. She chose to portray a powerful woman in chains but made her heroic in size, weighty in shape, and regal in manner.

By insisting on Zenobia's dignity and monumentality, Hosmer addressed an unspoken aspect of the story of this captive queen, one which, like the fictitious Turks in Powers' narrative, gave the statue an extra measure of interest to its nineteenth-century audience. Like the Greek slave, this captive queen must be considered sexually vulnerable. Although Gibbon had stressed what he considered Zenobia's unnatural control over her sexual destiny even in marriage, her capture by the Roman emperor implied her capitulation to male rule over her person, as well as her kingdom. Ware's fiction portrayed her transformation to a meek and fainting victim, perhaps suggesting sexual surrender. Nineteenth-century audiences recognized this hidden plot by speculating on whether or not Zenobia's pride was broken in captivity, thus asking indirectly whether the conquering Roman emperor had claimed sexual submission from his captive.

It is hard to imagine that the victorious emperor would not have translated his military triumph into a sexual one, although at least one modern historian has asserted that he did not.[43] Hosmer seems to have believed

that Zenobia was able to keep her pride, and by extension her sexual integrity, intact. Lydia Child wrote that Hosmer "was so much in love with her subject that she rejected, as unworthy of belief, the statement made by some that the fortitude of Zenobia was ever shaken by her misfortunes. To her imagination she was superbly regal, in the highest sense of the word, from first to last."[44]

In this insistence on Zenobia's unshaken pride, Hosmer moved away from the conventions of the acquiescent captive and presented a woman who did not surrender to male control. Hosmer, who had herself resisted social pressure to marry and live a domestic life, who had found her sustaining emotional ties in female communities in Italy and England, saw in the subject of the captive queen an opportunity to stress woman's strength rather than her weakness, her resistance rather than her acquiescence. In a letter to the *Cosmopolitan Art Journal*, Hosmer asserted, "I have tried to make her too proud to exhibit passion or emotion of any kind; not subdued, though a prisoner; but calm, grand, and strong within herself."[45] Interpreting Zenobia's story to portray the struggle of a strong woman to keep control of her destiny, Hosmer took a cautious step toward the celebration of woman's power rather than the portrayal of female powerlessness.

•

The reception of Hosmer's *Zenobia*, however, suggested that most of her contemporaries were no more prepared to admire a woman of power than they were to acknowledge the accomplishments of a female sculptor. Many of the reviews condescendingly praised *Zenobia* as good enough for the work of a woman. Hiram Powers probably intended kindly his comment, quoted in a New York newspaper: "If it were the work of a man, it would be considered as more than clever; but as it is from the chisel of a woman, why, it is an *innovation*."[46] Again, the gender of the artist all but obscured the vision of the artwork itself. A hostile review suggested that Hosmer and any other women "who feel the desire for work stirring within them" should be true to their "characteristic gift" and use their time decorating buildings "with sculptured flower-and-leaf ornament" instead of making ideal sculptures.[47]

The most dramatic assault on Hosmer's standing as a serious sculptor came in the pages of the prestigious London *Art-Journal*. An offhand comment in an obituary of a British artist suggested that *Zenobia* was not Hosmer's work at all but that of "an Italian workman at Rome."[48] Other nineteenth-century sculptors had encountered public suspicion of their use of studio assistants to perform the actual work of carving the finished

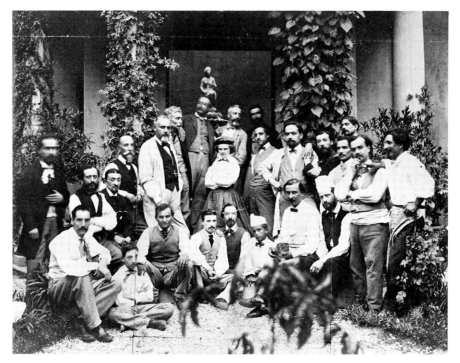

FIGURE 62. Harriet Hosmer and Her Workmen, photograph

statue guided by measurements from the artist's plaster model. But it was significant that the most insulting charges were filed against a woman sculptor who portrayed a woman of power. Hosmer answered the accusation with a detailed article on techniques of contemporary sculpture and with a letter that was published in the next edition of the *Art-Journal*.[49] Interestingly, Hosmer found it necessary not merely to defend herself but to have the letter cosigned by John Gibson. One might say that Hosmer still felt she must present herself as the protégée of a powerful man; alternatively, one could argue that her ability to enlist Gibson in her defense shows her wielding a sort of power. Surely this latter interpretation was the point of a photograph which she had made a few years later showing herself surrounded by twenty-four men who worked for her (fig. 62). The sculptor stands sternly in the center, arms crossed, characteristic sculptor's cap on her head, while the men sit, stand, or lounge around her. Hosmer referred to the photograph as "Hosmer and Her Men," adding "I did it by way of a joke, but it has had a great success, and I don't know how many photographs I might have given away if I had had them."[50] This final answer to her detractors' charges was a visual one. Like the painting of Erastus Dow Palmer in his studio, this photograph shows

FIGURE 63. "The Prince of Wales at Miss Hosmer's Studio"

Hosmer in command and implies that the artist, by directing the work of assistants whose tasks were only menial, demonstrated her own powers of mind and spirit.

Openly hostile criticism of Hosmer's work, like the attack in the *Art-Journal*, was rare. But even accounts of *Zenobia*'s success often had the effect of diminishing Hosmer's stature and questioning her power. In 1859 *Harper's Weekly* published an article, accompanied by an engraving, reporting on the visit of the Prince of Wales to Hosmer's studio. The article praised Hosmer and her works but stressed her debt to John Gibson, "that renowned master" under whose "guidance" she "fulfilled her youthful promise."[51] The engraving showed Hosmer standing next to *Zenobia*, while the Prince of Wales and his companions gathered in front of it (fig. 63). Beside the prince, gesturing and talking, John Gibson assumed the role of host, explaining the statue's merits, and by extension claiming a share of the credit for its success. Hosmer, silent and erect like her statue, was on display, while Gibson presented the sculptor he had made, as well as her statues. The engraving is quite inaccurate in its representation of the statue, but very precise in its depiction of Hosmer's picturesque studio garb.[52] The story being told in *Harper's* could have been titled, "Prince of Wales views quaint female sculptor" rather than "sculptor creates colossal statue."

Although Hosmer and some of her friends, like Lydia Child, tried to

provide *Zenobia* with a narrative setting that suggested female power and pride, most male observers saw the sculpture instead as another version of the captivity tale. A handsome brochure prepared for the statue's exhibition in New York used as its text a passage from William Ware's sentimental *Zenobia*, whose interpretation Hosmer emphatically rejected.[53] In Boston the sculpture was accompanied by a longer article that stressed "the majesty of the still unconquered queenly nature." The article also called attention to Hosmer's distinction as a *female* sculptor: "The subject is a noble one for sculpture, especially so for a woman to handle, as suited to express the more intense and finely strung temperament of the feminine nature." As if to suggest that the feminine nature was not only finely strung but weak and fragile as well, the Boston circular included a biographical sketch of Hosmer from the *New American Cyclopedia* which retold the story of her "naturally delicate constitution" and ended with the (untrue) assertion that her work on *Zenobia* had "so seriously impaired her health that her physicians sent her to Switzerland to save her life."[54]

Other reviews also insisted on keeping *Zenobia* safely within the bounds of feminine weakness. In an article published in the *Atlantic Monthly*, Fitzhugh Ludlow described Hosmer's captive queen in terms that suggested the luxuries of the harem as much as the majesty of a monarch's court: "she is proud as she was when she sat in pillared state, under gorgeous canopies, with a hundred slaves at her back." Even her aloof self-composure sounded like the acquiescent resignation of *The Greek Slave*: "That head is bowed only because she is a woman, and she will not give the look of love to the man who has forced her after him. . . . She is a *lady*, and knows that there is something higher than joy or pain." In the end, this observer adopted the point of view, not of the queen herself, but of her captor, Aurelian, speculating on Zenobia's possible "swerving," or sexual submission:

> "Did [Hosmer] believe the swerving, she must have felt that Aurelian had the right, after all pain and wrong, to come and claim the queen,—to say—
> 'I did all this wrong for you, and you were worth it.' "[55]

This narrative of desire and domination reversed completely the story of Zenobia's pride, dignity, and sexual integrity as Hosmer understood it.

That many of Hosmer's contemporaries read *Zenobia* as another narrative of female vulnerability may be inferred, also, from the company kept by the statue in a notable private collection. By the 1870s, *Zenobia* was

FIGURE 64. C. Von Piloty, *Thusnelda*, engraving

displayed in the entrance hall to A. T. Stewart's home; his collection also included a version of *The Greek Slave* and of Randolph Rogers' figure of feminine pathos, *Nydia, the Blind Girl of Pompeii*. Furthermore, Stewart owned a painting by a German painter, C. von Piloty, that told a story with obvious similarities to that of Hosmer's statue. *The Triumph of Germanicus*, also known as *Thusnelda*, depicted another Roman triumphal procession, this one featuring the wife of a German chieftan, captured by the Roman general Germanicus and forced to march through the streets of Rome (fig. 64). What one critic described as the "oft-abased, proud" queen was shown as "strong and haughty," but the artist surrounded her with other figures whose poses stressed the pathos of her situation: fainting attendants and a young son holding her hand. Even more pointedly, the chained queen was noticeably pregnant, clearly indicating her feminine vulnerability.[56] Stewart owned several paintings with imperial themes, including Roman scenes by Gérôme and Boulanger, and of course Meissonier's celebrated *1807*, a huge painting showing Napoleon reviewing his troops at the height of his power. Viewing Hos-

mer's captive queen against a background of such forceful images of masculine power, observers might be more likely to see her as another vulnerable captive, like Thusnelda, or a victim, like Nydia.

Like the viewers who saw in *The Greek Slave* an example of disrupted domesticity, some observers scrutinized *Zenobia* to discover themes of melancholy and nostalgia. A Boston friend sent Hosmer a poem that described the captive queen walking through Rome while dreaming of her lost country.

> Away
> Beyond the yellow Tiber and the flow
> Of the blue sea that laps the Syrian strand,
> Beyond the reach of desert and of plain
> She stands beside the temples of her gods
> In fair Palmyra.

Although the historical Zenobia was far from maternal, the poet pictured her nostalgia for "her children's voices, playing in the shade." In this version, the proud queen became a mournful maiden with "longing eyes that spoke the heart within," yearning for the tranquil past and the protected joys of home and family.[57] Another poem sent to Hosmer by an admirer described Zenobia regally—"more queen than captive"—but went on to focus on the Roman villa where she would live, perhaps as Aurelian's mistress:

> . . . Yonder there is left for thee
> A palace-garden in the purple wall
> Of those calm hills to close thy destiny.

The poet speculated that she would learn "to love and hate the throne / That robs an empire but repays a home."[58] This poem not only forecast Zenobia's sexual surrender, it suggested that her proper place might be in that home, safely enclosed behind garden walls.

Harriet Hosmer's *Zenobia* demonstrated how difficult it was for most nineteenth-century Americans to imagine a woman of power. Hosmer herself could not completely abandon the convention of the female captive, but she chose a historical subject that suggested strength, courage, and undaunted pride. Her narrative of female self-determination was read, however, by most of her contemporaries as a story of acquiescence and resignation. Just as they found it difficult to interpret Hosmer's energy, ambition, and success in a male-dominated field, both men and women viewers saw in *Zenobia* the values they expected to see: vulnerability, sexual availability, and pathos. *The Greek Slave* still cast its shadow

on sculptor and audience alike; in 1859 not even the most iconoclastic of American sculptors could profoundly challenge the prevailing expectations about woman's nature and woman's role. Confronted with an image of power, many nineteenth-century viewers continued to see an exemplar of powerlessness.

•

Even while *Zenobia* was reaping a mixed harvest of appreciation and misunderstanding, Hosmer continued to explore the question of female power. Her reputation was enhanced by *Zenobia*'s reception, and in 1860 she received a commission from the state of Missouri to sculpt a statue of Senator Thomas Hart Benton. This work, a portrait to be exhibited in a public place and financed by government patronage, enabled her to work in a field where women had rarely ventured. As she wrote in her letter accepting the commission, "your kindness will now afford me an ample opportunity of proving to what rank I am really entitled as an artist unsheltered by the broad wings of compassion for the sex; for this work must be, as we understand the term, a *manly* work."[59] Secure in the recognition she was gaining, Hosmer could more boldly claim for herself the masculine qualities her contemporaries were hesitant to acknowledge.

In designing her statue of Senator Benton, Hosmer further blurred conventional gender distinctions, for she chose a pose and even a costume that recalled her portrait of the unvanquished queen. Sharing John Gibson's dislike for "odious modern dress" in portrait statues, Hosmer wrapped Benton in a Roman cloak and put sandals on his feet.[60] Heavily draped, standing with head slightly bowed, left foot in front of the right, right hand down and the left holding a scroll at waist level, the Benton statue echoed the composition of *Zenobia*. This statue was even more colossal in size, a fact Hosmer stressed when she had a photograph made showing herself at work on the clay model, standing on a scaffold with sculpting tool in her hand, touching Benton's arm (fig. 65). Since, as we have seen, observers often commented on her small stature, she must have derived a considerable sense of power, as well as some amusement, from standing shoulder to shoulder with the monumental senator.[61] Furthermore, she was wearing what she had earlier described as "a Zouave costume," adding that she did not intend "to break my neck upon the scaffolding, by remaining in petticoats."[62] As if fulfilling Hawthorne's fears of what he would find if he looked below her waist, Hosmer showed herself dressed like a man, in command of a commanding figure.

The extraordinary similarity between Hosmer's statues of *Zenobia* and *Thomas Hart Benton* reinforces the idea that she intended to display

FIGURE 65. Harriet Hosmer at Work on Her Statue of Senator Benton, photograph

strength, not weakness, in the figure of the Queen of Palmyra. She had recognized that Benton's statue offered her an opportunity to present an image of strength and power as the world understood it. In the statue of Senator Benton, Hosmer used the visual vocabulary she had already developed in *Zenobia* to assert her subject's, and therefore her own, claim to strength and power.

After successfully completing her statue of Benton, Hosmer returned twice more to the theme of the powerful woman, and, secure in her later career, she expressed even more clearly her celebration of woman's power. In 1869 she began a portrait of a woman she had come to know in the Anglo-European social world, Maria Sophia, a Bavarian princess who had briefly ruled as Queen of Naples before being displaced by Garibaldi. Although Maria Sophia lived the comfortable life of European royalty in exile, Hosmer was struck by the "romance" of her career, particularly her bravery during the siege that preceded her husband's surrender.[63] Like the celebrated female sovereigns of the past about whom Anna Jameson had written, this contemporary woman had wrapped herself in a military cloak and "walked to and fro among the guns, encouraging the soldiers," ignoring "a veritable rain" of bullets and tending to the wounded.[64] Although Hosmer's life-sized portrait statue is now unlocated, a contemporary account describes it in a way that immediately suggests its relationship to both the Benton statue and *Zenobia*. "The pose of the Queen is erect and slightly defiant, defiance less of the foe than of the danger and death that surround her. While the right hand rests upon the folds of the cloak, where it is thrown across the breast and shoulder, the other points downward, to the cannon balls that lie at her feet. The head, surrounded by a splendid coronet of hair, is slightly thrown back. . . . It is an extremely handsome head, somewhat disdainful and breathing the utmost firmness and resolution." The writer added that the ample cloak was reminiscent of "ancient drapery," while the Queen's abundant hair had "the effect of a diadem."[65] A contemporary figure, like Benton an actor in world politics, Maria Sophia presented Hosmer with another chance to explore the subject she had broached in *Zenobia*, a portrait of a regal woman who had suffered military loss and exile. But this time she portrayed her subject as active rather than passive, pacing the battlements, head thrown back in defiance rather than bent forward in captivity. Wrapped in the same voluminous cloak, posed with one hand down and the other crossing her body, *The Queen of Naples* seemed to be an even more assured statement, ten years later, that Hosmer celebrated female power and resisted the notion that women's proper role lay in resigned acquiescence to her victimization.

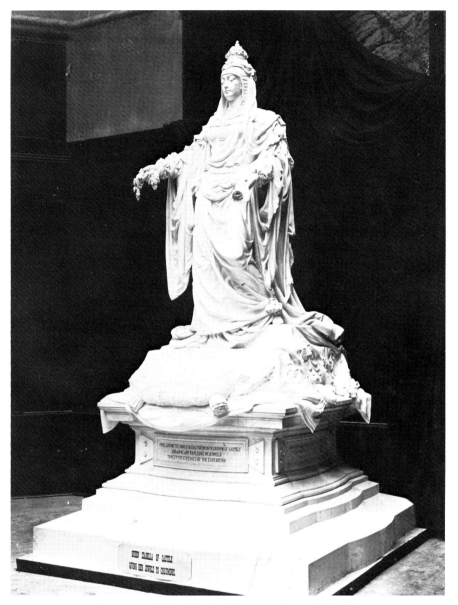

FIGURE 66. Harriet Hosmer, *Queen Isabella*

Hosmer's final statement on the subject of woman's power came twenty-five years later, at a time when she had largely retired from active practice as a sculptor. In 1889 she had been asked to model a statue of *Queen Isabella* for the World's Columbian Exposition of 1893. Although the promised funds were never raised to cast the statue in bronze, she did display the plaster version of it at the Columbian Exposition and

then in Golden Gate Park in San Francisco the following year (fig. 66).[66]
In her statue commemorating the discovery of the New World, Hosmer
portrayed not the explorer but the queen who commissioned the explo-
ration. Standing on a high throne, decked in voluminous robes, heavy
headdress and jewels, with arms outstretched instead of hanging at her
sides, Isabella was a truly regal figure, a queen who could be compared
to Zenobia at the height of her powers. As a friend wrote Hosmer, "You
have given us an Isabella Victrix! She is indeed a Queen, but she is also
a Victory, . . . the representative of all that is best in the ideal queen,
[uniting] kinghood and womanhood."[67] Hosmer's final queen was con-
queror rather than captive, victor rather than victim. In the last decade of
the nineteenth century, as Victorian culture began to give way to modern-
ism, Hosmer was finally able to look beyond the convention of woman's
victimization to portray a woman of undisputed power.

7

WOMAN'S OTHER FACE

Eve and *Pandora*

During the years of its greatest popularity, ideal sculpture provided an occasion for its makers, purchasers, and viewers to elaborate a narrative central to nineteenth-century culture: the story of woman's nature and woman's destiny. Transformed into a spectacle in the most literal sense, the sculptured woman invited responses that tapped her audience's deepest hopes and fears. Viewers were expected not only to look, but to feel and to express themselves. The powerless woman, whether captive or corpse, suggested the fragility of the domestic world she represented, under pressure in a rapidly changing society. At the same time, her physical vulnerability offered viewers a way to objectify their fears and anxieties about sexuality and the human body. Paradoxically, her very powerlessness seemed to give her a kind of moral authority, and viewers struggled to reconcile their attraction to and empathy for her with their sense of the appropriateness of her aloof acceptance of a tragic destiny. Amid barely acknowledged fantasies of overthrow and reversal and despite the efforts of sculptors like Harriet Hosmer to suggest an alternative female response to adversity, nineteenth-century observers insisted that woman's ultimate power lay in acquiescence, abnegation, even victimization.

Faint suggestions that some observers could imagine a radically different version of female identity had begun to stir by midcentury, although

intimations of female sexuality and power were muted in American culture until the early twentieth century. Much earlier, European art and literature had begun to display a fascination with the demonic aspects of woman's nature. Sultry Pre-Raphaelite beauties, grimacing Salomes by Gustav Klimt, Edvard Munch, and Aubrey Beardsley, devouring females in the poetry of Baudelaire, Wilde, and Swinburne, all brought the femme fatale to artistic prominence and visibility in Europe during the second half of the nineteenth century.[1] In her wide-ranging study of British Victorian culture, Nina Auerbach has commented on the bifurcation of literary images of women into the demonic and the divine: "While right-thinking Victorians were elevating woman into an angel, their art slithered with images of a mermaid."[2] More recently, Bram Dijkstra has documented how widespread were the images of "feminine evil" in academic art, popular illustration, and literature at the turn of the century.[3] Although ideal sculpture had faded from prominence by the 1880s, in its last decades of popularity it began to explore, in a characteristically ambivalent manner, the hidden powers residing in woman's nature that were only suggested by the narratives of powerlessness.

•

Earlier in the century, romantic literature had offered fleeting glimpses of woman's other face in sensational narratives that contradicted conventional assumptions about woman's nature. Just as Edgar Allan Poe had questioned the premises of consolation literature in "The Raven," in his tales he deconstructed the narrative of triumphant female spirituality. "Ligeia," first published in 1838, juxtaposed the sentimental themes of lost love and early death with a romantic concentration on the transgression of boundaries and the defiance of death itself in order to suggest a troubling view of female identity.

Poe's story focuses on a woman of extraordinary beauty, mystical powers, and indomitable will, the lady Ligeia, whose recondite studies make her a kind of female Faust, pursuing "a wisdom too divinely precious not to be forbidden."[4] Despite her erudition and her "wild desire for life,—for life—*but* for life," Ligeia becomes ill and dies, exclaiming on her deathbed, "O God! O Divine Father!—shall . . . this Conqueror [death] be not once conquered?" Mysterious (the narrator, who loved and married her, observes that he never knew her paternal name), strangely beautiful, with ivory skin, raven-black hair, and brilliant black eyes, Ligeia embodies the fascinating "dark lady" of romantic literature. She suggests, like Keats' "La Belle Dame Sans Merci," both passion and its

dangers.[5] Snatching at forbidden knowledge, defying death, and domi-
nating the narrator, as some critics have suggested, like a vampire, Ligeia
represents a woman of power—passionate, desired, and desiring.

After Ligeia's death, Poe's narrator marries again in what he describes
as "a moment of mental alienation," a phrase which suggests both in-
attention and also self-contradiction or reversal. His second wife ap-
pears to be Ligeia's polar opposite, "the fair-haired and blue-eyed Lady
Rowena Trevanion, of Tremaine," the romantic antithesis of the dark
lady whose very name evoked Sir Walter Scott's use of contrasting hero-
ines in *Ivanhoe*.[6] Unlike Scott's fair lady, who represented true love and
domesticity, Poe's Lady Rowena serves only as a foil for the narrator's
longing for Ligeia. "I loathed her with a hatred belonging more to de-
mon than to man. My memory flew back, (oh, with what intensity of
regret!) to Ligeia, the beloved, the august, the beautiful, the entombed."
When Rowena mysteriously sickens and dies, the narrator sits beside her
shrouded body remembering, not the blond but the dark-haired wife.
And, after a series of mysterious stirrings, terrifying ebbs and flows of
life in the shrouded body, the tale ends with the narrator facing a figure
who has defied death and returned to life: not the passive, blond victim
but the mysterious, powerful, black-haired Ligeia.

In many ways, "Ligeia" could serve as a central text for understand-
ing the thinking of nineteenth-century Americans about the mysteries
of woman's nature. The romantic convention of the dark and fair ladies,
used again and again by such writers as Cooper (*The Deerslayer*), Haw-
thorne (*The Blithedale Romance*), and Melville (*Pierre*), contrasted a pair
of opposites: safe woman and dangerous woman, domestic and demonic,
passionless and passionate, innocent and experienced. By emptying the
fair lady of all passion and experience, this metaphorical construction
left her passive, receptive, and eternally acquiescent, the "angel in the
house" which became a kind of cultural rubric for Victorian woman-
hood. In the person of dark lady were exemplified all the threatening,
devouring, disorienting powers of passion unleashed, of domesticity de-
fied. In Poe's fable, however, the power of the dark lady is so pervasive
that she infects the fair lady, dominates her, transforms her into her op-
posite. Cooper and Hawthorne conceived the fair lady and the dark lady
as sisters; in *Pierre* they were cousins. But for Poe, they were perme-
able avatars of each other. If the fair lady could become the dark lady,
then the passionless could become passionate, the pure woman could
become the fallen woman, the powerless victim could exercise demonic
power. One critic has referred to Ligeia's reincarnation as "the return
of the primordial repressed," and the fable resonates with the narratives

about woman's nature that were being created by nineteenth-century Americans in the form of art, literature, and popular culture.[7] What was repressed in the insistence of nineteenth-century Americans on woman's domestic, passionless, angelic nature would return to haunt them in the specter of the powerful woman out of bounds, out of control, infecting and perhaps transforming her idealized opposite.

•

American sculptors and those who elaborated on their implied narratives had evoked woman's other face when they contemplated the possibility that the captive maiden might after all be a willing captive, who would not remain aloof from the dangerous, passionate world of her captors. A related theme of female transformation, of dangerous liminality, of the interpermeability of the domestic and the demonic, lurks beneath the surface of a literary subject chosen by several American sculptors: *Undine*, representing the heroine of an 1811 romance by German author Baron Friedrich de La Motte-Fouqué and a 1845 opera by Albert Lortzig. At least five American versions of the subject are recorded, by Chauncey Bradley Ives, Joseph Mozier, Thomas Ridgeway Gould, Benjamin Paul Akers, and Louisa Lander.[8] In La Motte-Fouque's romance, Undine is transformed from a headstrong, willful water sprite to a loving, patient, dutiful woman when she marries a mortal and acquires a soul. The sign of her new, higher nature is her domesticity and submissiveness to her husband: " 'As my lord wills,' replied Undine humbly."[9] Accepting increasingly unreasonable behavior from her husband, bearing his infidelity and mistreatment with resignation and tenderness, Undine enacts the role of domestic saint, even though her husband sends her back to her undersea world. But when the faithless husband marries another woman, Undine is forced by the laws of the sea to return and take his life in a last, watery embrace. The melancholy victim has become an agent of terrible retribution, but the novel ends sentimentally, with Undine mourning her faithless husband by sacrificing herself. A white-veiled mourner at her husband's funeral, Undine dissolves into a little silver spring at the foot of his tomb. "Even to this day," wrote La Motte-Fouqué, turning the dangerous nymph back into an acquiescent captive, "the inhabitants of the village show the spring, and cherish the belief that it is the poor rejected Undine, who in this manner still embraces her husband in her loving arms."

Only two of the five American versions of *Undine* have been located, but in both cases artist and audience focused on Undine's graceful femininity rather than her destructive potential. Chauncey Bradley Ives' *Undine*

Receiving Her Soul (ca. 1855) portrayed the beautiful young girl springing upward from billowing waters, hands stretched over her head, holding a veil above her (fig. 67). Her clothing and veil cling tightly, covering and yet revealing her body, while her face is solemn and thoughtful, her eyes lifted to heaven. The statue seems to illustrate the climactic moment in the romance when Undine emerges from a spring, compelled to act as tragic nemesis: "From the opening of the fountain there rose solemnly a white column of water; at first [the onlookers] imagined it had really become a springing fountain, till they perceived that the rising form was a pale female figure veiled in white. She was weeping bitterly, raising her hands wailingly above her head and wringing them, as she walked with a slow and serious step to the castle-building." Yet Ives chose to depict, not an avenging spirit but a soulful one, Undine not as dark lady but as romantic victim. In 1860 a commentator detached the character from the plot in which she was embedded, describing the statue's pose as "decided, spirited, impressive—the expression full of sweetness, though touched with the consciousness of her divinity."[10] In contemplating this sprite who becomes an agent of terrible retribution, Ives and his viewers preferred to see a sweet and soulful woman, more akin to Hans Christian Anderson's self-sacrificing mermaid than to Edward Burne-Jones' deadly, smiling siren.[11] Ives' interpretation struck a responsive chord, for more than ten copies were ordered by American patrons.[12]

In another version of the same literary subject, Joseph Mozier's *Undine* portrayed a heavily draped figure, perhaps drawing on the description of the water spirit's appearance at her husband's funeral (fig. 68): "Suddenly, in the midst of the black-robed attendants in the widow's train, a snow-white figure was seen, closely veiled, and wringing her hands with fervent sorrow. Those near whom she moved felt a secret dread. . . . Some of the military escort were so daring as to address the figure, and to attempt to remove it from the procession; but she seemed to vanish from under their hands, and yet was immediately seen advancing again amid the dreadful cortege with slow and solemn step." Mozier's interpretation of the subject conveyed a sense of solemnity, and the heavy veil suggested both mourning and mystery. Emulating the Italian artist Rafaelle Monti, who was famous for his "see-through illusionism," Mozier achieved a remarkable impression of beautiful features beneath the clinging veil.[13] Like Ives, who used drapery both to reveal and to conceal the female figure, Mozier swathed his lithe and potentially powerful female subject in layers of clinging cloth. Tightly wrapped, contained, her face concealed like the ladies of the Turkish harem, Mozier's *Undine* remains the self-sacrificing, dutiful wife rather than the dangerously aggrieved vic-

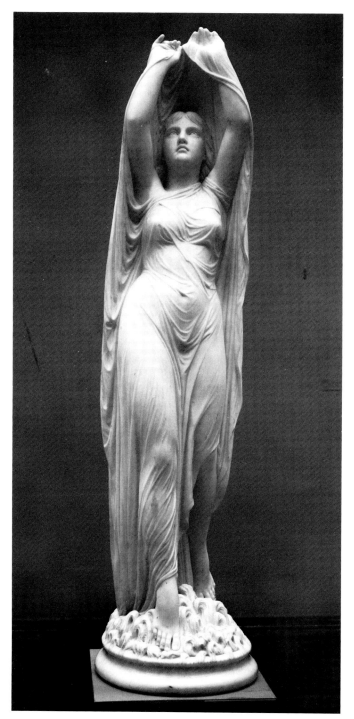

FIGURE 67. Chauncey Ives, *Undine Receiving Her Soul*

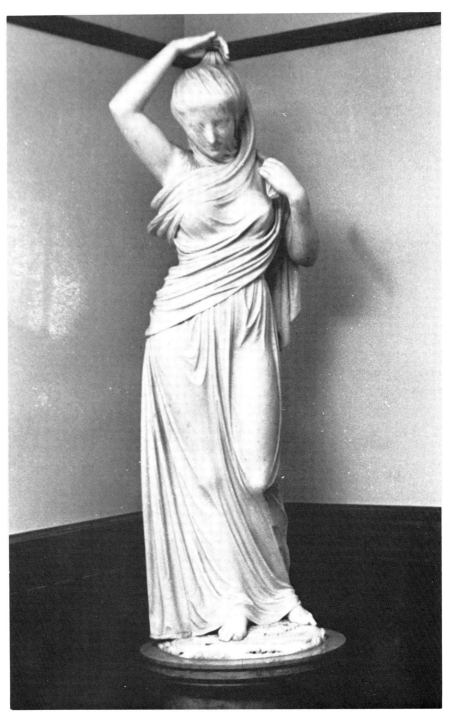

FIGURE 68. Joseph Mozier, *Undine*

tim. In an article written in 1876, a commentator described *Undine* as a figure "suggestive of grace and modesty," indicating that this potentially demonic female subject had been tamed and domesticated, seen as an exemplar of conventional female virtues instead of mysterious potency. [14]

.

The archetypal example of woman's transition from innocence to dangerous experience, of course, was the biblical story of Eve's temptation and fall in Eden. Nineteenth-century artists and audiences had access to a long tradition of religious art that depicted Eve's fateful transformation. In yielding to the seduction of the serpent, disobeying God's word, and tempting Adam to join her in disobedience, Eve represented in Jewish, Christian, and Islamic tradition alike the irrepressibility of humankind's sinful nature. Indeed, as one contemporary scholar has shown, a long tradition linked the biblical Eve with demonic representations of women, and many images of the temptation, from Hieronymous Bosch through William Blake to Max Klinger at the end of the nineteenth century, depicted the serpent as Eve's double.[15] That the forbidden knowledge Eve could not resist was explicitly sexual was indicated in numerous religious paintings portraying Eve's transformation as an erotic moment, including the *Temptation and Expulsion* section of Michaelangelo's Sistine Chapel ceiling.[16] In Milton's *Paradise Lost*, Eve experienced the temptation first in a dream, when Satan "squat like a toad" at Eve's ear, tried to reach the organs of her fancy, and offered her the experience of "high exaltation." As Raphael had warned, the Fall plunged Adam and Eve into the turbulent world of the passions, "both in subjection now / To sensual Appetite." [17]

As nineteenth-century art began to elaborate the image of the femme fatale, the figure of Eve often stood as the prototypical temptress.[18] Two statues by French sculptor Eugène Delaplanche, *Eve After the Fall* (1869) and *Eve Before the Fall* (1890) (fig. 69) portray seductive sensuality and exaggerated remorse.[19] During the mid–nineteenth century, Eve proved a popular subject for American sculptors, but their versions of the subject took a different cast. American artists and audiences preferred to soften the demonic implications of the Fall. Viewing Eve as a vulnerable victim rather than a sensual siren, they read in her story another version of the captivity narrative and denied the possibility that woman's nature might be active and sensual rather than acquiescent and spiritual.

One of the earliest and best-known American Eves was Hiram Powers' *Eve Tempted* (1842–43) (fig. 70). Begun a few months before *The Greek Slave*, *Eve Tempted* was Powers' first ideal statue, and the two works pro-

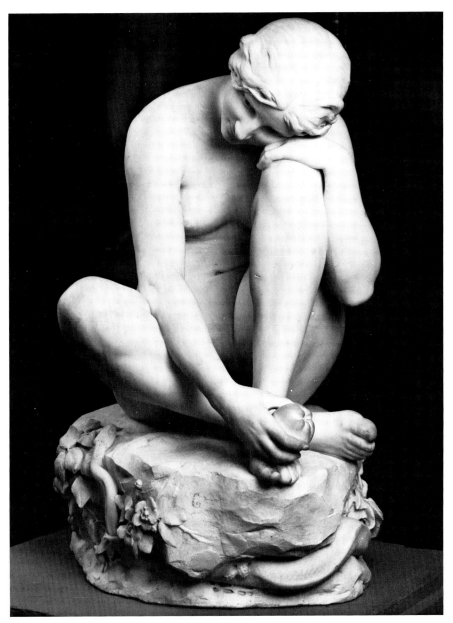

FIGURE 69. Eugène Delaplanche, *Eve Before the Fall*

gressed through the various sages of clay, plaster, and marble during the same three-year period.[20] Like the statue that was to become internationally famous, Powers' *Eve* took a potentially explosive, sensual subject and insisted on its chaste innocence.

According to his letters, Powers had first intended to portray a post-

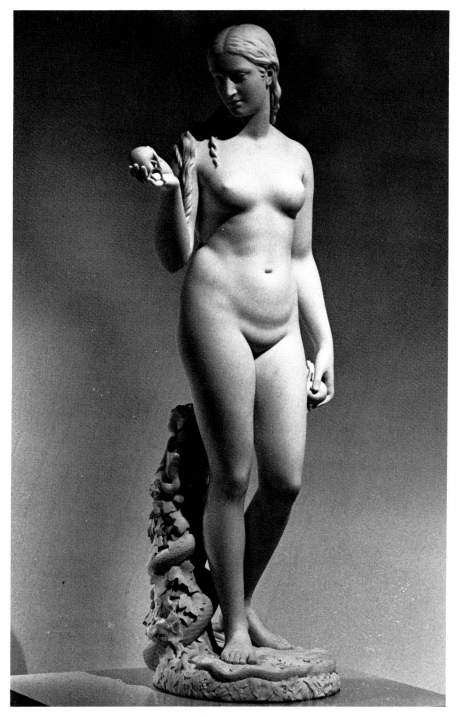

FIGURE 70. Hiram Powers, *Eve Tempted*

Edenic Eve, planning a sculpture drawn from the works of Swiss poet Salomon Gessner, which would illustrate "the moment when [Eve] is looking at a dove, which lies dead at her feet and which calls up disagreeable reflections in her mind on the consequence of her transgression."[21] However, Powers soon drew back from the implications of picturing the fallen Eve and chose instead to portray her on the very brink of her transformation. Like *The Greek Slave*, which showed a young woman suspended between the past and present, between freedom and slavery, virginity and violation, *Eve Tempted* portrayed metamorphosis in the making. Eve stands nude and unembarrassed, not yet fallen into sexual awareness. But she has picked the apples and gazes meditatively at the one she will soon taste. The snake's sinuous body flows around Eve's feet, while its head rears, erect, from the stump in a provocative, phallic gesture. Powers added another anecdote to the statue's base, a lizard watching a fly "to show," as the sculptor put it, "that the temptation was felt at the same moment throughout the animal kingdom."[22] In both cases, Powers' narrative details suggest that Eve is the victim of a powerful predator, threatened with transformation and violation as surely as *The Greek Slave*.

The statue's pose echoed that of Bertel Thorwaldsen's *Aphrodite with the Apple* (1805), although Powers' figure was more upright, her body less sensually arched (fig. 71). Thorwaldsen was revered as a model by American sculptors, and Powers was proud of receiving a compliment on *Eve Tempted* when the older sculptor visited his studio.[23] By recasting Thorwaldsen's pagan goddess of love as the yet-unfallen Eve, Powers offered viewers a graceful tribute to the female body that could nonetheless be interpreted within a morally respectable narrative framework.

Orville Dewey, whose approving remarks facilitated the acceptance of *The Greek Slave*, commented that *Eve* was "clothed with associations," and elaborated on the story he read in the sculpture. "I said to the artist: 'I see here two things; she meditates upon the point before her, and she is sad at the thought of erring.' He said: 'Yes, that is what I would express, but I must add another trait.' I feared to have him touch it; but when I next saw the work that expression of eager desire was added, which doubtless fills up the true ideal of the character."[24] In this complex narrative, the clergyman saw Eve primarily in terms of regret and remorse. The quality of desire, which he acknowledged almost as an afterthought, took the form of the "eager" longing of a curious child rather than the seductive attraction of a mature woman.

Although an early buyer had drawn back from Powers' *Eve Tempted*, fearing it would be too shocking for American audiences, later observers,

FIGURE 71. Bertel Thorwaldsen, *Aphrodite with the Apple*, engraving

perhaps schooled by the reception of *The Greek Slave*, insisted that they saw in the sculpture innocence rather than sin. In a poem published in *Godey's Magazine and Lady's Book* in 1847, J. Bayard Taylor described Eve as "a faultless being":

> Pure as when first from God's creating hand
> > She came, on man to shine;
> So seems she now, in living stone to stand—
> > A mortal, yet divine![25]

One viewer described Powers' Eve as a childlike victim rather than a perpetrator of crime. "She is holding the apple, and her face expresses thought and curiosity, mixed with a presentiment of future ill. Ah, poor Eve! we will not condemn thee! Who of her fair daughters could have resisted the rosy-cheeked apple, looking so harmless?"[26] A patron who later bought a bust-length version of *Eve Tempted* noted approvingly the overwhelming sense of innocence the sculpture conveyed. "Every limb speaks, not of passion, but of the feelings which we may conceive to have been Eve's between the period of gathering the fruit and eating it. She had taken the first step toward sin; hence the conflict of feelings—but she was still pure, still unconscious of shame, her eyes not yet opened. . . . [She was] a woman—innocent, sinless and perfect in outward form—as an angel, yet not an angel!"[27] Beneath the "innocent, sinless and perfect" outward form of the ideal woman lurked something this commentator, like others, chose not to articulate. Woman was "an angel, yet not an angel," but Powers neatly sidestepped this dilemma. His Eve avoided confronting the problem of woman's other face. Far from a woman of power or passion, *Eve Tempted* was a figure similar to *The Greek Slave*, embodying ideal womanhood as his generation understood it: pure, passionless, melancholy, endangered. Yet the sculpture acquired its interest, and the tension which infused the narratives with which it was surrounded, from its viewers' perception that this fair lady was trembling on the verge of a momentous and irreversible transformation and, like the Greek slave, a fall into carnality.[28]

In the mid-1850s, Powers began to think about the possibilities of showing woman's other face directly by portraying the consequences of Eve's fall. However, it was not until 1871, shortly before his death, that *Eve Disconsolate* was cut in marble (fig. 72). Larger in scale than *The Greek Slave* and *Eve Tempted*, the over-life-size nude figure clutches her bosom with one hand and points downward at the serpent with the other, her head tilted upward in despair or supplication. In the elongated body and mannered pose, Powers moved away from the sweetly rounded clas-

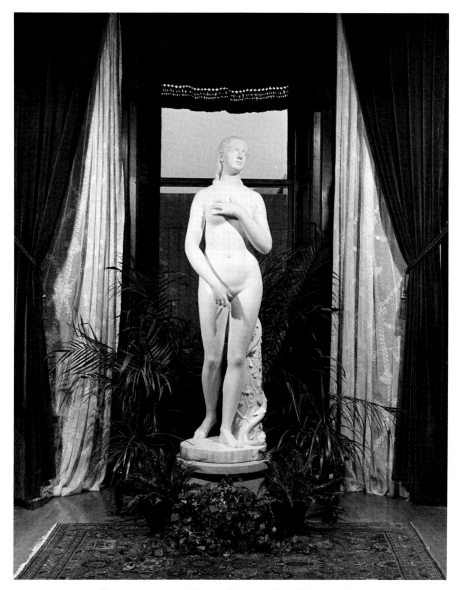

FIGURE 72. Hiram Powers, *Eve Disconsolate*

sicism of his earlier Eve. Yet unlike European contemporaries such as
Eugène Delaplanche, Powers did not portray an Eve writhing with new-
found sensuality; rather, he envisioned the transformed Eve as a grave,
spiritual, thoughtful figure. He first began to plan the sculpture while at
work on *La Penserosa* (1857), a figure of melancholy based on Milton's
poem (fig. 73). Although this female subject, in accordance with its pur-
chaser's wishes, was clothed, Powers worked from a nude sketch, and

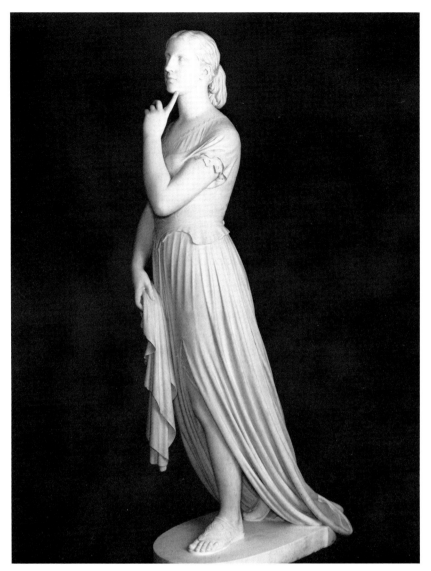

FIGURE 73. Hiram Powers, *La Penserosa*

he wrote in a letter that the figure made him think of Eve after the Fall because of its "deep meaning . . . and solemn dignity," adding that Eve would require "a shade of grief on the face."[29] By August 1862, Powers had adapted *La Penserosa*, changing its pose and expression slightly, and completed a plaster version of *Eve Disconsolate*, which, he wrote, "makes a greater impression on visitors than any other work in my studio."[30] Powers thought of the sculpture as a sequel to the story told in *Eve Tempted*; he tried to persuade the owner of his earlier statue to buy *Eve*

Disconsolate so they would both be in the same gallery.[31] As if to continue the narrative begun in the earlier sculpture, Powers carved a serpent twined around a tree stump in *Eve Disconsolate*, but now instead of the threatening, erect, phallic head, the snake hung limply, head-downward. The story was no longer that of imminent risk, but of transformation accomplished, virginity lost. The long hair that flowed abundantly down the back of the earlier Eve was knotted and looped behind the figure of *Eve Disconsolate*, suggesting constraint, acquiescence, and a post-Edenic world of toil.

Yet, as a portrait of the archetypal fallen woman, Powers' sculpture was remarkably gentle and benign. Whatever Powers' intentions, its purchaser saw it as another image of the idealized woman, complimenting the sculptor on making "so nearly . . . a perfect woman, only such an one as could come from the hand of God."[32] That Eve after the Fall was not exactly as she had come from the hand of God was the very point of the sculpture, but it was one that this viewer did not care to contemplate. Even in the fallen Eve, nineteenth-century American viewers preferred to see the fair lady rather than the dark lady.

Another American sculptor also attempted to portray the fallen Eve with some of the same qualities of noble acquiescence. Edward Sheffield Bartholomew's *Repentant Eve* (1858) displayed the crossed arms and legs that connoted sexual experience, but her inward-turning, drooping figure suggested passivity and submission to her fate (fig. 74). While Bartholomew included such narrative elements as the snake and an apple with tooth marks on it, Eve herself resembled a figure of grief or mourning rather than a seductive temptress. At the base of the octagonal pedestal, Bartholomew carved a series of relief sculptures showing the temptation in greater detail: Adam and Eve in the bower, Eve's encounter with the serpent, and the expulsion of a dramatically gesturing Adam and Eve. But the central figure on the pedestal seems to have renounced melodrama, as well as passion, to assume the pose, once again, of the romantic victim. Bartholomew, who began his artistic career in Hartford, sculpted as one of his first works a portrait of Lydia Sigourney, and Sigourney wrote a poetic tribute to the sculptor after his death.[33] In his depiction of Eve, Bartholomew referred not to a Miltonic but a sentimental context, stressing the pathos rather than the transformational power of the Fall.

•

The steadfast refusal of Americans to see Eve as a dark lady, but rather to envision her as a romantic victim, cannot be understood as simply an

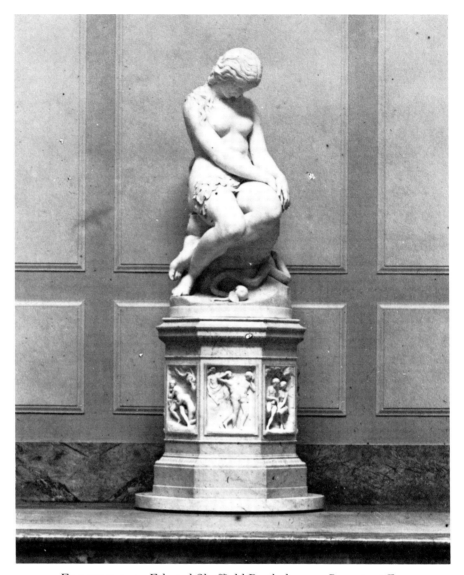

FIGURE 74. Edward Sheffield Bartholomew, *Repentant Eve*

aesthetic disposition. In their interpretation of this biblical story, artists and audiences were influenced by powerful forces that were transforming American Protestant thinking by the middle of the nineteenth century. Especially among the ranks of the economic elite who supplied the aspiring sculptors with benefactors and patrons, liberal theology had begun to challenge orthodox interpretations of the nature of God and human beings and, by implication, of religion and society. The most visible evidence of this movement was the expansion, starting in the first decade of

the nineteenth century, of the Unitarian Church, but the effects of liberal theology were also felt in traditional denominations throughout the antebellum period.[34]

One of the most significant aspects of the new liberal theology was its emphasis on a loving God and its shift away from a belief in predestination and total depravity. "Now it is the height of absurdity," wrote theologian Andrew Preston Peabody, "to maintain, that an almighty being can create what he hates and abhors, or that an infinitely good and holy being can create what is essentially evil and vile. It is intrinsically necessary, that whatever God creates should be good, very good, perfect in its kind and for its purpose."[35] According to Henry Ware, whose appointment to the Hollis professorship of divinity at Harvard in 1805 marked the transition from orthodoxy to liberalism at that institution, humankind possessed the potential for moral perfection as well as for sin and error. Each person is "an accountable being, a proper subject to be treated, according as he shall make a right or wrong choice, being equally capable of either, and as free to the one as to the other."[36]

The tenets of liberal Christianity had enormous social and theological importance. For Unitarian ministers like William Ellery Channing, Theodore Parker, and Joseph Tuckerman, belief in the essential goodness of humankind led directly to involvement in reform movements such as abolitionism and programs of social amelioration. Others, like Ralph Waldo Emerson and George Ripley, found that even Unitarianism was too intellectually confining, and they devoted their efforts increasingly to the literary and philosophical movement known as Transcendentalism.[37] Furthermore, the revulsion against the doctrine of innate depravity affected even members of more orthodox congregations. Leading Congregationalist ministers like Henry Ward Beecher and Horace Bushnell increasingly stressed the view that God is merciful and forgiving, a God of love rather than a God of wrath. And mystical movements such as Swedenborgianism offered optimistic assurances of human rationality and free will.[38]

Many of the makers and defenders of ideal sculpture belonged to liberal Protestant denominations. Hiram Powers was a Swedenborgian, and his influential commentator, Orville Dewey, was a Unitarian minister. Another Unitarian minister, James Freeman Clarke, wrote a poem in praise of *The Greek Slave* that appeared in the exhibition pamphlet. Harriet Hosmer and William Wetmore Story grew up in Unitarian families. The influential art critic Henry Tuckerman, who worried about the deadening impact of commercial life and suggested art as an antidote to spiritual deadness, was the nephew of the prominent Unitarian minis-

ter and reformer Joseph Tuckerman. Behind the moral and intellectual urgency that artists and commentators imparted to ideal sculpture, then, we may detect the assumptions and concerns of midcentury liberal Protestantism.

Such a theological context gives a meaning to the biblical story of the Fall very different from the Catholic or Anglican interpretations that informed many European depictions of Eve as a temptress. For liberal Protestants who rejected the notion of the innate depravity of human beings, the Fall represented no preordained plunge into evil but rather a sobering illustration of the human struggle with temptation. Instead of an exemplar of sin, Eve might thus be interpreted as a representative of all humankind. "We are born with a mixed constitution, physical, intellectual, and moral," wrote Unitarian theologian William Greenleaf Eliot. "Conscience claims the supremacy; it says, Thou must, or Thou must not; but the body, with its wants and its enjoyments, resists its commands."[39] The Eve who plucked the apples is, according to this point of view, morally culpable, but she is not a demonic agent of inevitable doom. Artists and audiences alike could thus see the figure of Eve sympathetically, as a victim of her own human weaknesses.

Moreover, from the point of view of liberal Christianity, the story of Adam and Eve also suggested a subject of burning importance in mid-nineteenth-century America, the fate of the family. In countless tellings of the biblical story in nineteenth-century America, Eve was portrayed not only as archetypal woman but also as the first wife and mother.[40] Like many other Americans, liberal Christians registered their uneasiness about the ways in which a changing economic and social structure threatened the stability of the family by the mid–nineteenth century. Theodore Parker, well-known Unitarian minister and reformer, preached a sermon on "Home Considered in Relation to its Moral Influence." "Home is the oldest of all human institutions," Parker began. "A man's home—it is to him the most chosen spot on the earth." Like other writers of the time who suggested that home provided protection against an increasingly hostile commercial environment, Parker framed his praise of the home in terms of its effect on the hard-pressed male participant in the sphere of worldly strife. "It affords him a rest from the toils of life. Here he can lay off the armor wherewith he is girt for the warfare of this world. . . . His habitual restraint and self-concealment, acquired by sad intercourse with the selfish, are here laid aside. . . . The hardness is softened; the selfishness is changed." Warning that the influence of home is enormous, both on the men who escape to it and on the children who are reared in it, Parker registered his sense that the home was an

embattled ground: "I know that to some men, perhaps to some women, all this seems idle, only talk; . . . They have their dreams of ambition, of wealth, or finery and display, or sloth, and intemperate indulgence of low appetites, and so they will care little about the moral influence of home." Nonetheless, he urged men and women "to build up a pleasant, a religious home," for in this lay true success.[41]

Similarly, Congregationalist minister Horace Bushnell saw the family as the essential institution in the struggle for a compassionate and moral society. "The tendency of all our modern speculations is to an extreme individualism," he wrote, insisting that, on the contrary, "all society is organic." Thus the essential test of Christian values was to be found in the home, and in the education of children. Bushnell, opposing the notion of innate depravity from within the Congregational church, insisted that Christian nurture should treat even young children as good, rather than evil in nature. He deplored the belief "that men are to grow up in evil, and be dragged into the church by conquest," insisting rather "that the child is to grow up a Christian, and never know himself as being otherwise."[42] By implication, the home thus became the crucial arena for moral education in a world that seemed to threaten Christian values.

Concern for the integrity of the home and glorification of domesticity colored numerous mid-nineteenth-century American tellings of the biblical story of Eve. Sarah J. Hale, the influential editor of *Godey's Lady's Book*, insisted that the Bible presented a far more positive view of Eve than did the rigorously Calvinist *Paradise Lost*. "Pray do not quote from Milton," she warned. "Pray examine the first three chapters of Genesis carefully. . . . Why was this recorded, if not to teach us that the wife was of the finer mould, and destined to the more spiritual uses—the heart of humanity, as her husband was the head?" Even after the expulsion, Hale argued, woman's finer qualities held the promise of redemption: "the divine Judge seems to have fixed the human duties thus: . . . Adam, sole sovereign of earth, chose the little plot of ground that was to be their home, where love, in the guise and graces of Eve, would, by her smiles and gentleness, make his hard tasks pleasant for her sake, and, by her goodness and her faith in God, she would draw him from the dark power of the evil Tempter into the sunshine of heavenly love." For Hale, the essential drama of human life was not temptation and sin, but rather the defense of an embattled domesticity. "Home!" she exclaimed. "Where in our language shall we find a word of four letters that stirs all the sweet pulses of life like this of home,—Our Home?" Yet she also warned her readers against the forces that threatened the sanctity of the home, particularly divorce. "Five divorces in a week! Five desolated homes! The

mind recoils from the contemplation; the heart shudders as the vision rises of what these words portray. All misery in them, all wretchedness, all woe."[43] Her construction of an Eve who was the polar opposite of the femme fatale, a domestic saint rather than an archetypal sinner, functioned as an anxious defense of the family. Insisting on woman's spiritual nature, she looked to the doctrine of separate spheres as a bulwark against the dangers that seemed to be threatening the family.

Other writers elaborated on the theme of the domestic Eve. In 1855 a Baptist minister from New York, George C. Baldwin, published a series of lectures telling the stories of twelve women drawn from the Old and New Testaments, beginning with "our great common mother," Eve.[44] From her very creation, Eve is portrayed in this account as a domestic being, brought into the world to make a home for Adam. The first man, though "enstamped [with] the moral image of his Creator," was lonely. "There was no one constituted like himself, to whom he could speak and say, 'how beautiful is this our home.'" The newly created Eve, the "divine ideal of a perfect woman," was also "the first bride— the first wife." The sin of disobedience, which this writer treats gently as "the unlawful exercise of elements natural to her constitution," led to a punishment appropriate to such a domestic being: the loss of her home. "Eden was her home—where she had spent so many blissful hours—the only place in which she had ever lived. Remember, what home is to a woman's heart. . . . But now she must leave it—leave it in consequence of her own act; leave it forever." The chapter closes with an account of "earth's *first family*," pointing out that Adam and Eve had given their children a religious education and had taught them to labor. Lingering over the spectacle of Cain's murder of Abel, the author nonetheless found hope that "our first parents were penitent," and he speculated that "even as she was the first woman who ever trod our earth, she was . . . the first female voice that mingled with angelic choirs."[45]

From this domestic narrative, Baldwin drew a set of explicit lessons for his readers that reflected his anxiety about the security of family life in America. Observing that Eve was created to be a helpmate for Adam, he cautioned, "let no false pride, no mawkish sentimentalism keep women from fulfilling this God-assigned mission, and cheerfully occupying this her noblest position." Recalling Eve's fall, he warned that women of his own generation faced numerous temptations: "Does not the unchecked desire to be different from what God intended: her desire to rise, not morally, not intellectually, but *positionally*, to get above the sphere in which Providence has placed her, to be herself the object of admiration and adoration, lead her to forget God?" Finally, he reminded women

that Eve taught a lesson about the importance of woman's influence in the world. "For many a man's poverty his wife is responsible; for many a man's dissipation, his *wife* may blame herself. And for what many men are, in their high position and lofty character, they are indebted to their wives."[46] Baldwin shared with his colleagues in the more liberal Christian denominations a fear that women were being distracted by the temptations of increasing prosperity and an anxiety about the integrity of the family and the moral health of society in general.

It is not surprising to find the image of a vulnerable, maternal Eve in a poem by Lydia Sigourney, "Eve" (before 1860). The poet stressed the positive aspects of post-Edenic life, sketching "a lovely scene," a mother "bending o'er a new-born child." For Sigourney, the joys of motherhood were strong enough to compensate Eve for her banishment from paradise.

> No more she mourn'd lost Eden's joy
> Or wept her cherish'd flowers
> In their primeval bowers
> By wrecking tempest riven
> The thorn and thistle of the exile's lot
> She heeded not
> So all-absorbing was her sweet employ.

But motherhood had its sorrows, too. Sigourney's Eve lamented Cain's "dark passion . . . and moody hate," but she was only a spectator, not an agent, in the violent fratricide that transformed the earth itself, according to the poet, into a weeping maiden who "hid her head and mourn'd, amid the planet-train."[47] The poet, like Powers and Bartholomew, declined to view Eve as a temptress, a pursuer of forbidden knowledge, and chose instead to portray her as a suffering mother. Thus, Sigourney, like Baldwin, saw the story of the Fall not as a drama of disobedience and temptation, of the demonic revelation of woman's other face, but rather as a domestic tragedy.

A similar interpretation of the domestic implications of the fall of Adam and Eve was displayed in a pair of sculptures by Joseph Bailly, a French artist who left his country after the Revolution of 1848. He worked for a short time in England, where he shared a studio with Edward Hodges Bailly, a British sculptor who had won great attention for his wistful *Eve at the Fountain*. By 1850 Joseph Bailly had settled in Philadelphia, where he ultimately became an instructor at the Pennsylvania Academy of Fine Arts. His paired statues, *Paradise Lost, the Expulsion* (1863–68) and *The First Prayer* (1864–68) were owned by a Philadelphia

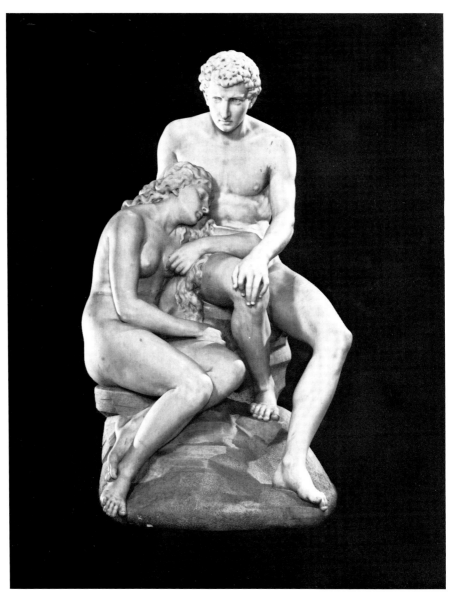

FIGURE 75. Joseph Bailly, *Paradise Lost, the Expulsion*

collector, Henry Gibson, and appeared together in the photograph of
Gibson's dining room that was published in *Artistic Houses* (figs. 75, 76).

Bailly's two statues used a rough-hewn rock base to define their set-
ting in the postlapsarian world. *Paradise Lost* shows Adam seated, gazing
sorrowfully into the distance, with Eve leaning on his lap, eyes half-
closed as if she has been weeping, body drooping mournfully. In *The First*

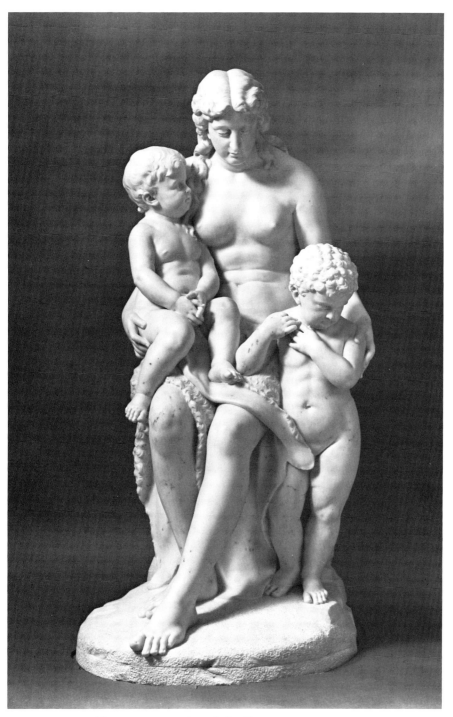

FIGURE 76. Joseph Bailly, *The First Prayer*

Prayer, Eve sits erect on a rock, with two children, Cain and Abel, who demonstrate through their poses their very different temperaments. Cain is sullen and restless, while Abel sits sweetly, hands folded, looking attentively at his mother. Like the literary narratives of Baldwin and Sigourney, Bailly's sculptures present the post-Edenic world as a story of family formation and family tragedy rather than a tale of female treachery and sensuality.

In mood and in composition, *Paradise Lost* and *The First Prayer* recalled a sculpture by another French artist, Antoine Étex, *Cain and His Family* (1832), which had won a medal at the Salon of 1833, and had subsequently been engraved and then exhibited at the Crystal Palace Exhibition of 1851 (fig. 77). The larger-than-life-size marble version was shown at the Salon of 1839 and the Exposition Universelle in Paris in 1855.[48] Étex, who may have been attracted to the subject by the popularity of Byron's drama *Cain* (1821), managed to interpret the figure of the killer in a sympathetic light, surrounded by his weeping wife and small children. Instead of the story of a demonic individual, Étex presented the drama of a doomed family. In the next few years, other European sculptors elaborated on the domestic life of the fallen Adam and Eve with such works as Auguste-Hyacinthe De Bay's *First Cradle* (1845), showing Eve holding Cain and Abel in her arms. Reproduced in an inexpensive terra cotta figure entitled *Eve Nursing Cain and Abel*, this sculpture was exhibited at the Philadelphia Centennial Exhibition (fig. 78).

In *Paradise Lost, the Expulsion*, Bailly, like his countryman Étex, showed a brooding husband and a weeping wife. Yet, in their intimate pose, Eve leaning on Adam's lap, there is an impression of unity, a sense that the couple will survive as a family. Eve is remorseful and submissive, a proper wife, and in the companion work, *The First Prayer*, she is portrayed as a loving mother, supporting and instructing her two children.[49] The domestic Eve is a hapless sufferer, a victim like the captive maidens, rather than a threatening dark lady.

•

At least one American sculptor addressed the issue of woman's other face by choosing a subject closely related to the theme of Eve's temptation. Chauncey Bradley Ives' *Pandora* received an enthusiastic response from audiences in the mid–nineteenth century. Ives modeled two versions of the sculpture, the first in 1851, the second, slightly altered, in 1863 (figs. 79, 80). One copy of the earlier version was exhibited and sold at the International Exposition in London in 1862, and he made at least nineteen copies of the second version throughout his long career.[50]

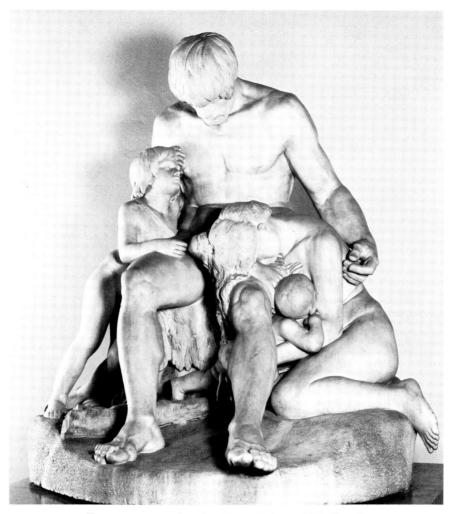

FIGURE 77. Antoine Etex, *Cain and His Family*

By the nineteenth century, a long tradition associated the stories of Eve and Pandora, as illustrated in a painting by Jean Cousin, *Eva Prima Pandora* (1550), found in the Louvre (fig. 81). A seductive, reclining nude rests one hand on a jar, the other on a skull, suggesting that in both cases, woman and her sexual allure brought sin and death into the world. Modern scholars have pointed out that the Pandora legend was used by the early church to support a sexual and mysogynist interpretation of the Fall.[51] The story of Pandora, best known in its rendition by Hesiod in *Works and Days*, similarly portrayed women in an explicitly critical light, perhaps, as the classicist Jane Harrison has suggested, to strengthen the position of the male Olympian gods at the expense of a

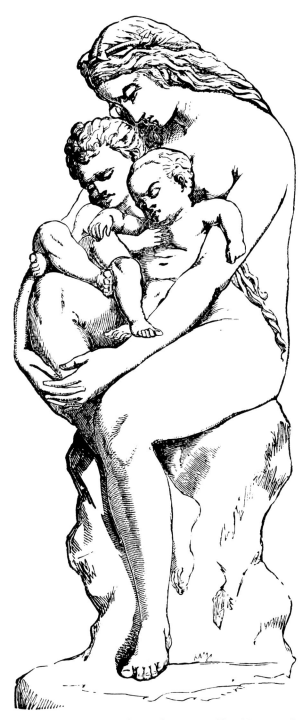

FIGURE 78. Watcomb Terra Cotta Company, *Eve Nursing Cain and Abel*

FIGURE 79. Chauncey B. Ives, *Pandora*, first version

FIGURE 80. Chauncey B. Ives, *Pandora's Box*, second version

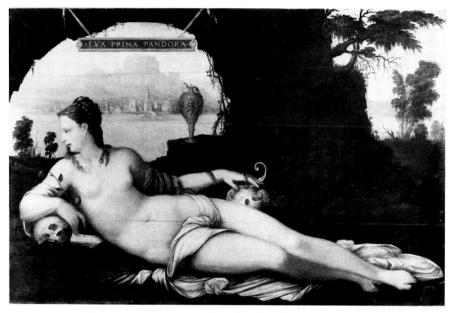

FIGURE 81. Jean Cousin, *Eva Prima Pandora*

more ancient tradition of worship associated with women.[52] According to Hesiod, Pandora was created by the gods as a punishment to Prometheus, who had stolen fire from them. Endowed with wonderful beauty and charm, "all-gifted," Pandora was sent to earth to torment mankind. Prometheus, whose name means "forethought," refused to accept Pandora, but his brother Epimetheus, or "afterthought," married her. When Pandora lifted the lid of a jar or *pithos,* a vessel used by the Greeks for storage and also for burial, all the evils previously unknown in the world flew out, leaving behind only hope. According to Hesiod, Pandora was "a beautiful evil [*kalon kakon*]," and he commented, "therefore do not let any sweet-talking woman beguile your good sense with the fascination of her shape. It's your barn she's after."[53] Thus Pandora, like Eve, was regarded as the instrument whereby death, disease, and hard work entered the world.[54]

By the nineteenth century, two elements had entered the story of Pandora, changing its original thrust somewhat. A famous version of the story by Erasmus had transformed *pithos,* or jar, into *pyxis,* or box, thus obscuring the ritual significance of the container, and weakening the suggestion that the evils in the story spring from the source of life and death, the female body itself. Even more significantly, Erasmus' version of the story succeeded in conflating the story of Pandora with that of

Psyche, subject of another Greek legend, who was sent on a mission involving a *pyxis*. In the story told by Lucius Apuleius in *The Golden Ass*, Psyche represented a young woman who earned the wrath of the gods because of her beauty. She was sent on a series of difficult quests, at the end of which she earned the love of Cupid. One of her assignments took her to Hades, where she had to bring back a box containing Proserpine's beauty ointment. Psyche was nearly destroyed when she gave way to her curiosity and opened the box, releasing vapors that plunged her into a deathlike sleep from which she was rescued by Cupid.[55] Instead of a primordial mother of humankind, the opener of the jar became an untrustworthy messenger, a female victim, threatened not by the forces of evil but by potent sexuality. In later tellings of Pandora's story, she took on many of the attributes of Psyche: the box became an item entrusted to her care, rather than a part of Epimetheus' household, and the narrative came to revolve around her uncontrollable curiosity. Both these variations had the effect of shifting the emphasis of the story. Instead of a mysterious and powerful "all-gifted" creation of the gods, Pandora became a prototype of untrustworthy, fallible womanhood.

When artists and writers began to search for subjects that portrayed the darker side of woman's nature in the mid–nineteenth century, Pandora was, like Eve, an obvious reference point. English Pre-Raphaelite painter and poet Dante Gabriel Rossetti portrayed Pandora as a sultry-looking temptress clutching a richly jeweled box from which ominous vapors rise.[56] But Ives rejected the seductive implications of Pandora's fate, choosing instead to follow a number of earlier neoclassical treatments of the subject that were cool and meditative. Jean-Pierre Cortot had exhibited a *Pandora* at the Paris salon of 1819, showing the half-nude subject gazing thoughtfully into the distance, holding a box in one hand (fig. 82). But even more significantly, Ives reached into the iconography of the myth that had been entangled with that of Pandora, the story of Psyche. Canova had sculpted a *Psyche*, as had Thorwaldsen (1811), and the London *Art-Journal* had published engravings of statues of *Psyche* in English collections by Richard Westmacott and W. Von Höyer in the 1840s and 1850s (figs. 83, 84). In each case, the drama of the work centered on the relationship between the subject's hands and the object she was carrying. In Westmacott's statue, Psyche delicately opens the lid of the box, while in Von Höyer's sculpture she holds one hand flexed at the wrist as if to shield her face from the light of the lamp she carries. Like the compelling passage in the Sistine Chapel ceiling, where the hands of God and of Adam are poised, outstretched, almost touching, the arrested

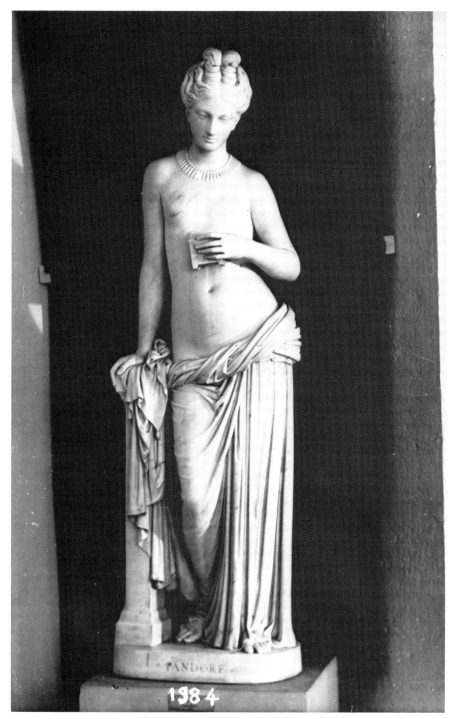

FIGURE 82. Jean-Pierre Cortot, *Pandora*

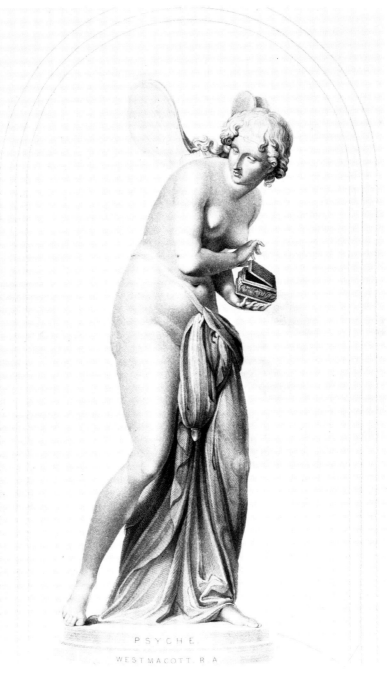

FIGURE 83. Richard Westmacott, *Psyche*, engraving

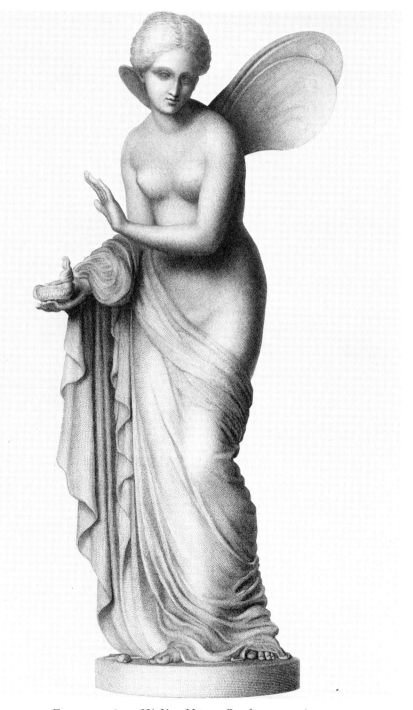

FIGURE 84. W. Von Höyer, *Psyche*, engraving

movement of Psyche's hands, reaching toward the object she holds, suggests a moment of heightened significance, of spiritual intensity.

Like these figures of *Psyche*, Ives' *Pandora* presented a standing half-nude, partially draped below the waist. The subject holds a small container in her left hand, and her right hand is spread out, wrist flexed, fingers raised, a short distance from it. This gesture, which breaks the smooth, sinuous flow of flesh and drapery, functions like the reaching hands in the Sistine Chapel ceiling, to suggest motion suspended at a particular moment in time. Ives clearly wished to represent, not just Pandora with her box, but Pandora on the point of deciding to open it. Like Von Höyer's *Psyche*, Ives' *Pandora* seems to be both reaching out and drawing back, registering both desire and hesitation. *Pandora* depicted a moment of transition, a borderline between two states of being that recalled the precarious drama of the captive maiden. In this sense Ives, like Powers, presented a glimpse of woman's other face, alluding to the powerful and terrifying forces that woman was able to unleash.

However, like Powers, Ives avoided direct acknowledgement of woman's demonic potential. By presenting his subject at the moment of opening the box, he suspended time at the instant before the occurrence of an act that would transform the world. He thus depicted the still-unfallen rather than the guilty woman. Hesiod's Pandora was created as a "beautiful evil," but in the tradition to which Ives was alluding, Pandora, like Eve, was considered guileless until the fatal moment of opening the box. In the first version of the statue, the vessel in Pandora's hands was a flat box with a serpent carved on the cover, strongly suggesting the parallel between Eve and Pandora and implying, too, Pandora's innocence before the fall. The catalog that accompanied the exhibition of the statue suggested that the jar, not Pandora herself, was the source of evil: "Pandora was sent by Jove to Prometheus, with a jar containing all the evils of life in punishment for his stealing fire from heaven." The description of Pandora's transgression suggests both Eve's disobedience and Psyche's curiosity: "Pandora was charged by Jove not to open the jar, but being seized with curiosity, she cautiously raised the lid, and at once there issued forth all the ills that beset mankind in body and in soul." Yet the transgressing woman is by no means demonic; she is "seized" with curiosity, carried away like a captive in spite of herself. Furthermore, in this narrative Pandora was redeemed by her domestic instincts: "Hastening to close the jar, she saved only hope which lay at the bottom, and thus, though a victim of every evil, man ever retains hope."[57] Like a good housekeeper, Pandora proved her worth by saving something that would otherwise have been lost. Ives' version of the subject presented a

domestic, even a bourgeois version of Pandora that resembled the Eve of Sarah Hale and George C. Baldwin. The act of opening the box became a familiar and domestic incident, a feminine mistake rather than the transgression of a dangerous dark lady.

Viewers who saw the sculpture in Ives' studio or at one of its public exhibitions responded to both the suggestion of female power and its successful containment. "[Pandora] possesses that delicate and sympathetic expression which at once lays violent hold on the fancy," wrote one critic. "The *anima* is so charming that it fairly captivates the imagination, and one gazes on under the kind of spell with which we repeat the cadence of some old song with a soft harmonious rhythm." The language of violence, captivity, and magic suggests the viewer's recognition of Pandora's potential power. It was with just such a soft old song that Isabel, Melville's dark lady in *Pierre*, captivated the hapless hero of the novel. Dark lady and fair lady struggle for dominance in this viewer's description of Pandora as "delicate, refined . . . a type of ideal womanhood," but at the same time as "coy," "inviting," and "enticing." Ultimately, however, the writer found the "fatal box" to be no more than a plaything the female subject fondled "coquettishly," and the potentially powerful subject was brought under control with the adjectives "prettiest," "most *etrannait*," and "domestic."[58] Similarly, another observer referred to the female figure as Ives' "dream," and called her pose "bewitching." Her "mingled expression of reflection, curiosity, and beauty," according to this viewer, "awakens one to love." As if such comments evoked too dangerous a female figure, the writer concluded lightly, "We all know that curiosity overcomes her at last, for she was a woman."[59]

By stressing Pandora's curiosity, an attribute superimposed on the story from the myth of Psyche, nineteenth-century observers were able to bring under control a potentially threatening dark lady and to transform her into the submissive, domestic fair lady. Condescendingly declaring curiosity to be a typically feminine trait, observers made the "all-gifted" woman little more than an overgrown child. Nathaniel Hawthorne seized upon the themes of innocence and curiosity when he included the Pandora myth in his retelling of classical legends for children, *The Wonder Book* (1852). In "The Paradise of Children," he depicted Pandora as a pettish and curious little girl and Epimetheus as her playfellow. Similarly, Ives portrayed his *Pandora* as childish rather than seductive.

Like Powers' sculptures and the images of the captive and dying women, Ives' *Pandora* moved viewers through its suggestion that women were both powerful and powerless. American artists and audiences alike strove to contain the threatening suggestion that woman's nature might

after all be fluid, seductive, and threatening rather than spiritual and acquiescent. So strongly did they wish to mute the dangerous implications of woman's other face that they managed to read archetypal stories of seduction and sin as dramas of persecuted innocence and domestic tragedy. If, like the narrator of Poe's "Ligeia," they sensed the stirrings of the dark lady's indomitable spirit beneath the graveclothes in which the fair lady was wrapped, these artists and viewers hastened to tighten the bonds and to affirm their belief in woman's harmlessness.

8

DOMESTICATING THE DEMONIC
Medea

Popular writer Grace Greenwood articulated the horror many mid-century American men and women felt about the possibility that women might display a dark and passionate, even demonic nature. In a collection of sentimental sketches and letters, *Greenwood Leaves* (1854), she wrote of her discomfort after reading a sensational novel by Sir Edward Bulwer Lytton, *Lucretia*. The heroine of the novel, named after the Renaissance duchess whose name seemed a byword for feminine evil, murdered her own husband and son, yet she turned a fair and feminine face to the world. Greenwood was not alone in feeling that Lytton had gone too far in his portrayal of depraved cruelty; in a preface to a revised edition that appeared in 1853, the author acknowledged that "hostile criticism" had greeted his portrayal of crime and passion, and he accordingly altered the ending, "diminishing the gloom of the catastrophe" it portrayed.[1] When Greenwood read the book in its original form, she wrote that it "haunted [me] like a shape of horror, vague and indescribable. . . . Would to Heaven that all such works could be kept from the hand of childhood!" But it was not the mechanics of the plot that so distressed Greenwood, the dark betrayals, executions, and poisonings. The fictional Lucretia, who openly expressed the wish that she had been born a man, seemed to Greenwood intolerably unfeminine. "It is difficult for me to credit the author's assertion—to believe that her prototype ever had existence," wrote Greenwood with a bristling forest of punctuation.

"The Caesar Borgia of womanhood! how inexpressibly fearful and detestable . . . Oh heaven! can such beings darken thy sunlight, and *dare* to assume the forms of those who wept around the cross, and watched beside the sepulchre!"[2] Whatever deplorable acts the fictional Lucretia might have committed, the ultimate horror for Greenwood was the challenge such a figure posed to conventional ways of reading female character. Power and violence might lurk beneath a beautiful surface; phallic woman might assume the forms of pious womanhood. Only a few years later, English poets and painters celebrated this mysterious masquerade. Algernon Swinburne provocatively declared that the heroine's namesake, Lucretia Borgia, was greater than Jesus Christ, and his friend Dante Gabriel Rossetti painted an alluring portrait of her as a femme fatale.[3] But the subject of the demonic woman, powerful and outside the boundaries of genteel culture, was one that Greenwood, despite her attraction to melancholy and romantic narratives, could not bear to contemplate.

Like Grace Greenwood, American ideal sculptors after the mid–nineteenth century were faced with the problem of reconciling their attraction to dramatic narratives of female identity with their reluctance to consider openly the darker aspects of human, and especially female, nature. The 1860s and 1870s saw a number of American treatments of the subject of women of beauty and demonic power: Cleopatra, Salome, Delilah, Judith, Clytemnestra, Cassandra. But the sculptors hedged their contemplation of female power with anxious qualifications, and so did their audiences. American ideal sculpture presented images of powerful women to titillate, to arouse anxiety, but ultimately to resolve viewers' fears by finding ways to affirm that even these potent women were, in a deeper sense, powerless.

·

The American sculptor who most consistently explored the theme of woman's demonic power was William Wetmore Story. Story came to sculpture from a background very different from most of his American contemporaries. The son of Joseph Story, an eminent lawyer, professor, and judge, he practiced law successfully for six years before acting on a long-standing interest and devoting his time to the practice of art. Significantly, it was the death of his father that opened the path to an artistic career for Story. Approached by a committee that had raised money to erect a monument to the elder Story in Mount Auburn Cemetery, William Wetmore Story agreed to design the monument himself after spending some time in Europe studying sculpture. The commis-

sion probably propelled Story on a path that he had been contemplating for some time, although his professional colleagues and even his mother considered his move from law to art a foolish choice.[4] After the death of his powerful father, Story appears to have been more willing to face the disapproval of his practical Boston friends and relatives and, in the guise of paying tribute to his father, to take a course of action he could not have chosen during his father's lifetime.

Unlike such artists as Powers, Palmer, and Brackett, who had only minimal schooling and who arrived at their historical and literary subjects largely by way of popular culture, Story had a privileged education and direct contact with contemporary literary figures. As a young man, he studied literature and classics at Harvard, and he wrote and published poetry, essays, and fiction throughout his life. He participated in Boston and Cambridge intellectual circles that included Ralph Waldo Emerson and Margaret Fuller, as well as his lifelong friend and competitor—poet, editor, and Harvard professor James Russell Lowell.[5] Like Horatio Greenough, Story had been deeply influenced by Washington Allston, the respected painter who exemplified a literary approach to the visual arts in his subjects as well as his career itself.[6]

During the late 1850s, Story lived in Italy, where he was for several years a close friend of Robert Browning. Both the Storys and the Brownings spent summers in Siena and winters in Rome, and the two men worked and socialized together. As Story recollected, they had "sat on our terrace night after night till midnight talking," traversing "the higher ranges of art and philosophy."[7] During these years, Browning was still developing his mature poetic voice, and Story was groping toward the emphasis on classical and literary themes in his sculpture that would bring him success and recognition in the 1860s. Both men crossed the boundaries between different arts: both wrote poetry and drama, and Browning frequently worked side-by-side with Story, modeling in Story's studio.[8] Although Browning's modern reputation has endured and Story's has not, during the period of their friendship they met as peers, both stimulated by the art and history of Italy, both searching for ways to express this fascination.

Story's literary works define the intellectual matrix from which his sculpture sprang. In 1868, he published *Graffiti D'Italia*, a volume of poems influenced in subject, as well as in style, by his friendship with Browning. In his dramatic monologues depicting historical and fictional characters drawn from classical, medieval, and Renaissance periods he returned again and again to two important themes: the making of art and the nature of women.

Story's poem, "A Contemporary Criticism," portrayed the painter Raphael articulating his creative principles in response to a critic who accused him of imitating the art of the past. Like Browning, and like the Pre-Raphaelite brotherhood of artists who were trying to define their own stance toward tradition, Story addressed a crucial Victorian problem: how to create art in an age that was acutely conscious of its own belatedness in relationship to the great art of the past.[9] "Who follows after, cannot go before," declared the speaker of Story's poem, voicing a criticism that haunted all artists who turned to the past for their inspiration. By contrast, Raphael insisted that the great artist could and must build on tradition.

> From all great men and minds I freely learn,
>
> Thank them for help, and taking what I find,
> Stamp on their forms the pressure of my mind.
> Well! who that ever lived did not the same?[10]

In Raphael's defense of his practices, Story also justified his own artistic fascination with the past as subject and as exemplar.

In another poem in the same collection, "Praxiteles and Phryne," which he dedicated to Browning, Story specifically explored the tradition of sculpture to which he could lay claim. The poem revolves around the contrast between the remote, aloof beauty of the works for which the Greek sculptor Praxiteles was known and the warm-blooded reality of his model, the renowned courtesan Phryne.[11] Like Keats, who had observed in "Ode on a Grecian Urn" that art had the power to preserve the fleeting moment, Story's speaker declared that the work of art represents beauty "saved from chance and change," that art can "grant what love denies, / And fix the fugitive." But at the same time he celebrated art's power to transform life, Story's Praxiteles found it melancholy to contemplate the marble woman's unchanging beauty:

> Sad thought! nor age nor death shall fade
> The youth of this cold bust;
> When this quick brain and hand that made,
> And thou and I art dust!

The sculpture on which Story depicted Praxiteles at work may have been his *Venus of Knidos*, one of Powers' sources for *The Greek Slave*. In this poem, Story suggests the uses to which he and other sculptors of his generation had put the tradition of classical sculpture. By its ability to transform hot-blooded humanity into cool and approachable marble, the

classical tradition gave nineteenth-century artists and viewers a way to explore—but at the same time contain—their fascination with its alluring and sometimes disturbing subjects. Yet Story saw in this tradition a forbiddingly chilly perfection: "Perennial youth, perennial grace, / And sealed serenity."[12] Heretically, he suggested that the sculptor might prefer the living, passionate woman to the marble idealization she inspired.

Other poems in the same collection indicated that Story was drawn to subjects more complex, more conflicted, and more passionate than the cool perfection of female beauty. "Ginevra da Siena," a monologue set in medieval Italy, was called by Henry James "the most important of that group of poems as to which it was inevitable that Story should incur the charge of trying to fit his tread to the deep footprints of Browning."[13] Like Browning's Pompilia in *The Ring and the Book*, and like the dead wife in "My Last Duchess," Ginevra is a young woman married to a brutal and neglectful husband. The poem tells the story of her passionate but chaste love for a handsome kinsman, and her husband's bloody vengeance. Like Browning, Story exonerates the woman who loved too well, but "Ginevra da Siena" lacks the rich layering of *The Ring and the Book*. Told from only one point of view, that of the imprisoned, ultimately repentant wife, Story's poem softens his portrayal of the passionate woman by turning her into an acquiescent captive.[14]

Story's ability to imagine the darker, more violent and passionate aspects of human nature appealed to Henry James when he read Story's journals. James observed that Story sought in Europe the "old associations, the splendor and crimes of the past." There was, he wrote, a "special turn of Story's artistic imagination which was to make him, as sculptor and poet, . . . strike with predilection the note of passion let loose. It was in their dangerous phases that the passions most appealed to him."[15] Yet, the note of passion in Story's works is always muted compared to the bolder voice of Browning. He never ventured into such deep water as his artistic contemporaries, French sculptor James Pradier, who produced a series of sensuous female nudes for the Salons of the late 1840s and who was at the peak of his popularity when Story visited Paris in 1850, or Dante Gabriel Rossetti, whom he met through Browning and who represented women as compelling seductresses in painting and poetry.[16] Story evoked images of dangerous female passions only to affirm that they could be contained and controlled.

•

Just such an exploration of female power earned Story his first success and established his artistic reputation. After a discouraging lack of recog-

nition in the late 1850s and early 1860s, Story was considering abandoning his career in sculpture when he sent *Cleopatra* (1860) and *The Libyan Sibyl* (1861) to a major international exhibition in England in 1862. He had been rejected by the American committee selecting works for display at the exhibition, but fortunately for Story, the Pope, Pius IX, offered to include his works in the exhibit of modern Italian sculpture. Like Hiram Powers eleven years earlier, Story found that favorable publicity in England increased his stature in America. As Henry James commented, "the year 1862 was a date, *the* date in Story's life; bringing with it the influence, the sense of possibilities of success, the prospect of a full and free development, under which he settled—practically for the rest of his days —and which was to encounter in the time to come no serious check."[17] Although *The Lybian Sibyl* was greatly admired, *Cleopatra* was the most famous of Story's sculptures (fig. 85).[18] At least four copies were carved of the original model and its 1864 revision, and he created a second, reclining version twenty-five years later.[19] Exploring the theme of female power within a context of history and literature, *Cleopatra* provided the leading note for Story's subsequent career.

The popularity of Shakespeare's *Antony and Cleopatra*, as well as the rage for fictionalized history, had made Cleopatra a familiar figure to most nineteenth-century audiences. In the figure of the Egyptian queen nineteenth-century commentators saw pomp and splendor, oriental mystery, and seductive sensuality. In 1852 the popular *Graham's Magazine* printed a highly wrought essay that described Cleopatra as a sensual dark lady: "Her hair, the uncurled raven hair of Ethiopia, fell to her feet in strange profusion. . . . Her form, her limbs, her swan-like neck, her swelling bust, the rounded outlines, the wavy motion, were of a loveliness which, while they baffled every attempt at description, explained at once and justified the passionate adoration of Julius, the frantic devotion of the wild triumver."[20] In *Celebrated Female Sovereigns* (1831), Anna Jameson declared that Cleopatra's "life and fate present something so wildly magnificent to the fancy, that we dare not try her by the usual rules of conduct, nor use her name to point a common-place moral, but must needs leave her as we find her, a dazzling piece of witchcraft, with which sober reasoning has nothing to do."[21] Readers and viewers must suspend their moral judgment, Jameson implied, for the very telling of Cleopatra's story would captivate them as surely as the queen herself conquered Caesar and Mark Antony.

Yet nineteenth-century depictions of Cleopatra did not banish moral considerations altogether, for many of them came to focus, not on her triumphs or her splendors, but on her suicide. In the queen's death,

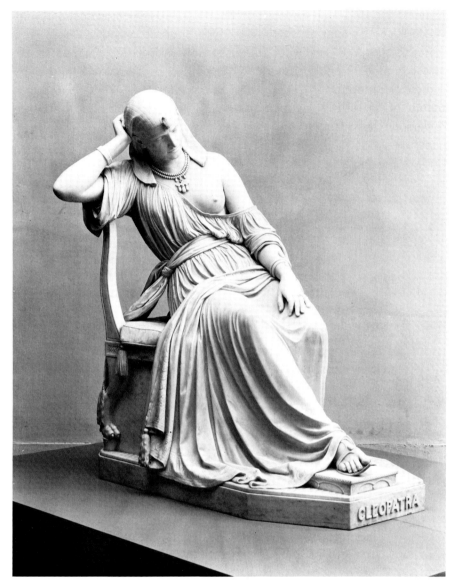

FIGURE 85. William Wetmore Story, *Cleopatra*

nineteenth-century audiences could see retribution for her sensuality, as well as an opportunity to bring the dark lady under control by converting her into a victim. "Her death commends her more than all her life," exclaimed a character in a verse fragment by American poet William Gilmore Simms.[22] The account in *Graham's Magazine* also depicted Cleopatra's death as her finest hour, contrasting her regal self-possession with the terrified "remorse, pain, or terror" of her serving women. "Her

hands were folded in her lap, the fingers unconsciously playing with a chain of mingled strands of golden thread and dark, auburn hair. Her face was very pale, and cold, and almost stern in its passionless rigidity. . . . All was composed, silent, self-restrained grief."[23] Facing death, Cleopatra could be portrayed as an exemplar of the feminine qualities whose absence made her so disturbing a figure in the days of her triumph: passionless, self-restrained, controlled.

Taken one step further, the suicidal Cleopatra, by her surrender of life and power, ceased to be a dark lady at all. A painting by the seventeenth-century Italian painter Guido Reni, whose soulful depictions of spiritual struggles were much admired in the nineteenth century, portrays Cleopatra not as a sensuous or powerful woman but as a sufferer (fig. 86). She gazes up to heaven as she holds the asp delicately to her bare breast. The tipped-back head and round face, the soulful eyes and the rosebud mouth of the dying queen, identify her as a powerless victim. The painting, part of the well-documented British Royal Collection, was engraved in the London *Art-Journal* in 1861. Even earlier, a crude copy of the painting (fig. 87) had found its way to America, where it was offered as a prize by the Cosmopolitan Art Association and engraved in their journal in December 1858. Although this Cleopatra is incongruously decked with ruffled dress and crown, the two elements that survive from Guido's painting are the soulful expression and the bared breast, both of which indicate a benign and spiritual interpretation of Cleopatra's nature. Like the famous *Beatrice Cenci* attributed at the time to Guido Reni, admired by Hawthorne and Harriet Hosmer and engraved in the same issue of the *Art-Journal*, this painting suggested a conclusion opposite to that suggested by Poe's "Ligeia"—that the victimized fair lady will ultimately possess and replace the passionate dark lady.

Story's earlier female figures had portrayed sweet, vulnerable, literary subjects, fair ladies such as *Little Red Riding Hood* (ca. 1853), *Hero Searching for Leander* (1857–58), drawn from Byron's *The Bride of Abydos*, and *Marguerite* (1858), from Goethe's *Faust*.[24] Visiting Story's studio in 1858, Hawthorne called *Marguerite* "a very type of virginity and simplicity," and commented that *Cleopatra*, on which the artist had been working for only two weeks, was "as wide a step from the little maidenly Margaret as any artist could take; it is a grand subject, and he appears to be conceiving it with depth and power, and working it out with adequate skill."[25] With *Cleopatra*, Story infused the theme of female victimization with the haunting suggestion of female passion tamed.

Story portrayed *Cleopatra* sunk in reverie, sitting in a chair with her feet outstretched and her arm resting on the chair's back, her body turned

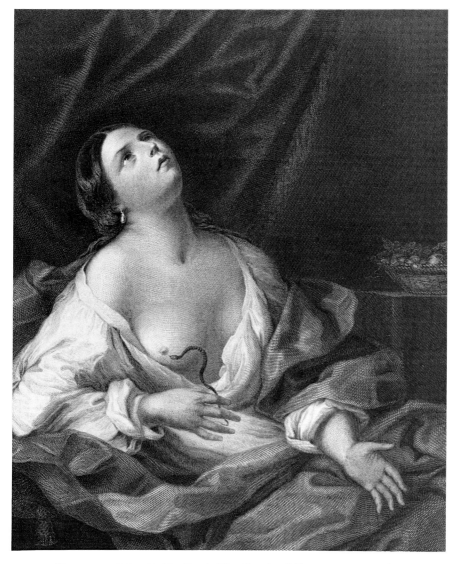

FIGURE 86. Guido Reni, *The Death of Cleopatra*, engraving

slightly to the side, her head leaning on her hand. As in Guido's painting, the bare breast suggests vulnerability, directing the viewer's thoughts to the suicide to come. However, the firm breast and the smooth curve of the exposed shoulder also served as a reminder of Cleopatra's famous beauty, offering a carefully controlled allusion to her sensual, erotic powers.

In choosing a brooding, seated pose for his statue, Story suggested both monumentality and constraint. Canova had used a seated figure in his monument to *The Mother of Napoleon* (1805) (fig. 88), which was en-

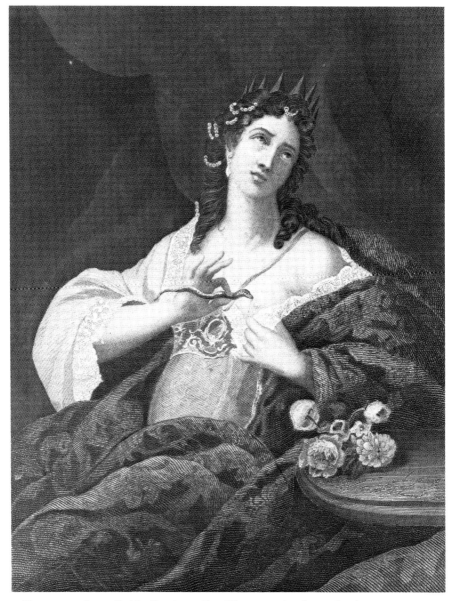

FIGURE 87. Guido Reni, attrib., *Cleopatra Applying the Asp*, engraving

graved in the London *Art-Journal* in 1852; its pose was said to be drawn from the *Agrippina* at the Capitol in Rome.[26] Story had chosen a seated posture for his portrait of his father, *Joseph Story Memorial* (1854–55), and had recently modeled a seated *Shakespeare* (ca. 1857). A few years earlier, Story's contemporary, James Pradier, had used the monumentality of the seated pose to explore the theme of the powerful woman

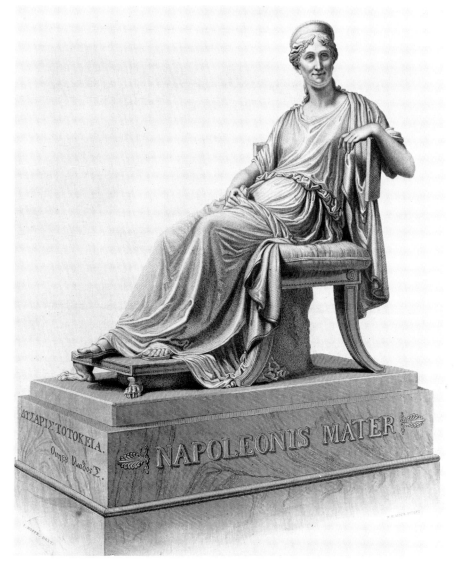

FIGURE 88. Antonio Canova, *The Mother of Napoleon*, engraving

rendered powerless. Pradier's *Sappho* (1852) depicted an accomplished woman who committed suicide (fig. 89). In this meditative posture, Pradier suggested both Sappho's intellectuality and the sense of defeat that led to her death. The statue itself made quite an impact during the 1850s: exhibited at the Salon of 1852, it was draped in crepe and displayed at the Palais Royal after Pradier's death in June of that year; bronze reductions in several sizes apparently sold briskly for several years afterward.[27] Giovanni Dupré, an Italian sculptor Story knew in Rome, used a similar

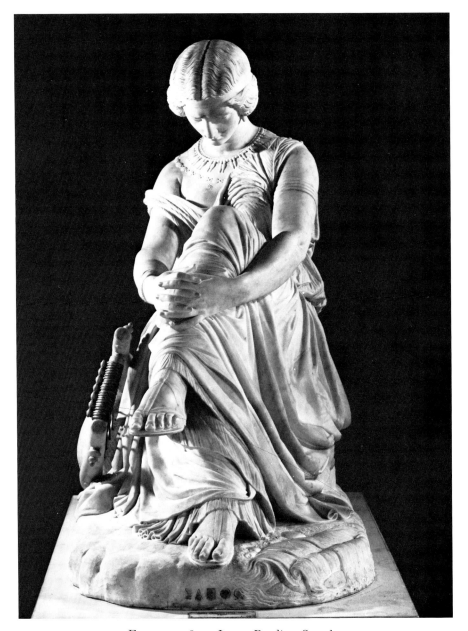

FIGURE 89. James Pradier, *Sappho*

pose for the same subject in *Saffo Dolente* (1857).[28] Thus, although Story did not include the asp or any overt suggestion of Cleopatra's suicide, the seated, melancholy pose clearly suggested both reverie and impending death.

Nineteenth-century viewers of Story's *Cleopatra*, of course, expected

to interpret the sculpture in terms of the history and literature with which they were familiar and responded by constructing a variety of sentimental narratives.[29] Like the captive maiden, the meditative queen was in transition between two states of being. This spectacle of liminality offered viewers an opportunity to reflect on the themes of change and human history by elaborating upon Cleopatra's past, present, and future. Reporting on a visit to Story's studio in a travel book of 1861, Edward Everett Hale declared that *Cleopatra* had convinced him that modern sculpture could speak directly "to our conception of history, to our conception of character," and he proceeded to discuss Cleopatra's feelings, her place in history, and the story the statue told. "Cleopatra has thrown her last die; and she has lost the game. The game was the world. She knows she has lost it. And she sits there,—majestic as Cleopatra still, and beautiful as Cleopatra still,—looking back into her past, and forward upon the future which is so short for her, as only Cleopatra can."[30] For Hale, who often wrote flippantly about the art he saw, the tale it told, rather than the visual pleasure it offered, was the chief attraction of Story's sculpture.[31] And that tale was one of female power rendered powerless by historical change.

The most famous narrative account of Story's *Cleopatra* was the one which contributed largely to its success, Nathaniel Hawthorne's description of the statue in *The Marble Faun* (1860). The novel was well known in England by the time Story's sculpture was exhibited there in 1862, and the sculptor reported that, even earlier, visitors to his studio were bringing Hawthorne's book with them to read aloud while viewing the statue.[32] Hawthorne embedded his description of *Cleopatra* in a book that bore directly on the question of woman's nature. *The Marble Faun* contrasted two women, the pure-minded and delicate Hilda, the "shy maiden" who "does not dwell in our moral atmosphere," and the beautiful, troubled Miriam, with a secret like a "dark-red carbuncle—red as blood." Hawthorne's sculptor, Kenyon, loves Hilda, but he shows his still-unfinished portrait of Cleopatra to the novel's dark lady, Miriam, who realizes at once that it represents a meditation on the possibilities of female sensuality and power. "What I most marvel at," says Miriam when she views the statue, "is the womanhood that you have so thoroughly mixed up with all those seemingly discordant elements. Where did you get that secret? You never found it in your gentle Hilda. Yet I recognize its truth."[33] The plot of the novel valorizes the fair lady, but it presents a sympathetic portrayal of the dark lady, who cannot escape the taint of history and of crime, and who is in the end transformed into a wandering penitent.

Similarly, Hawthorne found in Story's *Cleopatra* an intriguing image of passion tamed and power neutralized. Hawthorne's description of the sculpture seized upon its contradictory suggestions of power and powerlessness, energy and repose.

> The spectator felt that Cleopatra had sunk down out of the fever and turmoil of her life, and, for one instant—as it were, between two pulse-throbs—had relinquished all activity and was resting throughout every vein and muscle. It was the repose of despair, indeed; for Octavius had seen her, and remained insensible to her enchantments. But still there was a great, smouldering furnace, deep down in the woman's heart. The repose, no doubt, was as complete as if she were never to stir hand or foot again; and yet, such was the creature's latent energy and fierceness, she might spring upon you like a tigress, and stop the very breath that you were now drawing, midway in your throat. [34]

Hawthorne described Cleopatra in terms that implied power (queenly, enchantments, energy, fierceness, tigress) and passion (fever, turmoil, great, smouldering furnace), yet the moment Story captures is one in which she exercises neither. Her powers are held in abeyance, neutralized. She is in transition, "between two heart-throbs," suspended on the verge of two mighty transitions, from life to death, and from dark lady to romantic victim.

Story gave a graphic account of Cleopatra's smouldering passion in a poem he wrote and published in *Graffiti D'Italia* soon after finishing the sculpture. More openly sensuous than the sculpture, the poem, "Cleopatra," portrays the Egyptian queen, not in defeat, but at the height of her strength, reveling in fantasies of sensuality and power. She yearns for her lover, Mark Antony:

> Oh, cockatoo, shriek for Antony!
> Cry, "Come, my love, come home!"
> Shriek "Antony! Antony! Antony!"
> Till he hears you even in Rome.

Cleopatra tosses on her bed, alternatively calling for music and wishing "for a storm and thunder— / For lightning and wild fierce rain!" She dreams of the past and imagines herself as "a smooth and velvety tiger" drinking the blood of antelopes, toying with her "fierce mate." "How powerful he was and grand!" she exclaims. "And we met, as two clouds in heaven / When the thunders before them fly." The poem ends with her calling,

> Come to my arms, my hero,
> The shadows of twilight grow,
> And the tiger's ancient fierceness
> In my veins begins to flow. [35]

The animal imagery suggests both sexuality and energy. Yet Story's poem also implies that these qualities are out of keeping with human femininity, that the passionate woman is, like the tiger or the thunderstorm, a phenomenon of nature, powerful and dangerous.

In the subject of the meditative queen, the powerful woman rendered powerless, Story had found an image whose evocative power rivaled that of the captive maiden. Hinting at the sensuality for which Cleopatra was famous, a theme he could more fully explore in his poetry, Story's statue allowed viewers to contemplate the spectacle of woman's other face while still keeping her firmly within bounds. The melancholy Cleopatra is the dark lady tamed, constrained, neutralized. Story had found a fruitful theme, one he would pursue throughout his career.

•

After the success of *Cleopatra* and *The Libyan Sibyl*, Story embarked on a series of sculptures portraying women of power in a way that undermined or contained their potency. *Sappho* (1863) represented the renowned poet of antiquity as "a love-lorn lady, dreaming of *him*, whoever he was, . . . very tender, very sweet, very sentimental." [36] In *Judith* (1863) Story moved from the classical world to a biblical subject, the decapitation of the Assyrian general Holofernes by a young Jewish woman. The subject had received sensational treatment by such painters as Cristofano Allori and Guido Reni, copies of whose works Story had seen in the Boston Athenaeum, as well as the sculptor Donatello. [37] In a letter to a friend, Story described his determination to soften the murderous implications of Judith's deed by portraying the biblical heroine praying for strength to carry out her plan. "All other representations make Judith a criminal, an assassin, and it is only *before* the act that she is poetically and artistically grand." [38] The phallic woman at her most threatening, wielding a sword that mutilates her enemy, was thus converted by Story into another soulful, meditative fair lady, poised at the threshold of a momentous change. One reviewer praised the sculpture's "tenderness" and "true *feeling*," while another declared that *Judith* expressed "the consciousness of an untold sacrifice, the sense of a gulf between the present and the past." [39]

In the next few years, Story returned to the Bible to tame two more destroyers of men, *Dalilah* (ca. 1868) and *Salome* (1871). Unlike Judith,

whose bloody deed was done in the cause of the Hebrew people, both Delilah and Salome represent figures of evil in the Bible; even so, Story found a way to cloak these dark ladies in narratives of remorse and repentance. *Dalilah* stands with head slightly bowed, nude to the waist, with Samson's shorn hair at her feet and a purse dangling, limp as a severed phallus, from the hand that hangs at her side (fig. 90). But Story's contemporaries insisted that they saw in the sculpture not the triumph of evil but the workings of conscience. According to one reviewer, "the wanton girl, instead of gloating over the purse of gold in her hand, holds it in contempt and hate, with a look that seems to say, 'I would give that money and all the gold on earth, and this whole crew of savage Philistines, if I could only save that young hero from their clutches, and have him in my arms again.' "[40] Another reviewer wrote that Story "seized the moment when the siren is commencing to feel the Nemesis which has her in its grasp forever. Deep gloom is seated upon that brow, the heir of a deed of black treachery committed upon her sleeping husband, and there it will sit for all time. The sun in heaven has no brightness for her, and happiness has sighed, 'Farewell.' "[41] Like Delilah, the seated Salome, at rest after her deadly dance, was portrayed as a meditative figure, with a dreamy, faraway expression. Even in these forceful examples of woman's demonic power, Story suggested the dark lady's liminality, her capacity for remorse, and ultimately her kinship with the passionless fair lady.

•

Story's special talent for evoking, only to deny, the possibility of woman's demonic power can be seen clearly in a statue that resonated deeply with nineteenth-century anxieties about both women and the family, *Medea* (1866) (fig. 91). According to legend and the drama by Euripedes, Medea, the sorceress who had aided Jason in his quest for the Golden Fleece, left her home and country to follow him, but he later abandoned her in order to marry another woman. After engineering a horrible death for the fiancée, Medea avenged herself against Jason by killing her own children. Like the narrative that so distressed Grace Greenwood, the subject of Medea challenged nineteenth-century assumptions about woman's benign spirituality and the sanctity of the family.

Story explored the demonic potential of the subject in his poem, "Cassandra," published in *Graffiti D'Italia*. Through the agitated voice of the prophetic speaker, Cassandra, the poet emphasized the violence and depravity of the murders:

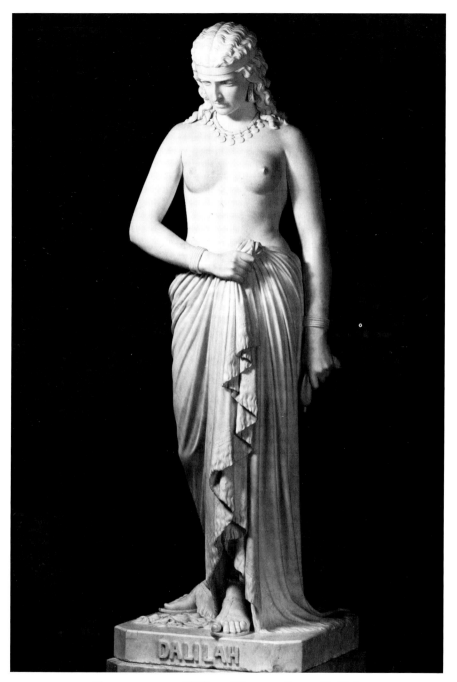

FIGURE 90. William Wetmore Story, *Dalilah*

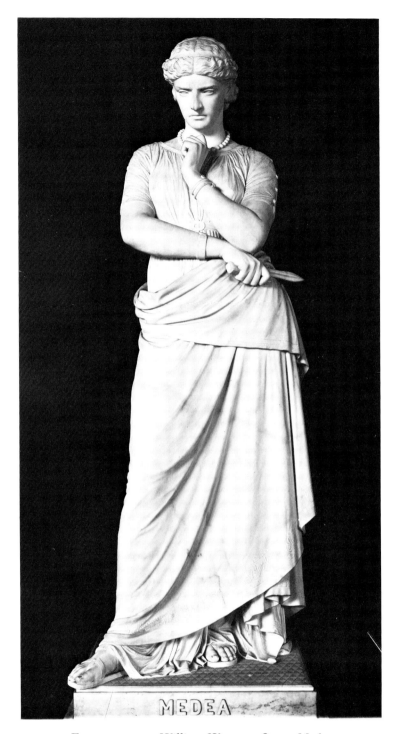

FIGURE 91. William Wetmore Story, *Medea*

> What does Medea there
> In that dim chamber? See on her dark face
> And serpent brow, rage, fury, love, despair!
>
> Her brow shut down, her mouth irresolute,
> Her thin hands twitching at her robes the while,
>
> Why that triumphant glance—that hideous smile—
> That poniard hidden in her mantle there,
> That through the dropping folds now darts its gleam?
> Oh Gods! oh, all ye Gods! hold back her hand.
> Spare them! oh, spare them! oh, Medea, spare!
> You will not, dare not! ah, that sharp shrill scream!
> Ah,—the red blood—'tis trickling down the floor!
> Help! help! oh, hide me! Let me see no more. [42]

With its almost Gothic imagery of dripping blood, dim chamber, twitching hands, and hidden poniard, this poem shows how disturbing was the theme of female passion and power, especially when combined with the suggestion of unnatural motherhood.

In his sculpture, Story characteristically chose to depict a meditative figure, poised on the brink of the awful deed the viewer knows she will commit. She is a towering, larger-than-life-size figure, wrapped in heavy drapery, standing with bowed head and fierce expression, holding a sharp dagger clenched in one fist. Like *Judith*, Medea has not yet struck the blow that will make her an assassin; like *Cleopatra* she lingers in a liminal state, on the verge of a momentous transformation. Although the work derives its tension from the spectator's knowledge of how the story ends, the worst has not yet happened, and the viewer escapes the necessity of confronting the demonic murderess Story was willing to present in his poem.

Numerous sources that were available to Story stressed the drama and passion of Medea's crime. He may have drawn his pose, and his emphasis on the moment before Medea strikes the fateful blow, from a fragmentary painting discovered at Herculaneum (fig. 92). The standing Medea in this painting, said to have been based on a Roman copy of Polyeuktos' *Demosthenes*, holds a sword that projects from her body like an erect phallus, stressing the unnatural potency of this powerful woman. [43] Among nineteenth-century artists, Eugène Delacroix had painted a *Medea* in 1838; he would return to the subject in 1859 and 1862. In his first, turbulent and fierce painting, the children writhe with fear as Medea clutches the knife, looking back toward her pursuers, her face ominously masked

FIGURE 92. *Medea*, copy. Original first century B.C.

in shadow (fig. 93). James Pradier's *Medea*, shown at the Salon of 1850, depicted the aftermath of the violence, the dagger dropping from her hands, her body bowed with spent passion (fig. 94).

But Story's immediate source for *Medea* was neither the classical play nor the artworks that had interpreted it so darkly. In *Medea*, Story paid homage to a popular Italian actress, Adelaide Ristori, whom he was reported to have followed "like her shadow" while he worked on the statue.[44] Story had seen Ristori perform in Paris in the mid-1850s, and wrote about her in *Roba di Roma*. "Her *Medea* is as affecting as it is terrible. . . . An infinite grief and longing possesses her. . . . the horror of the deed is obscured by the pathos of the acting and the exigencies of the circumstance."[45] Ristori's characterization of *Medea* was well known in America as well as Europe, for in 1866, when Story was completing work on his *Medea*, Ristori embarked on an American tour, performing *Medea* frequently during her 168 performances in thirty American cities. Although she performed in Italian, American audiences packed the theaters and reviewers raved about her "beauty, her talents, and her presence."[46] Engravings that accompanied reviews of her performance singled out, as Story did in his sculpture, the scene in which she drew her dagger as the most dramatic moment of the play (figs. 95, 96).

Ristori's interpretation of *Medea* was especially significant because the play itself was a nineteenth-century version of the story that differed drastically from the classical drama on which it was based. In the version Ristori performed, Ernest Legouvé's *Médée*, the demonic implications of the narrative were blunted to the point of unrecognizability. Rather than an unnatural monster, Legouvé's Medea is a devoted mother. She kills her children from an *excess* of maternal devotion, because they are going to be taken away from her to be raised by Jason and his new wife. Ristori reported in her autobiography that she had sternly refused to consider the part of *Medea* since "nature had developed the maternal instinct in me to a very large degree, and I instinctively revolted from the idea of a woman who, by her own hand, and with deliberate design, could murder her children. Even on the stage I would not portray such a monster." Only after meeting the playwright did she agree to read the script; then, as she reported it, she was overcome by tears as she realized that Medea emerged as a sympathetic figure, a "persecuted mother."[47]

In Ristori's scene-by-scene account of the play as she performed it, Medea's motherly instincts are paramount, from the first moment when the exhausted wanderers appear in a pose which, she explained, she based on the famous group of Niobe and her children in the Uffizi Gallery in Florence.

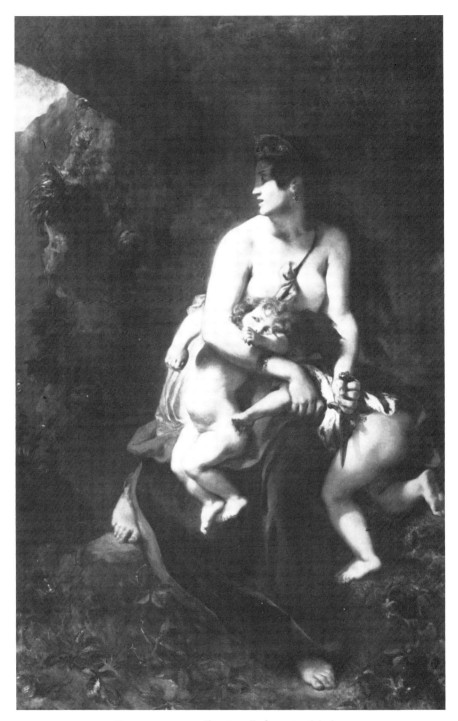

FIGURE 93. Eugène Delacroix, *Medea*

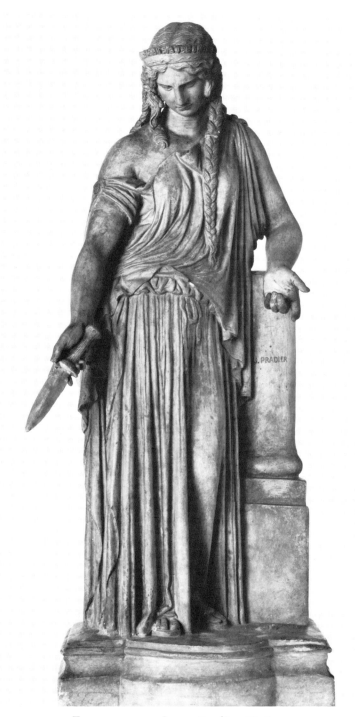

FIGURE 94. James Pradier, *Medea*

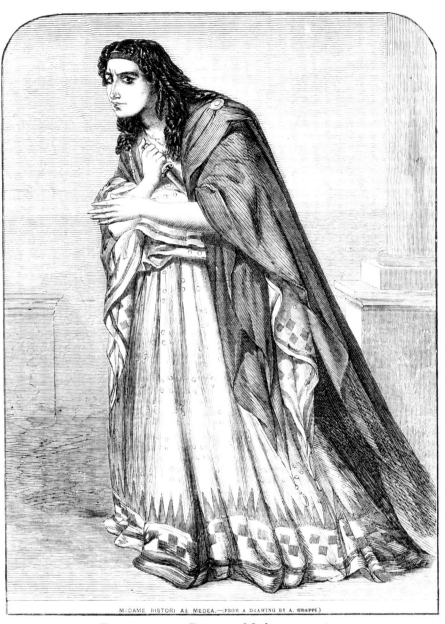

MADAME RISTORI AS MEDEA.—(FROM A DRAWING BY A. GRAPPI.)

FIGURE 95. Ristori as Medea, engraving

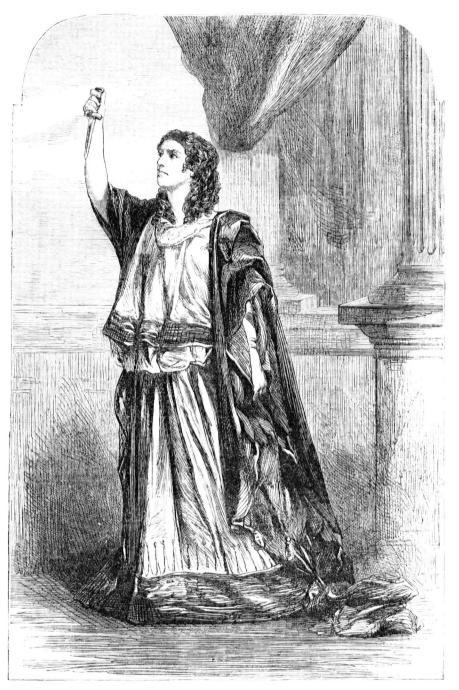

FIGURE 96. Ristori as Medea, engraving

Melanthe: Mother, I am weary.
Medea: Darling, you break my heart! no roof have we to shelter us.
 This bare rock must be your pillow today.
Lycaon: Mother, I am hungry. [. . .]
Medea: Why cannot I open my veins to their last drop and bid them
 partake, and from my blood draw the nourishment they need?

In the second act, Ristori reported, she created a tableau that "produced the greatest effect upon the audience," taking her children into her arms in "a transport of maternal affection." A photograph of this scene is one of the few documentary records of the performance and indicates how important was the establishment of Medea's maternal nature to Ristori's interpretation of the part (fig. 97).

Ristori's account of her performance also reveals that in the scene with the dagger she was threatening Jason's fiancée Creusa, not her children. A murderous woman is still a frightening figure, but the rage of a woman scorned against her rival was a more understandable and less unnatural emotion than a mother's premeditation of murder. Ristori's description shows that she was conscious of presenting Medea in this scene as a dangerous and powerful figure: "While I uttered these last words I drew myself up in such a manner as to appear of gigantic size, holding my dagger tightly clasped aloft, so that men might well have been thunderstruck at my aspect." However, Ristori asserted that Medea's "maternal love is stronger than her hate," and she presented the climactic murder as the result of her unbearable agony when Jason orders that her children must be taken from her. As the crowd closes in upon her, crying "Seize them! to death with her!" Medea shrieks "Never! you shall never have them!" and disappears behind the altar of Saturn. Ristori had felt strongly that the murder must take place out of sight of the audience, and the final scene of the play shows Jason receiving the report of his children's death. However, the last word, in this bravura performance, was reserved for Ristori. "Murdered?" exclaims Jason. "Who, who has murdered them?" As the curtain falls, Medea appears once more to answer firmly, "Thou!"[49] Ristori's performance went a long way toward exonerating Medea, turning her into a sympathetic character crazed by understandable grief.

American reviews of Ristori's performance stressed her successful ability to portray Medea's maternal side. "Did we require a knowledge of the language to know the story of Medea?" asked a writer in the *Boston Gazette*. "Was there not a sympathetic tone, a significant and graceful gesture, a change of expression to interpret the maternal joy and the maternal misery which agitates her when the loving mother yielded the con-

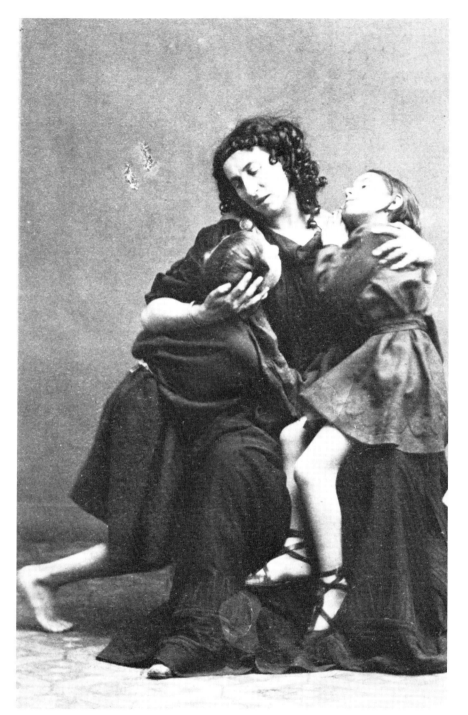

FIGURE 97. Ristori as Medea with children, photograph

test to the wronged wife?"[50] Theater critic William Winter commented, "In the tragedy of 'Medea' an irresistible appeal is made to sympathy with both passionate and maternal love. . . . To be wronged as a wife was a sufficiently miserable disaster. To be wronged as a mother is an overwhelming calamity." Winter went on to praise Ristori's interpretation of the part. "Not every actress can personate a mother."[51] Ristori, who was admired for her personal courage and her dedication to political liberty, was portrayed in admiring press accounts as a combination of fierce eloquence and maternal tenderness. "To such as know the tenderness of Ristori's heart it is amusing to be told by critics how the actress is best adapted by nature to the delineation of *roles* where 'the tiger element' predominates."[52]

The eagerness of Americans to read the story of Medea in the most favorable light, palpable in their response to Ristori's melodrama, was extended and exaggerated in a travesty of it. As the historian Lawrence Levine has observed, travesties of leading plays and operas represented a form of tribute, testifying to the works' popularity and cultural authority.[53] Americans registered their enthusiasm for the maternal Medea by staging not one but two burlesque versions of the play during Ristori's triumphant engagement in New York. In one case, as Ristori herself watched from a private box, a bust of the actress was unveiled at the final curtain to be sure that "the sting usually proposed in this class of piece was judiciously extracted."[54]

One of these plays, *Medea; or the Best of Mothers, with a Brute of a Husband, a Burlesque in One Act*, seized upon the very crux of Ristori's interpretation for its satire. At the beginning of the play, Medea is depicted as a stock shrew, as Jason sings to the tune of "The Girl I Left Behind Me,"

> A dame strong-minded I espoused
> Who round her thumb entwined me;
> One night in secret I "vamoused"
> And the old girl left behind me.

Meanwhile, Medea sings to the tune of "The Blue Bells of Scotland," "Oh where and oh where is these children's daddy gone?" However, the play's climax parallels the serious production in seeking a way to defuse the demonic implications of Medea's act. As a triumphant Medea stands, holding the dagger, over the bodies of her dead children, suddenly the knife turns to a jester's bauble, with cap and bells. The children come back to life, and the play ends happily as Medea exclaims,

Holloa! What's this? I thought it was a knife
With which I'd robbed my blessed babes of life!
Who's been employing magic and cajolery
To change my serious business to tom-foolery
Making a bauble of Medea's blade? [55]

In the burlesque as well as the serious play, and in the statue as well, Medea's blade was the symbol of the nineteenth-century audience's worst fears: the possibility of female power, destructive and unrestrained. Turning the knife into a jester's bauble, like satirizing or sentimentalizing this threatening figure, was a way of exorcising these fears.

By referring to the well-known figure of Ristori, whose portrayal of Medea suggested both female passion and moralistic sentimentalism, Story gestured to his audience's most deep-seated anxieties at the same time he allayed them. He suggested that Medea, the unnatural mother and destroyer of the family, exemplar of passion unrestrained, was a spiritual and maternal woman who had been driven to extreme action by tragic circumstances, as Ristori had portrayed her. In the narrative of the powerful woman, Story sought to read the same message that artists and audiences had found in the tale of the captive woman: the reassurance that female nature was stable, spiritual, and domestic, and that any deviation from this identity was forced upon women against their will.

Turning as he often did to literature in order to explicate art, Story appealed directly to the cultural authority of Shakespeare to argue for this benign view of woman's nature. In *Excursions in Art and Letters* (1891), he presented a sympathetic interpretation of another murderous female character, Lady Macbeth. Maintaining that Shakespeare's intentions had been distorted by actresses who portrayed her "without heart, tenderness, or remorse," Story insisted that, in the end, Lady Macbeth reasserted her feminine nature. Contrasting her to her husband, "the villain, who can never satiate himself with crimes," Story argued that she was never a criminal at heart. "She, having committed one crime, dies of remorse. She is essentially a woman—acts suddenly and violently, and then breaks down, and wastes her life and thoughts in bitter repentance." [56] In this essay, as in *Medea* and his other sculptures of passionate women, Story asserted that women could not be truly evil, that even the most sinister dark lady would ultimately break down and transform herself into the weeping, fainting, "feminine" woman.

Understanding Story's sympathetic interpretation of Medea's character, we may wish to look again at the statue's fierce, glowering expression. Although *Medea* is portrayed in an upright posture, her hand raised

thoughtfully to her chin suggests reverie or contemplation, not passionate action. Like the pensive Cleopatra, Medea could be seen as suspended in time, meditating on ultimate things. The scowl on her face might reflect consciousness and sorrow rather than anger and revenge.

Such an interpretation of Story's sculpture is reinforced by an engraving that appeared in the London *Art-Journal* in 1866, the same year Story was completing work on *Medea*. *Murder of the Innocents*, a painting by Belgian artist Nicaise de Keyser, showed a figure who could be readily recognized as the epitome of maternal devotion and mournful victimization (fig. 98). Sitting amid the ruins of shattered domesticity, clutching the body of her murdered infant, the nameless mother represents a version of the Pietà, a type of suffering womanhood. Yet, unlike the second woman in the background, who bends, weeping, over her baby, the central figure in de Keyser's painting sits, fist to her chin, looking off to the distance with a fierce scowl on her face. Clearly, in this painting the meditative pose and glowering expression suggest extreme grief. The accompanying text praises the "grandeur" of the painter's conception, which "elevates it to a point of sublimity."[57] Similarly, Story's use of a glowering expression does not necessarily signify evil but may suggest his sympathy with the plight of the desperate mother.

•

Nineteenth-century audiences responded positively to this sculpture that simultaneously provoked anxiety and offered reassurance about the nature of female identity. By the time Story began work on *Medea*, the fame he had earned in London had made his studio in Rome an important tourist attraction, and his new statues were received with great interest. The first version of *Medea*, completed in 1866, was sold to an Englishman, and two replicas were soon ordered by American patrons.[58] American journals such as *Harper's New Monthly Magazine* reported regularly on the arts in the 1860s, and for more than a decade these articles informed American readers about Story's works and praised his talents. In 1866 *Harper's* reported that "we saw in *Medea* a grander statue than those apt fingers had previously created," and thirteen years later the same journal reported that "no American in the art world now occupies a more prominent position or shows greater versatility" than Story.[59] *Medea* was first exhibited publicly in the United States in 1874, and it was seen by a very large audience when it was shown at the Philadelphia Centennial Exposition, where it received a medal for "artistic excellence."[60]

As James had observed, nineteenth-century audiences evaluated Story's sculpture largely in terms of its narrative content, and many view-

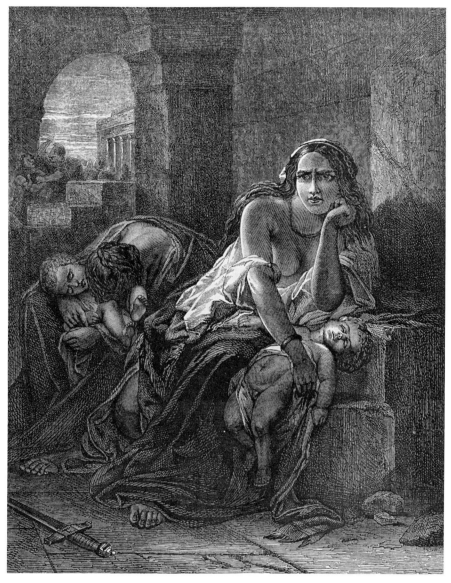

FIGURE 98. Nicaise de Keyser, *Murder of the Innocents*, engraving

ers of *Medea* commented on the *fact* of its literariness. "Of his sculpture it may be said that it indicates the work of a rich and highly cultivated mind," wrote one observer.[61] Art critic Earl Shinn, writing in a guide-book to the Philadelphia Centennial, criticized Story's "bookish culture," commenting, "we feel that he has approached his conception through literature." Shinn, who commented that Story's *Medea* seemed to him "somewhat *Americanized* . . . in type and visage" nonetheless thought

that the statue was most effective when it was seen, not as the murderous queen herself, but as "a tragedian on the stage . . . who stood before the Greeks in many a theatre."[62] In this comment, Shinn gestured to the rumors that the statue had been inspired by Ristori, but he also suggested a way in which American audiences could approach the glowering figure whose emotions they feared to contemplate. Viewers could distance themselves from the violent implications of her tale by reminding themselves that even in its original, more austere version, it was only a fiction.

At the Centennial Exhibition, Story's *Medea* took its place among artworks evoking the full range of interpretations of woman's nature that nineteenth-century viewers were willing to contemplate. Acquiescent captives were portrayed by English sculptor John Mott, whose nude *Andromache* perched on a rock with her hands chained behind her, and by French sculptor Jules Cambos, who contributed a bronze sculpture of a biblical subject, *The Erring Wife* (fig. 99). In the latter work, the woman whom Jesus saved from death by stoning raises her bound wrists above her head in penitent prayer, while an inscription engraved on the base spells out the moral: "Let he who is without sin among you cast the first stone."[63] On the other hand, sensual female figures by several European artists offered glimpses of woman's other face, that of the seductive dark lady. A bronze version of James Pradier's *Phryne* tempted the viewer's eye, as did the reclining nude figure of *The Bather*, painted by A. Perrault (fig. 100). Quite a few artists chose the complex and disquieting subject of Cleopatra, including American sculptors Margaret Foley and James Henry Haseltine. The American sculptor Edmonia Lewis and the English painter V. C. Prinsep (fig. 101) both portrayed the death of Cleopatra, stressing, as Story had done earlier, the moment of the Egyptian queen's transition from power to powerlessness. But two other depictions of Cleopatra displayed at the Centennial Exhibition presented a view of woman's nature that contrasted dramatically with Story's. A sculpture by Enrico Braga showed the seductive queen stepping out of the rug in which she had been smuggled into Caesar's presence, proud, domineering, sexually provocative (fig. 102). In the Annex, a moving wax sculpture like the ones Hiram Powers used to make showed Cleopatra in her barge in "extreme dishabille," attended by a slave, a Cupid, and a parrot; the statue of the queen "rolls her head alluringly from side to side and faintly lifts her right arm and lets it drop again." In a mixture of mock horror and real discomfort, the influential writer William Dean Howells wrote in the *Atlantic Monthly* that such an image would "bring tears to the eyes of the legislative gentleman who lately proposed to abolish the study

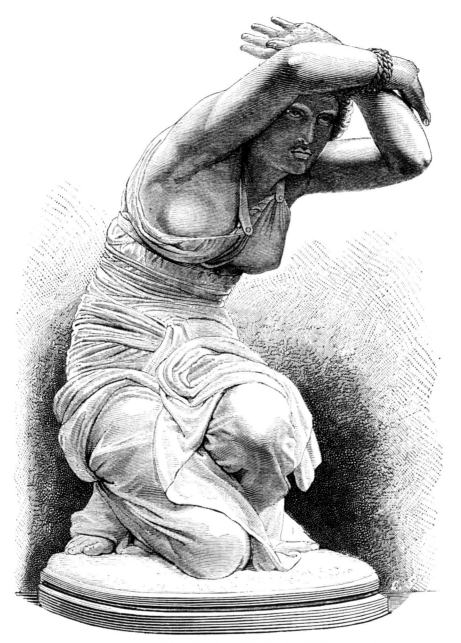

FIGURE 99. Jules Cambos, *The Erring Wife*, engraving

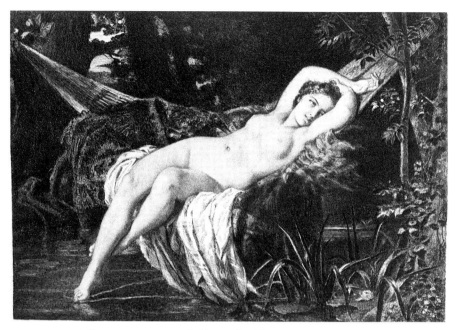

FIGURE 100. A. Perrault, *The Bather*, engraving

of the nude in our State drawing-schools."[64] By contrast, Story's *Cleo-patra* and even his *Medea* indeed seemed, as one critic wrote, "classically severe."[65]

One of the most admired artworks in Memorial Hall provides a telling comparison to Story's *Medea*; its popularity sheds further light on the way *Medea* was read by nineteenth-century audiences concerned about woman's nature and the future of the family. The monumental *Rizpah Protecting the Bodies of Her Sons*, by French painter George Becker, stretched from floor to ceiling in its Memorial Hall gallery (fig. 103). Art critic Earl Shinn called it "probably the most impressive picture in the Exhibition."[66] The painting illustrated a scene from the Book of Kings, in which the seven sons of King Saul have been sacrificed to ward off a famine; the mother of some of the sons, Rizpah, guards over their bodies, protecting them from desecration by enormous birds of prey. The painting shows the mother fiercely confronting such a bird, raising one arm above her head and wielding a club with the other. The painting had been exhibited at the Salon of 1875, where the reviewer for the *Gazette des Beaux-Arts* had found it powerful but exaggerated, Brobding-nagian.[67] Nonetheless, Earl Shinn and other American reviewers found it "Michael-Angelesque"; Shinn praised it for "the idea alone, the terrible

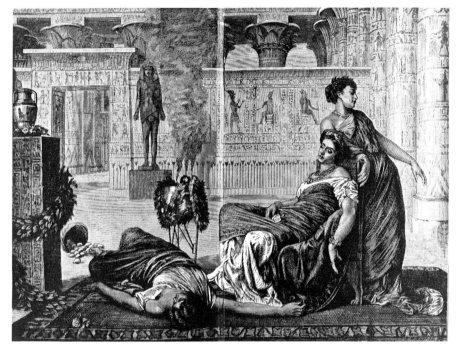

FIGURE 101. V. C. Prinsep, *The Death of Cleopatra*, engraving

ordeal of constancy and maternity." These viewers saw in the painting
an example of "maternal devotion," a heroic portrayal of "fierceness and
energy" expended in the protection of the family.[68] The phallic gesture,
the fierce expression, even the violence, in this painting were read by its
audience as an affirmation of maternity in the face of the most dire catas-
trophe a mother could face. From the scowling and powerful Rizpah to
the glowering Medea was a shorter step than twentieth-century viewers
might imagine.

In the context of the various portrayals of women at the Centennial Ex-
hibition, Story's *Medea* seems to reinforce Grace Greenwood's refusal to
contemplate the image of a powerful, threatening woman. Story alluded
to female demonism only to domesticate it. A fierce mother finally sup-
ported, rather than subverted, the integrity of the family. Art critic Earl
Shinn offered viewers an opportunity to interpret the statue in a benign
light, suggesting that Medea never killed her children at all. "The mur-
der of Mermerus and Pheres, the children of Jason by Medea, is said
by a Roman writer to have been really committed by the Corinthians.
Finding that Corinth suffered in consequence, in reputation and by the
scourge of pestilence, the inhabitants of that city engaged Euripedes, for
five talents, to write a tragedy which should clear them of the murder,

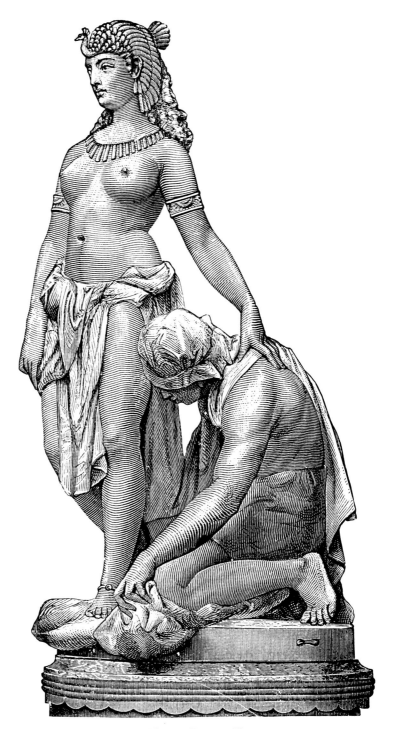

FIGURE 102. Enrico Braga, *Cleopatra*, engraving

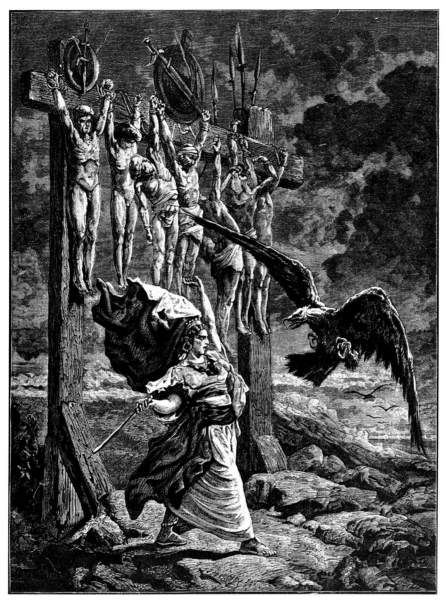

FIGURE 103. George Becker, *Rizpah Protecting the Bodies of Her Sons*, engraving

and represent Medea as the assassin of her own children."[69] To further contain the unsettling implications of the sculpture's subject, viewers at the Centennial Exhibition devised their own form of audience response. Vandals attacked the dagger, symbol of Medea's murderous—and specifically phallic—power, defacing the sculpture by breaking it off.[70]

In *Medea*, Story offered a glimpse of woman's other face at its most demonic, but at the same time he offered viewers a way to contain and control its frightening implications. Like the unfallen Eve, his subject is suspended in time, poised on the brink of an action she has not yet taken. The fierce glower on Medea's brow could express her jealous rage, or it could represent the grief of a persecuted mother. The meditative pose linked this powerful woman with the powerless victims of the captivity narratives. Like Powers, Palmer, and Brackett, Story also dramatized the disruption of domesticity, with the added complication that the victimized mother was the agent of destruction.

In the end, Story's excursions into history and literature produced much drama but few challenges to cultural presumptions about woman's nature. Sharing the fervent desire of his audience to affirm domesticity and feminine vulnerability, Story found these qualities even in subjects that seemed dangerously deviant. In his sculptures, nineteenth-century Americans' competing interpretations of woman's nature are locked in an uneasy embrace.

Conclusion
Gender and Power

The taste for ideal sculpture was already beginning to wane when William Wetmore Story exhibited *Medea* at the Centennial Exhibition in Philadelphia in 1876, and in the next few years American sculpture moved toward the more elegant beaux-arts style exemplified by Augustus Saint-Gaudens. Although the next generation of artists continued to produce idealized images of women, like Saint-Gaudens' *Diana*, created in 1891 to decorate Madison Square Garden, and although interpretive questions about women's nature were sometimes raised, as in the controversy over Frederick MacMonnies' *Bacchante and Infant Faun* (1893), the intense scrutiny and elaborate fictionalization that characterized the response to ideal sculpture was replaced by a greater emphasis on the plastic and decorative values of sculpture.[1]

At the same time, questions about woman's nature and role in society moved to the foreground of public debate with the growth of the woman suffrage movement in the 1880s and 1890s.[2] The rise of a new woman, whose sophisticated style and understated allure were exemplified in the popular illustrations of Charles Dana Gibson, made the old stereotypes of vulnerable femininity seem outdated or at least sweetly nostalgic. Writers from William Dean Howells to Hamlin Garland to Theodore Dreiser contemplated the fate of women who moved to the city and adopted the "cosmopolitan standard of virtue."[3] Jane Addams struggled with the genteel assumptions of her middle-class upbringing and rejected the life of a cultured invalid to grapple with the problems of poverty and urban alienation. Charlotte Perkins Gilman envisioned alternative social and

economic arrangements that could transform women's lives, and women marched on picket lines, attended universities, and campaigned for social justice.

The cultural moment in which ideal sculpture flourished, then, represented a period of social and economic transition for women and for society at large. Moving from an older, relatively homogeneous, largely agrarian society to a diverse, industrial, urban culture, Americans focused many of their anxieties about social change on woman's changing role in society. Those who campaigned for change, like Jane Addams, Charlotte Perkins Gilman, or Margaret Sanger, shared with those who opposed change, or worried about its consequences, a sense that home and family were the battlegrounds for the struggle between old and new ways. A clergyman and sometime art critic, Samuel Osgood, warned in 1857 of "reformers who promise to bring on a new future of woman by making her the rival of man," and affirmed his belief in the centrality of domestic relationships for the proper functioning of society. "We men can have no true heart or home without a good woman's blessing. . . . Why may not she honestly return the sentiment, and say that a woman never finds her true sphere until, in some relation of life, and chief of all in her own home, a true man's wisdom and strength harmonize with her trusting affections and quick perception!"[4]

Ideal sculpture, with its self-conscious symbolism and insistence on narrative, provided a useful arena for the adumbration of widespread anxiety about woman's nature. Promoted by art benefactors from among the established gentry of the older, preindustrial society, produced both by members of the same class, like Hosmer and Story, and by artisans aspiring to middle-class status like Powers, Palmer, Brackett, and Ives, and purchased by patrons who wanted to establish their genteel respectability, works of ideal sculpture expressed the values of a social elite in a way that found popular acceptance as well. Overtly, the sculptures and the narratives they inspired affirmed a sentimental view of woman's vulnerability and fragility by their emphasis on captivity subjects, portrayals of woman under duress or in transition from one state to another, and their insistent softening of any suggestions of female potency.

However, as we have seen, the nexus of power and gender was an extremely complex one. While telling a story of female victimization, the sculptures suggested a subtext of female empowerment. Nudity represented powerlessness but also the dangerous lure of sensuality. Captives and corpses were praised for their acceptance of a terrible fate, but narratives vibrated with the fear that the acquiescent victim would transform herself, like the irrepressible Ligeia, into a powerful and terrifying Other.

A psychoanalytic critic might ask, as Freud did, "what do these women want?" only to find, as Melanie Klein did, images of rapacious and devouring females.[5] Nude and submissive victims suggest, by their very anatomy, the anxieties of the castration complex, which both Freud and Lacan tied directly to the *sight* of the female body.[6] The studied insistence that women of power, from Eve to Medea, were actually devoted mothers may indicate a deep ambivalence about woman's most womanly function. At a time when doctors were increasingly concerned about female hysterics—women who raged out of control for no visible reason—viewers of ideal sculpture insisted only too emphatically that the women at whom they gazed would remain firmly within bounds.[7]

Although works of ideal sculpture were usually displayed in a context that suggested high moral earnestness, or at least genteel propriety—an international exhibition, a sculptor's studio, an art gallery, or a private home—the narratives they generated reveal an intense anxiety about the fragility of the conventional world. Behind the sentimental stories of spiritual triumph lurk untold tales of rape and murder. The persistent vision of woman's transformability suggests a nightmarish world where good and evil, safe and dangerous, domestic and demonic, prove indistinguishable.[8]

The fascination with ideal sculpture flourished just at the time when the position of woman and the family was undergoing rapid change in American society. Uneasiness about sexuality and the female body accounts for some of the urgency and tension these artworks display; but men and women alike also registered their anxiety about the fragility of the family. Narratives of separation, of family disintegration, were superimposed on stories that purported to affirm family ties and loyalties, like the descriptions of *The White Captive* and *Shipwrecked Mother and Child*. Viewers who insisted that *The Greek Slave* and *Zenobia* both yearned for their lost families may have been registering their sense that the domestic idyll existed nowhere but in fantasy. Disrupted in fact by industrialization and urbanization, devalued by its isolation and marginality, the domestic sphere was beginning to seem like a dungeon instead of a garden by the mid–nineteenth century. If the "angel in the house" were buried alive in the family mansion, might she not, like Poe's Madeline Usher, exact a terrible revenge on those who professed to love and protect her?

Examined in the context of the narrative webs that sculptors, purchasers, and viewers spun around them, these marble women suggest the turmoil that lay beneath the surface of nineteenth-century American culture. Sensing instability in the social bedrock—the family, sexuality,

gender identity itself—American audiences found compelling drama in visual images that seemed to a later generation flat and vapid. By resurrecting these forgotten artworks and reconstructing their narrative context, we gain sharper insights into the dynamics of the cultural construction of gender in nineteenth-century America.

Notes

Works cited in the selected bibliography appear here in shortened form.

INTRODUCTION

1. An exploration of the assumptions shared by viewer and artist must inevitably draw on the work of E. H. Gombrich, particularly *Art and Illusion*. On the "social production of art," see Wolff, *Social Production of Art*; and Arnold Hauser, *The Sociology of Art*, trans. Kenneth J. Northcott (1974; Chicago: University of Chicago Press, 1982). An exemplary study that examines art and its reception in cultural context is T. J. Clark, *Painting of Modern Life*.

2. On the uses of gender in historical analysis, see Scott, "Gender."

3. The first serious study of these works, and still the most valuable compendium of sculpture and artists, is Gerdts, *American Neoclassic Sculpture*. Among the 93 full-length ideal sculptures reproduced by Gerdts, 54 depict female figures, 16 male figures, 8 children, 5 persons of indeterminate gender, and 10 depict a male and female figure together.

4. Gerdts uses the term *neoclassic* broadly, to include portrait and public sculpture, as well as figurative sculpture based on romantic and Victorian literary sources.

5. See, e.g., the discussion of both these works in Janson, *Nineteenth-Century Sculpture*, 80–83 and 167.

6. One of the first narrative histories of this group of sculptors dubbed them the "literary sculptors" because of this storytelling quality (Thorp, *Literary Sculptors*).

7. James, *William Wetmore Story*, 2:76.

8. Contemporary feminist critics have observed how profoundly art and literature reflect the gendered nature of the culture from which they spring. A brief review of influential feminist studies would include Mary Ellmann, *Thinking About Women* (New York: Harcourt, Brace & World, 1968); Kate Millet, *Sexual Politics* (Garden City, N.Y.: Doubleday, 1970); and Judith Fetterley, *The Resisting Reader: A Feminist Approach to American Fiction* (Bloomington: Indiana University Press, 1978), all of whom stressed the ways patriarchal culture determined how women were construed and construed themselves. Other books stressed the ways in which women writers defined themselves, most notably Gilbert and Gubar, *Madwoman in the Attic*. See the useful reviews of recent American feminist criticism by Kolodny, "Dancing Through the Minefield"; and Jehlen, "Archimedes and the Paradox of Feminist Criticism."

9. For studies of nineteenth-century prescriptive writing about women, see Welter, "Cult of True Womanhood"; Smith-Rosenberg, "Hysterical Woman"; Smith-Rosenberg and Rosenberg, "The Female Animal"; Haller and Haller, *Physician and Sexuality in Victorian America*; Cott, "Passionlessness."

10. Ella Rodman, "The Mistress of the Parsonage," *Harper's Weekly* 4 (February 18, 1860):99.

11. John Ruskin, "Of Queen's Gardens." In *Sesame and Lilies* (1865. Rpt. New York: Charles E. Merrill, 1891). For Ruskin's influence in America, see Roger B. Stein, *John Ruskin and Aesthetic Thought in America* (Cambridge, Mass.: Harvard University Press, 1967).

12. See Charlotte Perkins Gilman, *Women and Economics: A Study of the Economic Relation Between Men and Women as a Factor in Social Evolution*, ed. Carl N. Degler (1898. Rpt. New York: Harper & Row, 1966). See also the incisive biography of Gilman by Mary Hill, *Charlotte Perkins Gilman: The Making of a Radical Feminist, 1860–1896* (Philadelphia: Temple University Press, 1980).

13. My generalizations about the nineteenth-century American family follow the lines of many studies that have grown out of the "new" family history. See Gordon, *American Family in Social-Historical Perspective*. The fullest exposition of the doctrine of separate spheres and its economic roots in America may be found in Degler, *At Odds*. On the economics of woman's sphere, see Branca, "Image and Reality." A different view is expressed, however, by Elizabeth H. Pleck, "Two Worlds in One," *Journal of Social History* 10 (1976): 178–95.

14. See Douglas, *Feminization of American Culture*; and Jeffrey, "Family as Utopian Retreat."

15. See Cecilia Morris Eckhardt, *Fanny Wright: Rebel in America* (Cambridge, Mass.: Harvard University Press, 1984).

16. Gay, *Education of the Senses*, and *Tender Passion*.

17. DeWitt Bodeen, *Ladies of the Footlights* (Pasadena, Calif.: Pasadena Playhouse Association, 1937).

18. Kelley, "Sentimentalists."

CHAPTER 1: IDEAL SCULPTURE

1. Jules Prown's biography of eighteenth-century painter John Singleton Copley demonstrated the importance of combining the history of art production with the history of patronage and social history. See Jules Prown, *John Singleton Copley*. 2 vols. (Cambridge, Mass.: Harvard University Press, 1966). A number of biographies of nineteenth-century artists have now been carefully documented. See, for example, Lloyd Goodrich, *Thomas Eakins*. 2 vols. (Cambridge, Mass.: Harvard University Press, published for the National Gallery of Art, Washington, 1982) and Elizabeth Johns, *Thomas Eakins: The Heroism of Everyday Life* (Princeton: Princeton University Press, 1983). Earlier studies, such as James Thomas Flexner's *That Wilder Image* (New York: Bonanza, 1962), had attempted to sketch a cultural context for American art in a general way, but the solid groundwork of investigative scholarship has, until fairly recently, been lacking in American art. The only modern monographs on American ideal sculptors are Rusk, *William Henry Rinehart*; Wright, *Horatio Greenough*; Gale, *Thomas Crawford*; Rogers, *Randolph Rogers*; Reynolds, *Hiram Powers*; and the recent *Erastus D. Palmer* by J. Carson Webster, although others should soon follow. An excellent dissertation by Jan Seidler [Ramirez], *A Critical Reappraisal of the Career of William Wetmore Story (1819–1895): American Sculptor and Man of Letters* (Ph.D. diss., Boston University, 1985), is available from University Microfilms International. The foundation laid by descriptive histories of taste, like Russell Lynes, *The Tastemakers* (New York: Harper & Brothers, 1955) has been ex-

panded by social histories like Miller, *Patrons and Patriotism*; and Harris, *Artist and American Society*.

2. The classic statement of the importance of the "beholder's share" in determining cultural acceptance of art objects is Gombrich's *Art and Illusion*. A useful summary of the sociology of art is Wolff, *Social Production of Art*.

3. Tuckerman, *Book of the Artists*, 278. Tuckerman also mentions a wax bust of a deceased child that was so realistic it had to be destroyed.

4. Herman Melville, "Hawthorne and His Mosses, by a Virginian Spending July in Vermont," *The Literary World* (August 17 and 24, 1850), reprinted in Perry Miller, ed., *Major Writers of America* (New York: Harcourt, Brace, & World, 1962), 895. F. O. Matthiessen's *American Renaissance* (New York: Oxford University Press, 1941) explores the literary significance of the search for a national identity. Perry Miller's *The Raven and the Whale: The War of Words and Wits in the Era of Poe and Melville* (New York: Harcourt, Brace & World, 1956) still remains one of the most thorough accounts of the debates over literary nationalism.

5. Washington Allston had been at the center of a literary-artistic group in Boston, as described in Edgar P. Richardson, *Washington Allston, A Study of the Romantic Artist in America* (New York: Thomas Y. Crowell, 1948). In New York writers and painters were drawn together by mutual friendships and participation in the Sketch Club, as documented by James T. Callow, *Kindred Spirits: Knickerbocker Writers and American Artists, 1807–1855* (Chapel Hill: University of North Carolina Press, 1967).

6. Tuckerman, *Book of the Artists*. The book was an expansion of his short work *Artist-Life, or Sketches of Ameri-*

can Painters, first published in 1847. The antebellum book is mostly confined to biographical sketches while the later book contains fuller reflections on the function and fate of the arts in American culture.

7. Horatio Alger, *Ragged Dick; or, Street Life in New York*, in *The Student and the Schoolmate*, vols. 19–20 (January 1867–December 1867). *Ragged Dick* was first published in book form in 1868.

8. Tuckerman, *Book of the Artists*, 368.

9. Ibid., 306.

10. Ibid., 278.

11. Ibid., 356.

12. Ibid., 34.

13. Ibid., 29.

14. Ibid., 356.

15. For a good description of the technical aspects of nineteenth-century sculpture, see Janson, *Nineteenth-Century Sculpture*, 10–16.

16. There is an excellent discussion of Palmer's studio, and a careful consideration of who and what Matteson's painting portrays in Webster, *Erastus D. Palmer*, 22–25.

17. James coined this phrase in his book *William Wetmore Story*, 1:257. For discussions of the Cushman group see Joseph Leach, *Bright Particular Star: The Life and Times of Charlotte Cushman* (New Haven: Yale University Press, 1970).

18. Nathaniel Hawthorne, *The French and Italian Notebooks*, ed. Thomas Woodson, The Centenary Edition of the Works of Nathaniel Hawthorne, vol. 14 (Ohio State University Press, 1980), 78.

19. Ibid.

20. Ibid., 615.

21. Nathaniel Hawthorne to Louisa Lander and Elizabeth Lander, November 13 [1858], in Nathaniel Hawthorne, *The Letters, 1857–1864*, ed. Thomas

Woodson, James A. Rubino, L. Neal Smith, and Norman Holmes Pearson, The Centenary Edition of the Works of Nathaniel Hawthorne, vol. 18 (Ohio State University Press, 1987), 158.

22. Nathaniel Hawthorne to James T. Fields, February 11, 1860 in ibid., 230.

23. John Rogers, Jr., to Henry Rogers; Rome, February 13, 1859. Rogers Collection. Courtesy of the New-York Historical Society, New York.

24. Ibid.

25. Public aspects of American patronage have been well discussed for the period 1790–1860 in Miller, *Patrons and Patriotism*. See also Fryd, "Two Sculptures for the Capitol."

26. Of the thirteen wealthy citizens of Boston who advanced money to Washington Allston during the 1820s, four were also contributors to the newly founded Boston Athenaeum. See Mabel Munson Swan, *The Athenaeum Gallery, 1827–1873: The Boston Athenaeum as an Early Patron of Art* (Boston: Boston Athenaeum, 1940), 8, 48.

27. Allston's career was a controversial one. William Wetmore Story, who also knew the painter, would later write that Allston's experience proved that the artist had to leave America in order to work: "Allston starved spiritually in Cambridgeport." James, *William Wetmore Story*, 1:297. Allston's modern biographer, E. P. Richardson, has presented a more balanced view of Allston's experience, pointing out that although he could never finish his historical painting, *Belshazzar's Feast*, he produced many other works in a gentler, more reflective key (Richardson, *Washington Allston*). I have elsewhere argued that Allston's difficulties after returning from England were related to a change in his financial status and his inability to earn a sufficient living after believing himself financially secure earlier

in his life. See Joy Kasson, *Artistic Voyagers, Europe and the American Imagination in the Works of Irving, Allston, Cole, Cooper, and Hawthorne* (Westport, Conn.: Greenwood, 1982).

28. Greenough expressed his feelings about Allston in a letter printed in William Dunlap, *History of the Rise and Progress of the Arts of Design in the United States*, 3 vols. ed. with additions Frank W. Bayley and Charles Goodspeed (1834; Boston: C. E. Goodspeed, 1918), 3:225. See also Wright, *Horatio Greenough*, 30–32.

29. See Wright, *Horatio Greenough*, 37.

30. Ibid., 56. See also letter from Horatio Greenough to Robert Gilmor, Jr., May 17, 1828, in Wright, *Letters of Horatio Greenough*, 14–16.

31. See Wright, *Letters*, 223. For an account of Greenough's works I have relied upon the list in the index of Wright, *Horatio Greenough*, 375–79.

32. Greenough thanked him for his help in a letter of May 17, 1828. Wright, *Letters*, 14–16.

33. See Greenough's letter to Gilmore, April 25, 1830, in Wright, *Letters*, 57–59. Gilmor was also an important early benefactor of the landscape painter Thomas Cole.

34. As he noted on his copy of one of Greenough's letters, Gilmor had arranged to show the sculpture in Boston and Baltimore, having tried unsuccessfully for engagements in New York and Philadelphia. See Wright, *Letters*, 135.

35. See Harris, *Artist in American Society*, 56–88, for a discussion of "the burden of portraiture" for nineteenth-century artists who aspired to other genres.

36. See Wright, *Horatio Greenough*, 66–75. "From December 1831 to September 1832 Cooper was Greenough's chief financial support. During this

period he lent the sculptor a total of sixteen hundred francesoni" (ibid., 70).

37. Bellows, "Seven Sittings with Powers" (June 26, 1869), 404.

38. Reynolds, *Hiram Powers*, 67.

39. "Masters of Art and Literature: Chauncey B. Ives," *Cosmopolitan Art Journal* 4 (December 1860): 163–64.

40. Quoted, together with a more florid version of the same encounter, in Rogers, *Randolph Rogers*, 12 and 171n.

41. See Carr, *Harriet Hosmer*, 29.

42. See Jan Seidler Ramirez's entry on Rinehart in Greenthal, Kozol, and Ramirez, *American Figurative Sculpture*, 148.

43. See Thorp, *Literary Sculptors*, 149–51.

44. Harris, *Artist in American Life*, 17–19, 24, 39, 47, 158, 188–200, 310, 337, 376, 380, and Miller, *Patrons and Patriotism*, especially chaps. 1 and 2.

45. See Robert Gallman, "The Pace and Pattern of American Economic Growth" in Lance Davis et al., *American Economic Growth: An Economist's History of the United States* (New York: Harper & Row, 1972), 21–33.

46. Cited in James Henretta, "Wealth and Social Structure," in Jack P. Greene and J. R. Pole, eds., *Colonial British America: Essays in the New History of the Early Modern Era* (Baltimore: Johns Hopkins University Press, 1984), 276.

47. Pessen, *Riches, Class, and Power*, 77–91.

48. See *Dictionary of American Biography* and *National Cyclopedia of American Biography* for entries on these figures. Pessen warns of unreliability in the *Wealthy Citizens* pamphlets assembled for New York by Moses Beach (Pessen, *Riches, Class and Power*, appendix B., 310–19), but Beach does have an entry for John Steward, Rogers' benefactor, suggesting that he too came from a family of some established wealth.

49. See Lester, *Artist, Merchant, and Statesman*.

50. Tuckerman, *Book of the Artists*, 30.

51. Ibid., 13.

52. Ibid., 25.

53. James Jackson Jarves, *Art Thoughts: The Experiences and Observations of an American Amateur in Europe* (New York: Hurd and Houghton, 1869), 340.

54. James Jackson Jarves, *Art-Hints: Architecture, Sculpture, and Painting* (London: Sampson Low, 1855), 305. See also Harris' illuminating discussion of art and social control in *Artist in American Society*, 165–68.

55. See Reynolds, *Hiram Powers*, 1079, 1083; Webster, *Erastus D. Palmer*, 150–51, 165, 181–82; James, *William Wetmore Story*, 1:231.

56. See Harris, *Artist in American Society*, chaps. 5 and 6; and Gerdts, *American Neoclassic Sculpture*, 7–8.

57. Tuckerman, *Book of the Artists*, 291.

58. See James Grant Wilson, "Alexander T. Stewart," *Harper's Weekly*, 20 (April 29, 1876): 345–46. Some of the details, such as his college education and his love for classical learning, seem to be fabrications.

59. See Richard V. West, "The Crockers and Their Collections: A Brief History," in *Crocker Art Museum Handbook of Paintings* (Sacramento: Crocker Art Museum, 1979), 7–12.

60. See Bourdieu, "Cultural Reproduction and Social Reproduction," 71–112, and *Distinction*. Bourdieu describes the importance of cultural capital as an indicator of social class in present-day France; in nineteenth-century America, individuals can be seen trying to acquire cultural competence along with their monetary capital. See also DiMaggio, "Cultural Entrepreneurship in

Nineteenth-Century Boston," 33–50.

61. These aesthetic ideas will be discussed further in the next chapter. Jarves, in many ways at odds with prevailing aesthetic thought, encapsulated these views eloquently in *Art-Hints*, 152–54, where he discussed nobility, beauty, and the human form.

62. See Wright, *Horatio Greenough*, 71–75.

63. See Degler, *At Odds*. See also Peter G. Filene, *Him/Her/Self: Sex Roles in Modern America*, 2d ed. (Baltimore: Johns Hopkins University Press, 1974, 1975, 1986), especially chaps. 1 and 2.

New Woman [handwritten marginal note]

64. Jane Addams had complained of this narrow range of concerns in "The Snare of Preparation." Although she escaped from it to some extent, her concept of Hull House continued to include the importance of art and culture as a means of social acclimation if not social control. See Jane Addams, *Twenty Years at Hull-House* (1910. Rpt. New York: New American Library, 1960).

65. See the listing of purchasers in the "Catalogue of Sculptures by Randolph Rogers" at the end of Rogers, *Randolph Rogers*.

66. See letters reproduced in Webster, *Erastus D. Palmer*, 267–68 and 277.

CHAPTER 2: VIEWING IDEAL SCULPTURE

1. *Artistic Houses, Being a Series of Interior Views of a Number of the Most Beautiful and Celebrated Homes in the United States, with a Description of the Art Treasures Contained Therein*, 2 vols. (New York: D. Appleton, 1883–84).

2. Samuel F. B. Morse had displayed his painting of the *Gallery of the Louvre* in New York in 1833; the *New York Mirror* described the gallery as "one grand constellation [in which shine] the brilliant effusions of those great names destined to live as long as the art of

painting exists." Quoted in Oliver W. Larkin, *Samuel F. B. Morse and American Democratic Art* (Boston: Little, Brown, 1954), 114–15. Photographs and engravings of French salons and English Royal Academy exhibitions also showed them hung with crowded walls. Even Gertrude Stein's iconoclastic collection of modern art at the turn of the century was displayed as a closely hung gallery of paintings.

3. See Gerdts, "*Medusa* of Harriet Hosmer."

4. Thorstein Veblen, *The Theory of the Leisure Class* (1899. Rpt. Boston: Houghton Mifflin, 1973), especially "Pecuniary Canons of Taste."

5. Bourdieu, *Distinction*, 55–56.

6. See W. G. Constable, *Art Collecting in the United States of America* (London: Thomas Nelson and Sons, 1964), 26–30.

7. See Lynes, *Tastemakers*, chaps. 6, 8, and 9.

8. *Artistic Houses*, 1: 117, 119.

9. "The Stewart Art Gallery," *Harper's Weekly* 23 (May 3, 1879): 350.

10. A full but rather sardonic account of Stewart's fortunes can be found in Wesley Towner, *The Elegant Auctioneers*, completed by Stephen Varble (New York: Hill and Wang, 1970), chap. 3.

11. Stewart had an extensive collection of American ideal sculptures, and it is particularly disappointing that his collection was broken up by sale at auction in 1887. By that time, tastes had begun to change, and some of his more important pieces remained unsold and have since disappeared. The works displayed among his paintings included three sculptures by Hiram Powers, *The Greek Slave*, *Eve Tempted*, and *Eve Repentant*. American artists Chauncey Ives and William Randolph Barbee were also represented, along with several British sculptors.

12. *Artistic Houses* 1:7.

13. Note the trappings of gentility at-

tributed to Stewart in James Grant Wilson, "Alexander T. Stewart," *Harper's Weekly* 20 (April 29, 1876):345–46.

14. In Henry James' fictional portrait of the Roman art world, *Roderick Hudson*, the imposing Mrs. Light bursts into Roderick's studio saying, "I trust we are at liberty to enter. . . . We were told that Mr. Hudson had no fixed day, and that we might come at any time. Let us not disturb you" (1875. Rpt. Boston: Houghton Mifflin, n.d.), chap. 8.

15. See, for example, Harriet Beecher Stowe, *Sunny Memories of Foreign Lands*, 2 vols. (Boston: Phillips, Sampson, 1856), and Grace Greenwood [Sara Jane Lippincott], *Haps and Mishaps of a Tour in Europe* (Boston: Ticknor, Reed, and Fields, 1854). There is a useful bibliography of travel literature in Gerdts, *American Neoclassic Sculpture*.

16. Hawthorne, *French and Italian Notebooks*, 78.

17. In the preface to *The Marble Faun*, Hawthorne acknowledged "stealing" from real sculptors to populate the studio of his imaginary "Man of Marble." Nathaniel Hawthorne, *The Marble Faun: Or, the Romance of Monte Beni*. The Centenary Edition of the Works of Nathaniel Hawthorne, vol. 4 (1860. Rpt. Ohio State University Press, 1968), 4.

18. Hawthorne, *French and Italian Notebooks*, 279, 281.

19. For information on art institutions, see Harris, *Artist in American Society*, especially chapter 10, and Miller, *Patrons and Patriotism*, especially chapters 8–12.

20. Morse failed to make a profit exhibiting his painting in New York in 1833, but art benefactor Robert Gilmor arranged exhibitions for Horatio Greenough's *Medora*, going to some trouble to arrange for showings and earning Greenough a substantial sum of money. See Larkin, *Samuel F. B. Morse*,

114–15, and Wright, *Letters of Horatio Greenough*, 135n. Sometimes patrons were less generous; James Robb of New Orleans engaged in a bitter controversy with Hiram Powers over who should reap the profits of the exhibition of *The Greek Slave*. See *Vindication of Hiram Powers*.

21. See Richard Altick, *The Shows of London* (Cambridge, Mass.: Harvard University Press, 1978) for a comparable glimpse of the variety of public entertainment in England during the same period.

22. These pamphlets were used to guide visitors to other forms of art, such as Thomas Cole's *The Voyage of Life*. I have found enough of these pamphlets to suggest that they constituted an important genre of art criticism in nineteenth-century America. The lengthy pamphlet accompanying *The Greek Slave* may be found in numerous libraries; I have found nearly identical versions printed for New York, Boston, Philadelphia, and New Orleans. In addition, I have discovered similar pamphlets pertaining to Edward Brackett's *Shipwrecked Mother and Child* and shorter announcements describing Horatio Greenough's *Angel and Child*, Erastus Dow Palmer's *The White Captive*, and Harriet Hosmer's *Zenobia*. The catalog accompanying a group of Palmer's sculptures on display in New York served the same function, as did catalog entries for group shows at institutions such as the Boston Athenaeum. No doubt further research will continue to turn up similar examples if they have been preserved.

23. Tears were described as an appropriate response by one writer in *Powers' Statue of the Greek Slave, Exhibiting at the Pennsylvania Academy of the Fine Arts* (Philadelphia: T. K. and P. G. Collins, 1848), 18. An hour-long reverie was recommended in *Edward A.*

Brackett's Marble Group of the Ship-wrecked Mother and Child (n.p. [New York], n.d.), 2. On the question of audience decorum in nineteenth-century America, see Levine, "William Shakespeare and the American People," and the same author's *Highbrow/Lowbrow*.

24. Nineteenth-century sex books and biological literature have been well discussed by Smith-Rosenberg and Rosenberg in "The Female Animal," as well as Smith-Rosenberg, "The Hysterical Woman," and Rosenberg, "Sexuality, Class, and Role in Nineteenth-Century America." See also Haller and Haller, *Physician and Sexuality*. On health and sexuality, see Nissenbaum, *Sex, Diet, and Debility*. On etiquette, see the forthcoming *Rudeness and Civility* by John F. Kasson (New York: Hill and Wang, 1990), to whose insights I am indebted.

25. James, *William Wetmore Story and His Friends*, 2:76.

26. Tuckerman, *Book of the Artists*, 27.

27. Horatio Greenough to William Cullen Bryant, February 5, 1852, ms. in Bryant-Godwin Papers, Rare Books and Manuscripts Division, New York Public Library, Astor, Lenox, and Tilden Foundations.

28. Palmer, "Philosophy of the Ideal," 18.

29. This is Hawthorne's phrase, suggesting a backward glance at Puritan typology, in *Marble Faun*, 151. Stowe's moral aims have been treated sympathetically by Tompkins in *Sensational Designs*. Dickinson and Twain, of course, had mixed feelings about art's moral nature; Twain could make fun of conventional moralism in a book like *Puddinhead Wilson*, but the book has a deeply moral message. Dickinson cast a cold eye on the notion that "truth is beauty" in "I died for Beauty," but her poems ask insistently what truth may be.

30. Levine, "William Shakespeare and the American People" and *Highbrow/Lowbrow*.

31. Roman Jakobson, "Linguistics and Poetics," in Richard T. de George and Fernande M. de George, eds., *The Structuralists: From Marx to Levi-Strauss* (Garden City, N.Y.: Doubleday, 1972), 85–122. Jonathan Culler, *The Pursuit of Signs, Semiotics, Literature, Deconstruction* (Ithaca: Cornell University Press, 1981).

32. Hans-Georg Gadamer, *Truth and Method* (1960. Rpt. New York: Seabury Press, 1975), 269ff.

33. Gombrich, *Art and Illusion*.

34. From the *Boston Post*, no date, quoted in *Edward A. Brackett's Marble Group of the Shipwrecked Mother and Child* (n.p. [New York], n.d.), 5–6.

35. "The Palmer Marbles," *The Crayon* 4 (January 1857): 19.

36. Grace Greenwood [Sara Jane Lippincott], *Greenwood Leaves: A Collection of Sketches and Letters*, 2d series. (Boston: Ticknor, Reed, and Fields, 1852), 234, 263.

37. Stowe, *Sunny Memories of Foreign Lands* 2:46–8.

38. Greenough, in *Edward Brackett's Marble Group of the Shipwrecked Mother and Child*, 2.

39. Jarves, *Art-Hints*. 152–54.

40. See Lewis, "Art and Artists of America," 397–401.

41. Mulvey, "Visual Pleasure and Narrative Cinema," 11.

42. Judith Mayne, "Women and Film: A Discussion of Feminist Aesthetics," *New German Critique* 13 (Winter 1978): 86. Quoted in de Lauretis, *Alice Doesn't*, 28. See also John Berger's comments about woman as spectacle in *Ways of Seeing* (London: Penguin, 1972), pp. 45–47.

43. See, for example, William Dean Howells, "A Sennight of the Centennial," *Atlantic Monthly* 38 (July 1876): 92–107.

44. See Phillip T. Sandhurst and others, *The Great Centennial Exhibition* (Philadelphia: P. W. Ziegler, 1876), 34, and Strahan [Shinn], *Masterpieces of the Centennial International Exhibition*, 55, for description and reproduction of this sculpture.

CHAPTER 3: NARRATIVES OF THE FEMALE BODY

1. *The Greek Slave* has been much discussed by art historians, but few commentators have carefully examined the written record to analyze precisely what nineteenth-century viewers saw when they looked at the sculpture. Gerdts devoted several pages to *The Greek Slave* in *American Neoclassic Sculpture*, and he also discussed it in *Great American Nude*. He and a coauthor had previously added much to our understanding of the sculpture in Roberson and Gerdts, " 'So Undressed, Yet So Refined.' " Reynolds discussed the statue and documented its production in *Hiram Powers and His Ideal Sculpture*. Some provocative comments about the cultural significance of *The Greek Slave* were made in Hyman, "*Greek Slave* by Hiram Powers." Recently another art historian has discussed *The Greek Slave* in cultural context by seeking to relate it to the abolitionist movement: Green [Fryd], "Hiram Powers's *Greek Slave*." In this study, I am more interested in the statue's implications for the wider question of gender and social change, and I try to press these questions farther than they were taken by Gerdts, Reynolds, or Hyman.

2. See Roberson and Gerdts, " 'So Undressed, Yet So Refined.' "

3. See *Cosmopolitan Art Journal* 2 (December 1857):40.

4. James, *William Wetmore Story*, 1:114–15.

5. Mary Douglas, *Purity and Danger: An Analysis of the Concept of Pollution and Taboo* (New York: Praeger, 1966), 120–24.

6. Frances Trollope, *A Visit to Italy* (London: Bentley, Richards, 1842) 1: 144–45. See Crane, *White Silence*, 196. Powers' *Eve Tempted* will be discussed in greater detail in chapter 7, below.

7. Isaiah Townsend to Hiram Powers, November 4, 1841, quoted in Reynolds, *Hiram Powers and His Ideal Sculpture*, 135.

8. Green [Fryd] discusses some of the literary responses to the Greek war for independence in "Hiram Powers's *Greek Slave*." Greek captive women form the chorus in Shelley's verse play *Hellas*. See Percy Bysshe Shelley, *Hellas: A Lyrical Drama*, ed. Thomas J. Wise (1822. Rpt. London: Reeves and Turner, 1886).

9. Gerdts, *Great American Nude*, 40–41, 44–45ff.

10. Kendall B. Taft, "Adam and Eve in America," *Art Quarterly* 23 (Summer 1960): 171–79.

11. Wright, *Horatio Greenough*, 71–75.

12. Hiram Powers to Col. John Preston, January 7, 1841, quoted in Reynolds, 137–38.

13. Lester, *Artist, Merchant, and Statesman*, 1:86–87.

14. Quoted in ibid., 1:88.

15. See, for example, the poignant description of a Western observer's combined horror and fascination at witnessing an Indonesian immolation ceremony so carefully analyzed by Clifford Geertz in "Found in Translation: On the Social History of the Moral Imagination," in *Local Knowledge: Further Essays in Interpretive Anthropology* (New York: Basic, 1983), 36–54.

16. Malek Alloula has recently analyzed the Western male fascination with the concealed women of the harem,

combining titillation, voyeurism, and a desire to control what they could not understand. See *The Colonial Harem* (Minneapolis: University of Minnesota Press, 1986).

17. Julius Mattfeld, *A Hundred Years of Grand Opera in New York, 1825–1925: A Record of Performances* (1927. Rpt. New York: AMS, 1976), 81.

18. See the description of this novel in Steven Marcus, *The Other Victorians: A Study of Sexuality and Pornography in Mid–Nineteenth Century England* (New York: Basic, 1966), 197–216.

19. See William W. Sanger, *The History of Prostitution: Its Extent, Causes and Effects Throughout the World* (1859. Rpt. New York: Eugenics, 1939), 442–43. See the accounts of travel to the seraglio described in N. M. Penzer, *The Harem* (London: George G. Harrap, 1936), especially chap. 2.

20. See Reynolds, *Hiram Powers and His Ideal Sculpture*, 262–67, 279–90, for a discussion of Ingres' influence on Powers.

21. See Georges Wildenstein, *The Paintings of J. A. D. Ingres* ([London]: Phaidon, 1954), 210, 213.

22. See *Statues de Chair, Sculptures de James Pradier (1790–1852)* (Genève: Musée d'art et d'histoire, 17 octobre 1985-2 février 1986; Paris: Musée du Luxembourg, 28 février-4 mai 1986), 131–33.

23. Said, *Orientalism*.

24. Strahan [Shinn], *Art Treasures of America*, 1:140. In its pose and subject, the painting also suggested the well-known subject of the rape of the Sabine women.

25. Ibid., 135.

26. A later review in the London *Art-Journal* reflected on that earlier exhibition: "We had not even heard of the name of Hiram Powers, and were consequently astonished to find so fine a work from one whose fame had not

already reached the shores of England." "The Greek Slave," *Art-Journal* 12 (1850): 56.

27. "Greek Slave: Sculpture," reprinted from *Literary Gazette*, in *Eclectic Magazine* 5 (August 1845): 568.

28. The pamphlet *Vindication of Hiram Powers* offers testimonials to Powers' integrity in his dispute with Robb. Kellogg defended Powers in *Justice to Hiram Powers*; he stated his case against Powers in Miner Kellogg, *Mr. Miner K. Kellogg to His Friends*.

29. A reviewer commented, "he has known how . . . to impart to her a most sweet expression of love; and to her eyes, soul and speech, grace to her attitude, and to clothe her whole person with nobleness." Melchior Missirini, *The Evening Post*, apparently November 1846, from a clipping in the Miner Kellogg scrapbook, Microfilm no. 986, Archives of American Art.

30. At least one copy of the *Circassian* had been purchased by James Robb, the owner of *The Greek Slave*, suggesting that Kellogg had his own interests as well as Powers' at heart. See the exhibition records collected in Yarnall and Gerdts, *National Museum of American Art's Index* 3:1992–94.

31. Tuckerman, *Book of the Artists*, 423–24. For reviews, see clippings in Miner Kellogg Scrapbook, Microfilm no. 986, Archives of American Art.

32. For example, the pamphlet published in Philadelphia was *Powers' Statue of the Greek Slave, Exhibiting at the Pennsylvania Academy of the Fine Arts*. Virtually identical pamphlets were published in New York, Boston, and New Orleans.

33. Quoted from the entry on Dewey in *The National Cyclopaedia of American Biography* (New York: James T. White, 1894) 5:47.

34. Eleven years earlier, in a travel book called *The Old World and the New*,

Dewey had made some awkward and thoroughly conventional comments about art. In his earlier book, Dewey could only say about the Apollo Belvedere, "I am paralyzed by this wonderful work, so often as I see it. I sit down and gaze upon it, in a sort of revery, and do not know but I sometimes say aloud, 'Oh! Heaven!'—for really it is difficult to resist exclamations and tears." Orville Dewey, *The Old World and the New*, 2 vols. (New York: Harper & Brothers, 1836) 2:108. Perhaps Kellogg helped him to refine his critical vocabulary.

35. Dewey, "Powers' Statues," 160–61.

36. Duganne, "Ode to the Greek Slave," 25.

37. L. E., "To Powers' 'Greek Slave.' "

38. Clara Cushman in *Neal's Saturday Gazette*, quoted in *Powers' Statue of the Greek Slave* (Philadelphia), 18.

39. Ibid.

40. See the description of the treatment of the Pygmalion story in Marina Warner, *Monuments & Maidens: The Allegory of the Female Form* (New York: Atheneum, 1985), 227–28.

41. In James Joyce's novel, *Ulysses*, Leopold Bloom inspects the private parts of classical statues to satisfy a similar curiosity. Joyce, *Ulysses* (1914, 1918, 1934. Rpt. New York: Random House, Modern Library, 1961), 176, 201.

42. Gay, "Victorian Sexuality," 377.

43. Gay, *The Education of the Senses*, 396–98.

44. See Hyman, "*The Greek Slave* by Hiram Powers," 216–23.

45. Kappeler, *Pornography of Representation*.

46. Lewis, "Art and Artists of America," 399. Cushman, from *Neal's Saturday Gazette*.

47. See Christine Stansell, *City of Women* (New York: Knopf, 1986), 175,

for a description of one such tableau, Susannah and the Elders.

48. G. G. Foster, *New York By Gas-Light* (New York: Dewitt & Davenport, 1850), 12–13.

49. Hiram Powers to Thomas Powers, n.d., quoted in Reynolds, 141.

50. An announcement of such a showing is reproduced in Roberson and Gerdts, " 'So Undressed, Yet So Refined,' " 16.

51. Duganne, "Ode to the Greek Slave, " 25.

52. James Freeman Clarke, "The Greek Slave," quoted in Roberson and Gerdts, " 'So Undressed, Yet So Refined,' " 18.

53. H. S. C. in *The Knickerbocker Magazine*, quoted in *Powers' Statue of the Greek Slave* (Philadelphia), 19.

54. One critic demanded, "how can she stand thus serene and erect, when the sanctity of her nature is outraged by this exposure? Where is the bending and shrinking of her form, that expression in every feature and every limb of her unutterable agony, which should make the gazer involuntarily to turn away his eyes . . . ?" W. H. F., "Art Review, The Greek Slave," 62. But another writer rebuked this critic in a later edition of the same journal, *The Harbinger*, saying that a "cry of anguish would be a very poor subject for a work of art, and . . . the artist would naturally choose the serene moment following, when the triumph of the spirit was revealed in Godlike resignation." Dwight, "Greek Slave," 78.

55. James Freeman Clarke, quoted in Roberson and Gerdts, " 'So Undressed, Yet So Refined,' " 18.

56. Henry Tuckerman, "The Greek Slave," *The New York Tribune*, September 9, 1847, quoted in *Powers' Statue of the Greek Slave* (Philadelphia), 12.

57. Sigmund Freud, "On Narcissism: An Introduction," *The Standard Edition*

of the Complete Psychological Works of Sigmund Freud, 24 vols., trans. from the German under general editorship of James Strachey, in collaboration with Anna Freud, assisted by Alix Strachey and Alan Tyson (London: The Hogarth Press and the Institute of Psycho-Analysis, 1957), 14:88–89.

58. Bram Dijkstra has commented on the theme of female narcissism in nineteenth-century European and American art. He discounts claims for women's spirituality as part of a repressive misogyny that constituted a "cultural war on women." It should be evident that I view the cultural matrix as more complex and conflicted. Dijkstra, *Idols of Perversity.*

59. Nissenbaum, *Sex, Diet, and Debility.*

60. Smith-Rosenberg and Rosenberg, "The Female Animal," 332–56. See also Haller, and Haller, *Physician and Sexuality in Victorian America.*

61. See *Art-Journal* 12 (1850), opp. 56.

62. Cott, "Passionlessness."

63. See Sheila Ryan Johansson, "Sex and Death in Victorian England: An Examination of Age- and Sex-Specific Death Rates, 1840–1910," in Martha Vicinus, ed., *A Widening Sphere, Changing Roles of Victorian Women* (Bloomington: Indiana University Press, 1977), 163–81. See also Allan M. Brandt, *No Magic Bullet: A Social History of Venereal Disease in the United States Since 1880* (New York: Oxford University Press, 1985).

64. Lewis, "Art and Artists of America," 399.

65. W. H. Coyle, "Powers' Greek Slave," *Detroit Advertiser*, quoted in Roberson and Gerdts, "'So Undressed, Yet So Refined,'" 18.

66. Clarke, quoted in ibid., 18.

67. Green [Fryd], "Hiram Powers's *Greek Slave.*"

68. *Punch* 20 (1851): 236.

69. *Cosmopolitan Art Journal* 1 (June 1857): 132.

70. *New-York Evening Express*, quoted in ibid., 133.

71. See de Lauretis, *Alice Doesn't*, especially chaps. 2 and 5.

72. Claude Levi-Strauss, *The Elementary Structures of Kinship* (Boston: Beacon, 1969); see discussion of this idea in Gayle Rubin, "The Traffic in Women: Notes on the 'Political Economy' of Sex," in Rayna R. Reiter, ed., *Toward an Anthropology of Women* (New York: Monthly Review Press, 1975), 157–210. Also see de Lauretis, *Alice Doesn't*, 18–22.

73. Cushman, from *Neal's Saturday Gazette*, 18.

74. Tuckerman, *Book of the Artists*, 25.

75. H. T. Tuckerman, "The Greek Slave," from the *New York Tribune*, September 9, 1847, quoted in *Powers' Statue of the Greek Slave* (Philadelphia), 12.

76. See the debate over *The Greek Slave* in *The Harbinger*, cited in note 54.

77. Quoted in Wallace, *John Rogers*, 70.

78. *Powers' Statue of the Greek Slave* (Philadelphia), 3.

79. Lydia Sigourney, "Powers's Statue of the Greek Slave," in *Poems* (New York: Leavitt and Allen, 1860), 112.

80. Elizabeth Barrett Browning, "Hiram Powers' 'Greek Slave,' *Poems, 1850* in *The Complete Works of Elizabeth Barrett Browning*, 6 vols., ed. Charlotte Porter and Helen A. Clarke (New York: Thomas Y. Crowell, 1900) 3:178.

81. Quoted in ibid., 16.

82. W. H. Coyle, quoted in Roberson and Gerdts, "'So Undressed, Yet So Refined,'" 17.

83. For measurements, see *American Art in the Newark Museum* (Newark, N.J.: Newark Museum, 1981), 415. The Newark version was the one distributed

by the Cosmopolitan Art Association in 1855 and 1858; it was the third replica made, and identical to the one displayed at the Crystal Palace.

84. *New York Courrier and Enquirer*, quoted in *Cosmopolitan Art Association Catalogue 1854*, 26.

85. Ibid.

CHAPTER 4: BETWEEN TWO WORLDS

1. Palmer was first referred to as a sculptor in the *Albany Evening Journal* in July 1849, although he was still listed in the city directory of Utica as a "concheghea artist," or cameo-cutter. See Webster, *Erastus Dow Palmer*, 20.

2. Erastus Dow Palmer to Hiram Powers, April 10, 1867, in ibid., 296. On Palmer's visit to New York, see ibid., 20.

3. [Henry Tuckerman], "The Sculptor of Albany," 400.

4. *New York Herald*, December 2, 1859, 4. Cited in Webster, *Erastus D. Palmer*, 30.

5. Erastus Dow Palmer to John Durand, January 11, 1858, quoted in Webster, *Erastus D. Palmer*, 278. The finished statue, carved a year later, differs only in a few details. The shackles have been changed from bark to a softer materials, either cloth or rawhide, and the nightdress lies not so much at her feet as alongside the stump, suggesting the fringed clothing on the post beside *The Greek Slave*.

6. Wendell L'Amoreux, *Springfield Republican*, February 19, 1858, 2, cited in Webster, *Erastus D. Palmer*, 184.

7. Tuckerman, *Book of the Artists*, 359.

8. James Fenimore Cooper, *The Last of the Mohicans, or a Narrative of 1757* (New York: G. P. Putnam's Sons, Leatherstocking Edition, n.d.), 406. See Leslie Fiedler, *Love and Death in the American Novel* (1960. Rev. ed. New York: Stein and Day, 1966), especially chap. 7. On Cooper's fear of miscegenation, see Tompkins, *Sensational Designs*, chap. 4. On images of the Indian in American literature, see Roy Harvey Pearce, *The Savages of America; A Study of the Indian and the Idea of Civilization* (Baltimore, Johns Hopkins Press, 1953), and Robert Berkhofer, *The White Man's Indian: The History of an Idea from Columbus to the Present* (New York: Knopf, 1978).

9. Greenough's sculpture, *Rescue* (1850), was assembled after his death by architect Robert Mills. As Mills constructed the group, an Indian with raised tomahawk and a rescuing pioneer stand in the center, with a woman and baby on one side and a dog on the other. At least one friend of Greenough's, however, insisted that the sculptor had intended to place the mother and child in front of the Indian, intensifying the sense of incipient violence. See Fryd, "Two Sculptures for the Capitol," 25.

10. Frances Palmer Gavitt, "Extracts of Interest from the Diaries of Erastus Dow Palmer, with Notations Largely by F. P. G." (North Hollywood, Calif.: John Cornell), cited in Webster, *Erastus D. Palmer*, 184. As Webster points out, the book that provided a full account of Oatman's captivity was published too late to serve as the model for *The White Captive*, but Palmer may have read of the incident in a newspaper. For discussions of Indian captivity narratives, see Slotkin, *Regeneration Through Violence*, and Kolodny, *The Land Before Her*.

11. Kolodny, "Turning the Lens."

12. Described in ibid., and in Slotkin, *Regeneration Through Violence*, 256-59.

13. Miss M. Louisa Southwick, "The White Captive," *Godey's Lady's Book* 54 (January 1857), 61.

14. See Arnold Van Gennep, *The Rites of Passage* (1908. Rpt. Chicago: University of Chicago Press, 1960).

15. See Victor Turner, *The Ritual Process, Structure and Anti-Structure* (1969. Rpt. Ithaca, N.Y.: Cornell University Press, 1977), 94–110.

16. L. J. Bigelow, "Palmer, the American Sculptor," *Continental Monthly* 5 (1864):263, quoted in Webster, *Erastus D. Palmer*, 67.

17. "Palmer's 'White Captive,' " *The Atlantic Monthly* 5 (January 1860): 108–9. Subsequent quotations are taken from this article.

18. The phrase refers to Christopher Lasch, *Haven in a Heartless World: The Family Besieged* (New York: Basic, 1977). See also Jeffrey, "Family as Utopian Retreat," 21–41.

19. *Palmer's Statue: The White Captive, on Exhibition at Schaus' Gallery, 629 Broadway* (n.d., n.p.).

20. [Henry Tuckerman], "Palmer's Statue, The White Captive," reproduced in Webster, *Erastus D. Palmer*, 29.

21. This fascination with the expressiveness of individual body parts may help to explain why Palmer made at least one cast of the foot of *The White Captive*. This curiosity is reproduced in Gerdts, *American Neoclassic Sculpture*, *140*.

22. See Allan Nevins, *Hamilton Fish: The Inner History of the Grant Administration*. Rev. ed. (New York: Frederick Ungar Publishing, 1936, 1957), especially 1:42–43, 63–65.

23. My understanding of this event has been enhanced by the interesting research of Harlan Gradin. See Harlan Joel Gradin, "Losing Control: The Caning of Charles Sumner" M.A. thesis, Department of History, University of North Carolina at Chapel Hill, 1981.

24. "There was no friend's house in Washington where Sumner ever enjoyed [himself] so much as at Mr. Fish's, and no one was for many years so wel-

come a guest there. The latter's home in New York and his seat on the Hudson were always open to the senator." Edward L. Pierce, *Memoir and Letters of Charles Sumner*, 4 vols. (Boston: Roberts Brothers, 1894) 4:377–78. Years later, when Fish was ambassador to England, the two men had a serious falling-out.

25. *Harper's Weekly* 3 (1859): 787. Adam Badeau, *New York Times and Noah's Weekly Messenger*, November 20, 1859, quoted in Webster, *Erastus D. Palmer*, 75.

26. [Bigelow], "Palmer."

27. Ibid., 260.

28. "Naked Art," *The Crayon* 6 (December 1859): 377–78. See also Webster, *Erastus D. Palmer*, 74–78, for an account of the debate over Palmer's use of nudity. Much of the imagery and many of the assertions are familiar restatements of the argument over *The Greek Slave*.

29. *New York Times*, November 12, 1859, 4.

30. *Century*, November 19, 1859, 382. Quoted in Webster, *Erastus D. Palmer*, 66.

31. See for instance [George William Curtis], "Editor's Easy Chair," *Harper's New Monthly Magazine* 14 (February 1857): 414–15.

32. See Webster's summary of contemporary praise for Palmer's realism, *Erastus D. Palmer*, 69–71 and 83–85. See also Webster's thorough comparison of *The White Captive* and *The Greek Slave*, 100–105.

33. [Curtis], "Editor's Easy Chair," *Harper's New Monthly Magazine* 22 (January, 1861): 270.

34. *Courrier*, 1. As cited by Webster, *Erastus D. Palmer*, 77.

35. *Musical World*, November 19, 1859, 4. Quoted in Webster, *Erastus D. Palmer*, 66.

36. *New York Times*, December 30, 1859, 2.

37. See, for example, Jean-Antoine Houdon, *Diana*; Bertel Thorwaldsen, *Venus*; James Pradier, *Satyr and Bacchante*; all reproduced in Janson, *Nineteenth-Century Sculpture*, 44, 58, 109.

38. Lester, *Artist, Merchant, and Statesman*, 2:188–89. Powers later repudiated Lester and claimed he had been misquoted in the book, possibly because of frank passages like this one.

39. Quoted in R. W. B. Lewis, *Edith Wharton, A Biography* (New York: Harper & Row, 1975), 53.

40. Sigourney, "Virginia Dare."

41. "Louisa Lander," *Cosmopolitan Art Journal* 5 (March 1861): 28.

42. "Virginia Dare," *Boston Evening Transcript*, March 1, 1865, 2.

43. Gerdts, *American Neoclassic Sculpture*, 128. See also Gerdts, "Marble Savage."

44. *Catalogue of the Palmer Marbles*, 10–13. Subsequent quotations are from the same catalog.

45. E. D. Palmer to John Durand, January 11, 1858, in Webster, *Erastus D. Palmer*, 278.

46. Hiram Powers to Sidney Brooks, November 1866, quoted in Reynolds, *Hiram Powers and His Ideal Sculpture*, 206.

47. "Palmer's White Captive," *New-York Times*, December 30, 1859, 2.

48. The two statues are shown in a photograph of the entrance hall of the home of LeGrand Lockwood in Norwalk, Connecticut. See *Carved and Modeled: American Sculpture, 1810–1940*, April 20–June 4, 1982 (New York: Hirschl & Adler Galleries, 1982), 26.

49. As Leslie Fiedler pointed out, *The Wept of Wish-ton-Wish* represented Cooper's "attempt to deal nonmythically . . . with the problem of miscegenation."

Fiedler, *Love and Death in the American Novel*, 203.

50. Cooper, *Wept of Wish-ton-Wish* (New York: G. P. Putnam's Sons, Leatherstocking Edition, n.d.), 321–22.

51. *Catalogue of Marble Statuary*.

52. Tuckerman, *Book of the Artists*, 591. The statue was listed as colored in *Catalogue of Marble Statuary*.

53. Atkinson, "Modern Sculpture of all Nations," 322.

54. For eighteenth-century versions of the story, see Slotkin, *Regeneration Through Violence*, 100–101. See Francis Parkman, *A Half-Century of Conflict* (Boston: Little, Brown, 1892) 1:86–87, and George Bancroft, *History of the Colonization of the United States* (Boston: Little, Brown, 1846–75) 3:212–14.

55. Bancroft, *History of the Colonization* 3:212.

56. Ibid., 3:213.

57. Ibid., 3:241.

58. "Chauncey B. Ives," *Cosmopolitan Art Journal* 4 (December 1860): 164.

CHAPTER 5: DEATH AND DOMESTICITY

1. Randolph Rogers' *Nydia the Blind Flower Girl of Pompeii* (1855), for example, depicted a moment of pathos from Edward Bulwar-Lytton's *The Last Days of Pompeii*, in which a young blind slave gropes through the ruins of the destroyed city to rescue the man she loves, for whose happiness she will soon sacrifice her life. Rogers sold more than twenty copies of this sculpture, which rivaled *The Greek Slave* in popularity. See the discussion of this work in Rogers, *Randolph Rogers*, chap. 4.

2. See, for instance, Halttunen, *Confidence Men and Painted Women*; Anita Schorsch, *Mourning Becomes America: Mourning Art in the New Nation* (Harris-

burg, Pa.: Pennsylvania Historical and Museum Commission, 1976); and Lou Taylor, *Mourning Dress: A Costume and Social History* (London and Boston: G. Allen and Unwin, 1983).

3. Gorer, "The Pornography of Death."

4. Ernest Hemingway, *A Farewell to Arms* (New York: Charles Scribner's Sons, 1929), 185.

5. For a discussion of the significance of present-day sentimental popular culture, see Janice Radway, *Reading the Romance: Women, Patriarchy, and Popular Literature* (Chapel Hill: University of North Carolina Press, 1984).

6. See "Vital Statistics and Health and Medical Care" in U.S. Bureau of the Census, *Historical Statistics of the United States, Colonial Times to 1970*, Bicentennial Edition, Part 2 (Washington, D.C.: U.S. Government Printing Office, 1975), 44–63.

7. Stone, *Family, Sex and Marriage*.

8. See Ariès, *Western Attitudes toward DEATH*.

9. Tompkins, *Sensational Designs*.

10. Douglas, *Feminization of American Culture*.

11. See the many moving examples culled from the letters of ordinary Americans in Saum, "Death in the Popular Mind," 30–48.

12. Sigourney forged a long and successful career writing poetry and sketches for gift books such as *The Token*, then later for *Godey's Lady's Book* and other fast-rising periodicals. Throughout her life she also wrote many memorial tributes for friends and acquaintances, like the former students she commemorated at yearly reunions of the school in which she had once taught. She also, for additional income, wrote elegies by request, including one for "a canary-bird, which had accidentally been starved to death," or one for a child "drowned in a barrel of swine's food." It has been hard for modern critics to write about Mrs. Sigourney without ridicule, especially since the tone was set by her Hartford neighbor, Mark Twain, in his characterization of the lachrymose Emmeline Grangerford in *The Adventures of Huckleberry Finn* (1884). Emmeline painted mourning pictures with titles like "Shall I Never See Thee More, Alas," "I Shall Never Hear Thy Sweet Chirrup More Alas," or "And Art Thou Gone Yes Thou Art Gone Alas," and wrote poems with titles like "Ode to Stephen Dowling Botts, Dec'd." In fact, like Mrs. Sigourney, she specialized in the prompt production of "tributes" to the recently deceased. "The neighbors said it was the doctor first, then Emmeline, then the undertaker—the undertaker never got in ahead of Emmeline but once, and then she hung fire on a rhyme for the dead person's name." Mark Twain, *The Adventures of Huckleberry Finn* (1884; New York: Harper & Brothers, Stormfield Edition, 1918), 141–43. On Sigourney, see Gordon S. Haight, *Mrs. Sigourney: The Sweet Singer of Hartford* (New Haven: Yale University Press, 1930), and Douglas, *Feminization of American Culture*, especially 205–7.

13. The actor Charles Macready recorded in his diary an agonizing minute-by-minute account of his four days at his dying daughter's bedside in 1850; when it was published in 1912 the editor commented, "To those who have suffered a great bereavement every word of this heart-rending record will go home. The reality and vividness of its anguish have certainly no parallel in fiction." William Toynbee, ed., *The Diaries of William Charles Macready, 1833–1851* (London: Chapman and Hall, 1912), 2:461.

14. As Ann Douglas has pointed out, Sigourney even scripted her own death-

bed scene: her dying words echoed those she had put in the mouth of a fictional character years before. See Douglas, "Heaven Our Home," and later in *The Feminization of American Culture*.

15. Sigourney, *Poems* 144, 94. Future references will be found in parentheses in the text.

16. In a recent book, J. Gerald Kennedy has argued that the very act of writing was, for Poe, the product of his encounter with death. Kennedy, *Poe, Death, and the Life of Writing*. There were biographical reasons for Poe's repeated exploration of the theme of bereavement and separation. His mother had died of tuberculosis when he was almost three years old, and although he later said he did not remember her, biographers have speculated that his fascination with loss of breath, suffocation, and premature burial might be related to his mother's slow and painful death. These events are most notably discussed in Marie Bonaparte, *The Life and Works of Edgar Allan Poe: A Psycho-Analytic Interpretation*, trans. John Rodker (London: Imago, 1949). See also the off-beat but penetrating comments of Daniel Hoffman in *Poe, Poe, Poe, Poe, Poe, Poe, Poe* (Garden City, N.Y.: Doubleday, 1972). Thomas Ollive Mabbott believed Poe was too young to have attended his mother's funeral (see "Annals" in *Collected Works of Edgar Allan Poe*, Vol. 1, Poems, Thomas Ollive Mabbott, ed. [Cambridge, Mass.: Harvard University Press, 1969], 552), but I do not think that the presence of a young child would have been considered unusual at the time.

17. Edgar Allan Poe, "The Raven," in *Collected Works of Edgar Allan Poe*, Mabbott, 1:364–69.

18. Edgar Allan Poe, "Berenice," *Collected Works of Edgar Allan Poe: Tales and Sketches, 1831–1842*, ed. Thomas

Ollive Mabbott, with the assistance of Eleanor D. Kewer and Maureen C. Mabbott (Cambridge, Mass.: Harvard University Press, 1978), 214.

19. See the introduction to "Berenice," in ibid., 207–8.

20. Ibid., 217.

21. Edgar Allan Poe, "The Fall of the House of Usher," in ibid., 410.

22. Ibid., 416.

23. See Kennedy's chapter, "The Horrors of Translation: The Death of a Beautiful Woman" in *Poe, Death, and the Life of Writing*, 60–88.

24. See Penny, *Church Monuments*.

25. See Penny, "English Church Monuments."

26. See Stowe's discussion of the tomb to Princess Charlotte in *Sunny Memories of Foreign Lands*, 2:46–48.

27. See French, "Cemetery as Cultural Institution," 70. See also Cornelia W. Walter, *Mount Auburn Illustrated* (New York: R. Martin, 1851); Wilson Flagg, *Mount Auburn: Its Scenes, Its Beauties, and Its Lessons* (Boston: James Munroe, 1861); and Edmund V. Gillon, Jr., *Victorian Cemetery Art* (New York: Dover, 1972). Mount Auburn's sculpture has been discussed in Sharf, "Garden Cemetery and American Sculpture."

28. Grace Greenwood [Sara Jane Lippincott], *Greenwood Leaves: A Collection of Sketches and Letters* (Boston: Ticknor, Reed, and Fields, 1850), 192–93.

29. Albee, *Henry Dexter*, 59–60. Hawthorne referred to *The Binney Child* in one of his short stories, "The New Adam and Eve," first published in 1843, and included in the collection *Mosses from an Old Manse* (1846).

30. The sculpture, badly weathered, was removed in 1934; see the description of it in Craven, *Sculpture in America*, 194.

31. Both sculptures were exhibited

at the Royal Academy in London and inspired poetry, commentary, and reviews in British and American journals; Chantrey's sculpture was reproduced in engravings and in ceramic ware. See Penny, *Church Monuments*, 115–18.

32. For information on *Medora*'s exhibition in the United States, see Wright, *Letters of Horatio Greenough*, 135n.

33. Quoted in *A Concise History of, and Guide Through Mount Auburn* (Boston: Nathaniel Dearborn, 1843), 60.

34. Lydia Sigourney, "Infant Child of C. J. F. Binney," in ibid., 59.

35. Poem by Miss C. F. Orne, quoted in Albee, *Henry Dexter, Sculptor*, 61.

36. Sigourney, "Not Dead, But Sleepeth," in *Poems* (1842), 15–16. The image of the sleeping dead who rise was used by Mrs. Hemans in a poem suggested by Chantrey's monument, "The Child's Last Sleep." See Penny, *Church Monuments*, 119.

37. See the photograph reproduced in Webster, *Erastus D. Palmer*, 181.

38. In a letter to Palmer, Williams commented, "We have a lingering doubt as to the nudeness of that part of the person of the model just above the drapery. If some slight undergarment, a fold of drapery, could be introduced to cover that particular part only, it might, considering the monumental purpose of the statue and the prejudices of the community, be desirable." J. Watson Williams to Erastus Dow Palmer, August 29, 1865, quoted in Webster, *Erastus D. Palmer*, 188. Palmer may well have adjusted the drapery to meet the Williams' objections, for he wrote on November 12, 1857, that he had "changed the drapery somewhat." E. D. Palmer to J. Watson Williams, November 12, 1757, in Webster, 275.

39. Erastus D. Palmer to J. Watson Williams, March 11, 1856, in ibid., 268.

See also Webster's entry on *Sleep*, 174–75.

40. Ibid., 188.

41. Unfortunately, the commission is poorly documented. In an extremely thorough discussion of the sculpture, art historian Barbara Groseclose wrote that "repeated scholarly efforts" had been unable to uncover many of the facts about Falconnet and her family, the cause of her death, or the reason for the choice of Hosmer as the artist. Groseclose, "Harriet Hosmer's Tomb to Judith Falconnet."

42. This much information about the commission was given by Hosmer's friend and neighbor, Lydia Child, in a biographical sketch published in 1861. Child, "Harriet E. Hosmer."

43. Groseclose, "Harriet Hosmer's Tomb to Judith Falconnet."

44. See Child, "Harriet E. Hosmer," 1. Child misstates Hosmer's year of birth, but if she is correct that Hosmer's sister died when she was twelve years old, that would place the event in 1842. Hosmer's father, Hiram Hosmer of Watertown, is listed as the owner of plot number 367 in *Guide Through Mount Auburn*, 24, 38.

45. Mr. Layard to Madame Falconnet, quoted in Child, "Harriet E. Hosmer," 6.

46. "Resignation. Sir F. Chantrey, R. A.," *The Art-Union* 9 (1847): 204.

47. The two sculptures were paired, and the chronology confirmed, in "Harriet Hosmer," *Cosmopolitan Art Journal* 3 (December 1859): 216.

48. Hawthorne, *French and Italian Notebooks*, 158. See also Barnett, "American Novelists and the Portrait of Beatrice Cenci." Today the painting is believed to be neither a portrait of Beatrice Cenci nor a work of Guido Reni. See D. Stephen Pepper, *Guido Reni* (New York: New York University

Press, 1984), 304. Pepper suggests the painting may be a sibyl by Elisabetta Sirani, based on a tradition derived from Guido and his studio.

49. Percy Bysshe Shelley, *The Cenci*, vol. 2 in *The Works of Percy Bysshe Shelley in Verse and Prose*, ed. Harry Buxton Forman (London: Reeves and Turner, 1880), 131.

50. "Art Gossip," *Cosmopolitan Art Journal* 2 (December 1857): 58.

51. Thurston, "Harriet G. Hosmer," 577. See also the comments in "Art Gossip"; "The Beatrice Cenci," *The Crayon* 4 (December, 1857):379; and L. Maria Child, "Miss Harriet Hosmer," reprinted from the *Boston Daily Advertiser* in *Littell's Living Age* 56 (March 13, 1868): 698.

52. Wayne Craven provides basic biographical information in *Sculpture in America*. More extended treatment may be found in Gardner, "Memorials of an American Romantic," and Hennessey, "White Marble Idealism." Much of my information about Brackett has been culled from primary sources.

53. The call for a subscription to purchase *Nydia* is found in a circular, "To Admirers of Fine Arts," September 27, 1859. Chicago Historical Society. Longworth's comment, from a letter to Hiram Powers, September 22, 1859, is quoted in Craven, *Sculpture in America*, 187. Longworth was attacked for his stinginess by another disappointed Cincinnati artist, John Frankenstein, in *American Art: Its Awful Altitude, A Satire*, which took for its epigraph the exclamation "American Artists, *ah!/* American Patrons, PSHAW!!/ American Critics, BAH!!!" See Frankenstein, *American Art: Its Awful Altitude, A Satire*, ed. William Coyle (1864. Rpt. Bowling Green, Ohio: Bowling Green University Popular Press, 1972), title page and 14.

54. [Brackett], *Brackett's Works*.

55. See the report of a meeting of art patrons signed by Edward Everett, March 4, 1852, in the Boston Athenaeum. A committee was formed to raise three thousand dollars to purchase the sculpture. One art historian reported that "the custodian of the funds set aside for the piece's purchase found better use for them." Hennessey, "White Marble Idealism." The sculpture remained on exhibit at the Boston Athenaeum until that institution returned it to the sculptor in 1904; after apparently placing it for a time in Mount Auburn Cemetary, Brackett subsequently gave it to the Worcester Art Museum. See Hennessey, "White Marble Idealism," 8, and Mabel Munson Swan, *The Athenaeum Gallery, 1827–1873: The Boston Athenaeum as an Early Patron of Art* (Boston: Boston Athenaeum, 1940), 156.

56. See Craven, *Sculpture in America*, 189. Craven thought Brackett's bust of John Brown was an imaginary portrait, but an article published on the occasion of Brackett's death describes his trip to visit Brown. [Sanborn], "The Late Edward Brackett."

57. See Penny, *Church Monuments*, 94–95.

58. T. B. Read, "The Ascension," in *Brackett's Works*.

59. *Brackett's Works*.

60. By 1861, most of the monuments that had been built at Mount Auburn were architectural rather than figurative. See engravings in Wilson Flagg, *Mount Auburn: Its Scenes, Its Beauties, and Its Lessons* (Boston: James Munroe, 1861).

61. Brackett, *Twilight Hours*, 70. The central metaphor of this poem suggests Horatio Greenough's statue, *The Ascension of a Child Conducted by an Infant Angel* (1833), which asked viewers to distinguish between two babyish figures, and see a mortal child in one, an

angel in the other. Brackett's poetry reflects the influence of Washington Allston, whose bust Brackett had exhibited the previous year.

62. Brackett, *Twilight Hours*, 65–66. Thomas O. Mabbott did not include Brackett's poem in his discussion of predecessors of Poe's "Annabel Lee," but perhaps it deserves mention. *Collected Works of Edgar Allan Poe*, 1:468–76.

63. Gerdts mentioned Margaret Fuller in *American Neoclassic Sculpture*, 90. However, I have seen no nineteenth-century comments that make that connection. The date of Brackett's completed clay can be inferred from the comments of Grace Greenwood in a letter dated January 9, 1850, published in Greenwood, *Greenwood Leaves*, 2d series (1852), 284–88.

64. Brackett, *My House*, 71–73.

65. See the discussion of *Death on the Pale Horse* in Helmut von Erffa and Allen Staley, *The Paintings of Benjamin West* (New Haven: Yale University Press, 1986), 388–91.

66. A contemporary writer was reminded of Dupré's sculpture when he viewed *Shipwrecked Mother and Child*, although he could not recollect its name. A writer in the *New York Tribune*, quoted in *Edward A. Brackett's Marble Group of the Shipwrecked Mother and Child*, 6.

67. Exceptions include the dramatic monument to Princess Charlotte by M. C. Wyatt at Windsor, which showed the princess' body sprawled under a shroud. See Penny, "English Church Monuments," 326–30. Among others, Stowe commented on this sculpture in *Sunny Memories of Foreign Lands*, 2:46–48.

68. Leland, "Brackett's Wreck," 371–72.

69. In a letter to Asher B. Durand, Richard Henry Dana acknowledged that attendance at the exhibition had not lived up to his expectations. He added that Greenough had "spoken to me & others of it, in private, with even more praise than he has given it publicly, as he wished to avoid all appearance of a *puff* in that communication." R. H. Dana to Asher B. Durand, March 3, 1852, Manuscripts Collection, Boston Athenaeum.

70. Horatio Greenough to Richard Henry Dana, February 23, 1852, in Wright, *Letters of Horatio Greenough*, 406–7.

71. Letter 18, New Brighton, Pennsylvania, January 9, 1850, from Greenwood *Greenwood Leaves*, 2d series (1852), 287. This description was reprinted in the pamphlet that accompanied the sculpture's exhibition in New York, *Edward A. Brackett's Marble Group of the Shipwrecked Mother and Child*, 3–5.

72. Greenwood, *Greenwood Leaves*, 2d series (1852), 286–87.

73. *Edward A. Brackett's Marble Group of the Shipwrecked Mother and Child*, 8.

74. Leland, "Brackett's Wreck," 372.

75. *Edward A. Brackett's Marble Group of the Shipwrecked Mother and Child*, 7.

76. Ibid., 9.

77. Ibid., 5, 10.

78. Ibid., 11.

79. *Bulletin of the American Art-Union*, July 1849, 23–24, cited in Rosemary Booth, "A Taste for Sculpture."

80. R. H. Dana to Asher B. Durand, March 3, 1852. Manuscripts collection, Boston Athenaeum.

81. *Edward A. Brackett's Marble Group of the Shipwrecked Mother and Child*, 6.

82. Ibid., 5, 10.

83. Leland, "Brackett's Wreck," 372–73.

84. *Edward A. Brackett's Marble Group of the Shipwrecked Mother and Child*, 6, 7, 9.

85. Craven, *Sculpture in America*, 188.

86. William Butler Yeats, "Leda and the Swan," *The Collected Poems of W. B. Yeats* (London: Macmillan & Co., 1965), 241.

87. Penny, "English Church Monuments," 332.

CHAPTER 6: THE
PROBLEMATICS OF
FEMALE POWER

1. Lewis, "Art and Artists of America," 399. For biographical information on Lewis, see Sarah Josepha Hale, *Woman's Record . . .* (New York: Harper & Brothers, 1855), 727–28.

2. Letter 18, New Brighton, Pennsylvania, January 9, 1850, from Greenwood, *Greenwood Leaves*, 2d series (1852), 287. Her description was reprinted in the pamphlet that accompanied the sculpture's exhibition in New York, *Edward A. Brackett's Marble Group of The Shipwrecked Mother and Child*, 3–5.

3. Browning, "Hiram Powers' 'Greek Slave,'" 3:178.

4. See James, *William Wetmore Story*, 1:257. Scholars include in this group Sarah Fisher Ames, Louisa Lander, Emma Stebbins, Margaret Foley, Florence Freeman, Anne Whitney, Edmonia Lewis, Blanche Nevin, and Vinnie Ream Hoxie. For a catalog of the works of American women sculptors in Rome, see Nicolai Civosky, Jr., Marie H. Morrison, and Carol Ockman, *The White, Marmorean Flock*, introduction by William H. Gerdts, Jr., Catalogue of an Exhibition at Vassar College Art Gallery, April 4–April 30,

1972, Poughkeepsie, New York.

5. Thurston, "Harriet G. Hosmer," 566–98. See also Mrs. Ellet, *Women Artists in all Ages and Countries* (New York: Harper & Brothers, 1859), pp. 349–69.

6. "Harriet Hosmer, the Woman Eminent in Sculpture," *The Phrenological Journal and Life Illustrated* 54 (March, 1872):169–71.

7. Ellet, *Women Artists*, 535.

8. See, for instance, Mary Jacobus, *Reading Women: Essays in Feminist Criticism* (New York: Columbia University Press, 1986), 110–36.

9. Hawthorne, *French and Italian Notebooks*, 158–59.

10. "Harriet Hosmer," *Cosmopolitan Art Journal*, and Child, "Harriet E. Hosmer," 1–2. Some of the same stories about her boyish childhood were repeated in her obituary, " 'Most Famous of American Women Sculptors,' Miss Harriet Hosmer of Watertown," *Boston Sunday Globe*, March 1, 1908, 11.

11. For help in estimating Sophia Peabody Hawthorne's height, I would like to thank Megan Marshall.

12. J. N. McDowell to Harriet Hosmer, October 1852, quoted in Carr, *Harriet Hosmer, Letters and Memories*, 19.

13. As reported in Child, "Harriet E. Hosmer," 3.

14. John Gibson to Harriet Hosmer, September 5, 1857, and August 31, 1858, in Carr, *Harriet Hosmer, Letters and Memories*, 87, 131.

15. "Florentia," "A Walk Through the Studios of Rome, Part IV," 354.

16. "Miss Hosmer, the Sculptor," *New York Times*, February 3, 1858, 2. A similar story was told by her old friend L. Maria Child in "Harriet E. Hosmer," 1.

17. Child, "Miss Harriet Hosmer," 697.

18. In 1854 her father suffered financial losses, and Hosmer's career seemed to be in jeopardy. It was at this point that she turned to the fancy subjects, *Puck* and later *Will O' the Wisp*, which provided the basis for her financial security. More than thirty copies of *Puck* were eventually sold. One biographical account suggests that she chose these subjects specifically with the goal of gaining financial independence. See Ellet, *Women Artists*, 366–67. Hosmer's correspondence indicates her determination to find a way to support herself. See the letter to Wayman Crow, January 9, 1854, quoted in Carr, *Harriet Hosmer, Letters and Memories*, 28–30. Later Hosmer obtained one public commission, for the statue of Thomas Hart Benton, and competed unsuccessfully for two others, monuments to Lincoln. See Civosky, Morrison, and Ockman, *White, Marmorean Flock*, entry on Hosmer.

19. See engravings of the following sculptures: W. Calder Marshall, *Sabrina*, *Art-Journal* 11 (1849); P. MacDowell, *Early Sorrow*, *Art-Journal* n.s. 3 (1851); J. H. Foley, *Innocence*, *Art-Journal* n.s. 3 (1851); J. Wyatt, *Musidora*, *Art-Journal* n.s. 4 (1852); W. Theed, *Psyche*, *Art-Journal* n.s. 4 (1852); P. MacDowell, *The Day-Dream*, *Art-Journal* n.s. 1 (1855).

20. See the very full discussion of this sculpture and its sources in Gerdts, "The *Medusa* of Harriet Hosmer."

21. Apparently Hosmer went to great lengths to model the snakes, hiring a herdsman to catch a live snake, which she chloroformed, cast in plaster, and then released. See " 'Most Famous of American Women Sculptors,' Miss Harriet Hosmer of Watertown," *Boston Sunday Globe*.

22. From a letter written by Rev. Robert Collyer in 1867, quoted in Carr, *Harriet Hosmer, Letters and Memories*, 222.

23. See the discussion of this work in Civosky, Morrison, and Ockman, *White, Marmorean Flock*, entry 1.

24. *London Art-Journal*, quoted in Carr, *Harriet Hosmer, Letters and Memories*, 42.

25. Alfred Tennyson, "Oenone," in *The Poetic and Dramatic Works of Alfred Lord Tennyson*, Students' Cambridge Edition (Boston: Houghton Mifflin, 1898), 38–42.

26. Advertisements in the Boston papers claimed an attendance of 25,000, and a friend wrote Hosmer that more than 6,000 had seen it in New York. "Queen Zenobia," *Boston Daily Advertiser*, March 14, 1865; see also Carr, *Harriet Hosmer, Letters and Memories*, 202.

27. One of her English well-wishers had specifically mentioned Powers when he suggested she send something to the exhibition. Sir Henry Layard to Harriet Hosmer, June 27, 1860, quoted in Carr, *Harriet Hosmer, Letters and Memories*, 160.

28. Anyone who works on Hosmer must be indebted to the extensive bibliography prepared by Curran, "Hosmeriana," copy in the Schlesinger Library, Radcliffe College.

29. See the very thorough discussion of Hosmer's work on the statue and her relationship to Jameson in Waller, "Artist, Writer, and Queen."

30. On Jameson's ideas, see Clara Thomas, *Love and Work Enough: The Life of Anna Jameson* (Toronto: University of Toronto Press, 1967).

31. Jameson, *Celebrated Female Sovereigns*, 2 vols. (London: Henry Colburn and Richard Bentley, 1831) 1:xi, xiii.

32. Child, "Harriet E. Hosmer," 6.

33. See Agnes Carr Vaughan, *Zenobia of Palmyra* (Garden City, N.Y.:

Doubleday, 1967), 9–10. This book narrates the story of Zenobia with some poetic license, but it carefully explains what is known from which sources.

34. Edward Gibbon, *The History of the Decline and Fall of the Roman Empire*, with notes by Dean Milman and M. Guizot, 8 vols. (1776–78. Rpt. London: John Murray, 1854), 2:20.

35. Gibbon asserted "it is *almost* impossible that a society of Amazons should ever have existed either in the old or new world," and in the 1854 edition, one of the commentators added that the legend of the Amazons may have originated when the men of some tribe were massacred, leaving the women to carry on alone until the male children grew up to assume their rightful role. Gibbon, *Decline and Fall*, 2:27.

36. Ibid., 2:21, 26.

37. [William Ware], *Letters from Palmyra, by Lucius Manlius Piso, to His Friend Marcus Curtius, at Rome, Now First Translated and Published*, 2 vols. (London: Richard Bentley, 1838), 2:326. This book was later reprinted with the title *Zenobia; or, the Fall of Palmyra*.

38. Nathaniel Hawthorne, *The Blithedale Romance*, in *The Blithedale Romance and Fanshawe*, Centenary Edition of the Works of Nathaniel Hawthorne, vol. 3 (1852. Rpt. Columbus: Ohio State University Press, 1964), 224.

39. Hawthorne, *Marble Faun*, 4.

40. Hawthorne, *French and Italian Notebooks*, 509.

41. This word is used in a letter from Lydia Child to Hosmer, October 21, 1859, Folder #18, Hosmer Collection, Schlesinger Library. It is quoted by Waller, "Artist, Writer, and Queen," 28.

42. Gibbon, *Decline and Fall*, 2:28.

43. A twentieth-century classicist thought Zenobia retained her sexual independence, although she also reported legends of children descended from Zenobia and Aurelian. Vaughan, *Zenobia of Palmyra*, 213, 229.

44. L. M. C., "Miss Hosmer's Zenobia," *Boston Evening Transcript*, February 2, 1865, 2.

45. Quoted in "Harriet Hosmer," *Cosmopolitan Art Journal*, 217.

46. "Miss Hosmer's Zenobia," *New York Evening Post*, November 12, 1864, 2.

47. "Miss Hosmer's Statue of Zenobia," *The New Path* 2 (April 1865): 55, 54.

48. "Mr. Alfred Gatley," *Art-Journal*, n.s. 2 (1863):181.

49. Harriet Hosmer, "The Process of Sculpture," *Atlantic Monthly* 14 (December 1864):734–37. "Correspondence," *Art-Journal* n.s. 3 (1864):27.

50. Harriet Hosmer to Wayman Crow, November 1867, in Carr, *Harriet Hosmer, Letters and Memories*, 250.

51. "Miss Hosmer's Studio at Rome," *Harper's Weekly* 3 (May 7, 1859):293.

52. The engraving shows Zenobia bare-headed, but we know that Hosmer had given her a helmet or a diadem even in early versions, for in October 1859, Anna Jameson commented on a photograph that showed a diadem even more prominent than that of the finished statue. Anna Jameson to Harriet Hosmer, October 10, 1859, quoted in Carr, *Harriet Hosmer, Letters and Memories*, 151.

53. *Zenobia, by Harriet Hosmer, Now on Exhibition at the Fine Art Institute*.

54. "Zenobia by Harriet Hosmer," Boston Public Library.

55. [Ludlow], "Harriet Hosmer's Zenobia." Also reprinted in *Boston Evening Transcript*, January 17, 1865, 1.

56. See illustration and description in Strahan [Shinn], *Art Treasures of America*, 25–27.

57. Anna Ticknor, "Zenobia, Queen of Palmyra," quoted in Carr, *Harriet*

Hosmer, Letters and Memories, 200.

58. William B. Philpot [?], "To Miss Hosmer—With the Writer's Respectful Regards," dated Rome, April '59. Harriet Hosmer Papers, Schlesinger Library, Radcliffe College.

59. Harriet Hosmer, June 22, 1860. Quoted in Thurston, "Harriet G. Hosmer."

60. John Gibson to Wayman Crow, October 25, 1861, in Carr, *Harriet Hosmer, Letters and Memories*, 181.

61. While working on *Zenobia*, she had written to a friend that the statue was "of a size with which I might be compared as a mouse to a camel." Harriet Hosmer to Cornelia Carr, March 4, 1858, in Carr, *Harriet Hosmer, Letters and Memories*, 122.

62. Ibid., 122.

63. Carr's biography of Hosmer contains many references to the Queen of Naples, whom Hosmer visited in Germany and England. See ibid., 297–98, for example.

64. From a description by Clara Tschudi, quoted in ibid., 297.

65. From "a friend in Rome," quoted in ibid., 271.

66. This statue is presently unlocated. William Gerdts believes it may have been destroyed in the earthquake of 1906. Gerdts, introduction to Civosky, Morrison, and Ockman, *White, Marmorean Flock*, 7. For the history of the commission and the vicissitudes of planning for the World's Columbian Exposition, see Jeanne Madeline Weimann, *The Fair Women* (Chicago: Academy Chicago, 1981), 39–40, 68–70.

67. H. W. R. S. to Harriet Hosmer, January 19, 1894, quoted in Carr, *Harriet Hosmer, Letters and Memories*, 329.

CHAPTER 7: WOMAN'S OTHER FACE

1. See the classic discussion of the femme fatale in Praz, *Romantic Agony*, chap. 4. See also Kingsbury, "Femme Fatale and Sisters," 182–205; and Bade, *Femme Fatale*. Virginia M. Allen places the development of the image of the femme fatale in the mid–nineteenth century in *Femme Fatale, Erotic Icon*, an expansion of her 1979 Ph.D. thesis. A thorough study of female demonism in late nineteenth-century art, literature, and popular culture may be found in Dijkstra, *Idols of Perversity*.

2. Auerbach, *Woman and the Demon*, 7. Auerbach's first two chapters, on victims and queens, present an analysis of the covert relationship between power and powerlessness quite similar to my own, which I had already elaborated in lectures at the time the book appeared. I have learned much from her thoughtful study, which focuses primarily on texts and art objects as windows into Victorian culture. My study, of course, seeks to place art in a more concrete cultural context through analysis of audience response.

3. Dijkstra, *Idols of Perversity*. Dijkstra insists that these images represent an "iconography of misogyny" (p. viii), whereas I see them as more organically connected to the images that idealized women.

4. Poe, "Ligeia," in *Collected Works of Edgar Allan Poe: Tales and Sketches, 1831–1842*, ed. Thomas Ollive Mabbott with the assistance of Eleanor D. Kewer and Maureen C. Mabbott (Cambridge, Mass.: Harvard University Press, 1978), pp. 310–34. All further quotations refer to this edition.

5. See Praz, *Romantic Agony*, chap. 4.

6. See the introduction to "Ligeia" in *Collected Works of Edgar Allan Poe, Tales and Sketches*, 306.

7. Kennedy, *Poe, Death, and the Life of Writing*, 86.

8. See Gerdts, *American Neoclassic Sculpture*, 89.

9. [Friedrich Heinrich Karl] de la Motte Fouqué, *Undine*, F. E. Burnett, trans. (Philadelphia: Henry Altemus, 1895), 85. All further quotations are from this edition.

10. "Chauncey B. Ives," *Cosmopolitan Art Journal* 4 (December 1860), 164.

11. See Hans Christian Andersen, "The Little Mermaid," first published in 1837 and found, for example, in Hans Christian Andersen, *Wonder Stories Told for Children* (New York: Hurd and Houghton, 1878), 239–62. See Auerbach's discussion of Burne-Jones and the mermaid theme in *Woman and the Demon*, 90–96.

12. See Craven, *Sculpture in America* 286.

13. See Gerdts, *Great American Nude*, 91.

14. Sheirr, "Joseph Mozier."

15. See J. A. Phillips, *Eve: The History of an Idea* (San Francisco: Harper & Row, 1984), chaps. 4 and 5.

16. See the interesting discussion of this work in Leo Steinberg, "Eve's Idle Hand," *Art Journal* 35 (Winter 1975/6), also discussed in Phillips, *Eve*, 67–70.

17. John Milton, *Paradise Lost* IV, 800–803; IX, 1128–31.

18. See Allen, *Femme Fatale, Erotic Icon*, for a discussion of the figure of the temptress in European art.

19. See Ruth Butler, "Religious Sculpture in Post-Christian France," in Peter Fusco and H. W. Janson, eds., *The Romantics to Rodin: French Nineteenth-Century Sculpture from North American Collections* (Los Angeles: Los Angeles County Art Museum and George Braziller, 1980), 90–94.

20. Visitors to Powers' studio saw both statues together, and one patron apparently changed his order from one to the other. Powers at first planned to use *Eve Tempted* to establish his American reputation and changed his mind only after receiving such enthusiastic reviews from the London exhibition of *The Greek Slave*. See Reynolds, *Hiram Powers and His Ideal Sculpture*, 145, 153.

21. Hiram Powers to Nicholas Longworth, April 22, 1839, quoted in ibid., 133.

22. Hiram Powers to Col. John Preston, May 20, 1840, quoted in ibid., 135.

23. "You say, sir it is your *first* statue —any man might be proud of it as his last." Quoted in Lester, *Artist, Merchant, and Statesman*, 1:84. In 1856 the *Cosmopolitan Art Journal* featured an engraving of a copy of Thorwaldsen's *Aphrodite* in the same issue as a reproduction of Powers' *Eve. Cosmopolitan Art Journal* 1 (October 1856):52, 55.

24. Dewey, "Powers' Statues," 160.

25. Taylor, "'Eve' of Powers."

26. H. F. Lee, *Familiar Sketches of Sculpture and Sculptors*, 2 vols. (Boston: Crosby, Nichols, 1854) 2:151.

27. Lady Lovelace Stamer Bart, February 8, 1842, quoted in Reynolds, *Hiram Powers and His Ideal Sculptures*, 138–39.

28. In 1845, Powers had remodeled *Eve Tempted*, changing the pose slightly and altering the face. This version found its way into the collection of A. T. Stewart and was lost after the liquidation of that collection. It was, however, engraved in several places, including the *Cosmopolitan Art Journal*, and the plaster version may be found in the National Museum of American Art in Washington, D.C. From the point of view of this discussion, its features—a stress on Eve's innocence and the threat of the coming transformation—remain the same.

29. Hiram Powers to James Lenox, December 27, 1853, quoted in Reynolds,

Hiram Powers and His Ideal Sculpture, 180.

30. Hiram Powers to Sidney Brooks, January 1, 1862, quoted in ibid., 203.

31. See ibid., 209.

32. N. D. Morgan to Hiram Powers, March 13, 1872, quoted in ibid., 209–10.

33. See the biographical sketch of Bartholomew, "Edward S. Bartholomew," *Cosmopolitan Art Journal,* and the poem, Lydia H. Sigourney, "Edward Sheffield Bartholomew," *Cosmopolitan Art Journal* 4 (March 1860):5.

34. For a comprehensive account of theology and church organization during this period, see Ahlstrom, *Religious History of the American People,* Part 4. William R. Hutchinson wrote about the rise of Unitarian thought in *Transcendentalist Ministers: Church Reform in the New England Renaissance.* Daniel Walker Howe offered a thorough intellectual history of Unitarianism in *Unitarian Conscience: Harvard Moral Philosophy, 1805–1861.* Howe shed light on the social and economic implications of the Unitarian movement.

35. Andrew Preston Peabody, *Lectures on Christian Doctrine,* quoted in Ahlstrom and Carey, *American Reformation,* 36. See the introduction of this book for a brief but thorough discussion of Unitarian theology.

36. Henry Ware, quoted in Ahlstrom and Carey, *American Reformation,* 202.

37. According to one historian, seventeen members of the original Transcendentalist discussion circle were ministers, but six eventually left their calling, and seven others changed denominations. Hutchinson, *Transcendentalist Ministers,* 39.

38. See the excellent summary of Swedenborg's ideas and their relationship to liberal theology in Ahlstrom, *Religious History,* 483–88.

39. William Greenleaf Eliot, quoted in Ahlstrom and Carey, *American Reformation,* 272–73. Eliot was the grandfather of T. S. Eliot and was a founder of Washington University in St. Louis.

40. In his influential book, *The American Adam,* R. W. B. Lewis traced the nineteenth-century literary response to the notion of the American as a new Adam. Lewis actually says very little about the theological uses of the figure of Adam during the nineteenth century, and almost nothing about Eve. In other books, the figure of Eve is used as a shorthand for American women, but again the theological context is not examined in any detail. See Fryer, *Faces of Eve.*

41. Theodore Parker, "Home Considered in Relation to its Moral Influence," in *Sins and Safeguards of Society,* ed. Samuel B. Stewart (Boston: American Unitarian Association, 1907), 207–9, 218.

42. Horace Bushnell, *Christian Nurture* (1847, 1861, 1888. Rpt. New Haven: Yale University Press, 1967), 20, 22, 27, 4.

43. Sarah J. Hale, *Manners; or, Happy Homes and Good Society All the Year Round* (1868. Rpt. New York: Arno, 1972), 19, 310, 20–22.

44. His book presented biographies of twelve biblical women with the purpose of explicating, he put it in the dedication, the "true position and world wide influence" of women. George C. Baldwin, *Representative Women, from Eve, the Wife of the First, to Mary, the Mother of the Second Adam* (1855; New York: Sheldon, 1860), 18.

45. Ibid., 19, 21, 24, 27–28, 30, 33.

46. Ibid., 34–38.

47. Sigourney, *Poems* (New York: Leavitt and Allen, 1860), 208–11.

48. See Fusco and Janson, *Romantics to Rodin,* 252–53, 90–91.

49. *The First Prayer* is so convincing

as a genre scene that I have never seen it noted that the scene actually portrays Eve with Cain and Abel.

50. See Gerdts, "Chauncey Bradley Ives," 715, and catalog entry on Pandora in *Carved and Modeled: American Sculpture 1810–1940*, 25.

51. See J. A. Phillips, *Eve: The History of an Idea*, 22–23.

52. Jane Harrison, "Pandora's Box," *Journal of Hellenic Studies* 20 (1900): 108–9, cited in Phillips, *Eve*, 20.

53. Hesiod, "Theogeny," *Works and Days and Theogeny*, trans. Richard Lattimore (Ann Arbor, Mich.: University of Michigan Press, 1959), line 585; "Works and Days," line 374. Quoted in Phillips, *Eve*, 20.

54. See Türck, "Myths of Pandora and the Fall of Man," 431–54. The best discussion of the history and iconography of the Pandora legend is Panofsky and Panofsky, *Pandora's Box*.

55. See Panofsky and Panofsky, *Pandora's Box*, 15–18. See also Edward Tripp, *Crowell's Handbook of Classical Mythology* (New York: Thomas Y. Crowell, 1970), 503–6.

56. See Auerbach, *Woman and the Demon*, 50.

57. Exhibition catalog, quoted in Craven, *Sculpture in America*, 286.

58. "Florentia," Part IV, *Art-Journal* n.s. 1 (1855):228.

59. "Chauncey B. Ives," *Cosmopolitan Art Journal*, 164. The second quotation is found in a letter to the *Newark Daily Advertiser*, reprinted in *Bulletin of the American Art-Union*, April 1851, and quoted by Jan Seidler Ramirez in her catalogue entry on *Pandora* in Greenthal, Kozol, and Ramirez, *American Figurative Sculpture*, 45.

CHAPTER 8: DOMESTICATING THE DEMONIC

1. Edward Bulwer Lytton, "Preface to the Present Edition," *Lucretia or the Children of Night* (Charleston, S.C., Martin & Hoyt, n.d.), iii.

2. Greenwood, *Greenwood Leaves* (1850), 319–21. Greenwood, who published several volumes of sentimental sketches and letters, admired the portrayals of female victimization in *The Greek Slave* and *Shipwrecked Mother and Child* and saw only the conventionally feminine face of Harriet Hosmer, "the *child-woman*, as I call her . . . I have never known a more charming and lovable person." Greenwood's imagination was drawn to tales of melodrama and melancholy, such as her meditations on an antique Roman lamp: "I never use it without losing myself in dreamy conjectures concerning the dead whose tomb it once feebly illuminated." Greenwood, *Haps and Mishaps of a Tour in Europe*, 217, 209–10. Yet, as her comments on *Lucretia* suggest, there were certain narratives she refused to contemplate.

3. See Bade, *Femme Fatale*, 13.

4. Story recounted his mother's reaction in an undated letter, ca. 1880, to Enrico Nencioni in the Berg Collection, New York Public Library. On Story's early career, see the thoughtful comments of Seidler [Ramirez], *Career of William Wetmore Story*, 1:1–146.

5. Story was one of the participants in the Conversations directed by Margaret Fuller, described by Caroline Dall in *Margaret and Her Friends, or Ten Conversations with Margaret Fuller* Reported by Caroline W. Healey (Boston: Roberts Brothers, 1895).

6. Seidler [Ramirez] points out the influence of Allston and also of Charles Sumner in encouraging Story's inter-

est in art (*Career of William Wetmore Story*).

7. James, *William Wetmore Story*, 2:68. The relationship between Browning and Story was sketched in an article by DiFederico and Markus, "Influence of Robert Browning on William Wetmore Story."

8. Browning playfully referred to himself in a letter to Story as "SCULPTOR & poet." See Robert Browning to Mr. and Mrs. William Wetmore Story, March 19, 1862, in Hudson, *Browning to his American Friends*, 101.

9. My thinking here has been stimulated by Elliot Gilbert's paper, "No Originals, Only Copies," delivered at the Humanities Institute symposium, University of California at Davis, May 24, 1988.

10. William Wetmore Story, "A Contemporary Criticism" in *Graffiti D'Italia*, p. 131. First published in *Fortnightly Review* 3 (1866):330–36.

11. French sculptor James Pradier had displayed a sensuous *Phryne* in the Salon of 1845. Pradier used the controversial technique of coloring the marble in order to distinguish his work from the cool remoteness of the neoclassical style. See *Statues de Chair, Sculptures de James Pradier*, 137–40.

12. Story, "Praxiteles and Phryne," in *Graffiti D'Italia*, 201–3. Compare Keats' "Ode on a Grecian Urn," in, for example, M. H. Abrams, ed., *The Norton Anthology of English Literature* (New York: W. W. Norton, 1982), 822–23.

13. James, *William Wetmore Story*, 2:231–32.

14. Story, "Ginevra da Siena," in *Graffiti D'Italia*, 3–79.

15. James, *William Wetmore Story*, 2:193–94.

16. On Story's visit to Paris before Pradier's death, see ibid. 1:219. On Story's acquaintance with Rossetti, see Browning's greetings to the Storys from

Rossetti in a letter, September 5, 1863, in Hudson, *Browning to his American Friends*, 128–29.

17. James, *William Wetmore Story*, 2:75.

18. *The Lybian Sibyl*, whose prototype in Michaelangelo's Sistine Chapel ceiling had been illustrated in the London *Art-Journal* in 1859, was a massive female figure, a powerful visionary. As Story described the sculpture, it represented not beauty but strength. It had "nothing of the Venus in it, but, as far as I could make it, luxuriant and heroic." Yet Story, on the eve of the American Civil War, used this heroic female figure to express a tragic theme. "She is looking out of her black eyes into futurity and sees the terrible fate of her race. This is the theme of the figure—Slavery on the horizon, and I made her head as melancholy and severe as possible." (James, *William Wetmore Story*, 2:71.) Harriet Beecher Stowe claimed that Story had based his sculpture on her account of the powerful abolitionist and women's rights orator, Sojourner Truth. (Harriet Beecher Stowe, "Sojourner Truth, the Libyan Sibyl," *Atlantic Monthly* 11 (April 1863):473–81.) However, Story's figure forecast not triumph but enslavement and expressed not power but melancholy.

19. See Gerdts, "William Wetmore Story," 20.

20. Henry Wilson Herbert, "Antony and Cleopatra," *Graham's Magazine* 41 (August 1852):133–39.

21. Jameson, *Memoirs of Celebrated Female Sovereigns*, 1:46.

22. William Gilmore Simms, "Fragment," quoted in Mrs. Starr King, "Cleopatra, the Queen, the Mistress, the Suicide," *Cosmopolitan Art Journal* 3 (December 1858):42.

23. Herbert, "Antony and Cleopatra," 133–39.

24. *Venus Anadyomene* (1860) was a

small classical nude that was originally made as a prank to test the perceptiveness of an archaeologist friend. See the very useful discussion of these sculptures in Seidler [Ramirez], *Career of William Wetmore Story*, 1:278–82, 318–45, 352–59.

25. Hawthorne, *French and Italian Notebooks*, 73.

26. "The Mother of Napoleon," *Art-Journal* n.s. 4 (1852):272.

27. *Statues de Chair, Sculptures de James Pradier*, 171–76.

28. Story created his own mournful, seated *Sappho* in 1863. See Ramirez, "'Lovelorn Lady'."

29. Such narratives have struck twentieth-century viewers as unconvincing, but an understanding of their interpretive framework reinfuses them with urgency. See, for example, Gardner's undisguised impatience with Story's literary qualities in "William Story and Cleopatra."

30. Edward E. Hale, *Ninety Days' Worth of Europe* (Boston: Walker, Wise, and Company, 1861), 142–43.

31. On the *Venus de Medici*, Hale commented, "if you would throw in Powers's 'California' with a good copy, I had rather have the two than the original." Hale also explained to his Boston viewers the dimensions of St. Peter's Cathedral by superimposing its floorplan on a map of the Boston Common. Ibid., 95, 128.

32. Letter from Story to Enrico Nencioni, undated (ca. 1880), Berg Collection, cited by Seidler [Ramirez] in *Career of William Wetmore Story*, 2:556n.

33. Hawthorne, *Marble Faun*, 121, 130, 127.

34. Ibid., 126–27.

35. Story, "Cleopatra" in *Graffiti D'Italia*, 147–54.

36. William W. Story to Charles Eliot Norton, May 3, 1862, quoted in James,

William Wetmore Story, 2:72.

37. See Seidler [Ramirez], *Career of William Wetmore Story*, 2:442.

38. William W. Story to Charles Eliot Norton, August 15, 1861, quoted in James, *William Wetmore Story*, 2:70.

39. "Sculpture: The Dublin Exhibition of 1865," *Temple Bar* 15 (November 1865):51, quoted in Seidler [Ramirez], *Career of William Wetmore Story*, 2:544n. *The Spectator*, June 1868, quoted in ibid., 2:444.

40. [Osgood], "American Artists in Italy," 423.

41. Quoted in Phillips, *Reminiscences of William Wetmore Story*, 153.

42. Story, "Cassandra," *Graffiti D'Italia*, 158–59.

43. For drawing this to my attention I would like to thank Seymour Howard.

44. [Walker], "American Studios in Rome and Florence," 101.

45. William Wetmore Story, *Roba di Roma*, 1:228.

46. Lisle Lester, "Adelaide Capranica Marchesa del Grilla Nata Ristori," *Frank Leslie's Popular Monthly* 19 (March 1885):257–62.

47. Adelaide Ristori, *Studies and Memoirs, and Autobiography* (Boston: Roberts Brothers, 1888), 197–98, 201.

48. Ristori, *Studies and Memoirs*, 206–7, 211–12.

49. *Ibid.*, 212, 215, 220–21.

50. *Boston Gazette* [?], November 1866, clipping in Harvard Theater Collection, Harvard University.

51. William Winter, "Adelaide Ristori," in James Parton, et. al., *Eminent Women of the Age* (Hartford, Conn.: S. M. Betts, 1869), 446–47.

52. [Kate Fields], "Ristori," *Harper's New Monthly Magazine* 34 (May 1867): 752.

53. Levine, "William Shakespeare and the American People," 34ff. Expanded in Levine, *Highbrow/Lowbrow*.

54. "The Theatres, &c," unidenti-

fied clipping, July 19, 1866, in Harvard Theater Collection, Harvard University.

55. Robert B. Brough, *Medea; or, the Best of Mothers, with a Brute of a Husband: A Burlesque in One Act* (London: Thomas Hailes Lacy, n.d.), 9, 16.

56. Story, *Excursions in Art and Letters*, 241.

57. "Nicaise de Keyser, modern painter of Belgium," *Art-Journal* n.s. 5 (1866):8.

58. See Ramirez' catalog entry on *Medea* in Greenthal, Kozol, and Ramirez, *American Figurative Sculpture*, 126.

59. [Walker], "American Studios in Rome and Florence," 101. [Benjamin], "Sculpture in America," 668.

60. See Ramirez' catalog entry on *Medea* in Greenthal, Kozol, and Ramirez, *American Figurative Sculpture*, 126.

61. [Benjamin], "Sculpture in America," 668.

62. Strahan [Shinn], *Masterpieces of the Centennial International Exhibition*, 215–16.

63. Described in ibid., 201.

64. William Dean Howells, "A Sennight of the Centennial," *Atlantic Monthly* 38 (July 1876):93.

65. [Benjamin], "Sculpture in America," 668.

66. Strahan [Shinn], *Masterpieces of the Centennial International Exhibition*, 66.

67. "Ce n'est qu'un tableau de genre, mais Gulliver ne l'aurait pu trouver que dans le pays des géants de Brodignac. Il y a là une disproportion énorme entre l'effort et le résultat. Le peintre a frappé fort au lieu de frapper juste, et pourtant la force et le talent sont incontestables." Anatole de Montaiglon, "Salon de 1875," *Gazette des Beaux-Arts* ser. 2, v. 11 (1875):502.

68. Strahan [Shinn], *Masterpieces of the Centennial International Exhibition*, 67.

69. Ibid., 214.

70. As reported in ibid., 214.

CONCLUSION: GENDER AND POWER

1. See the discussion of Saint-Gaudens and MacMonnies in Taft, *History of American Sculpture*, for a reflection of turn-of-the-century views about sculpture. See also Louise Hall Tharp, *Saint-Gaudens and the Gilded Age* (Boston: Little, Brown, 1969), and Walter Muir Whitehall, "The Vicissitudes of Bacchante in Boston," *New England Quarterly* 27 (December 1954):435–54.

2. See Aileen S. Kraditor, *Ideas of the Woman Suffrage Movement 1890–1920* (New York: Columbia University Press, 1965).

3. Hamlin Garland, *The Rose of Dutcher's Coolley* (New York: Harper, 1899). See such works as William Dean Howells, *A Modern Instance* (Boston: James R. Osgood, 1882) and Theodore Dreiser, *Sister Carrie* (New York: Doubleday and Page, 1900).

4. [Samuel Osgood], "Our Daughters," *Harper's New Monthly Magazine* 16 (December 1857):77.

5. See Joan Riviere, "Womanliness as a Masquerade," (1929) in Victor Burgin, James Donald and Cora Kaplan, eds., *Formations of Fantasy* (London: Methuen), 35–44.

6. See Stephen Heath, "Difference," *Screen* 19 (Autumn 1978):53–55.

7. See Smith-Rosenberg, "The Hysterical Woman," 652–78. Also see Showalter, *Female Malady*. See also the very different discussion of the hysteric in Cixous and Clement, *Newly Born Woman*, 3–39.

8. See Auerbach's persuasive discussion of female transformations in Victorian art and literature in *Woman and the Demon*, chaps. 1 and 3.

Selected Bibliography

NINETEENTH-CENTURY
AMERICAN CULTURE

Ahlstrom, Sydney. *A Religious History of the American People*. New Haven and London: Yale University Press, 1972.

Ahlstrom, Sydney E., and Jonathan S. Carey. *An American Reformation: a Documentary History of Unitarian Christianity*. Middletown, Conn.: Wesleyan University Press, 1985.

Allen, Virginia. *The Femme Fatale, Erotic Icon*. Troy, N.Y.: Whitston, 1983.

Ariès, Philippe. *Western Attitudes toward DEATH: From the Middle Ages to the Present*. Trans. Patricia M. Ranum. Baltimore: Johns Hopkins University Press, 1974.

Auerbach, Nina. *Woman and the Demon: The Life of a Victorian Myth*. Cambridge, Mass.: Harvard University Press, 1982.

Bade, Patrick. *Femme Fatale: Images of Evil and Fascinating Women*. New York: Mayflower, 1979.

Berger, John. *Ways of Seeing*. London: Penguin, 1972.

Bourdieu, Pierre. "Cultural Reproduction and Social Reproduction." In *Knowledge, Education and Cultural Change: Papers in the Sociology of Education*, ed. Richard Brown. London: Tavistock, 1973.

———. *Distinction: A Social Critique of the Judgement of Taste*. Trans. Richard Nice. Cambridge, Mass.: Harvard University Press, 1984.

Branca, Patricia. "Image and Reality: The Myth of the Idle Victorian Woman." In *Clio's Consciousness Raised: New Perspectives on the History of Women*, ed. Mary S. Hartman and Lois Banner, 179–91. New York: Harper & Row, 1974.

Cixous, Helene, and Catherine Clement. *The Newly Born Woman*. Minneapolis: University of Minnesota Press, 1986.

Cott, Nancy. "Passionlessness: An Interpretation of Victorian Sexual Ideology." *Signs* 4 (1978): 219–36.

de Lauretis, Teresa. *Alice Doesn't: Feminism, Semiotics, Cinema*. Bloomington: Indiana University Press, 1984.

Degler, Carl. *At Odds: Women and the Family in America from the Revolution to the Present*. New York: Oxford University Press, 1980.

Dijkstra, Bram. *Idols of Perversity: Fantasies of Feminine Evil in Fin-de-Siecle Culture*. New York: Oxford University Press, 1986.

DiMaggio, Paul. "Cultural Entrepreneurship in Nineteenth-Century Boston: The Creation of an Organizational Base for High Culture in America." *Media, Culture and Society* 4 (1982): 33–50.

Douglas, Ann. *The Feminization of American Culture*. New York: Alfred A. Knopf, 1977.

———. "Heaven Our Home: Consolation Literature in the Northern United States, 1830–1880." *American Quarterly* 26 (December 1974):496–515.

Fiedler, Leslie. *Love and Death in the American Novel.* Rev. Ed. New York: Stein and Day, 1966.

French, Stanley. "The Cemetery as Cultural Institution: The Establishment of Mount Auburn and the 'Rural Cemetery' Movement." In *Death In America,* ed. David E. Stannard. [Philadelphia]: University of Pennsylvania Press, 1975.

Fryer, Judith. *The Faces of Eve, Women in the Nineteenth-Century American Novel.* New York: Oxford University Press, 1976.

Gay, Peter. *Education of the Senses: The Bourgeois Experience, Victoria to Freud.* Vol. 1. New York: Oxford University Press, 1984.

———. *The Tender Passion: The Bourgeois Experience, Victoria to Freud.* Vol. 2. New York: Oxford University Press, 1986.

———. "Victorian Sexuality: Old Texts and New Insights." *American Scholar* 49 (Summer 1980):372–78.

Gilbert, Sandra, and Susan Gubar. *The Madwoman in the Attic: The Woman Writer and the Nineteenth-Century Literary Imagination.* New Haven and London: Yale University Press, 1979.

Gordon, Michael, ed. *The American Family in Social-Historical Perspective.* 3d ed. New York: St. Martin's, 1983.

Gorer, Geoffrey. "The Pornography of Death." In *Death, Grief, and Mourning.* New York: Doubleday, 1965.

Haller, John S., and Robin M. Haller. *The Physician and Sexuality in Victorian America.* Champaign, Ill.: University of Illinois Press, 1974.

Halttunen, Karen. *Confidence Men and Painted Women: A Study of Middle-Class Culture in America, 1830–1870.* New Haven and London: Yale University Press, 1982.

Heath, Stephen. "Difference." *Screen* 19 (Autumn 1978):53–55.

Howe, Daniel Walker. *The Unitarian Conscience: Harvard Moral Philosophy, 1805–1861.* 1970. Rpt. Middletown, Conn.: Wesleyan University Press, 1988.

Hutchinson, William R. *The Transcendentalist Ministers: Church Reform in the New England Renaissance.* New Haven and London: Yale University Press, 1959.

Hyman, Linda. "*The Greek Slave* by Hiram Powers: High Art as Popular Culture." *College Art Journal* 35 (Spring 1976): 216–23.

Jacobus, Mary. *Reading Women: Essays in Feminist Criticism.* New York: Columbia University Press, 1986.

Jameson, Mrs. [Anna]. *Memoirs of Celebrated Female Sovereigns.* 2 vols. London: Henry Colburn and Richard Bentley, 1831.

Jeffrey, Kirk. "The Family as Utopian Retreat from the City." In *The Family, Communes, and Utopian Societies,* ed. Sallie TeSelle, 21–41. New York: Harper & Row, 1972.

Jehlen, Myra. "Archimedes and the Paradox of Feminist Criticism." *Signs* 6 (Summer 1981):575–601.

Kappeler, Suzanne. *The Pornography of Representation.* Minneapolis: University of Minnesota Press, 1986.

Kelley, Mary. "The Sentimentalists: Promise and Betrayal in the Home." *Signs* 4 (Spring 1979):434–46.

Kennedy, J. Gerald. *Poe, Death, and the Life of Writing.* New Haven and London: Yale University Press, 1987.

Kingsbury, Martha. "The Femme Fatale and Her Sisters." In *Woman as Sex Object: Studies in Erotic Art, 1730–1970.* Art News Annual 38, ed. Hess Thomas B. and Linda Nochlin. New York: Newsweek, 1972.

Kolodny, Annette. "Dancing Through the Minefield: Some Observations on

the Theory, Practice, and Politics of a Feminist Literary Criticism." *Feminist Studies* 6 (1980):1–25.

——— . *The Land Before Her: Fantasy and Experience of the American Frontiers, 1630–1860*. Chapel Hill: University of North Carolina Press, 1984.

——— . "Turning the Lens on 'The Panther Captivity': A Feminist Exercise in Practical Criticism." *Critical Inquiry* 8 (Winter 1981): 329–45.

Levine, Lawrence W. *Highbrow/ Lowbrow: The Emergence of Cultural Hierarchy in America*. Cambridge, Mass.: Harvard University Press, 1988.

——— . "William Shakespeare and the American People: A Study in Cultural Transformation." *American Historical Review* 89:1 (February 1984): 34–66.

Lewis, R. W. B. *The American Adam: Innocence, Tragedy, and Tradition in the Nineteenth Century*. Chicago: University of Chicago Press, 1955.

Mulvey, Laura. "Visual Pleasure and Narrative Cinema." *Screen* 16 (Autumn 1975).

Nissenbaum, Stephen. *Sex, Diet, and Debility in Jacksonian America*. Westport, Conn.: Greenwood Press, 1980.

Norton, Frank H., ed. *Frank Leslie's Historical Register of the United States Centennial Exposition, 1876*. New York: Frank Leslie's, 1877.

Panofsky, Dora, and Erwin Panofsky. *Pandora's Box: the Changing Aspects of a Mythical Symbol*. Bollingen Series 52. New York: Pantheon, 1956.

Penny, Nicholas. *Church Monuments in Romantic England*. New Haven and London: Yale University Press, 1977.

——— . "English Church Monuments to Women who Died in Childbed Between 1780 and 1835." *Journal of the Warburg and Courtauld Institutes* 38 (1975): 314–32.

Pessen, Edward. *Riches, Class and Power Before the Civil War*. Lexington, Mass.: D. C. Heath, 1973.

Phillips, J. A. *Eve: The History of an Idea*. San Francisco: Harper & Row, 1984.

Praz, Mario. *The Romantic Agony*. 2d ed. 1951. Rpt. London: Oxford University Press, 1970.

Rosenberg, Charles E. "Sexuality, Class and Role in Nineteenth-Century America." *American Quarterly* 25 (May 1973): 131–53.

Said, Edward. *Orientalism*. New York: Pantheon, 1978.

Sandhurst, Phillip T., and others. *The Great Centennial Exhibition*. Philadelphia: P. W. Ziegler, 1876.

Saum, Lewis O. "Death in the Popular Mind of Pre-Civil War America." In *Death in America*, ed. David E. Stannard. Philadelphia: University of Pennsylvania Press, 1975.

Scott, Joan W. "Gender: A Useful Category of Historical Analysis." *The American Historical Review* 91:5 (December 1986): 1053–75.

Showalter, Elaine. *The Female Malady: Women, Madness and Culture in England, 1830–1980*. New York: Pantheon, 1985.

Slotkin, Richard. *Regeneration Through Violence: The Mythology of the American Frontier, 1600–1860*. Middletown, Conn.: Wesleyan University Press, 1973.

Smith-Rosenberg, Carroll. *Disorderly Conduct: Visions of Gender in Victorian America*. New York: Alfred A. Knopf, 1985.

——— . "The Hysterical Woman: Sex Roles and Role Conflict in Nineteenth-Century America." *Social Research* 39 (Winter 1972):652–78.

Smith-Rosenberg, Carroll, and Charles Rosenberg. "The Female Animal:

Medical and Biological Views of Woman and Her Role in Nineteenth-Century America." *Journal of American History* 60 (September 1973): 332–56.

Stone, Lawrence. *The Family, Sex and Marriage in England 1500–1800*. New York: Harper and Row, 1977.

Strahan, Edward [Earl Shinn]. *The Masterpieces of the Centennial International Exhibition*. Illustrated Vol. 1, Fine Art. Philadelphia: Gebbie & Barrie, 1875.

Swan, Mabel Munson. *The Athenaeum Gallery, 1827–1873: The Boston Athenaeum as an Early Patron of Art*. Boston: Boston Athenaeum, 1940.

Thomas, Clara. *Love and Work Enough: The Life of Anna Jameson*. Toronto: University of Toronto Press, 1967.

Tompkins, Jane. *Sensational Designs: The Cultural Work of American Fiction*. New York: Oxford University Press, 1985.

Türck, Hermann. "The Myths of Pandora and the Fall of Man." In *The Man of Genius*, trans. George J. Tamson. 1896. Rpt. London: Adam and Charles Black, 1914.

Welter, Barbara. "The Cult of True Womanhood." *American Quarterly* 18 (Summer 1966):151–74.

————. "Female Complaints: Medical Views of American Women (1790–1865)." In *Dimity Convictions: The American Woman in the Nineteenth Century*, 57–70. Athens, Ohio: Ohio University Press, 1976.

Wolff, Janet. *The Social Production of Art*. London: Macmillan, 1981.

AMERICAN IDEAL SCULPTURE

Albee, John. *Henry Dexter, Sculptor, A Memorial*. Cambridge, Mass.: John Wilson and Son, 1898.

American Art Association. *Catalogue of the A. T. Stewart Collection*. New York: J. J. Little, 1887.

Artistic Houses, Being a Series of Interior Views of a Number of the Most Beautiful and Celebrated Homes in the United States, With a Description of the Art Treasures Contained Therein. 2 vols. New York: D. Appleton, 1883–84.

Atkinson, J. Beavington. "Modern Sculpture of all Nations, in the International Exhibition, 1862." *Art-Journal Illustrated Catalogue of the International Exhibition 1862*. 1862. Rpt. East Ardley, Wakefield: E. P. Publishing, 1973.

Barnett, Louise K. "American Novelists and the Portrait of Beatrice Cenci." *New England Quarterly* 53 (June 1980):168–83.

"The Beatrice Cenci." *The Crayon* 4 (December 1857):379.

Bellows, Henry W. "Seven Sittings with Powers, the Sculptor." *Appleton's Journal of Popular Literature, Science, and Art* (June 12, 19, 26, July 10, August 7, 28, September 11, 1869).

[Benjamin, Daniel G. W.] "Sculpture in America." *Harper's New Monthly Magazine* 68 (April 1879):657–72.

[Bigelow, L. J.] "Palmer, the American Sculptor." *The Continental Monthly* 5 (1864): 263.

Booth, Rosemary. "A Taste for Sculpture." In *A Climate for Art: The History of the Boston Athenaeum Gallery, 1827–1873*. Boston: Thomas Todd, 1980.

[Brackett, Edward Augustus]. *Brackett's Works*. Boston: n.p., 1844.

————. *Twilight Hours; or Leisure Moments of an Artist*. Boston: Freeman and Bolles, 1845.

————. *My House; Chips the Builder Threw Away*. Boston: Richard G. Badger, Gorham, 1904.

Carr, Cornelia, ed. *Harriet Hosmer: Letters and Memories*. New York: Moffat, Yard, 1912.

Carved and Modeled: American Sculpture, 1810–1940. April 20–June 4, 1982. New York: Hirschl & Adler Galleries, 1982.

Catalogue of Marble Statuary, Comprising Eleven Pieces by the late Joseph Mozier, esq New York: n.p., 1873.

Catalogue of the Palmer Marbles at the Hall Belonging to the Church of the Divine Unity, 548 Broadway, New York, November 1856. Albany: J. Munsell, 1856.

Child, L. Maria. "Harriet E. Hosmer: A Biographical Sketch." *The Ladies' Repository* 21 (January, 1861):5.

———. "Miss Harriet Hosmer." *Littell's Living Age* 56 (March 13, 1868):697.

Civosky, Nicolai Jr., Marie H. Morrison, and Carol Ockman. *The White, Marmorean Flock*. Introduction by William H. Gerdts, Jr. Catalog of an Exhibition at Vassar College Art Gallery, April 4–April 30, 1972, Poughkeepsie, New York.

Clark, Kenneth. *The Nude: A Study in Ideal Form*. Bollingen Series 35.2. New York: Pantheon, 1956.

Clark, T. J. *The Painting of Modern Life: Paris in the Art of Manet and His Followers*. Princeton: Princeton University Press, 1984.

Clark, William J., Jr. *Great American Sculptures*. Philadelphia: Gebbie & Barrie, 1878.

Crane, Sylvia. *White Silence: Greenough, Powers, and Crawford, American Sculptors in Nineteenth-Century Italy*. Coral Gables, Fla.: University of Miami Press, 1972.

Craven, Wayne. *Sculpture in America*. New York: Thomas Y. Crowell, 1968.

Crawford, John S. "The Classical Tradition in American Sculpture:

Structure and Surface." *American Art Journal* 11 (July 1979): 38–54.

Curran, Joseph L. "Hosmeriana: A Guide to Works by and about Harriet G. Hosmer." 1975.

Dewey, Orville. "Powers' Statues." *Union Magazine of Literature and Art* 1 (October 1847): 160–61.

DiFederico, Frank R., and Julia Markus. "The Influence of Robert Browning on the Art of William Wetmore Story." *Browning Institute Studies* 1 (1973):63–85.

Duganne, Augustin. "Ode to the Greek Slave, Dedicated to the Cosmopolitan Art and Literary Association." In *The Cosmopolitan Art Association Illustrated Catalogue, 1854*, 25. New York: John A. Gray, 1854.

Dunlap, William. *History of the Rise and Progress of the Arts of Design in the United States*, ed., with additions, Frank W. Bayley and Charles Goodspeed. 3 vols. (1834. Rpt. Boston: C. E. Goodspeed, 1918).

Dwight, John S. "The Greek Slave." *The Harbinger* 7 (July 8, 1848).

Edward A. Brackett's Marble Group of the Shipwrecked Mother and Child [New York]: n.p., n.d.

"Edward S. Bartholomew." *Cosmopolitan Art Journal* 2 (September 1858): 184–85.

Ellet, Mrs. *Women Artists in All Ages and Countries*. New York: Harper & Brothers, 1859.

"Florentia." "A Walk Through the Studios of Rome." *The Art Journal* n.s. 6 (1854): 184–87, 287–89, 322–24, 350–55, and *The Art-Journal* n.s. 1 (1855):225–28.

[Fryd], Vivien Green. "Hiram Powers's *Greek Slave*, Emblem of Freedom." *American Art Journal* 14 (Autumn 1982): 31–39.

———. "Two Sculptures for the Capitol: Horatio Greenough's *Rescue*

and Luigi Persico's *Discovery of America*," *American Art Journal* 19:2 (1987):16–39.

Fusco, Peter, and H. W. Janson, eds. *The Romantics to Rodin: French Nineteenth-Century Sculpture from American Collections*. Los Angeles, Calif.: Los Angeles County Art Museum and George Braziller, 1980.

Gale, Robert L. *Thomas Crawford, American Sculptor*. [Pittsburgh]: University of Pittsburgh Press, 1964.

Gardner, Albert TenEyck. *American Sculpture: A Catalogue of the Collection of the Metropolitan Museum of Art*. New York: Metropolitan Museum of Art, 1965.

———. "Memorials of an American Romantic." *Metropolitan Museum of Art Bulletin* new series 3 (October 1944): 54–59.

———. "William Story and Cleopatra." *Metropolitan Museum of Art Bulletin* n.s. 2 (December 1943): 147–52.

Gerdts, William. *American Neoclassic Sculpture: The Marble Resurrection*. New York: Viking, 1973.

———. "American Sculpture: The Collection of James H. Ricau." *Antiques* 86 (September 1964): 291–98.

———. "Chauncey Bradley Ives, American Sculptor." *Antiques* 94 (November 1968):714–18.

———. *The Great American Nude: A History in Art*. New York: Praeger, 1974.

———. "Marble and Nudity." *Art in America* 59 (June 1971):60–67.

———. "The Marble Savage." *Art in America* (July/August 1974): 64–70.

———. "The *Medusa* of Harriet Hosmer." *Bulletin of the Detroit Institute of Arts* 56 (1978): 96–107.

———. *A Survey of American Sculpture: Late Eighteenth Century to 1962*. Newark, N.J.: Newark Museum, 1962.

———. "William Wetmore Story." *American Art Journal* 4 (November 1972):16–33.

Gombrich, E. H. *Art and Illusion: A Study in the Psychology of Pictorial Representation*. The A. W. Mellon Lectures in the Fine Arts, 1956. National Gallery of Art, Washington, D.C. Princeton: Princeton University Press, 1960.

Greenthal, Kathryn, Paula M. Kozol, and Jan Seidler Ramirez. *American Figurative Sculpture in the Museum of Fine Arts Boston*. Boston: Museum of Fine Arts, 1986.

Groseclose, Barbara. "Harriet Hosmer's Tomb to Judith Falconnet: Death and the Maiden." *American Art Journal* 12 (Spring, 1980):78–89.

"Harriet Hosmer." *Cosmopolitan Art Journal* 3 (December 1859): 216.

"Harriet Hosmer, the Woman Eminent in Sculpture." *The Phrenological Journal and Life Illustrated* 54 (March 1872):169–71.

Harris, Neil. *The Artist and American Society: The Formative Years, 1790–1860*. New York: George Braziller, 1966.

Hennessey, William J. "White Marble Idealism: Four American Neo-Classical Sculptors." *Worcester Art Museum Bulletin*, n.s. 2 (November 1972): 1–9.

Hiram Powers' Paradise Lost. New York: Hudson River Museum. 1985.

Hudson, Gertrude Reese, ed. *Browning to His American Friends: Letters Between the Brownings, the Storys, and James Russell Lowell, 1841–1890*. New York: Barnes and Noble, 1965.

Hyman, Linda. "*The Greek Slave* by Hiram Powers: High Art as Popular Culture." *College Art Journal* 35 (Spring 1976): 216–23.

James, Henry. *William Wetmore Story and His Friends*. 2 vols. Boston: Houghton Mifflin, 1903.

Janson, H. W. *Nineteenth-Century Sculpture*. New York: Harry N. Abrams, 1985.

"Joseph Mozier." *The Art-Journal* n.s. 10 (1871):6.

Kellogg, Miner. *Justice to Hiram Powers: Address to the Citizens of New Orleans, 1848.* Cincinnati, 1848.

————. *Mr. Miner K. Kellogg to His Friends*. Paris: Simon Racon, 1858.

L. E. "To Powers' 'Greek Slave.' " *The Cosmopolitan Art Journal* 2 (March and June 1858), 68.

Leach, Joseph. "Harriet Hosmer: Feminist in Bronze and Marble." *Feminist Art Journal* 5 (Summer 1976): 9–13 and 44–45.

Leland, Charles G. "Brackett's Wreck." *Sartain's Magazine* 6 (May 1850): 370–74.

Lester, C. Edwards. *The Artist, the Merchant, and the Statesman, of the Age of the Medici, and of our Own Times.* 2 vols. New York: Paine & Burgess, 1845.

Lewis, E. Anna. "Art and Artists of America: Hiram Powers." *Graham's Magazine* 48 (November 1855):397–401.

[Ludlow, FitzHugh]. "Art: Harriet Hosmer's Zenobia." *The Atlantic Monthly* 15 (February 1865):248–50.

"Masters of Art and Literature: Chauncey B. Ives." *Cosmopolitan Art Journal* 4 (December 1860): 163–64.

Miller, Lillian B. *Patrons and Patriotism: The Encouragement of the Fine Arts in the United States, 1790–1860.* Chicago: University of Chicago Press, 1966.

"Miss Louisa Lander's Work." *Cosmopolitan Art Journal* 4 (March 1860): 31.

" 'Most Famous of American Women Sculptors,' Miss Harriet Hosmer of Watertown." *Boston Sunday Globe.* March 1, 1908:11.

Nochlin, Linda. "Eroticism and Female Imagery in Nineteenth-Century Art." In *Woman as Sex Object: Studies in Erotic Art, 1730–1970.* Art News Annual 38, ed. Thomas B. Hess and Linda Nochlin. New York: Newsweek, 1972.

[Osgood, Samuel]. "American Artists in Italy." *Harper's New Monthly Magazine* 41 (August 1870):420–25.

Palmer, Erastus Dow. "Philosophy of the Ideal." *Crayon* 3 (January 1856): 18–20.

"The Palmer Marbles." *Cosmopolitan Art Journal* 1 (March 1857):85.

"The Palmer Marbles." *The Crayon* 4 (January 1857):18–19.

Palmer's Statue: The White Captive, on Exhibition at Schaus' Gallery, 629 Broadway. n.p., n.d.

"Palmer's 'White Captive.' " *The Atlantic Monthly* 5 (January, 1860): 108–9.

Phillips, Mary E. *Reminiscences of William Wetmore Story.* Chicago: Rand, McNally, 1897.

"Powers' Greek Slave." *Putnam's Monthly Magazine* 4 (December 1854):666.

Powers' Statue of the Greek Slave. New Orleans: Norman's 1848.

Powers' Statue of the Greek Slave. New York: R. Craighead, 1847.

Powers' Statue of the Greek Slave, Exhibiting at the Pennsylvania Academy of the Fine Arts. Philadelphia: T. K. and P. G. Collins, 1848.

[Ramirez], Jan Seidler. *A Critical Reappraisal of the Career of William Wetmore Story (1819–1895): American Sculptor and Man of Letters.* Ph.D. diss., Boston University, 1985.

————. "The 'Lovelorn Lady': A New Look at William Wetmore Story's *Sappho.*" *American Art Journal* 14 (Summer 1983): 80–90.

[Ramirez], Jan Seidler, and Kathryn Greenthal. *The Sublime and the*

Beautiful: Images of Women in American Sculpture, 1840–1930. Boston: Museum of Fine Arts, 1979.

Read, Benedict. *Victorian Sculpture.* New Haven and London: Yale University Press. Published for the Paul Mellon Centre for Studies in British Art, 1982.

Reynolds, Donald Martin. *Hiram Powers and His Ideal Sculpture.* New York: Garland, 1977.

———. "The 'Unveiled Soul': Hiram Powers' Embodiment of the Ideal." *The Art Bulletin* 59 (September 1977): 394–414.

Roberson, Samuel A., and William H. Gerdts. "'. . . So Undressed, Yet So Refined . . .' The Greek Slave." *The Museum* 17 (Winter–Spring, 1965): 1–29.

Rogers, Millard F., Jr. *Randolph Rogers, American Sculptor in Rome.* Amherst: University of Massachusetts Press, 1971.

Roos, Jane Mayo. "Another Look at Henry James and the 'White, Marmorean Flock.'" *Women's Art Journal* 4 (Spring/Summer 1983):29–34.

Rosenblum, Robert. "Caritas Romana after 1760: Some Romantic Lactations." In *Woman As Sex Object: Studies in Erotic Art, 1730–1970.* Art News Annual 38, ed. Thomas B. Hess and Linda Nochlin. New York: Newsweek, 1972.

Rosenblum, Robert, and H. W. Janson. *Nineteenth-Century Art.* Englewood Cliffs, N.Y.: Prentice-Hall, and New York: Harry N. Abrams, 1984.

Rusk, William Sener. *William Henry Rinehart, Sculptor.* Baltimore: Norman T. A. Munder, 1939.

[Sanborn, Frank]. "The Late Edward Brackett and How He Made the Marble Bust of John Brown." *Boston Evening Transcript*, March 23, 1908.

Reprinted from the *Springfield Republican.*

Scharf, Frederic A. "'A More Bracing Morning Atmosphere': Artistic Life in Salem, 1850–1859." *Essex Institute Historical Collections* 95 (April, 1959): 149–64.

———. "The Garden Cemetery and American Sculpture: Mount Auburn." *Art Quarterly* 24 (Spring 1961):80–88.

Sheirr, Rodman J. "Joseph Mozier and His Handiwork." *Potter's American Monthly* 6 (January 1876):26.

Sigourney, L. H. "Virginia Dare." *Graham's Magazine* 41 (October 1852): 442–43.

Statues de Chair, Sculptures de James Pradier (1790–1852) Genève, Musée d'art et d'histoire, 17 octobre 1985-2 février 1986; Paris, Musée du Luxembourg 28 février-4 mai 1986.

Story, William Wetmore. *Excursions in Art and Letters.* 1891. Rpt. Boston: Houghton Mifflin, 1899.

———. *Graffiti D'Italia.* New York: Charles Scribner, 1868.

Strahan, Edward [Earl Shinn]. *The Art Treasures of America* 3 vols. Philadelphia: George Barrie, 1879–82.

———. *The Masterpieces of the Centennial International Exhibition.* Vol. 1. Fine Art. Philadelphia: Gebbie & Barrie, 1875.

Taft, Lorado. *The History of American Sculpture.* New York: Macmillan, 1903.

Taylor, J. Bayard. "The 'Eve' of Powers." *Godey's Magazine and Lady's Book* 34 (1847): 12.

Thorp, Margaret Farrand. *The Literary Sculptors.* Durham, N.C.: Duke University Press, 1965.

Thurston, R. B. "Harriet G. Hosmer." In James Parton, et al., *Eminent Women of the Age.* Hartford, Conn.: S. M. Betts, 1869.

Tuckerman, Henry. *Book of the Artists: American Artist Life*. New York: G. P. Putnam & Son, 1867, 1870.

[————.], "The Sculptor of Albany." *Putnam's Monthly Magazine* (April 1856): 394–400.

Vindication of Hiram Powers in the 'Greek Slave' Controversy. Cincinnati: Office of the Great West, 1849.

W. H. F. "Art Review, The Greek Slave." *The Harbinger* 7 (June 24, 1848):62.

[Walker, Katharine C.]. "American Studios in Rome and Florence." *Harper's New Monthly Magazine* 33 (June 1866):101–5.

Wallace, David H. *John Rogers, The People's Sculptor*. Middletown, Conn.: Wesleyan University Press, 1967.

Waller, Susan. "The Artist, the Writer, and the Queen: Hosmer, Jameson, and *Zenobia*." *Woman's Art Journal* 4 (Spring/Summer 1983):21–28.

Webster, J. Carson. *Erastus D. Palmer.* Newark: University of Delaware Press, 1983.

Wright, Nathalia. *Horatio Greenough: The First American Sculptor*. Philadelphia: University of Pennsylvania Press, 1963.

Wright, Nathalia, ed. *Letters of Horatio Greenough, American Sculptor*. University of Wisconsin Press, 1972.

Yarnall, James L., and William H. Gerdts. *The National Museum of American Art's Index to American Art Exhibition Catalogues From the Beginning Through the 1876 Centennial Year*. 5 vols. Boston: G. K. Hall, 1986.

"Zenobia by Harriet Hosmer," ([Boston]: n.p., [1865]), Boston Public Library.

Zenobia, by Harriet Hosmer, Now on Exhibition at the Fine Art Institute, Derby Galleries, No. 625 Broadway, New York (n.p., n.d.). Schlesinger Library, Radcliffe College.

INDEX

Page numbers for figures are in italics.